Speaking
WITH
Hands

PHOTOGRAPHS FROM *The Buhl Collection*

Speaking WITH Hands

PHOTOGRAPHS FROM The Buhl Collection

Jennifer Blessing WITH ESSAYS BY Jennifer Blessing, Kirsten A. Hoving, AND Ralph Rugoff

GuggenheimMUSEUM

Published on the occasion of the exhibition
Speaking with Hands: Photographs from The Buhl Collection
Organized by Jennifer Blessing

Solomon R. Guggenheim Museum, New York
June 4–September 8, 2004

ISBN: 0-89207-301-2 (hardcover)
ISBN: 0-89207-302-0 (softcover)

Guggenheim Museum Publications
1071 Fifth Avenue
New York, New York 10128

Hardcover edition available in the U.S. through
D.A.P./Distributed Art Publishers
155 Sixth Avenue, 2nd floor
New York, New York 10013
Tel: (212) 627-1999; Fax: (212) 627-9484

Design: Bethany Johns
Production: Lara Fieldbinder, Susan McNally, Melissa Secondino
Editorial: Lisa Cohen, Elizabeth Franzen, Laura Morris, Edward Weisberger

Printed in Germany by GZD

Dust jacket and softcover, front: László Moholy-Nagy, *Photogram*, 1925 (page 29); and back: Gary Schneider, *Henry*, 2000 (page 135).

Hardcover, front: Man Ray, *Rayograph with Hand and Egg*, 1922 (page 97); and back: Eugène Ducretet, *X-ray Study of a Hand*, 1897 (page 28).

Title pages: detail of Annette Lemieux, *Transmitting Sound*, 1984 (page 167).

Contents

13 Photophilia
 JENNIFER BLESSING

60 *Plates*

93 "Blond Hands over the Magic Fountain":
 Photography in Surrealism's Grip
 KIRSTEN A. HOVING

114 *Plates*

153 The Telltale Hand
 RALPH RUGOFF

170 *Plates*

198 Catalogue Entries
 MATTHEW S. WITKOVSKY
 with MELANIE MARIÑO *and* NAT TROTMAN

260 Index of Reproductions

Foreword

In 1939 when the Museum of Non-Objective Painting opened, the art on its walls came from the collection of Solomon R. Guggenheim, who had shortly before started a foundation for "the enlightenment of the public." Subsequently the foundation's collection grew through individual acquisitions, but the bequests of the Justin K. Thannhauser and Peggy Guggenheim collections significantly augmented its holdings. The Solomon R. Guggenheim Museum, as the Museum of Non-Objective Painting came to be known, has devoted several exhibitions to important private collections, including that of George Costakis, for example, as well as Patsy R. and Raymond D. Nasher. These exhibitions and their catalogues have given our visitors the opportunity to see less-accessible masterpieces of modern art. Throughout its history, the Guggenheim Museum's staff has been particularly conscious of the character a particular collection can have, and in the process of exhibiting and publishing them we have examined the nature of collecting itself.

Speaking with Hands: Photographs from The Buhl Collection continues that exploration. This exhibition is drawn from one of the world's foremost private collections of photographs, which includes major works in the medium from its inception. In slightly more than ten years, Henry M. Buhl has amassed over one thousand images devoted to the subject of the hand. A sampling of the fruit of his prolific activity is displayed in the exhibition that this catalogue accompanies. Henry's collection spans the history of photography and a comprehensive range of practices, including scientific, journalistic, and fine-art photography, with a strong component of contemporary art. And yet this wide spectrum of images is narrowed by a particular lens, the theme of hands, which is a telling subject for photographic representation. We are grateful to Henry for his generosity in allowing our curator Jennifer Blessing to study and present this unique collection to the public.

Henry's philanthropic activities are wide-ranging; at the same time that he began to seriously collect photographs, he founded the SoHo Partnership and the Association of Community Employment Programs for the Homeless. He is an active supporter of the revitalization of Lower Manhattan as well as other important causes. Shortly after it was formed in 1998, Henry joined our Photography Committee, which he chaired from 2001 to 2003, and we are very grateful for his leadership there. I would like to extend my sincere thanks to Henry M. Buhl for his unflagging commitment to this exhibition and the Guggenheim Museum.

THOMAS KRENS
Director, The Solomon R. Guggenheim Foundation

Preface

Everyone asks me, "Why hands?" As a photographer in the late 1980s, I had been sporadically purchasing photographs and had no specific objective. Howard Greenberg, a trusted advisor and early mentor on collecting photography, had been urging me to focus on one subject or on one period. In 1993 a friend introduced me to Doris Bry, Georgia O'Keeffe's longtime secretary and confidant who owned an Alfred Stieglitz gelatin-silver print of O'Keeffe (*Hands with Thimble*, 1920). Bry wanted to sell her print before a Stieglitz palladium print of the same image was to be sold at Christie's. After consulting with Howard about the authenticity of Bry's offering, I purchased the print two days before Christie's sale on October 8, 1993. The picture was one of the most beautiful images I had ever seen—and still is. It motivated me to look at other photographers' images of hands, which ultimately inspired the theme of The Buhl Collection.

My first selections on this theme seemed obvious, including works by Irving Penn, Richard Avedon, Diane Arbus, Robert Mapplethorpe, Man Ray, Imogen Cunningham, Paul Strand, Ruth Bernhard, and Andy Warhol. As time passed I grew more open to purchasing great images by lesser-known and even anonymous artists. Just two years after I began the collection, Marianne Courville joined me as curator in 1995 and has been most instrumental in collecting contemporary artists. Marianne's keen eye has contributed greatly to this collection.

In 1995 I acquired Tina Modotti's beautiful photograph of a cactus plant resembling a delicate hand (*Flor de manita*, 1925), and this led the way to more abstract images that challenged the theme of hands. Another example of how we have drawn out the subject is William Henry Fox Talbot's *A Stanza from the "Ode to Napoleon" in Lord Byron's Hand* (1840), in which Talbot made a photogenic drawing negative from a contact of the handwritten manuscript by Byron completed in 1811. With no hands visible, this picture still honors the spirit of the theme through handwriting.

I also became interested in works representative of the various ways photographic prints are made, including gelatin silver, platinum, chromogenic, lithograph, daguerreotype, tintype, and inkjet. Perhaps the most enriching part of collecting is how it has awakened me to the immense variety of the creative process no matter what the parameters or themes or focus may be. That has been one of the most surprising and satisfying parts of the process.

For the same number of years as I have been collecting photography, I have also devoted my time and resources to help New York City's recovering homeless population. The SoHo Partnership, TriBeCa Partnership,

and their parent organization, the Association of Community Employment Programs for the Homeless (A.C.E.), have been my parallel passion. It would be impossible not to speak about one without recognizing the other. Artists, possibly more than any other group, continually show me what people can create from and of themselves and that gives me faith that the people we serve in our job-training and placement programs are capable of similar successes.

I want to thank all of the artists who have touched my life and this collection. It is their ultimate expression that makes all of this worthwhile. Over the years I have enjoyed each of the more than one thousand works in my collection, and I wish that every one of these photographs could hang on the walls of the Guggenheim Museum. I thank Thomas Krens, whose vision carried this project from its inception to its fruition, and appreciate Lisa Dennison's support and enthusiasm. It has been a pleasure to work with Jennifer Blessing who organized *Speaking with Hands: Photographs from The Buhl Collection*. I consider her a great curator as well as a friend. My thanks also must go to many dealers, several of whom have become good friends, most notably Howard Greenberg, Peter MacGill, and Nathalie Karg. Blair Rainey has done a great job over the years editing The Buhl Collection calendar and Lorraine DePietro has been very helpful in every aspect of the collection. As mentioned earlier, Marianne Courville has been invaluable in forming this collection, and I appreciate her talent and friendship.

I recently learned that Goethe wrote, "The most happy man from all over the world is the collector." I must agree because I feel blessed to be able to collect, and it is my hope that through the Guggenheim's vision and dedicated assistance, *Speaking with Hands* will allow many others to share in my happiness.

HENRY M. BUHL

Acknowledgments

At first glance a collection of photographs of hands may seem like an unusual or idiosyncratic subject. It is not a standard art-historical theme; it is not linked to chronology or style. But the more I have studied The Buhl Collection, the more I have come to see that hands are a very logical and illuminating subject for a photography collection, and for the person who amassed this one in particular. It is my intention, through this exhibition and its accompanying publication, to show why hands are a significant theme—in many ways uniquely photographic—and also to explore the nature of collecting itself.

In October 1993, Henry M. Buhl purchased a photograph by Alfred Stieglitz of Georgia O'Keeffe's hands. This photograph would come to be the cornerstone of a collection that now includes over one thousand images by the medium's foremost practitioners as well as little-known and emerging artists. In five galleries of the Guggenheim Museum, we will display a selection of more than 170 objects from the collection. The breadth and depth of the collection has made the process of choosing the photographs and deciding how to organize them tremendously challenging, but also incredibly rewarding. I enormously admire Henry for the energy and insight it took to gather so many pictures in such a relatively short time. And I am thankful that he has been so generous as to make them accessible to the public through this exhibition. But I am perhaps most appreciative of his hospitality, the graciousness with which he has shared his passion for this project, and his ongoing commitment and support. Certainly it would not have been possible to realize *Speaking with Hands: Photographs from The Buhl Collection* without Henry's conviction that these photographs should be shown to as broad an audience as possible and his ongoing efforts to facilitate that goal.

The Buhl Collection has an incredibly dedicated curator in Marianne Courville, whose guidance and collaboration have been essential to me. Marianne's sensibility is represented among the collection's acquisitions, but she has also influenced my thinking about the work through her intimate knowledge of individual pieces as well as the conceptual underpinnings of various collection subcategories. I have also benefited on myriad occasions from Curatorial Assistant Lorraine DePietro's genial and helpful efficiency. Blair Rainey, Calendar Editor, has provided indispensable advice as well. It has been my privilege to work with all of The Buhl Collection staff, whose contribution to the realization of this project is immeasurable.

I would like to thank Kirsten A. Hoving and Ralph Rugoff for their thoughtful and thought-provoking catalogue essays. Kirsten's insights on Surrealist photography and Ralph's on contemporary art vitally

illuminate the images in The Buhl Collection. Matthew S. Witkovsky, Melanie Mariño, and Nat Trotman, have contributed informative inter-pretive entries on all of the artists and works in the exhibition. I am grateful for all that I have learned from these colleagues and delighted that readers will have access to the scope of their knowledge. Bethany Johns has designed a wonderful book that manifests the conceptual underpinnings of the exhibition. As ever, it has been a pleasure to work with her, and to marvel at her creativity. Masamichi Udagawa and Sigi Moeslinger of Antenna Design produced an inspiring concept, though yet unrealized, for a handheld-device intervention in the exhibition.

Many individuals have kindly responded to research questions about works in the collection or otherwise provided important advice for which I am sincerely appreciative: Vito Acconci; Janine Antoni; George Baker; Tracey Baran; Tina Barney; Miles Barth; Geoffrey Batchen; Catherine Belloy and William Petroni, Marian Goodman Gallery, New York; Dawoud Bey; Joan Blessing; Mel Bochner; A. P. H.-Christian Bouqueret, Paris; Sarah Bowman; Kay Broker and Alexis Smith, Pace/MacGill Gallery; Adam Boxer; Haan Chau, Casey Kaplan Gallery; Denis Canguilhem; Alison Card, Metro Pictures; Victoria Cuthbert and Katie Lane, Matthew Marks Gallery; Scott B. Davis, Museum of Photographic Arts, San Diego; Jay and Rose Deutsch, Leica Gallery, New York; Rineke Dijkstra; Predrag Dimitrijevic, The Metropolitan Museum of Art; Kathi Doak, Time Inc.; Jeanne Dunning; Edward Earle, International Center of Photography; Margit Erb, Howard Greenberg Gallery; Elliott Erwitt; Natalie Evans, Commerce Graphics; Donna Ferrato; Mia Fineman, The Metropolitan Museum of Art; Monah Gettner, Hyperion Press; Sergio Getzel; Ralph Gibson; Irene Grassi and Robert Mann, Robert Mann Gallery; Sophie Greig, White Cube, London; Joseph Grigely; Vicki Harris and Heather Taylor, Laurence Miller Gallery; Christopher Harty; Mark Haworth-Booth, Victoria and Albert Museum, London; Virginia A. Heckert, Norton Museum of Art, West Palm Beach; Michelle Heinrici, Robert Miller Gallery; Graham Howe; W. M. Hunt, Ricco/Maresca Gallery; Nic Iljine; Steven Kasher; Ivan Kaminoff, Black Star; Nathalie Karg; Annette Lemieux; Natalia Mager, Luhring Augustine Gallery; Raymond W. Merritt; Maki Nanamori, Paula Cooper Gallery; Jennifer Parkinson, Hans P. Kraus, Jr., Inc.; Sheri Pasquarella, Gorney Bravin + Lee; Antony Penrose, Lee Miller Archive, Chiddingly, East Sussex, England; Christopher Phillips, International Center of Photography; Katie Rashid, Rhona Hoffman Gallery, Chicago; Ann-Marie Rounkle, McCarthy Studios, Altadena, California; Julie Saul; Gary Schneider; Michael Senft; Michael Scott, Folger Shakespeare Library, Washington, D.C.; Allan Sekula; David Strettell, Magnum Photos; Leslie Tonkonow; Anne Wilkes Tucker, Museum of Fine Arts, Houston; Lisa Usdan, Gilles Peress Studio;

Frank R. Wilson; and Natica Wilson and Cynthia Honores, Gagosian Gallery, New York.

Many Guggenheim staff members contributed to the success of this exhibition and catalogue. They are each noted in the Project Team on page 259; their talent and dedication is gratefully acknowledged. I am also thankful for the advice and support of colleagues who did not work directly on *Speaking with Hands*. First of all, of course, is Thomas Krens, Director, who has maintained his enthusiasm for this project over the course of several years. Lisa Dennison, Deputy Director and Chief Curator; Anthony Calnek, Deputy Director for Communications and Publishing; and Mark Steglitz, Deputy Director, Finance and Operations, have provided crucial leadership in the realization of both the catalogue and the exhibition. I constantly rely on the wisdom of Nancy Spector, Curator of Contemporary Art, for many, many issues, related to this project and not. John Hanhardt, Senior Curator of Film and Media Arts, has also offered sage suggestions.

Various members of the museum's curatorial department have given me guidance as I have worked on *Speaking with Hands*. I am grateful to Sarah Bancroft, Assistant Curator; Tracey Bashkoff, Associate Curator for Exhibitions and Collections; Susan Cross, Associate Curator; Susan Davidson, Curator; Vivien Greene, Associate Curator; Jon Ippolito, Associate Curator of Media Arts; Maya Kramer, former Administrative Curatorial Assistant; Brooke Minto, Administrative Curatorial Assistant; Karole Vail, Assistant Curator; Maria-Christina Villaseñor, Associate Curator of Film and Media Arts; and Joan Young, Assistant Curator. Matthew Drutt, former Guggenheim Museum curator, began work on this project before he became Chief Curator at the Menil Collection, Houston.

I must also additionally recognize the tremendous contributions of Elizabeth Levy, Director of Publications, Elizabeth Franzen, Managing Editor, and the entire staff of the Publications department. Without their talent and professionalism you would, in fact, not be reading this now.

Finally, I gratefully acknowledge my family and friends whose warm embrace sustains me. I have been inspired above all by the work of the many artists and photographers whose creations comprise The Buhl Collection, and once again, my sincere thanks go to Henry M. Buhl.

JENNIFER BLESSING
Project Curator

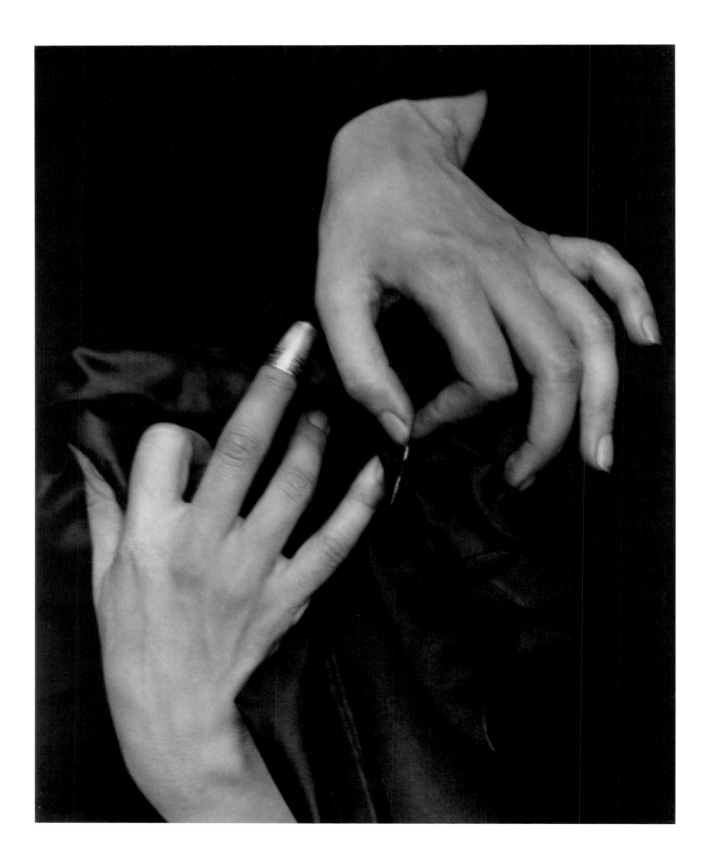

Photophilia

JENNIFER BLESSING

*The most profound enchantment for the collector is the
locking of individual items within a magic circle in which
they are fixed as the final thrill, the thrill of acquisition,
passes over them.*[1]
—WALTER BENJAMIN

In the last ten years, Henry M. Buhl has amassed a collection of more than
one thousand photographs of hands. The collection spans the history of
photography, from images by some of the medium's nineteenth-century
inventors to contemporary works of art. The Buhl Collection is compre-
hensive enough to illustrate a chronological outline of the history of
photography. Yet the specificity of its theme raises the question, "Why
a collection of photographs of hands?" This line of inquiry is not only
inescapable when considering this body of work but also forces us to
examine the nature of collecting, the fact that photography itself is emi-
nently collectible, and why the hand is a logical subject for the medium
of photography and a photography collection.

On Collecting

It can be hard not to feel defined—owned—by objects, rather
than the other way around. I am interpolated and fixed by objects. The
boxes of junk that fill closets and storage containers seem to become
animate, a hydra that threatens to overwhelm. What I own—clothes,
furnishings, shelter—is determined by my economic circumstances and
my ethnic and religious background, among other variables. The objects
that surround me—the cumulative detritus of my life and of my ancestors'
lives as well—communicate a message about who I am or would like to
be, and they do so whether I like it or not. They tell a story of my life.

There are two contradictory responses to this situation. One is to
join the voluntary simplicity movement by committing to own as few
possessions as possible (and to use as few nonrenewable resources), a
theoretically appealing though not oft-followed approach. The other is
to succumb to the fantasy of control that is collecting. Collecting seems
to be a basic human instinct, which at times flowers into something
sublime and amazing, and there are more and less socially acceptable
types of collecting, ranging from the elite forms of high-art collecting to
what is essentially uncontrolled hoarding. (The purposeful accumulation
of consumer effluvia like bottle tops falls somewhere in the middle.)

Alfred Stieglitz *Hands with
Thimble*, 1920. Gelatin-silver
print, 9 1/2 x 7 1/2 inches
(24.1 x 19.1 cm)

1. Walter Benjamin, "Unpacking
My Library: A Talk about
Book Collecting" (1931), in
Benjamin, *Illuminations*, ed.
Hannah Arendt, trans. Harry Zohn
(New York: Schocken Books,
1969), p. 60.

In its most mundane form, we could describe collecting as any accumulation of like purchases, ranging from a preference for a brand-name shirt to a style in furniture. But this sort of activity pales in comparison to the kind engaged in by individuals who become known as collectors and are identified with the objects they collect, whether these are baseball caps, Lladró figurines, or old master paintings. It is these collectors whose passion is inspiring and whom we remember.

My maternal grandfather was a collector, so my first experience of a museum was a domestic one. He and my grandmother lived in the same house from shortly before my birth to their last days, thirty years later. Every room except the kitchen was given over to my grandfather's collections; the finished basement housed the central galleries for some of the most important large pieces. His primary collection was of antique music boxes. The most plebeian were a series of gramophones and a player piano; the rarer pieces included carved and inlaid wood cases that played exchangeable metal cylinders, punctured tin disks, or accordion-folded paper books. For a child, the most ostentatious, loudest pieces were the most memorable: the leaded-glass cabinet of the nickelodeon packed with mechanical cymbals, piano hammers, and drums; and the miniature Swiss chalet with dancing dolls and bells rung by metal butterflies. When I was young, I yearned to touch and activate the magical devices that were locked behind glass or otherwise forbidden. As I grew older, I appreciated the artistry of the individual objects. But I was also awed by the obsessional quality of my grandfather's pursuit of acquisitions, and the sheer magnitude of the evidence of his passion. It was intriguing, sometimes mystifying, and a little frightening to observe what appeared to be unbridled desire in action.

His music-box collection spawned others. In the 1960s, the period of his greatest activity, my grandfather often bought mixed lots at auction, which meant that he acquired unwanted objects along with the pieces he craved. Some of these unrelated things formed the basis of new collections. He added elegant antique clocks, small bronze sculptures, pocket watches, carved ivory statuettes, miniatures on ivory, enamels. Except for some outré items, like the pewter golfer figurines from the Franklin Mint, almost everything had been made in the late eigteenth or nineteenth century, was exceedingly ornate, and suggested aristocratic pedigree.

My grandfather became known in his community as a collector; from an early age, I understood that he was both admired and considered strangely obsessed. He had many objects that few had seen before, and certainly not in such preponderance, and gave tours of his house-museum to anyone who visited. I am sure that he preferred the identity

he fostered as a collector to others he worked hard to obscure. Of these, mortal human being was the hardest to deny, although he managed. As he grew older, he continued to collect and tinker with his objects, albeit at a slower pace, but he avoided the prospect of his eventual demise by failing to make arrangements for the collection's future care or preservation. When he did pass away, his objects were dispersed among family members, and some were sold. While I am delighted to have inherited some pieces that are dear to me, nothing can compare to my memory of the collection as a whole.

Many studies of collecting are descriptive, reveling in the novelty of a specific group of objects or perhaps investigating them in terms of the knowledge they yield about material culture.[2] In *The System of Objects*, first published in 1968, Jean Baudrillard argues that the passion for objects is a constant feature of our daily lives, that we exert control over these objects through possession, and that as we organize them in our consciousness they come to define us.[3] Thus any collection of objects, in its collectivity, creates an identity for the collector. Baudrillard writes: "For it is invariably *oneself* that one collects. . . . A given collection is made up of a succession of terms, but the final term must always be the person of the collector."[4]

All collections are embodiments of a specific individual's desire—even those girded by the most apparently scientific or scholarly rationales— a notion that is not hard to grasp when the collection bears the name of a particular collector, such as Peggy Guggenheim. Despite her reliance on various advisers, the objects she amassed would never have been linked if it had not been for her specific relationships and aspirations, exercised at a particular time and place. It may be harder to understand the role of the individual in relation to museum collections, which are generally conceived as encyclopedic or specialist and less in terms of the collectors who obtained the objects, unless of course the institution (or a reserved gallery, or an object itself) is identified by a collector's name. Yet it is certainly possible to view museum collections as agglomerations of the passions of individuals—curators as well as benefactors. A number of recent exhibitions, with their emphasis on curatorial sensibility in the context of thematic shows, suggest greater self-consciousness in this regard.

Collecting can also be defined as the search for an unending series of unique objects. Baudrillard argues that no collector seeks a finite set, not primarily because it is likely impossible to achieve but because the dynamic of the collection is the process of desiring and seeking objects to acquire. There must always be trophies to hunt. This is a kind of fetishism, a motivation based on fear of finality and death, which the

2. Recent studies of collecting include Susan M. Pearce, *On Collecting: An Investigation into Collecting in the European Tradition* (London: Routledge, 1995) and Susan M. Pearce, ed., *Interpreting Objects and Collections* (London: Routledge, 1994). See also Werner Muensterberger, *Collecting: An Unruly Passion: Psychological Perspectives* (Princeton: Princeton University Press, 1994).
3. Jean Baudrillard, "The System of Collecting," trans. Roger Cardinal, in John Elsner and Cardinal, eds., *The Cultures of Collecting* (Cambridge, Mass.: Harvard University Press, 1994), pp. 7–24. Baudrillard's original text is published in full as Baudrillard, *Le système des objets* (Paris: Editions Gallimard, 1968). The English edition is Baudrillard, *The System of Objects*, trans. James Benedict (New York: Verso, 1996). See also Susan Stewart, "Part II: The Collection, Paradise of Consumption," in Stewart, *On Longing: Narratives of the Miniature, the Gigantic, the Souvenir, the Collection* (Durham, N.C.: Duke University Press, 1993), pp. 151–69. Stewart's meditation on objects was influenced by Baudrillard's text.
4. Baudrillard, "The System of Collecting," p. 12.

finished or fixed system represents.[5] It is a means to achieve a sense of control over the uncontrollable, as the promise of an unending stream of potential acquisitions makes it possible to elude the anxiety of impending demise. "In our era of faltering religious and ideological authorities," Baudrillard writes, objects "are by way of becoming the consolation of consolations, an everyday myth capable of absorbing all our anxieties about time and death."[6]

Writers have often been drawn to portraying collectors and their collections. Certainly, collecting makes picturesque subject matter—as any obsessional pursuit of the unusual might be—and it lends itself to the construction of allegorical tales about human nature. But perhaps writers are most drawn by the metaphorical similarity between their endeavors and those of collectors, as writers are assiduous collectors themselves, though of a more immaterial form, amassing information, facts, observations, and life stories for their work.[7] That search for knowledge and expression is symptomatic of a similarly anxious desire to manage the unmanageability and mysteriousness of existence itself. And ultimately writers and collectors both attempt to achieve immortality—to forestall death—through recognition of their pursuits.

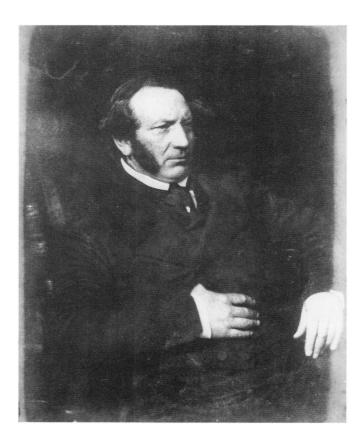

D. O. Hill and Robert Adamson John Clow of Liverpool; Merchant and Art Collector, ca. 1845. Salt print from calotype negative, 7 1/2 x 6 inches (19.1 x 15.2 cm)

5. Ibid., p. 19. Baudrillard equates the motivation for collecting with fetishism in the sense that both involve fixation on single items: "Indeed, just as possession is coloured by the discontinuity of the series (be it real or virtual) and by the targeting of just one privileged term, so sexual perversion consists in the inability to grasp the partner, the supposed object of desire, as that singular totality we call a person. Instead, it is only able to operate discontinuously, reducing the partner to an abstract set made up of various erotic parts of its anatomy, and then exercising a projective fixation on a single item."

6. Ibid., p. 17.

7. A fictional study of collecting is Bruce Chatwin's *Utz* (New York: Viking, 1989). See also John Forrester's interesting essay on Sigmund Freud as collector of antiquities and of case studies, dreams, and slips of the tongue: "'Mille e tre': Freud and Collecting," in Elsner and Cardinal, eds., pp. 224–51.

Collecting Photographs

To collect photographs is to collect the world. A photography collection has more in common with the *wunderkammer*—the sixteenth- and seventeenth-century European "chamber of wonders," or cabinet of curiosities, which often united pictures and natural objects—than it does with a Meissen porcelain collection, for example. For one thing, the Meissen production of any given period is finite, although how many pieces still exist is unknown. But most significantly, the photograph has a presumed relationship to the real world: Each image seems to be directly connected to the thing it represents; it is an echo of this thing, whether animal, mineral, or vegetable. Porcelain retains its identity as tableware no matter the pattern, but photographs really seem to *be* the objects they represent, to have more in common with what they reproduce than with each other. Photographs are a kind of booty, the spoils of the thing they picture.

This special relationship to the real is due to the fact that each photograph traces, like a footprint or a shadow, the outline of a subject that exists at a given moment in time. Light reflected by the object before a camera leaves a kind of stamp on sensitive paper, creating a marker or index of what was there. This operation defines the photograph in relation to painting, which is not imprinted by its source, though it may similarly resemble it. Art historian Rosalind Krauss has elaborated these distinctions between categories of visual signs, succinctly defining the photograph as an index: "The type of sign which arises as the physical manifestation of a cause, of which traces, imprints, and clues are examples."[8]

The photo is an index because it has a literal connection to the thing it portrays. It is not imagined; something was there before the camera. The photograph is also seen to have a special power because of this privileged relationship to the real. Even though we may know that photographic images can be and always have been manipulated, we continue to presume that photography has a more legitimate relationship to reality than other mediums. This explains (in part) why a photo of a naked child is more likely to be considered pornographic—and its maker prosecuted—than a drawn or written description of the same image. Photographs of violence seem to be more disturbing than drawings, even when they share the same (real) source. We are able to insulate ourselves by calling the nonphotographic image a mediated one; but we remain susceptible to the "truth" of the still photograph, despite its history of pictorial invention.

It is this actual and perceived relationship to the real that gives photographs their uncanny power to disturb us. Roland Barthes, in his insightful essay on photography, *Camera Lucida*, argues that photographs

8. For the seminal essays outlining the indexical status of the photograph, see Rosalind E. Krauss, "Notes on the Index: Part 1," and "Notes on the Index: Part 2," in Krauss, *The Originality of the Avant-Garde and Other Modernist Myths* (Cambridge, Mass.: The MIT Press, 1985), pp. 196–219. These texts are reprinted from *October*, no. 3 (spring 1977) and no. 4 (fall 1977). Krauss cites the semiotic theory of Charles Sanders Peirce, "Logic as Semiotic: The Theory of Signs," in Justus Buchler, ed., *Philosophical Writings of Peirce* (New York: Dover, 1955), pp. 98–119. For a summary of the notion of indexicality, see Philippe Dubois, *L'acte photographique et autres essais* (Paris: Editions F. Nathan, 1990), pp. 55ff.

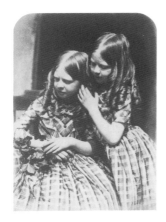

allow us to fetishistically entertain impossible contradictions in our notions of time and, specifically, to imagine that the dead live, thus both foreshadowing and seemingly postponing our own deaths.[9] Of historical photographs Barthes writes: "There is always a defeat of Time in them: *that* is dead and *that* is going to die."[10] Examining an old photograph of two little girls, he remarks, "They have their whole lives before them; but also they are dead (today), they are then *already* dead (yesterday)."[11]

It is in the intimate embrace of familial relationships that we first experience the delirium of the photographic image—its magical message that time is somehow fungible. The image that most absorbs Barthes is a photograph of his mother as a little girl. He looks through many pictures after her death, trying to find one that captures her essence. It is also within the context of family that we absorb the obsession of collecting, specifically of collecting photos, as we overwhelm ourselves in the frantic production of images with which we attempt to fix time (or represent our imaginary ideals). So we fill albums with snapshots of events that prove our bonds and record the growth of children into adulthood, all in an effort to prove to ourselves that we really exist, that our loved ones will be with us always, that we are happy. The "reality effect" of the photograph, the sense that it scientifically proves existence through its insistent detail, serves to shore up our delusional beliefs.[12] Yet no matter how many photographs you have, they are never enough to suppress the melancholy tide of anxious fears, the knowledge that the child you once were no longer remains, and that the moment in which your child was photographed is forever unrecuperable. This seeming ability to stop time is appealing because of a pathetic fallacy, the desire to believe that the inevitable can be postponed.[13]

Collecting Photographs of Hands

Krauss has argued that readymades—Marcel Duchamp's aesthetic transformations of utilitarian objects—are akin to snapshots.[14] Both are created by pulling an object out of its context through an act of selection. In fact, the readymade and the found object, like the act of taking a photograph, are forms of collecting, a process by which a subject nominates an object to be removed from one context and placed in another.[15] Even though the process of selection is often referred to as mechanical—either figuratively, in the readymade conceit of downplaying responsibility, or literally, through the mechanism of the camera—both instate an author. Which brings us to the notion of the collector as auteur.

It is a commonplace that many photography collections, exhibitions, and books are thematic, rather than chronological or based on movements or stylistic criteria. Because of their indexical connection to their referent, it is difficult to separate photographs from their subject matter. The

D. O. Hill and Robert Adamson *The Misses Grierson*, ca. 1845. Salt print from calotype negative, 8 x 5 ½ inches (20.3 x 14 cm)

9. Roland Barthes, *Camera Lucida: Reflections on Photography*, trans. Richard Howard (New York: Hill and Wang, 1981). Originally published as *La chambre claire* (Paris: Editions du Seuil, 1980).
10. Ibid., p. 96.
11. Ibid.
12. Barthes's description of the "reality effect" of detail in realist fiction is useful to think about in relation to photography; see Barthes, "The Reality Effect," in Barthes, *The Rustle of Language*, trans. Richard Howard (New York: Hill and Wang, 1986), pp. 141–48.
13. So much of the response to photographs of 9/11 is tied to this fetishistic desire to deny the known future and stop time. Not only do the many memorial photographs of victims feed this desire, but the images of people falling from the towers operate in this way as well. There is a horror in knowing the victim's ultimate fate, and yet a need to stare at the picture, as if one's fixed attention will stop the person from continuing to fall.
14. Krauss, "Notes on the Index: Part 1," p. 206.
15. Note Stewart's comment, p. 166: "Collecting combines a preindustrial aesthetic of the handmade and singular object with a postindustrial mode of acquisition/production: the readymade."

object of the photograph constantly rises to the surface and overwhelms it; thus producers of iconic photographs are often less familiar, and less likely to be associated with movements or periods, than artists in other mediums. There are collectors who focus on historical topics, such as nineteenth-century photographs of African Americans, and others whose themes are more whimsical, such as photographs of people with their eyes closed. The subjects of many photography collections are hard to imagine as collecting criteria in other mediums.

Henry Buhl decided to focus on hands after he purchased a photograph that moved him greatly, Alfred Stieglitz's portrait of Georgia O'Keeffe, *Hands with Thimble* (1920, p. 12). But Buhl has interpreted his theme liberally; his collection does not simply contain photographs of cropped images of hands. There are many photographs that do not immediately speak to the subject, subtly indicating the importance of the hand as a bearer of meaning within the larger context of the image. I am thinking here especially of reportorial or documentary photographs in which characteristic gestures convey a narrative. Other work in the collection has a conceptual rather than literal relationship with hands. Yet there remains a rather strict consistency within this diversity, which is ultimately determined by Buhl. Hands in themselves are an interesting subject for the collector, since the hand itself frequently symbolizes the means of acquisition and possession, and thus also functions as a sort of emblem or trademark. Buhl's collection is thus also a self-portrait, a kind of metaphorical trace of his numerous acts of pointing, of nominating objects to acquire. It is worth noting that Buhl is the founder of a philanthropic organization to help homeless people gain employment by teaching them rudimentary work skills; for him, representations of the hand acting as a tool, engaged in work, has particular significance, as does the notion of the helping hand.[16]

The hand is one of the most fascinating and most likely subjects of photographic representation, quite apart from these personal references for Buhl. It is the locus of many kinds of indexical marks, demonstrating a relationship to the real that is also the defining characteristic of photography. Ancient handprints in caves, the first intentional gestures of marking by early humans, are indexes of individual existence. Other such markers that we use today to indicate individuality include the fingerprint and signatures created through handwriting. The gesture of pointing is an indexical act. Finally (though not exhaustively), the shadow, which is an index, is often employed in photography, frequently as the shadow of a hand in photograms. In all of these images and gestures, the hand, like the photograph, operates as an existential proof.

Another reason the hand is so fitting a subject for photography is the fact that—like photographs themselves—fragments of the body, and

Unknown artist *Untitled*, ca. 1930. Photolithograph, 13 ¾ x 10 ¾ inches (34.9 x 27.3 cm)

16. The organization is the Association of Community Employment Programs for the Homeless (A.C.E.).

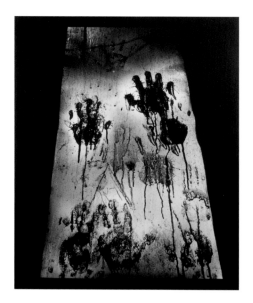

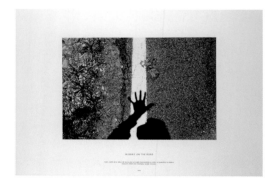

particularly the hand, often generate a frisson of anxiety. There is a history of representations of the severed hand in modern literature and art that ranges from legal amputation for criminal acts to the conventions of the fantasy horror genre. On some level, any image of a hand not integrated with a body recalls these histories. Even the hand incorporated in a larger composition can have this effect, when it is symbolically detached by being the focus of attention. Sigmund Freud mentions the severed hand as an uncanny object fraught with the symbolism of castration anxiety.[17] While there are certainly images in Buhl's collection for which this psychoanalytic interpretation is not farfetched, one might view this anxiety as a metaphor for a more generalized fear of loss and ultimately death. As such, the frequent photographic depictions of disembodied hands seem like so many fetishes. It is through the logic of the fetish that the fragmentation of the hand, like collecting itself and like photography, also suggests a kind of obsessional denial of death.[18]

The Buhl Collection makes clear that the hand has been, and continues to be, a prime subject of visual imagery in a way that it never was before the advent of photography. There are many reasons for this primacy, all of which are intertwined with fundamental aspects of the nature of photographic representation. In the following pages, I outline a number of classic photographic themes illustrated by this collection of hands.

Touhami Ennadre Traces of *Bleeding Hands*, 1998. Gelatin-silver print, 57 x 47 inches (144.8 x 119.4 cm)

Richard Long Midday on the *Road*, 1994. Gelatin-silver print and pencil, 32 x 44 inches (81.3 x 111.8 cm)

Rena Small Andy Warhol's *Hands*, 1985. Gelatin-silver print, 6 3/8 x 8 7/8 inches (16.2 x 22.5 cm)

17. Sigmund Freud, "The 'Uncanny'" ("Das Unheimliche," 1919), in *The Standard Edition of the Complete Psychological Works of Sigmund Freud*, trans. J. Strachey, vol. 17 (London: The Hogarth Press, 1955), p. 244.
18. For an interesting discussion on photography and death, see Christian Metz, "Photography and Fetish," *October*, no. 34 (fall 1985); reprinted in Carol Squiers, ed., *The Critical Image* (Seattle: Bay Press, 1990), pp. 155–66.

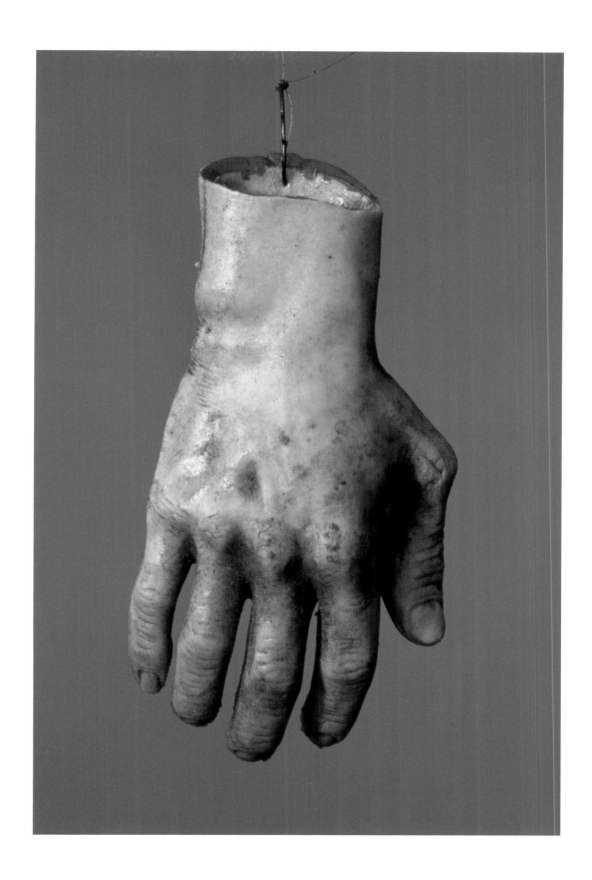

Paul McCarthy *Right Hand*
(Propo Series), 2001. Cibachrome,
70 x 48 inches (177.8 x 121.9 cm)

Documentation: The Hand as Proof

*Unless I see in his hands the print of the nails, and place
my finger in the mark of the nails, and place my hand in
his side, I will not believe.*
—JOHN 20:25

From the inception of photography, the photographic image
has been used to document phenomena in order to scientifically record
and prove. The photograph's seemingly passive reflection of reality
encourages its use in this context, as does its mechanical mode of
production, which suggests it is more truthful and less subject to human
error than traditional forms of representation like drawing. The photo-
graph's ability to record information has long been seen as a paramount
virtue. In 1840, William Henry Fox Talbot made direct contact prints of
Lord Byron's handwritten texts in an attempt to provide authentic access
to the workings of genius. In the 1870s, Eadweard Muybridge invented a
multiple-camera system to produce rapid consecutive exposures in an
effort to prove hypotheses about human and animal movement. In the
late nineteenth century, photography was used to document various aspects
of the bodies of criminals in order to demonstrate that physiognomic
indicators could be predictive of behavior. These projects and many
others harnessed the authority of the photograph, an authority based on
its perceived relationship to reality, to gird their representations with
an aura of scientific impartiality.[19]

A fascinating result of this ideology was that the supposed transparency
of photographic reproduction lent the air of authenticity to images that
actually document nothing more than the materialization of light. With
the goal of recording phenomena invisible to the naked eye, some pho-
tographers, often under the auspices of scientific institutions, used the

William Henry Fox Talbot
*A Stanza from the "Ode to Napoleon"
in Lord Byron's Hand*, prior to
April 4, 1840. Photogenic drawing
negative, from an original ink-
on-paper manuscript, 5 3/16 x
7 1/2 inches (13.2 x 19 cm)

19. For a critical evaluation of
photographic realism in the
service of criminal investigation,
see Allan Sekula, "The Body and
the Archive," *October*, no. 39
(winter 1986); revised version
in Richard Bolton, ed., *The Contest
of Meaning: Critical Histories of
Photography* (Cambridge, Mass.:
The MIT Press, 1989), pp. 343–88.

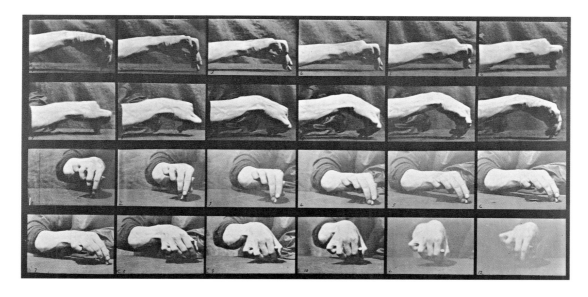

medium to suggest an indexical connection to their phantasmatic objects of study. Examples include attempts to photograph the last images on the retinas of murder victims (in order to capture the perpetrator of the crime), and efforts to portray the spiritual auras of human beings, dead or alive.[20] The resulting photographs seem to be the consequence of technical manipulations, whether witting or unwitting. In other ostensibly scientific endeavors, the documentation may be based in visible reality, in that the image could have been witnessed without a camera, but its interpretation is highly debatable. These include the various records of mediums whose bodies are temporarily possessed by the dead, such as Jules Courtier's photos of Eusapia Palladino's hands (1908, p. 24). All of these activities, including, of course, Jean-Martin Charcot's famous

20. For more on this, see Dubois, "Le corps et ses fantômes," in *L'acte photographique*, pp. 205–23. It is interesting to note that Sir Arthur Conan Doyle—the inventor of Sherlock Holmes, that avatar of deductive reasoning— wrote a book defending photos of ghosts; see *The Case for Spirit Photography* (New York: George H. Doran Company, [1923]).

Eadweard Muybridge
Movement of the Hand; Drawing a Circle, plate 532 of *Animal Locomotion*, 1887. Collotype, 7 ¹/₂ x 15 inches (19.1 x 38.1 cm)

James Nasmyth *Back of Hand & Shrivelled Apple. To Illustrate the Origin of Certain Mountain Ranges by Shrinkage of the Globe.*, 1874. Two Woodburytypes, each 4 ¹/₂ x 3 ¹/₄ inches (11.4 x 8.3 cm)

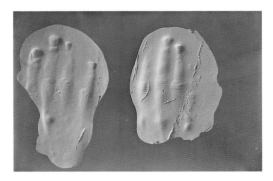

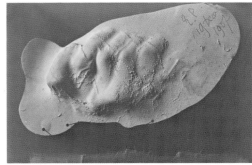

photographs of hysterics in evocative poses, were sponsored by medical doctors.[21] As Philippe Dubois has written: "Photography is exactly the place and the means through which science (medicine, psychiatry) makes fiction."[22] This is not an intentional fiction however. Rather it is based on a belief in photography's ability to represent reality. Krauss describes this property of photography when she writes: "Truth is understood as a matter of evidence, rather than a function of logic."[23]

Scientific forms of evidence gathering, such as fingerprinting, were born in the midst of these kinds of photographic documentation. However, the survival of fingerprinting is most likely due to its directly indexical production and its analysts' strict adherence to typological criteria for identification purposes only. Today no one tries to *predict* criminal behavior through fingerprints, as nineteenth-century physiognomists did with other body parts. Something like this strategy is still at work, however, in the science of chirognomy, or palm reading, in which the patterns of lines on the hand are interpreted as legible inscriptions, cosmologically determined. For the believer, the handprint is a form of empirical evidence, as fingerprints are for a forensic scientist.

In the nineteenth and early twentieth centuries, the residue of the historical bond between scientific practice and the occult was arguably stronger than it is today, despite constant pressure to professionalize the medical establishment. Freud, for example, was quite eager to distinguish his methods from dubious practices and practitioners. His was an especially difficult task, given the complexity and lack of understanding regarding human consciousness. It is not difficult to imagine, therefore, that Freud's *Interpretation of Dreams* might have been compared to reading tea leaves when it was first published in 1900. So it was only with consternation that Freud viewed the Surrealists' interest in the workings of the unconscious, and their consultation of his texts, while they concurrently flirted with occult manifestations. The pope of Surrealism, André Breton, regularly posited his own interpretations of the human psyche, at the same time investigating all kinds of superstitious practices. In fact, the winter 1935 edition of the Surrealist journal *Minotaure*

Jules Courtier *Cast Hands of Eusapia Palladino*, 1908. Two gelatin-silver prints, each 4 1/2 x 7 inches (11.4 x 17.8 cm)

Adrien Majewski *Mr. Majewski's Hand*, ca. 1900–10. Gelatin-silver print, 7 1/8 x 5 1/8 inches (18.1 x 13 cm)

21. See Georges Didi-Huberman, *Invention de l'hystérie: Charcot et l'iconographie photographique de la Salpêtrière* (Paris: Macula, 1982). In the context of this discussion, it is also worth noting the fascinating essay by Didi-Huberman in which he describes how the image of a body on the Shroud of Turin was first made "visible" through photographs. See "The Index of the Absent Wound (Monograph on a Stain)," trans. Thomas Repensek, *October*, no. 29 (summer 1994), pp. 63–81.

22. Dubois, p. 219: "La photographie est très exactement le lieu et le moyen par lequel la science (médecine, psychiatrie) fait fiction."

23. Krauss, "Notes on the Index: Part 2," p. 218.

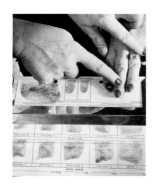

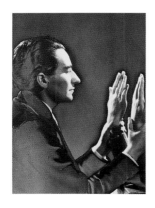

presented an article by a noted expert in chirognomy, Dr. Lotte Wolff.[24] This essay included reproductions of the handprints of famous literary and artistic figures, with brief analyses underneath, in the manner of a scientific report.

Some thirty years later, the Fluxus artist Robert Filliou, in his portfolio *Hand Show*, compiled photographs of the palms of artists such as Jasper Johns, Claes Oldenburg, and Andy Warhol. His accompanying statement, "The Key to Art (?)," is notably tongue-in-cheek; Filliou suggests that by comparing the various artists' hands one can form a "judgement about their art without intermediary interpretation by critics."[25] Where the Surrealists seemed apt to take hand reading seriously, as yet another means to tap into the unconscious, Filliou is more interested in using its dubious pretensions to send up both critical interpretation and the documentary status of photographic representation.

In the 1970s, many Conceptual and performance artists employed photography to document the intersection of their bodies and their environment to produce deadpan renderings of daily life and experience. They often used the hand as a unit of measure and a device to locate the artist in relation to the creation of the piece, and preferred a purposefully unartful aesthetic: simple black-and-white photographs shot in flat light. This straight style played upon the scientific aspirations of earlier photographic traditions, in which the camera was presumed to be an unthinking recorder of the real. And yet the Conceptual work of the 1970s frequently has a sly humor; these artists carefully record and document activities that often seem meaningless. While the presentational style of their projects—typically grids of photographs accompanied by dryly important captions—seems to imbue the projects with scientific import, these artists have reduced this format to just that, a style, in the process questioning its imputation of reliability and rationality.

24. Lotte Wolff, "Les révélations psychiques de la main," *Minotaure* 2, no. 6 (winter 1935), pp. 38–44. This essay is illustrated and discussed in Kirsten H. Powell, "Hands-On Surrealism," *Art History* 20, no. 4 (Dec. 1997), pp. 516–33.
25. "Hand Show of Robert Filliou, Photos of Scott Hyde," sheet accompanying portfolio of twenty-four photolithographs, 1967.

Andreas Feininger Untitled *(Finger Printing)*, 1942. Gelatin-silver print, 13 1/2 x 10 3/4 inches (34.3 x 27.3 cm)

Man Ray Untitled *(Dr. Lotte Wolff)*, 1932. Solarized gelatin-silver print, 6 1/4 x 4 1/2 inches (15.9 x 11.4 cm)

Robert Filliou Hand Show (cover and two sheets), 1967. Portfolio of twenty-four photolithographs, 11 7/8 x 9 1/2 x 1 1/2 inches (30.2 x 24.1 x 3.8 cm). Photos by Scott Hyde

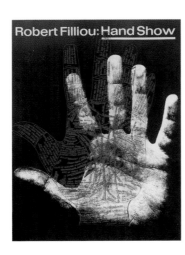

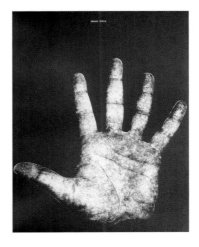

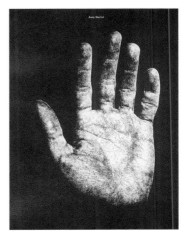

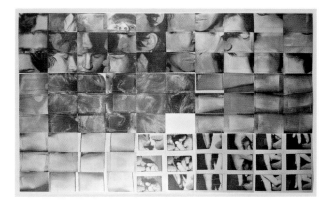

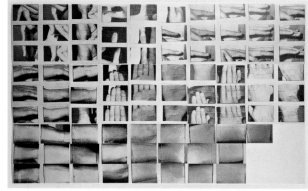

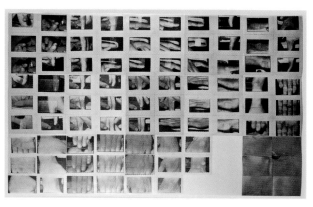

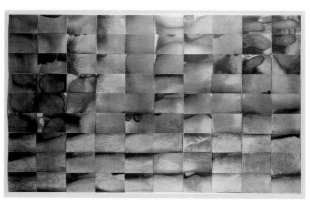

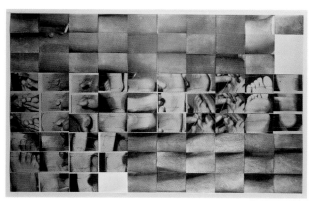

Giuseppe Penone *To Unwrap*
One's Skin, 1971. Seven zinc-plate
photographs, each 27 ¹/₂ x
39 ¹/₂ inches (69.9 x 100.3 cm)

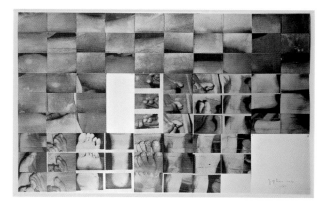

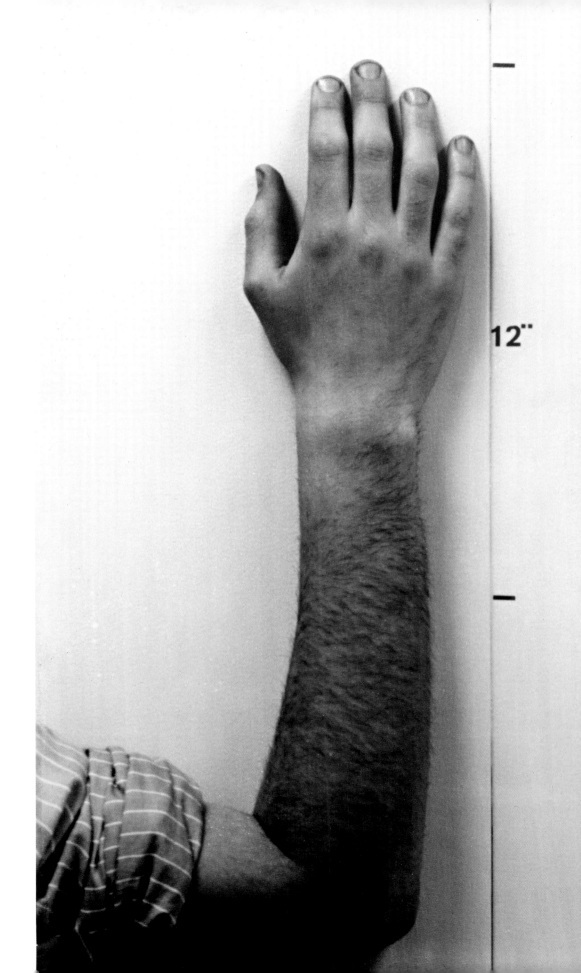

12"

Mel Bochner *Actual Size (Hand)*, 1968. Gelatin-silver print, 23 x 15 inches (58.4 x 38.1 cm)

The Manipulated Image: Photograms

The photogram is the essence itself of photography.[26]
—Lászlò Moholy-Nagy

Created without a camera, the photogram is an entirely hand-made photograph. Objects placed on treated paper are briefly exposed to light, and then the paper is developed. The resulting image traces the outlines of forms, in a reversal of positive and negative such that the items that blocked the light appear white on a dark field. The photogram is a perfect photograph in that it is a pure index. "But the photogram only forces, or makes explicit," writes Krauss, "what is the case of all photography."[27] Photograms frequently include representations of hands. One reason for this is as simple as the fact that hands are a convenient darkroom prop—the technology leads to temptation just as the photocopier does. In part due to their accessibility, hands have been a subject of photographic reproduction from the inauguration of its various techniques, from Charles Nègre's waxed-paper negative of the 1850s, for example, to the first X rays in the 1890s. An alternate explanation is that hands, as we have seen, are so frequently linked with indexical signs—fingerprints, pointing, signatures—that they beckon to be employed in the photogram, reinforcing the essential aspect of photography that the photogram exemplifies. Thus Brassaï's photograph of Pablo Picasso's fist (ca. 1943, p. 100) becomes a kind of *mise-en-abyme* of indexicality:

26. Lászlò Moholy-Nagy quoted in Dubois, p. 68. See also Moholy-Nagy, "Photography Is Manipulation of Light," in Andreas Haus, *Moholy-Nagy: Photographs and Photograms*, trans. Frederick Samson (New York: Pantheon Books, 1980), p. 47: "Above all, this knowledge [of the manipulation of light] is valid if one wants to take photographs without a camera, i.e., if we succeed in making use of the essence of photographic procedure, the potential of the light-sensitive layer, for purposes of composition." Originally published as Moholy-Nagy, "Fotografie ist Lichtgestaltung," *Bauhaus*, no. 1 (1928), p. 2.
27. Krauss, "Notes on the Index: Part 1," p. 203.

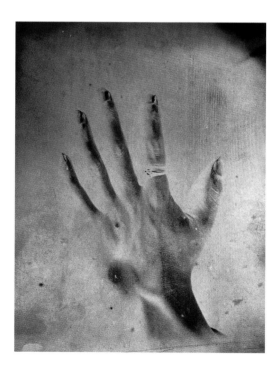

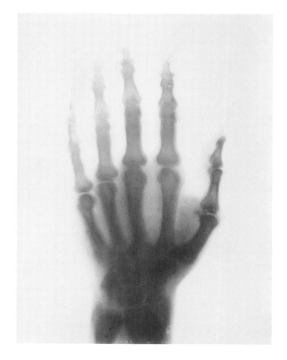

Charles Nègre *Hand Study*, 1850s. Waxed-paper negative, 11 x 8 ¼ inches (27.9 x 21 cm)

Eugène Ducretet *X-ray Study of a Hand*, 1897. Albumen print, 9 ½ x 7 inches (24.1 x 17.8 cm)

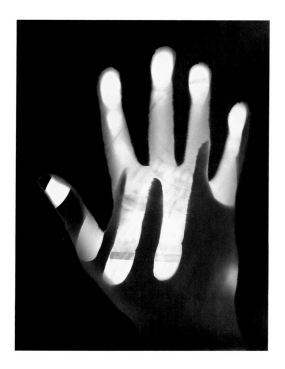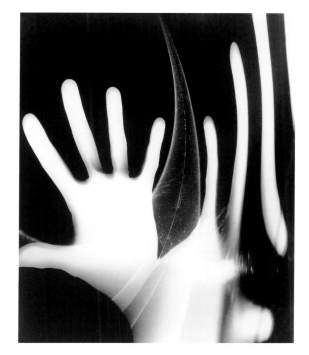

It takes a subject associated with the production of indexical marks (the artist's hand), presents it in the form of an indexical sign (a plaster-cast replica of the fist), and reproduces it via the epitome of the indexical reproduction, a photograph.

Another reason for their frequent representation in photograms might be that hands are a symbol for creativity and individual sensibility. By including the hand that made it, the photogram reinforces the idea that the picture is handcrafted. From the inception of photography, practitioners with artistic inclinations fought the common perception of photography as a mechanical, artless inscription of the real; they followed the conventions of painting by emphasizing their skill through bravura technical manipulations and painterly conceits—that is, by making photographs that looked handmade. It was not until the rise of modernist photography in the early twentieth century that this attitude toward painting diminished in favor of a systematic investigation of the unique properties of photography and an emphasis on images that explored reproductive technical capacities for their own sake. Yet certain themes—the hands in photograms, photographers' self-portraits with their cameras, and images of hands holding the lens, all of which seem to say, "Remember the manipulator behind the machine"—suggest the durability of an anxiety regarding the photographers' artistry.[28]

Another complication for the recognition of photography as an art form has been the ubiquity of images produced in the cradle of the family. Images of cropped hands might, in some small way, herald a professional

László Moholy-Nagy
Photogram, 1925. Gelatin-silver print photogram, 10 x 8 inches (25.4 x 20.3 cm)

György Kepes *Hand*, ca. 1939. Gelatin-silver print photogram, 14 x 11 inches (35.6 x 27.9 cm)

28. Likewise, the prefix to the word "retouching" emphasizes the photograph's initial manual production.

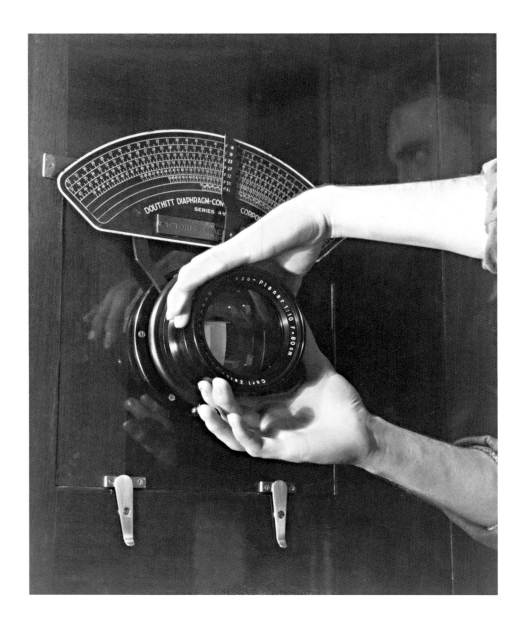

as opposed to an amateur subject matter. Since the Kodak revolution in 1888, anyone who snaps a photo of a beloved person has seemed a capable practitioner—more easily than the Sunday painter. So modernist devices of photography such as fragmentation and blown-up detail become a means of distinguishing artistic production from the more commonplace variety. It is safe to say that for every one picture of hands in family albums (if there is even one) there probably exist ten thousand photos of carefully centered smiling faces.[29]

These sociological explanations, however, obscure the fact that photography traditionally has demanded a labor-intensive, handcrafted

René Zuber *Hands and Lens*, 1928. Gelatin-silver print, 4 3/4 x 3 3/4 inches (12.1 x 9.5 cm)

29. For a sociological approach to photography, with an emphasis on its function within the family, see Pierre Bourdieu, "The Cult of Unity and Cultivated Differences," in Bourdieu et al., *Photography: A Middle-Brow Art*, trans. Shaun Whiteside (Stanford: Stanford University Press, 1990), pp. 13–72. Originally published as *Un art moyen* (Paris: Les Editions de Minuit, 1965).

production.[30] The hands that appear in photograms materialize the gestures and movements of the photographer in the darkroom; the negative image obliquely recalls the fact that its creation occurs in near darkness, where the sense of touch is privileged. Photographs are a distinctly tactile medium: We are familiar with handling them from a young age, whether family snapshots or in magazines and newspapers. Some photographers especially emphasize the haptic quality of the medium, by seemingly inviting touch through their images' shallow depth of field and lack of sharp focus in combination with careful renderings of texture. Art historian Carol Armstrong characterizes Tina Modotti's work in these terms, noting the way her photographs adhere "to things produced by and solicitous of the hand rather than the eye alone, and to a sensuous physicality never free of the poignancy of its own transience."[31]

Paul McCarthy *#14 Untitled (Taking Photo)*, 1999. Cibachrome, 70 x 48 inches (177.8 x 121.9 cm)

30. This is less obvious today, with the widespread severing of the photograph's creation and production through mechanical developing and printing as well as digital technology. Yet even digital manipulation requires just that, manual intervention.
31. Carol Armstrong, "This Photography Which Is Not One: In the Gray Zone with Tina Modotti," *October*, no. 101 (summer 2002), p. 32. See also Haus, pp. 19ff, regarding the haptic character of Moholy-Nagy's photograms.

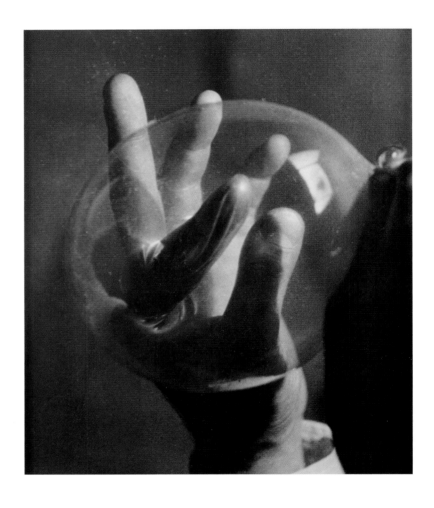

Tina Modotti *Flor de manita,*
1925. Platinum print, 4 ³/₄ x
3 ³/₄ inches (12.1 x 9.5 cm)

Lee Miller *Condom,* 1930.
Gelatin-silver print, 9 x
6 ³/₄ inches (22.9 x 17.1 cm)

**Jenny Saville and Glen
Luchford** *Closed Contact #3,*
1995–96. C-print mounted on
Plexiglas, 72 x 72 x 6 inches
(182.9 x 182.9 x 15.2 cm)

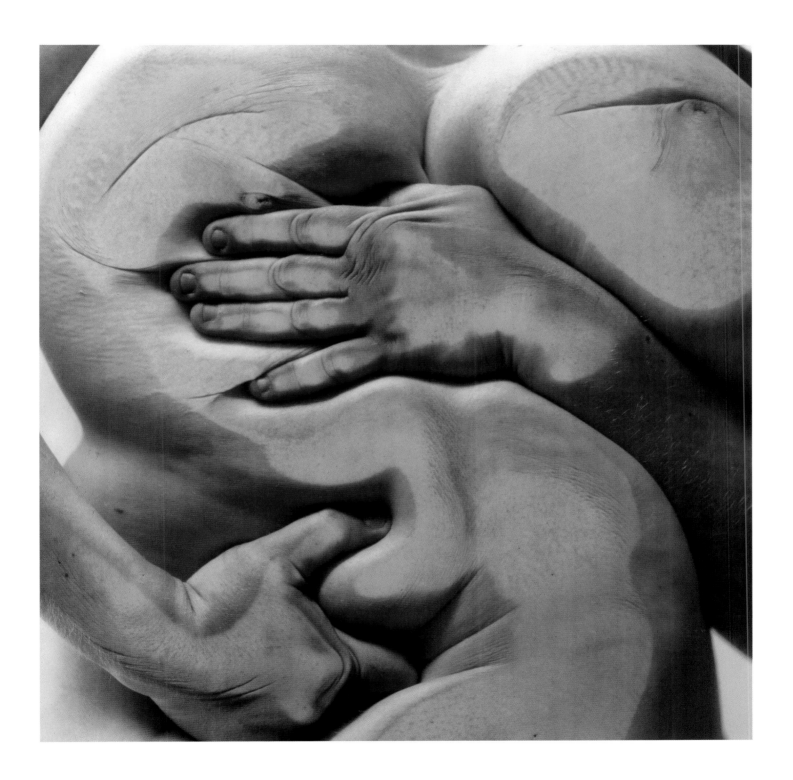

Ephemerality and the Rhetoric of Gesture

And what about our hands? With them we request,
promise, summon, dismiss, menace, pray, supplicate,
refuse, question, show astonishment, count, confess,
repent, fear, show shame, doubt, teach, command, incite,
encourage, make oaths, bear witness, make accusations,
condemn, give absolution, insult, despise, defy, provoke,
flatter, applaud, bless, humiliate, mock, reconcile, advise,
exalt, welcome, rejoice, lament; show sadness, grieve,
despair; astonish, cry out, keep silent and what not else,
with a variety and multiplicity rivalling the tongue.[32]
—MICHEL DE MONTAIGNE

One of photography's defining characteristics is its ability to arrest time, to capture an ephemeral moment and hold it still—something the eye is incapable of doing on its own. The invention of fast lenses permitted stopped-time photographs like Harold Eugene Edgerton's shot of a popping champagne cork. Pictures like these suggest a scientific means of recording events that are invisible to the naked eye. Previously, photographers were tethered by long exposure times and intense artificial lighting. Once they could take advantage of available light and convenient speedy cameras, they were freed to document life as it unfolded around them. An image like Robert Frank's 1958 photo of a gesticulating old man provides a slice of life, as if it is a frame cut out of a movie (a neorealist masterpiece in this case). Momentary images capture movements and gestures, which, especially when combined with haphazard cropping signifying lack of premeditation, create a reality effect, a sense that the camera's view is guileless and therefore truthful.

Photography also excels at documenting the rhetoric of gesture, both ephemeral and explicit. It captures the transitory motions of the hands in everyday life, thus freezing a gesture—like a word isolated from a sentence—and communicates something of the speed and transience of action and the intensity of the moment. Photographs of political figures from the 1930s and 1940s (such as Robert Capa's 1932 shot of Leon Trotsky, p. 36) capture a thunderous fervor that seems absent from contemporary politicians, who must subdue their movements due to the magnifying effects of television. Since antiquity, the meaning of specific hand gestures has been codified and promulgated in literature and art. Ancient authors such as Cicero and Quintilian outlined the importance of hand gestures for orators, and their ideas have been perpetuated to the present day.[33] Literary theorist Michael Neill, in an essay on representations of hands in Shakespeare and early modern English society, notes how Renaissance writers saw hand gestures as a means of synthesizing a universal language, which led to detailed study of expressive

Harold Eugene Edgerton
Champagne Bottle, ca. 1939.
Gelatin-silver print, 10 x 8 inches
(25.4 x 20.3 cm)

32. Michel de Montaigne, *An Apology for Raymond Sebond*, trans. and ed. M. A. Screech (1588; London: Penguin Books, 1987), p. 18. Another version of this passage is quoted by Michael Neill in "'Amphitheaters in the Body': Playing with Hands on the Shakespearean Stage," in Neill, *Putting History to the Question: Power, Politics, and Society in English Renaissance Drama* (New York: Columbia University Press, 2000), pp. 453–54, n. 27.
33. For Cicero and Quintilian citations, see Claire Richter Sherman, *Writing on Hands: Memory and Knowledge in Early Modern Europe* (Seattle: University of Washington Press, 2000), p. 195; and Neill, p. 454, n. 28. I thank Frank R. Wilson for bringing both of these publications to my attention. See also Fritz Graf, "Gestures and Conventions: The Gestures of Roman Actors and Orators," in Jan Bremmer and Herman Roodenburg, eds., *A Cultural History of Gesture* (Ithaca: Cornell University Press, 1991), pp. 36–58.

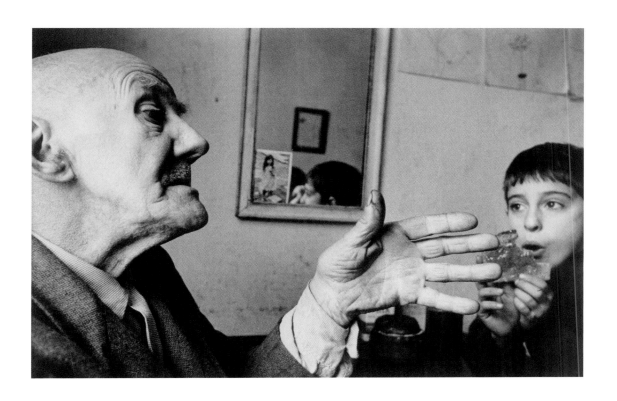

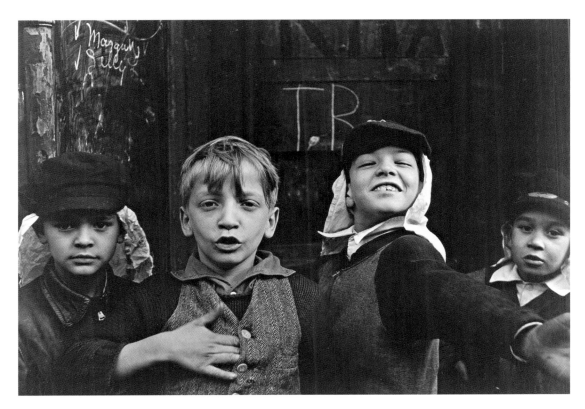

Robert Frank Pablo and old
man—New York City 2, 1958.
Gelatin-silver print, 7 ³/₄ x
11 ¹/₂ inches (19.7 x 29.2 cm)

Helen Levitt New York, ca. 1939.
Gelatin-silver print, 6 x 9 inches
(15.2 x 22.9 cm)

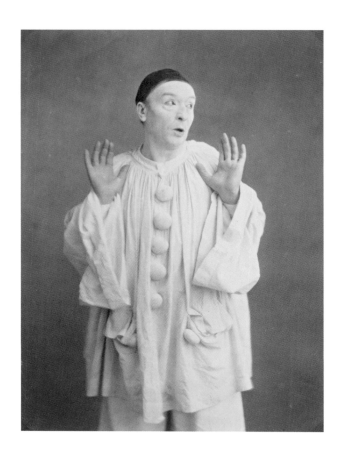

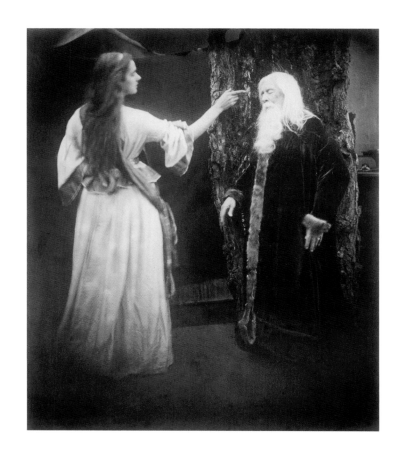

Nadar *Paul Legrand*, ca. 1855.
Salt print, 8 ¹/₂ x 6 ¹/₄ inches
(21.6 x 15.9 cm)

Julia Margaret Cameron
Vivien and Merlin, 1874. Albumen
print, 12 ³/₄ x 10 ³/₄ inches
(32.4 x 27.3 cm)

Robert Capa *Leon Trotsky
Lecturing Danish Students on the
History of the Russian Revolution,
Copenhagen, Denmark, November 27,
1932*, 1932. Gelatin-silver print,
8 ³/₄ x 13 ¹/₂ inches (22.2 x 34.3 cm)

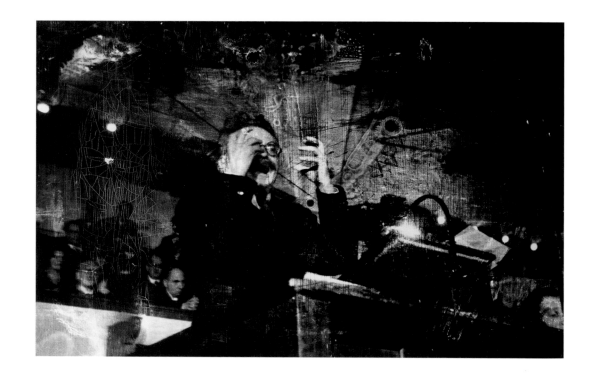

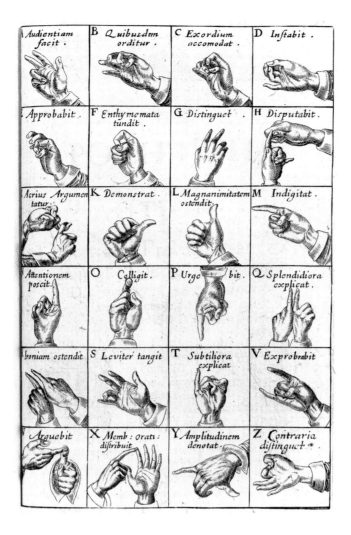

A Audientiam facit.	B Quibusdam orditur.	C Exordium accomodat.	D Instabit.
I Approbabit.	F Enthymemata tundit.	G Distinguet.	H Disputabit.
Acrius Argumentatur.	K Demonstrat.	L Magnanimitatem ostendit.	M Indigitat.
Attentionem poscit.	O Colligit.	P Urgebit.	Q Splendidiora explicat.
Ironiam ostendit.	S Leviter tangit.	T Subtiliora explicat.	V Exprobrabit.
Arguebit.	X Memb: orati: distribuit.	Y Amplitudinem denotat.	Z Contraria distinguet.

John Bulwer Chirogram from *Chironomia: Or, the Art of Manuall Rhetoricke*, 1644. The Folger Shakespeare Library, Washington, D.C.

movements.[34] He points out that traveling troupes became especially adept at hand gestures, since they could not rely on a common language to convey meaning in foreign countries. Of course, the silent art of pantomime is entirely dependent on gesture, especially hand gestures.

Photography is an excellent medium for creating compendiums of hand signs, realistically rendered updates of primers such as John Bulwer's 1644 treatises *Chirologia: Or the Naturall Language of the Hand* and *Chironomia: Or, the Art of Manuall Rhetoricke*, with their "chirograms," or grids of hand diagrams.[35] In 1994, for example, the graphic designer Bruno Munari published a handbook, *Il dizionario dei gesti italiani* (Dictionary of Italian gestures), consisting of photographs of (mostly Southern) Italian gestures, with brief explanations in Italian, English, French, German, and Japanese.[36] In the first of his two seventeenth-century treatises, Bulwer reviews the ancient literature praising the hand and argues that hand gestures provide a universal discourse. In the second book, he examines the specific gestures of public speakers,

34. Neill, pp. 167–203.

35. John Bulwer, *Chirologia: Or the Naturall Language of the Hand. Composed of the Speaking Motions, and Discoursing Gestures Thereof. Whereunto Is Added Chironomia: Or, the Art of Manuall Rhetoricke. Consisting of the Naturall Expressions, Digested by Art in the Hand, as the Chiefest Instrument of Eloquence, by Historicall Manifesto's, Exemplified Out of the Authentique Registers of Common Life, and Civill Conversation. With Types, or Chyrograms: A Long-Wish'd for Illustration of This Argument.* (London: Tho. Harper, 1644; facsimile Ann Arbor, Mich.: University Microfilms, 1975).

36. Bruno Munari, *Il dizionario dei gesti italiani* (Rome: AdnKronos Libri, 1994). This book was inspired by Andrea de Jorio's *La mimica degli antichi investigata nel gestire napoletano* (Naples: Stamperia e Cartiera del Fibreno, 1832), recently published as *Gesture in Naples and Gesture in Classical Antiquity*, introduction and notes by Adam Kendon (Bloomington: Indiana University Press, 2000). There are also contemporary publications on Brazilian, French, Russian, Sicilian, Spanish, and Spanish American gestures.

whether politicians or actors. While many of Bulwer's chirograms are readable today, some are not (certainly not with the detailed meanings he describes), which demonstrates the historical and cultural specificity of many hand movements. A more modern case in point is the meaning of the American peace sign. This World War II victory sign, when reversed by gesturing with the front of the hand rather than the palm forward, is considered obscene in Britain. Photographs capture the subtlest nuances of gesture, underlining the cultural differences embodied in the way a cigarette is held between the fingers, for example. Mudra—codified rather than incidental hand gestures—also exemplify a culturally distinct form of signification. To the Western eye, these finger and hand formations—signifying spiritual states in Hindu and Buddhist religious practice and sculpture—suggest a basic difference in conceiving of how to arrange the fingers in movement. The hand appears to be ethereally pliable, seemingly boneless, in Eastern dance forms like Balinese dance or the style of Thai dance notable for its performers' exaggerated, artificial fingernails.

In the late nineteenth century, publishers produced albums of photographs of posed bodies and body parts, providing painters and sculptors with an alternative to live models. An artist would not have to worry about his model's availability or ability to hold a pose, since a lexicon of photographs was at his constant disposal. Photographer Louis Igout produced eight- and sixteen-shot grids of images for the Calavas publishing house, in one such example supplying multiple illustrations of an anonymous female hand in gestures signifying feminine grace (ca. 1880, p. 40).[37]

Many explicit forms of hand language have developed in contexts that are defined by verbal silence, such as religious meditation, hunting and war maneuvers, secret societies, certain performance traditions (especially ballet and mime), and, of course, the discourse of the deaf. In these sign systems the hand is a way to speak in silence. Photography, as a visual medium, is an apt form to reproduce this language; however, its static nature tends to reduce continuous speech to its constituent parts, to words rather than phrases. In photographic representation, the flow of language is often simulated through accumulations of serial and sequential images, so that sentences can be formed from frozen gestural words.

Like Bulwer's suppositions regarding the versatility of gesture, photography since its inception has been promoted as a means of crossing cultural and linguistic boundaries and thus providing a universal language. The apotheosis of this ideal is Edward Steichen's 1955 Museum of Modern Art exhibition that toured the world, *The Family of Man*, which presented enlarged photographic portraits of an array of human beings involved in various activities. It is only relatively recently that historians and theorists of photography have argued that the medium is as historically and culturally specific as any other form of discourse.[38]

37. See André Rouillé and Bernard Marbot, *Le corps et son image: Photographies du dix-neuvième siècle* ([Paris]: Contrejour, 1986), p. 51.

38. For relevant criticism, see Bolton, ed., especially the essays by Christopher Phillips, "The Judgment Seat of Photography," pp. 15–46, and Sekula, pp. 343–88.

Helen Pierce Breaker *India Ramosay's Hand*, 1935. Gelatin-silver print, 7 ⁷/₈ x 6 ¹/₄ inches (20 x 15.9 cm)

E. O. Hoppé *"Snakes": The Sinuous Arms of the Famous Dancer Roshanara*, ca. 1918. Gelatin-silver print, 9 ³/₄ x 7 ¹/₄ inches (24.8 x 18.4 cm)

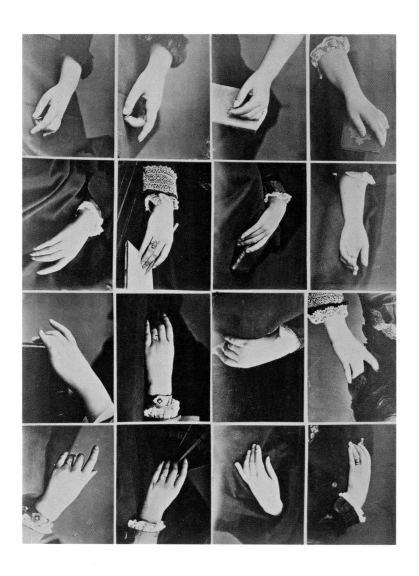

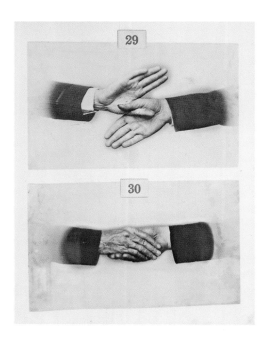

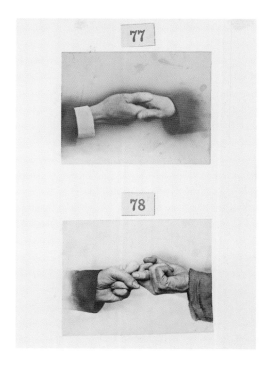

Louis Igout *Set of Hands*,
ca. 1880. Albumen print, 7 ¹/₂ x
5 ¹/₄ inches (19.1 x 13.3 cm)

Unknown photographer
*The Sovereign Grand Lodge
I. O. O. F.* (two pages), 1890s.
Album with platinum prints,
12 ³/₄ x 10 ¹/₂ x 2 ³/₄ inches
(32.4 x 26.7 x 7 cm)

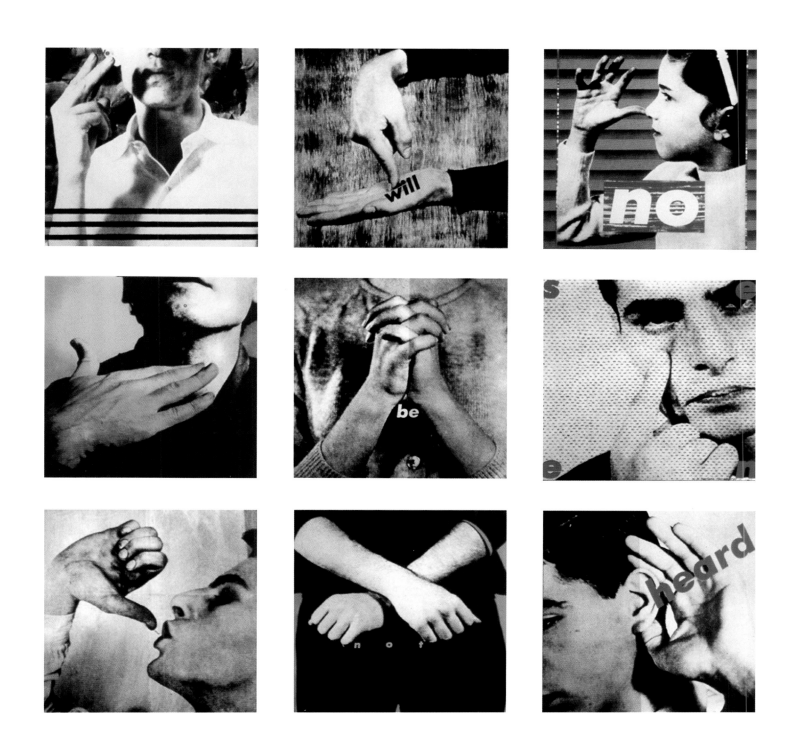

Barbara Kruger *Untitled*, 1985.
Nine color photolithographic and
silkscreen prints, each 20 ¹/₂ x
20 ¹/₂ inches (52.1 x 52.1 cm)

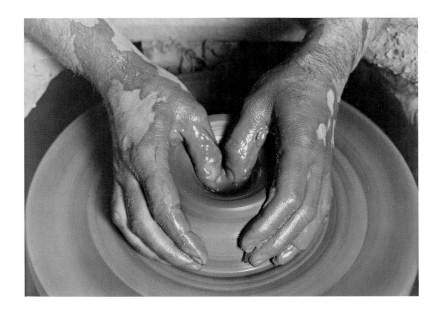

The Fragment as Portrait

In more than one respect, man's hands
have been his destiny.[39]
—ELIAS CANETTI

Straightforward photographs of hands, primarily in repose, often function as portraits, as metonymic indicators of a subject who is presented only in part. They characterize the whole body, stand in for the person. Typically, what the individual does with his or her hands is significant, and the hands—their physical form, their condition—indicate the use they are put to. In the case of unnamed sitters, images of hands can become a kind of genre subject, a representation of generic ideas about the nature of work, for example, or about age, gender, ethnicity. Many photographs in The Buhl Collection fit into this category. Manual expertise seems to be the emphasis in some, while the character of the subject is more the point in others.

In his essay "The Social Definition of Photography," the sociologist Pierre Bourdieu reproduces a photograph of an old woman's hands with the caption, "Those hands mean work," a generalized reference to the response of peasants to whom he showed the photo.[40] He asserts that they perceived the photo allegorically to indicate "old age, work and honesty." This allegorical reading is common in photographs of hands that are ideologically oriented, that intend to effect change, bettering the position of workers, or to present them as heroic. Grimy and calloused hands can indicate the hardship of a laborer's existence. Conversely, Gustav Klutsis's *Let Us Fulfill the Plan of the Great Projects* (1930) presents a reiteration of strong hands to assert workers' solidarity.

Albert Renger-Patzsch
Hands (Potter), ca. 1925. Gelatin-silver print, 6 3/4 x 9 inches (17.1 x 22.9 cm)

39. Elias Canetti, *Crowds and Power*, trans. Carol Stewart (Harmondsworth: Penguin Books, 1973), p. 219, quoted by Neill, p. 167.
40. Bourdieu, "The Social Definition of Photography," in Bourdieu et al., p. 93.

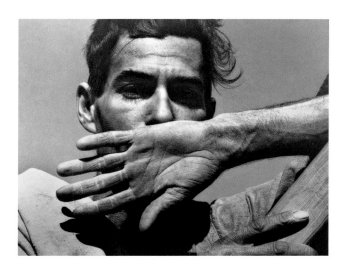

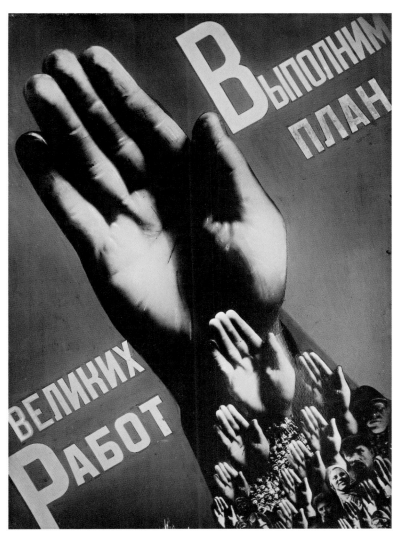

Dorothea Lange *Migratory*
Cotton Picker, Eloy, Arizona, 1940.
Gelatin-silver print, 13 ¹/₂ x
10 ¹/₂ inches (34.3 x 26.7 cm)

Gustav Klutsis *Let Us Fulfill*
the Plan of the Great Projects,
1930. Gelatin-silver print
photomontage, 8 ¹/₂ x 5 ¹/₂ inches
(21.6 x 14 cm)

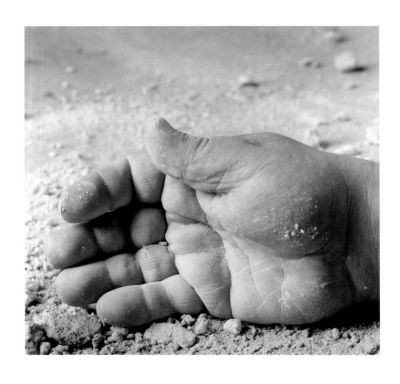

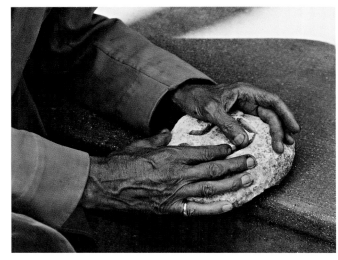

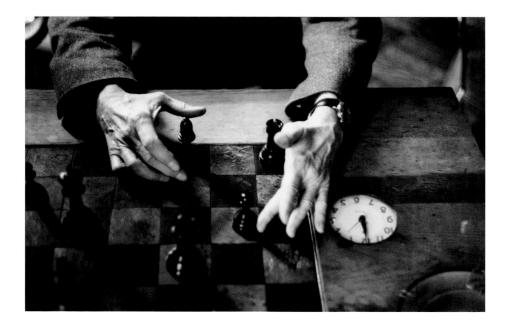

Many portraits of hands are of known sitters, usually people whose use of their hands in their work is significant, for example, artists, musicians, athletes, and actors. In some cases it may be possible to identify an artist by his or her hands alone, but more typically we construct identity backward: We learn the name of the person first, then we search the hands for an understanding of the connection between those hands and the work the individual does. In many cases, hands appear to perfectly embody people, like a horoscope or palm reading that seems to reveal events that have already taken place. In other instances, the discontinuity between the form of the hands and our beliefs about the nature of their owners serves to emphasize the folly of reading people through this body part.

Cropped images of hands in portrait photographs are ubiquitous in photography, as they are not, prior to the twentieth century, in other mediums. The face has always been considered the primary bearer of meaning in the portrait and the natural focus of attention. Because of the technical difficulty and laboriousness of painting hands, they were often obscured, or a premium was charged for their inclusion. With the advent of photography it became no more or less time-consuming to represent hands than any other part of the body.[41] The detail, as Barthes has argued about literature, is a sign for the real, for accuracy and truth.[42] Focusing on details is a characteristic of photographic visualization not just because it is technically feasible but also because it emphasizes the ontology of the photograph, its relation to the real world.

In *The Body in Pieces: The Fragment as a Metaphor of Modernity*, Linda Nochlin interprets the cropped pictorial space of Impressionist painting as the result of "total contingency," in other words, the image, like a photograph, is spontaneously produced out of the random passage of modern life.[43] At the same time, this fragmentation also indicates "total determination," the fact that the artist has willfully cropped the picture, forcing to the forefront of consciousness an acknowledgment of its mode of production. Both of these modernist devices are characteristic of photographic portraits and photography in general. Photographs can appear to be created spontaneously and randomly (the hand as incidental), as well as deliberately (the cropped hand as modern subject). The fragmented, fetishized body of modernism, the "body-in-pieces," is a particularly photographic subject.

Lord Snowdon *Eduardo Paolozzi*, 1988. C-print, 15 3/8 x 16 1/8 inches (39.1 x 41 cm)

Paul Strand *Hands of Georges Braque, Varengéville, France*, 1957. Gelatin-silver print, 4 1/2 x 5 3/4 inches (11.4 x 14.6 cm)

Alexander Liberman *The Hands of Marcel Duchamp*, 1959. Gelatin-silver print, 16 x 20 inches (40.6 x 50.8 cm)

Richard Avedon *Joe Louis, Prize Fighter, New York City*, 1963. Gelatin-silver print, 20 x 16 inches (50.8 x 40.6 cm)

41. The photographer and educator Albert Renger-Patzsch specifically argued for the inclusion of hands in photographic portraiture. See Renger-Patzsch, "Einiges über Hände und Hände Aufnahmen," *Photographie für Alle* 23, no. 11 (June 1, 1927), pp. 177–78. I thank Virginia A. Heckert for bringing this text to my attention.
42. Barthes, "The Reality Effect," pp. 141–48.
43. Linda Nochlin, *The Body in Pieces: The Fragment as a Metaphor of Modernity* (New York: Thames and Hudson, 1994), p. 37.

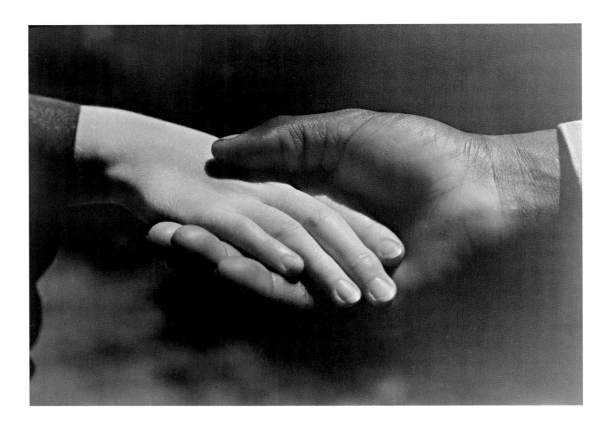

The Lovers Embrace

*A sort of umbilical cord links the body of the photographed
thing to my gaze: light, though impalpable, is here a
carnal medium, a skin I share with anyone who has been
photographed.*[44]
—ROLAND BARTHES

It is a commonplace of love that a lover can recognize her
beloved through a corporeal fragment, that love endows the lover with
the power to memorize the intimate topography of the body. Portraits
of hands suggest this intimacy. They call for a viewer who will inhabit
the space of the lover and recognize the hands. Pictures of two people's
hands entwined serve as a metaphor for this recognition, and for the
physical and emotional communion of the couple whose hands repre-
sent them.[45] Rather than express individual identity, these dual portraits
tend to embody iconic motifs. A classic subject is the photograph of the
hands of an adult and a child, in which the sinuous adult hand signifies
experience and mastery—the bestowing of life—while the child's tender,
small hand suggests vulnerability and a tabula rasa. These photographs
also speak of intimacy and love, although rather than sexual passion it
is "parental passion" that is invoked.[46]

Consuelo Kanaga Hands,
1930. Gelatin-silver print,
8 x 9 ¹/₂ inches (20.3 x 24.1 cm)

[44]. Barthes, *Camera Lucida*, p. 81.
[45]. Since at least the Early
Christian period in the West, the
custom of wearing a matrimonial
band on the ring finger of the
left hand was linked to the belief
that a vein runs directly from
that finger to the heart.
[46]. Anne Higonnet develops this
distinction in an essay about the
critical and legal interpretation
of nude photographs of children.
See Higonnet, "Conclusions Based
on Observation," in Marianne
Hirsch, ed., *The Familial Gaze*
(Hanover, N.H.: University
Press of New England, 1999),
pp. 325–42.

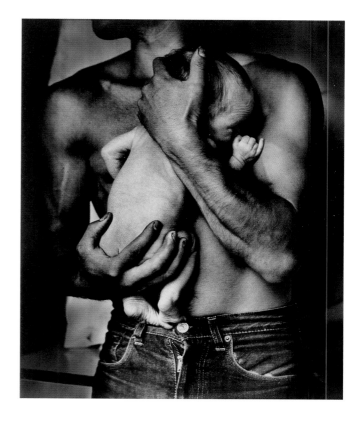

Southworth and Hawes *Mother and Nursing Child*, ca. 1844–50. Half-plate daguerreotype, 5 ¹/₂ x 4 ¹/₂ inches (14 x 11.4 cm)

Jan Saudek *My Son*, 1966. Gelatin-silver print, 14 ³/₄ x 11 ¹/₄ inches (37.5 x 28.6 cm)

I have already described Barthes's response to the photograph of his mother as a child, his elucidation of the uncanniness of photographs in their representation of people we would like to believe are immortalized in the photograph yet are dead—or will die too soon, depriving us of their presence. His reading examines photographic portraits and specifically portraits of loved ones, including those we wish to love. Photographs of children also embody a fetishistic desire to hold them fast. Images of children's hands held by parents or of the hands of parents cradling children may be emblems of safety and assurance. They are like the myriad Madonna and child paintings in cathedrals, yet the photographic realism suggests specific human beings and a specific tactility. As a viewer I cannot help comparing every photograph of a parent holding a child to my own experience as a mother who holds children and as a child who was held. Of the five senses, only touch not only receives the sensation of perception but also causes it. But like the other senses, its activation is transient. We may want to preserve the loving embrace, carry it with us always, but this is impossible. Photographs of parents and children memorialize this separation and loss. In a literal portrayal of this lost embrace, the photojournalist Harald Henden documented a man holding a child with his prosthetic hands.[47] The victim in this image is not only the man who has lost the function of his hands and the ability

[47.] Reproduced in World Press Photo Foundation, *World Press Photo 2001* (New York: Thames and Hudson, 2001), pp. 80–81.

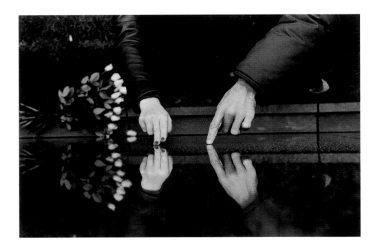 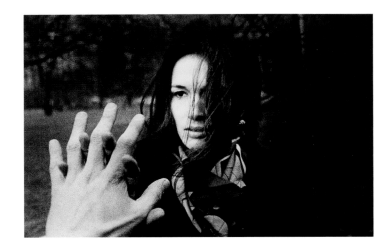

to touch this child but also the child who will never again feel the touch of the man. The violence perpetrated against him in Sierra Leone radiates out to all those who love him, and they are not only hurt materially by the deprivation of their breadwinner's livelihood but wounded physically and emotionally by being robbed of his warm embrace. Visitors to the Vietnam Veterans Memorial in Washington, D.C., who are faced with the total absence of a beloved body touch the name that evokes it on the granite walls.

Photographs attempt to transcend the distance created by bodies separated by time and space. Some images literalize this distance by actually marking the space between the camera/photographer and the photographed subject. In a photo from *The Somnambulist* (1967), Ralph Gibson's left hand reaches to clasp a woman's, while he takes a shot of her with his right. In Vito Acconci's sequential photos, residue of the performance *Passes* (1971, p. 165), Acconci's hands progressively mark the space from the camera's lens until finally they deform the flesh of his face. This work creates a metaphor for the photographic eye and visuality itself as an aggressive exchange laced with narcissism.

Photographs frequently embody a kind of yearning that they cannot quell despite their efficiency at representing it. The proliferation and repetition of sexual subject matter in photographic imagery from the inception of the medium to the present day is a record of this insatiable quest. Photos of naked individual bodies create an imaginary space for the viewer-lover. These photographs often suggest a moment of passion—the ecstatic climax depicted in the image and that presumably elicited by the photo—and yet the insurmountable distance that Barthes laments is ultimately only emphasized. That lover has been there but is no longer.

Wendy Watriss *Vietnam Veterans Memorial*, 1984. Gelatin-silver print, 11 x 14 inches (27.9 x 35.6 cm)

Ralph Gibson From *The Somnambulist*, 1967. Gelatin-silver print, 16 x 20 inches (40.6 x 50.8 cm)

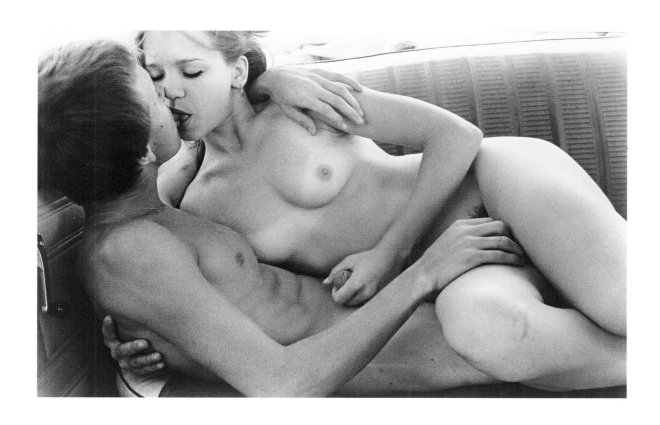

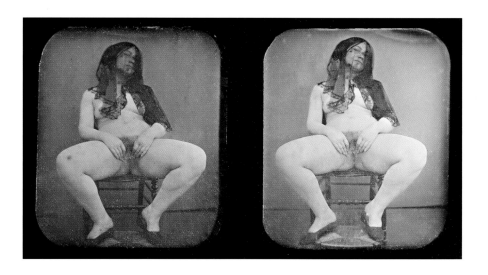

Larry Clark *Untitled*, 1972.
Gelatin-silver print, 8 ¼ x
12 ½ inches (21 x 31.8 cm)

Unknown photographer
Study of a Seated Veiled Woman,
ca. 1854. Stereo daguerreotype,
3 ⁵/₁₆ x 6 ¹³/₁₆ inches (8.4 x 17.3 cm)

The Uncanny: Photographs and Hands

From having been an assurance of immortality,
it becomes the uncanny harbinger of death.[48]
—Sigmund Freud

The "it" to which Freud refers here is the double. He is describing various sources of the uncanny, but he could just as well be describing photography. In fact, Freud does not write about photographs at all in the essay just quoted, but his conclusions seem to describe photographic subjects and effects particularly well. The uncanny is something familiar yet somehow strange. Freud explains the feeling by citing the literary figure of the double—the doppelgänger, alter ego, or ghost, for instance (not surprisingly, his examples come from horror stories)—as well as experiences from daily life, like being frightened by one's reflection in a mirror or by one's shadow. Significantly, the double, especially mirror reflections and shadows, is an index, which unites it structurally with the photograph. Every photographic portrait creates a double, a trace of a person.

Another uncanny effect that Freud cites is the uncertainty as to whether something is alive or dead. His discussion relates to dolls and automatons but also to dead bodies, which he describes as uncanny due to our primitive fear of death, our inability to comprehend its finality. But the question of whether something is alive or dead is also a characteristic of the photographic double. Barthes describes this aspect in other terms when he realizes while looking at a photograph that the person who is looking out at him had looked at others who are now dead, and that the person himself is no longer living.[49]

When describing literature, Freud argues that the uncanny sensation in response to a text derives from confusion about whether what takes place in the story is real or fantasy—the subject of an occult force heretofore believed to be fantastic, or the imaginings of an infirm mind. Though he focuses on literary devices, Freud claims to be examining aesthetics more generally, and his observations serve just as well to describe the work of photographers as creators of another species of "imaginative productions."[50] The question of what is real and what is fantastic seems especially apt in relation to spirit photography—attempts to capture images of the dead as well as people's auras. But it is a fundamental issue for many photographic images, whether photojournalistic or artistic; viewers are frequently disturbed by their inability to determine where the truth lies, whether an image is based in reality or fabricated.

In his essay on the uncanny, Freud particularly cites the hand as an independent fragment:

Cindy Sherman Untitled, #256, 1992. Color photograph, 68 x 45 inches (172.7 x 114.3 cm)

48. Freud, "The 'Uncanny,'" p. 235.
49. Barthes, *Camera Lucida*, p. 3.
50. Freud, "The 'Uncanny,'" p. 249.

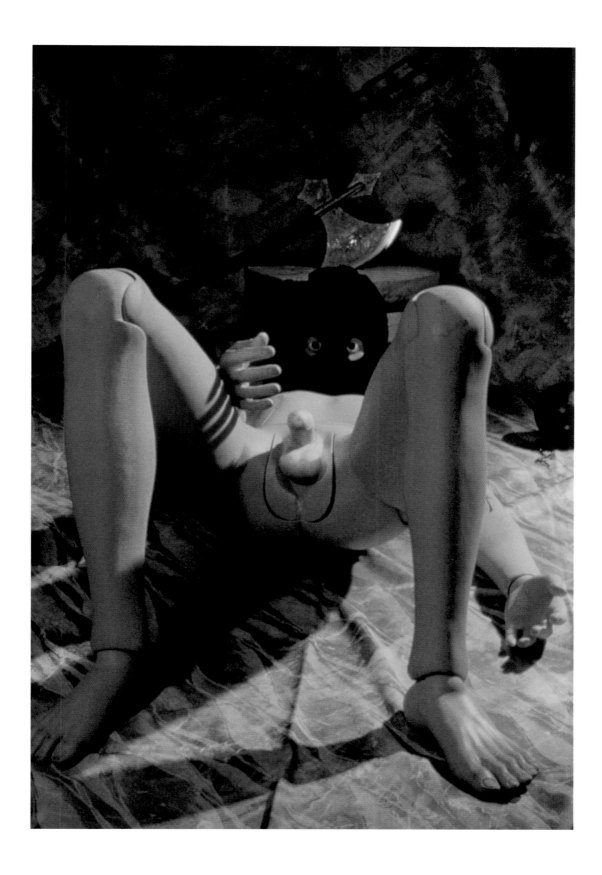

51. Ibid., p. 244. It is interesting to note, in light of a photograph such as Maurizio Cattelan's *Mother*, that Freud continues in this passage to cite as uncanny the fear of being buried alive.

52. There is a rich history of films about demonic severed hands; see for example, Robert Wiene, dir., *The Hands of Orlac* (1925; also known as *Die unheimlichen Hände des Doktor Orlac*). In this film, a pianist's severed hands are surgically replaced with those of a murderer. It was remade in various versions including Karl Freund, dir., *Mad Love* (1935) and Edmond T. Gréville, dir., *The Hands of Orlac* (1961). Maurice Tourneur's *La main du diable* (1942) concerns the Faustian pact made by the owner of a severed hand. Other movies feature independently animate, severed hands, such as Herbert L. Strock, dir., *The Crawling Hand* (1963) and Oliver Stone, dir., *The Hand* (1981). In both of these films, a severed hand, detached from a body, murders people. By the 1960s, the undead, severed hand was such a staple of horror movies that it easily took its place as a character ("Thing") on the television horror send-up *The Addams Family*. A more recent example of uncanny hands, by a director much enamored of the B horror genre, is Tim Burton's *Edward Scissorhands* (1990).

It is interesting to note in this regard an expansion in the graphic gruesomeness of dead bodies and body parts, especially hands, on television crime dramas that feature forensic evidence. See, for example, the CBS franchise *Crime Scene Investigation*. What had at one time appeared to be disturbingly explicit in Cindy Sherman's photographic work is now commonplace in the mass media. Could this reflect attempts to manage anxiety caused by the need for DNA identification of victims of the attack on the World Trade Center and other mass-casualty disasters like plane crashes?
(The notes continue on page 55.)

Dismembered limbs, a severed head, a hand cut off at the wrist, as in a fairy tale of Hauff's ["The Story of the Severed Hand"], feet which dance by themselves, . . . all these have something peculiarly uncanny about them, especially when, as in the last instance, they prove capable of independent activity in addition. As we already know, this kind of uncanniness springs from its proximity to the castration complex.[51]

Freud had previously analyzed the manifestations of castration anxiety in a story by E. T. A. Hoffmann that involved blinding and death. For Freud, the fear of losing one's eyesight (more specifically, having one's eyes plucked out as in the Oedipus myth), is a potent symbol of castration anxiety. The detached hand has a similar symbolic potential and is frequently a subject of cinematic as well as literary productions in the horror genre.[52] Freud argues that the repetition of this frightening motif is fetishistic in that it serves to reassure us against the loss it evokes.[53] It is also worth noting that hands are themselves mirror doubles, and thus embody a prime aspect of the Freudian uncanny.

Krauss, in her groundbreaking essay "Corpus Delicti," has shown how the uncanny is an essential notion for understanding Surrealist photography.[54] But many aspects of photographic practice are uncanny, even when they are not created specifically within the context of Surrealism.[55] On some level, the argument can be made that the basic tenets of modernist practice produce uncanny images, as fragmentation is a characteristic of modern experience and creative production, and yet "a will to totalization," to overcoming the sensation of dispersal, results in the suturing of fragments into marvelous new wholes made out of the

Maurizio Cattelan *Mother*, 1999. Gelatin-silver print, 45 ¹/₂ x 40 ³/₄ inches (115.6 x 103.5 cm)

Ralph Eugene Meatyard *Untitled (Hand in Doorway)*, 1961. Gelatin-silver print, 10 x 8 inches (25.4 x 20.3 cm)

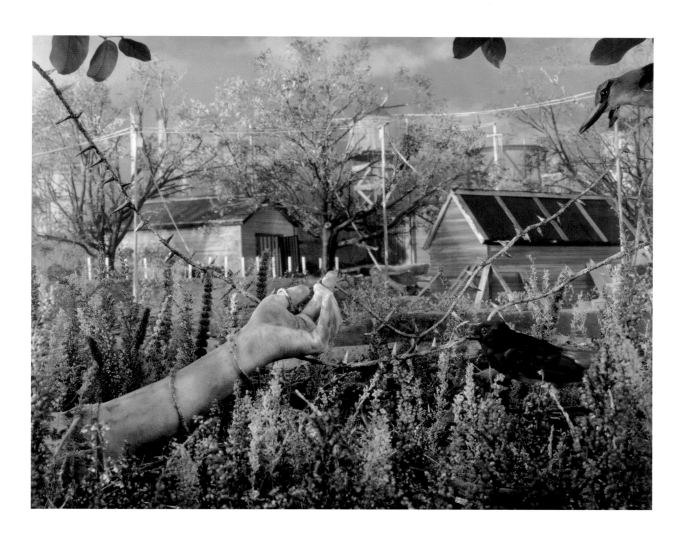

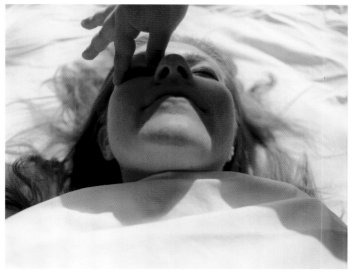

Gregory Crewdson *Untitled*,
1995. C-print, 40 x 50 inches
(101.6 x 127 cm)

Anna Gaskell *Untitled #84
(resemblance)*, 2001. C-print,
19 ¹/₈ x 23 ³/₄ inches (48.6 x
60.3 cm)

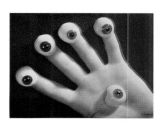

parts.[56] This is also a reason for the strangeness of the *wunderkammer*, in which so many disparate objects are wrenched from their context (a bird's nest, an embalmed fetus) and juxtaposed by a collector into a discordant symphony of objects. Surrealists above all celebrated this process and exaggerated it in their work; the poetic motto for their process was "the fortuitous encounter on a dissecting table of a sewing machine and an umbrella."[57] Their photographs, and photos inspired by them, frequently include hands treated in an uncanny fashion—for example, violently snipped, with ocular accessories, or as phantasmatic ghosts. Given that our hands are our most familiar body part (in that we have direct and constant visual access to them in an unparalleled way), the aroma of the uncanny is especially strong when they are made strange.

So far I have examined the uncanny strictly in terms of the photographic equivalent of fictional literary production. This is in keeping with Freud's mandate. But I should also note the prominence of the uncanny, severed hand in political violence and its symbolism. For Freud, fears about the loss of sight or limbs are manifestations of castration anxiety. It seems reasonable to argue that historical representations of amputated hands can also be read through Freud's logic, in that political violence often is, or seems to threaten, sexual violence. The lost member is a threat to the viewer who identifies with the injured party, and conversely a sign of dominance for the one who identifies with the victor/victimizer. The obvious intention of the maimer is to rob his victim of the ability to challenge, to render the hand incapable of action. The symbolism of the severed limb—whether in French Revolutionary cartoons, prints of conquerors subduing native people, or contemporary photos of terrorists' victims—suggests castration, such that the amputee himself is a graphic reminder of who is powerful and who is powerless.[58] In part because hands are associated with writing, the severed hand is an extremely powerful symbol of repression, since the handless arm is incapable of producing seditious texts.[59]

Herbert Bayer *The Lonely Metropolitan*, 1932. Gelatin-silver print photomontage with gouache and airbrush, 16 1/8 x 11 3/4 inches (41 x 29.8 cm)

top left:
Marc Foucault *Untitled*, 1946. Photocollage, 11 1/2 x 9 inches (29.2 x 22.9 cm)

top right:
Pierre Jahan *Hand with Five Eyes*, 1947. Gelatin-silver print, 11 1/2 x 15 3/8 inches (29.2 x 39.1 cm)

bottom:
Gilles Peress *French Hospital, Sarajevo, August–September, 1993*, 1993. Gelatin-silver print, 24 x 36 inches (61 x 91.4 cm)

53. According to Freud, fetishes are compensatory responses created out of the male subject's belief that the maternal phallus was castrated, thus raising the fear that the subject will be castrated as well. See Sigmund Freud, "Fetishism" ("Fetischismus," 1927), in *Standard Edition*, vol. 21, pp. 152–57.
54. Rosalind E. Krauss, "Corpus Delicti," in Krauss, *L'Amour Fou: Photography and Surrealism* (Washington, D.C.: Corcoran Gallery of Art; New York: Abbeville Press, 1985), pp. 55–100.
55. For an analysis of the relationship between Surrealism and photography, see also Susan Sontag, "Melancholy Objects," in Sontag, *On Photography* (New York: Farrar, Straus & Giroux, 1977), pp. 51–82.
56. Nochlin, p. 53.
57. Comte de Lautréamont, as quoted by Maurice Nadeau in *The History of Surrealism*, trans. Richard Howard (Cambridge, Mass.: The Belknap Press of Harvard University Press, 1989), p. 25.
58. For French Revolutionary and mid-nineteenth-century imagery, see Nochlin, pp. 4ff, and Neil Hertz, "Medusa's Head: Male Hysteria under Political Pressure," *Representations*, no. 4 (fall 1983), pp. 27–54. For colonialist imagery, see Neill, figs. 6 and 7.
59. See Neill, pp. 186ff.

Handedness, or the Ambivalent Duality of Hands: A Conclusion

> But I say unto you, That whosoever looketh on a woman
> to lust after her hath committed adultery with her already
> in his heart.
>
> And if thy right eye offend thee, pluck it out, and cast
> it from thee: for it is profitable for thee that one of thy
> members should perish, and not that thy whole body
> should be cast into hell.
>
> And if thy right hand offend thee, cut it off, and cast it
> from thee: for it is profitable for thee that one of thy
> members should perish, and not that thy whole body
> should be cast into hell.[60]
> —MATTHEW 5:28–30
>
> Every contact, for the lover, raises the question of
> an answer: the skin is asked to reply.[61]
> —ROLAND BARTHES

Henry Buhl's process of selecting and collecting photographs of hands severs each image from its original context, as part of a photo essay, for example, or of an artist's oeuvre, or a historical moment. Concomitantly, my attempts to read these photographs by way of their hands cut that single feature from its pictorial background and exaggerate it, creating a metaphor for uncanny disembodiment that is willfully repressed through suturing the disparate hands together in a collection and in a text. It is worth noting literary critic Michael Neill's argument that Freud's postulation of the castration complex at the root of the hand's uncanniness is too narrow: "The persistence of the hand as a suggestive motif in human culture has less to do with any single universal significance than with its extraordinary symbolic adaptability."[62]

And yet there is something undeniably uncanny about hands, just as there is about photographs. Perhaps it is their ability to be two things— two hands, each one the double of the other—and to be two things at once or at various times, active and passive, subject and object. Maurice Merleau-Ponty notes: "When one of my hands touches the other, the hand that moves functions as subject and the other as object."[63] Could it be that this functional aspect of hands is the source of the uncanny idea, elaborated so frequently in horror stories, that the hand can operate independently of its owner? Barthes describes a similar transition from subjecthood to objecthood as his photograph is taken: It is for him a moment of creation, as well as a "dissociation of consciousness from

60. See also Mark 9:43–44: "And if thy hand offend thee, cut it off: it is better for thee to enter into life maimed, than having two hands to go into hell, into the fire that never shall be quenched: Where their worm dieth not, and the fire is not quenched."
61. Roland Barthes, *A Lover's Discourse: Fragments*, trans. Richard Howard (New York: Hill and Wang, 1978), p. 67. Originally published as *Fragments d'un discours amoureux* (Paris: Editions du Seuil, 1977).
62. Neill, p. 169.
63. Maurice Merleau-Ponty, *Phenomenology of Perception*, trans. Colin Smith (New York: Routledge, 1989), p. 315.

identity" in which he feels himself to have become an uncanny specter.[64] Every image is a kind of ghostly other hand of the hand-object that is reproduced.

Symbolically, the hand oscillates between the irrational and the rational. It can represent the irrational—as in the out-of-control hand of the murderer—or the rational, as in the exquisitely skilled hand that operates at the behest of the highest mental faculties. It alternately symbolizes the power to create (the godlike hand that bestows life) and the power to destroy (the evil hand that kills). The duality of meaning that hands embody is reflected in the divergent symbolism of the left and right hands. In his 1909 study of the right hand, sociologist Robert Hertz indicates these distinctions:

> *To the right hand go honours, flattering designations, prerogatives: it acts, orders, and* takes. *The left hand, on the contrary, is despised and reduced to the rôle of a humble auxiliary: by itself it can do nothing; it helps, it supports, it holds.*

> *The right hand is the symbol and model of all aristocracy, the left hand of all common people.*

He adds:

> *The same contrast appears if we consider the meaning of the words "right" and "left." The former is used to express ideas of physical strength and "dexterity," of intellectual "rectitude" and good judgement, of "uprightness" and*

64. Barthes, *Camera Lucida*, p. 12.

Alan Govenar *The Hand of the Murderer #7*, 1995. Gelatin-silver print, 16 x 20 inches (40.6 x 50.8 cm)

Margaret Bourke-White *Untitled (Hands Playing Violin and Cello)*, ca. 1940s. Gelatin-silver print, 6 3/4 x 4 3/4 inches (17.1 x 12.1 cm)

moral integrity, of good fortune and beauty, of juridical norm; while the word "left" evokes most of the ideas contrary to these. . . . The power of the left hand is always somewhat occult and illegitimate; it inspires terror and repulsion.[65]

Hertz and others have speculated about whether the right/left distinctions of the hand and the bias toward the right are rooted in the bicamerality of the human brain. After a century, there is still no clear answer to this question, yet the binary differentiation of the hand remains.

The hand, especially the right hand that holds the pen, has tradition-ally been associated with writing. Photographs of hands writing, or of writing itself, are interesting because of the way they literalize the paral-lels between writing and photography. Both record the transitory and try to fix it in place.[66] (The word "photography" means writing with light.) Both are modes of communication that fetishize rules of objectivity in order to emphasize their facticity, their power to provide proof. Both have played a major role in the mass dissemination of information, where they are inextricably locked in an embrace of image and text. And both elicit the specter of the uncanny when we are left to puzzle over whether a threatening image is based in reality or the imaginary.

Today handedness seems less significant than ever, and ascriptions of good and evil to the right or left quaintly superstitious. This must be due, in part, to the rise of a de facto lefties-rights movement as the parents of southpaw kids are no longer willing to let their children be forced into right-handedness. But it is also a contemporary reality that most writing (often primarily as a vehicle of social interaction) occurs via the computer keyboard, which calls for the use of both hands, if not entirely equally.

As I write this text I feel my fingertips press the keys. I hear the staccato tapping of each letter interspersed with the thudding pause of the space bar. I shuffle through scraps of paper clotted with handwritten notes and try not to be distracted by the young man cracking his knuckles, as he reshelves books in the library outside my office. I glance up at the pictures of my children, imagining recrimination for abandonment in the eyes that look back at me. I yearn to touch flesh instead of plastic. This page records the trace of my movements; the words are my foot-prints in the snow, the indexical markers of my writing, my signature, repeatedly removed via technology, like a digital photo sent via e-mail and printed years later.

Annette Messager Lines of the Hand ("Fear"), 1987. Gelatin-silver print with acrylic, charcoal, and pastel, framed in wood, and colored pencil on wall; installation variable, photograph 5 x 3 1/2 inches (12.7 x 8.9 cm)

Shirin Neshat Stories in Martyrdom, 1995 (detail). Gelatin-silver print, 54 1/4 x 39 3/4 inches (137.8 x 101 cm)

65. Robert Hertz, "The Pre-Eminence of the Right Hand: A Study in Religious Polarity" (1909), in Hertz, *Death and the Right Hand*, trans. Rodney and Claudia Needham (Aberdeen: Cohen and West, 1960), pp. 89, 99, 105. Also note in this regard the custom in Middle Eastern and North African cultures to use the right hand exclusively for the consumption of food, the left for toilet functions, as noted by John Napier, "Handedness," in Napier, *Hands*, revised by Russell H. Tuttle, rev. ed. (Princeton: Princeton University Press, 1993), p. 121.
66. Rosalind E. Krauss makes this point in her essay, "When Words Fail," *October*, no. 22 (fall 1982), p. 95. I thank Luis Croquer and George Baker for bringing this article to my attention.

۱۳۷

ر صدای زنی را نشنیدم،
که می خواند. گفتم شاید یکی از
زنهای آبادی، دم غروب به سرش
زده که بیاید و دریا نزدیک تر بشود. صدا
آرامتر نشد. معلوم نبود چه می گفت. اما
صداش غصه دار بود. انگار ته دریا دست
و پا به زنجیر مانده باشد. چشم چشم
کردم کسی نبود. لنگر به دریا انداختم
صدا گفت: مرد برو!

۱۳۶

مرد از اینجا برو! صدای
خودش بود. خنده ام گرفت و
گفتم: حالا چه وقت رفتنه؟ هنر
کلام نود دهنی چرخید که زنی از زیر
آب بیرون آمد. دو تا چشم داشت،
مثل خرنگ آتش، برو بزنگاهم کرد. بعد
چنان نو لوشم زد که بی هوش شدم؛ با
منصور ناگهان سردش شد خودش را
وجمع کرد و بیشتر در پناه.....

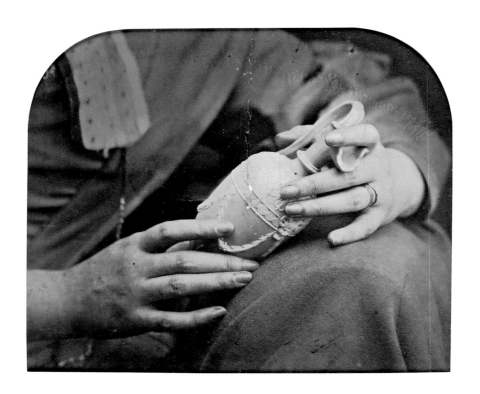

O. G. Rejlander *Study of Hands*, 1850s. Albumen print from wet-collodion negative, 5 ¹/₂ x 6 ¹/₂ inches (14 x 16.5 cm)

Ringl + Pit *Soapsuds*, 1930. Gelatin-silver print, 7 x 6 ¹/₄ inches (17.8 x 15.9 cm)

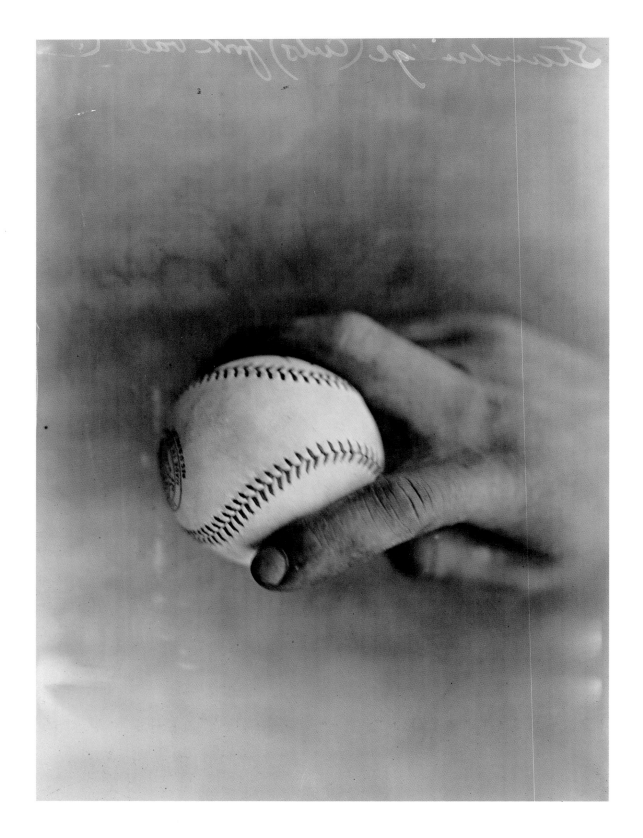

Charles M. Conlon *Eddie Cicotte*, ca. 1913. Gelatin-silver print, 6 ⁷/₈ x 5 ¹/₄ inches (17.5 x 13.3 cm)

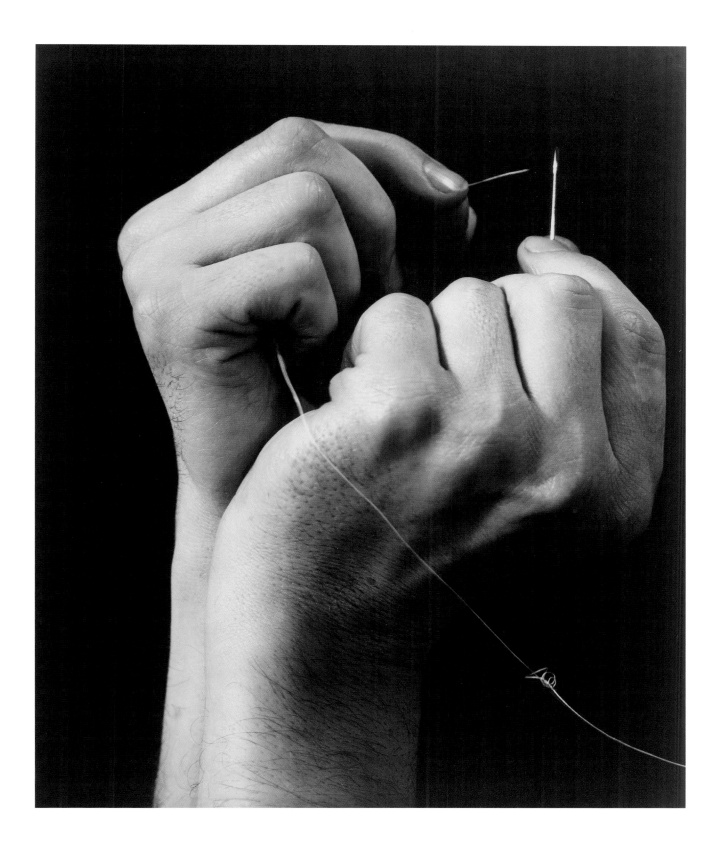

Anton Bruehl *Threading the Needle*, 1929. Gelatin-silver print, 20 x 16 inches (50.8 x 40.6 cm)

Jacques-Henri Lartigue *Florette in Cannes*, 1942. Gelatin-silver print, 2 x 2 ¹/₄ inches (5.1 x 5.7 cm)
Paolo Roversi *Hands of Ines de la Fressange*, 1980. Polaroid print, 10 x 8 inches (25.4 x 20.3 cm)

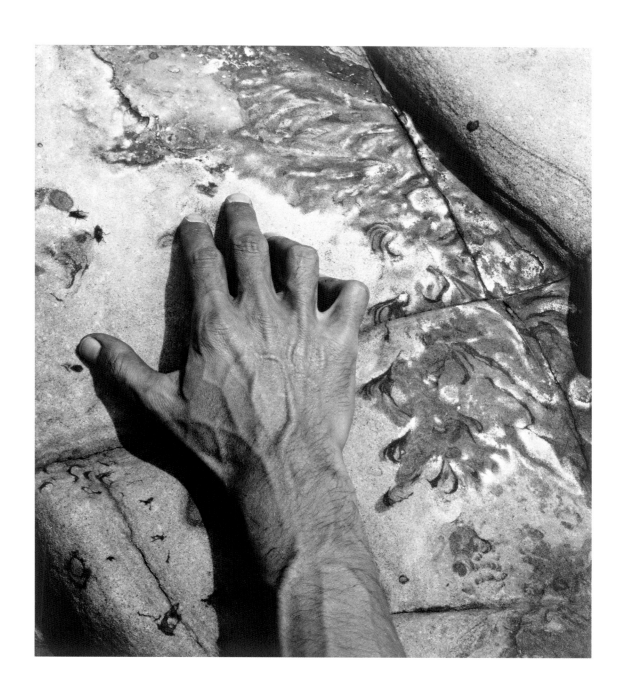

Minor White *William Larue*, 1960. Gelatin-silver print, 8 $^5/_8$ x 7 $^3/_4$ inches (21.9 x 19.7 cm)

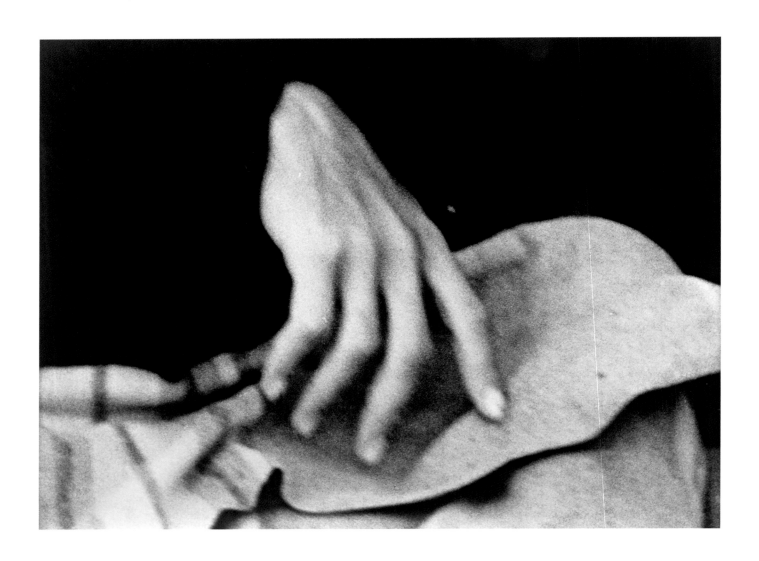

Mario Giacomelli *My Head Is Full, Mama*, 1985–87. Gelatin-silver print, 11 ³/₄ x 15 ³/₄ inches (29.8 x 40 cm)

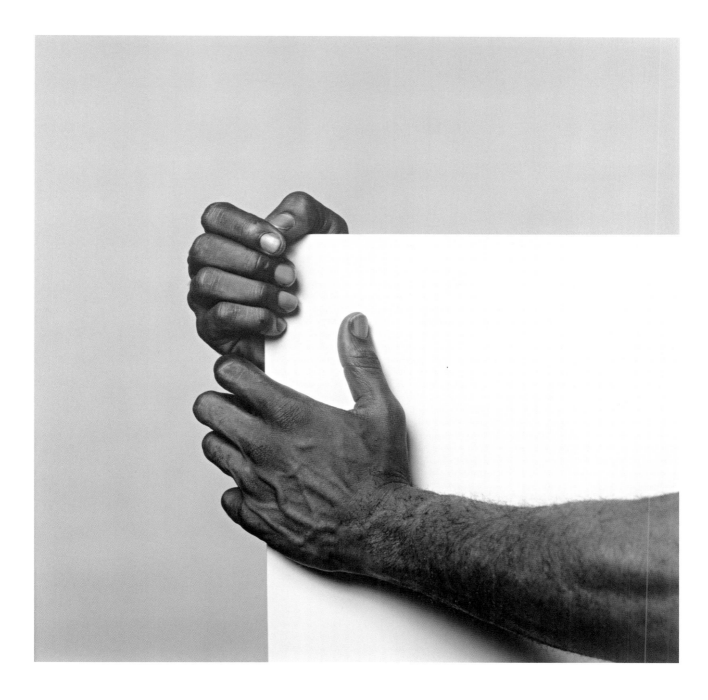

Robert Mapplethorpe *Lowell Smith*, 1981. Gelatin-silver print, 20 x 16 inches (50.8 x 40.6 cm)

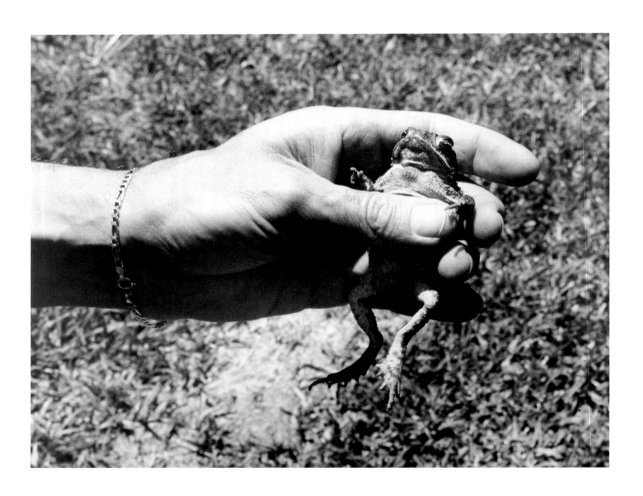

David Wojnarowicz *Untitled (Frog)*, 1988–89. Gelatin-silver print, 16 x 20 inches (40.6 x 50.8 cm)

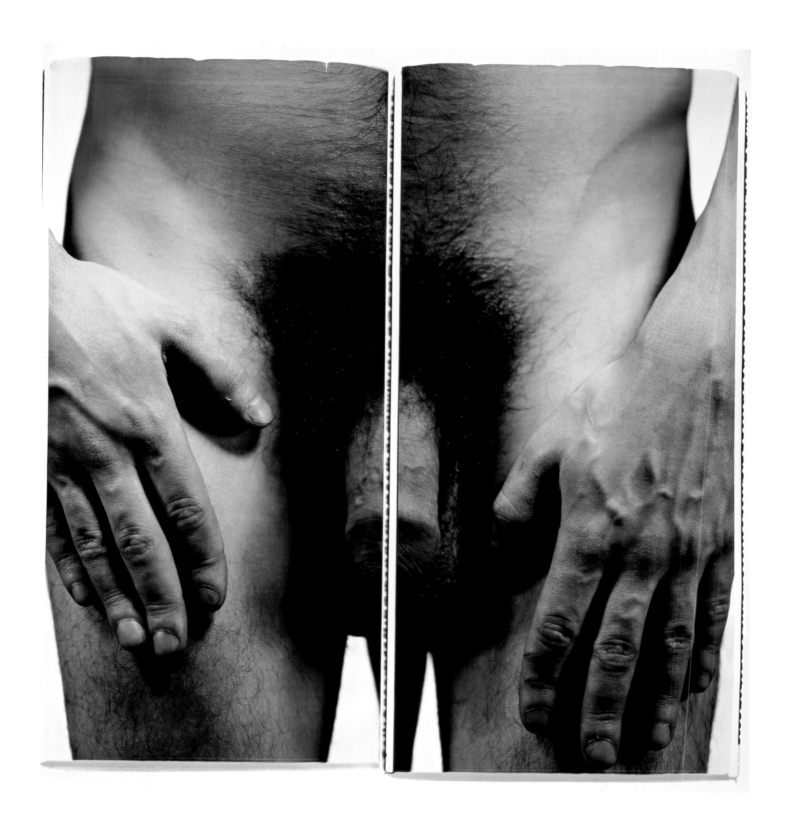

Chuck Close *Mark Morrisroe*, 1984. Two Polaroid prints, each 80 x 40 inches (203.2 x 101.6 cm)

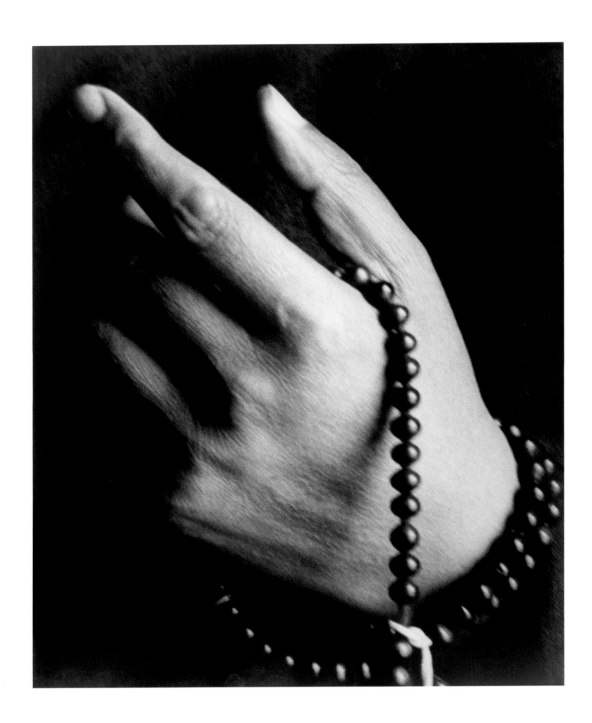

Herb Ritts *His Holiness the Dalai-Lama, New York*, 1987. Gelatin-silver print, 18 ¹/₂ x 14 ³/₄ inches (47 x 37.5 cm)

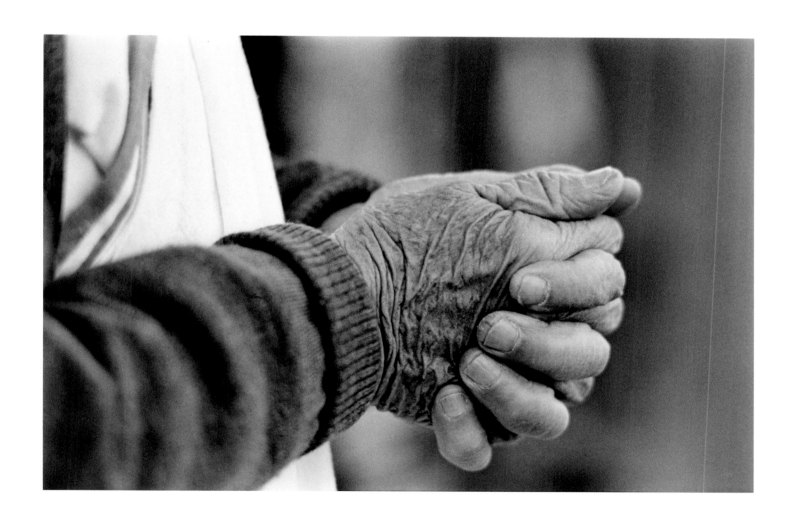

Mary Ellen Mark *Mother Teresa, Meerut*, 1981. Gelatin-silver print, 6 ¹/₂ x 9 ¹/₂ inches (16.5 x 24.1 cm)

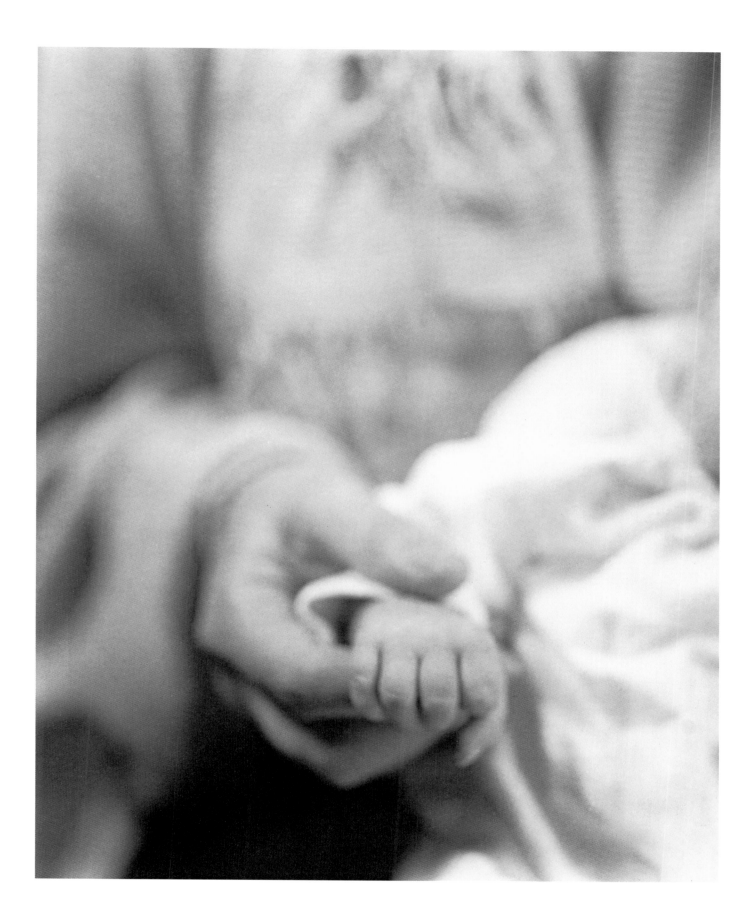

Joseph Grigely *Josephine P., Rotterdam, 1996,* 1997. R-print, 3 x 4 ³/₄ inches (7.6 x 12.1 cm)
Joseph Grigely *Amy V., Ghent, January 30, 1997,* 1997. R-print, 3 x 4 ¹/₂ inches (7.6 x 11.4 cm)
Joseph Grigely *Wassily Z., Vienna, June 9, 1997,* 1998. R-print, 3 x 4 ¹/₂ inches (7.6 x 11.4 cm)

Roy Pinney *Reading Braille*, ca. 1936. Gelatin-silver print, 13 ¹/₂ x 10 ¹/₄ inches (34.3 x 26 cm)

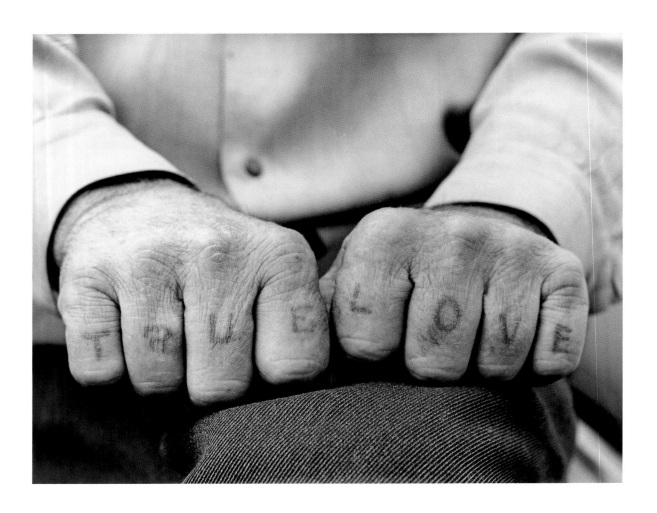

Ernest Lowe *A Union Organizer's Fists*, 1961. Gelatin-silver print, 11 x 14 inches (27.9 x 35.6 cm)

David Shrigley *Hate*, 2002. C-print, 11 x 16 inches (27.9 x 40.6 cm)

Frederick H. Evans *Portrait of Aubrey Beardsley*, 1894. Platinum print with ink-on-paper border by Beardsley, 4 ⁷/₈ x 3 ³/₄ inches (12.4 x 9.5 cm)
Claude Cahun *Self-Portrait ("I Am in Training Don't Kiss Me")*, ca. 1927. Gelatin-silver print, 4 ¹/₈ x 3 inches (10.5 x 7.6 cm)

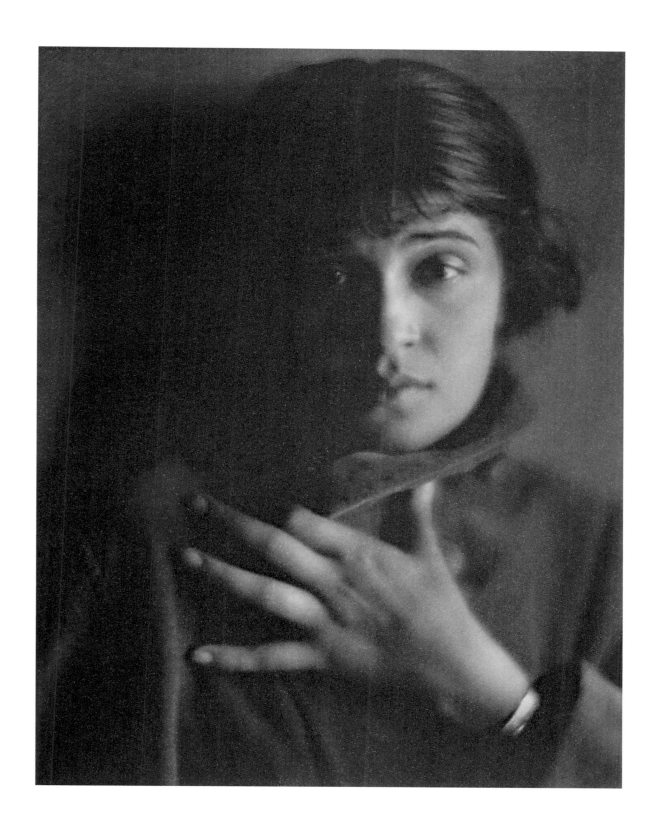

Edward Weston *Tina Modotti, Glendale*, 1921. Platinum print, 9 ¹/₂ x 7 ¹/₂ inches (24.1 x 19.1 cm)

Edward Steichen *J. P. Morgan, Esquire*, 1903. Gelatin-silver print, 9 ¹/₂ x 7 ³/₄ inches (24.1 x 19.7 cm)

Alexander Rodchenko *Mother*, 1924. Gelatin-silver print, 9 x 6 ¹/₄ inches (22.9 x 15.9 cm)

Ansel Adams Georgia O'Keeffe, 1976. Gelatin-silver print, 10 x 8 inches (25.4 x 20.3 cm)

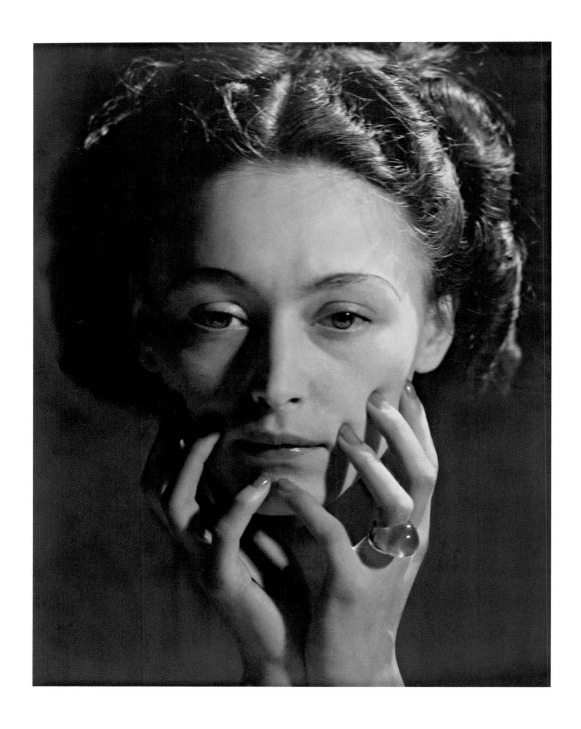

Dora Maar *Nusch Eluard, Paris*, 1936. Gelatin-silver print, 10 5/8 x 7 1/2 inches (27 x 19.1 cm)

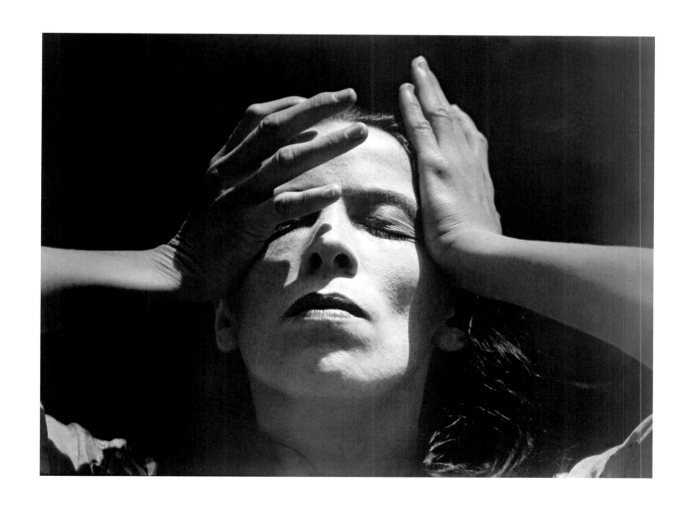

Imogen Cunningham *Martha Graham, Dancer*, 1931. Gelatin-silver print, 7 ¹/₄ x 9 ³/₄ inches (18.4 x 24.8 cm)

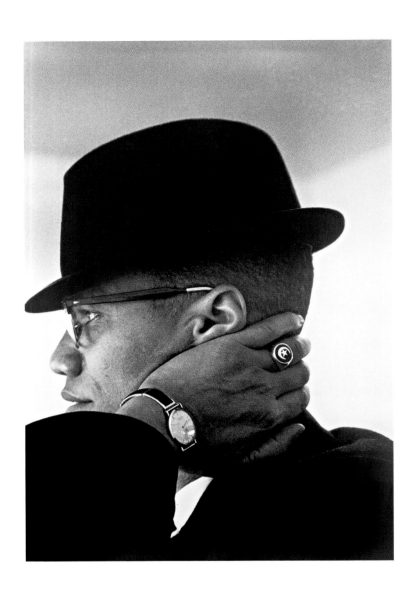

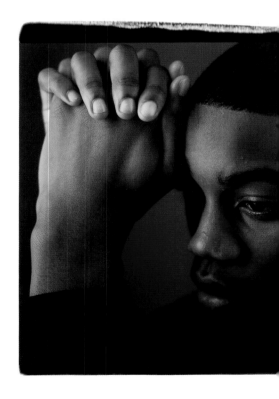

Eve Arnold *Malcolm X*, 1961. Gelatin-silver print, 20 x 16 inches (50.8 x 40.6 cm)

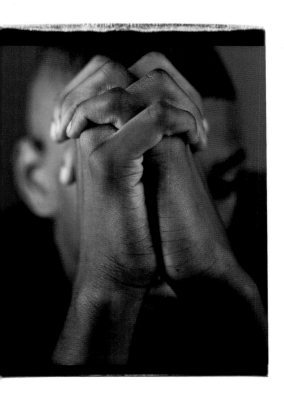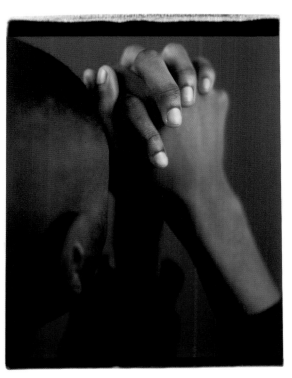

Dawoud Bey *Shinaynay*, 1998. Three Polaroid Polacolor ER prints, each 24 x 20 inches (61 x 50.8 cm)

Peter Hujar David Wojnarowicz, 1981. Gelatin-silver print, 14 $\frac{1}{2}$ x 14 $\frac{1}{2}$ inches (36.8 x 36.8 cm)

88

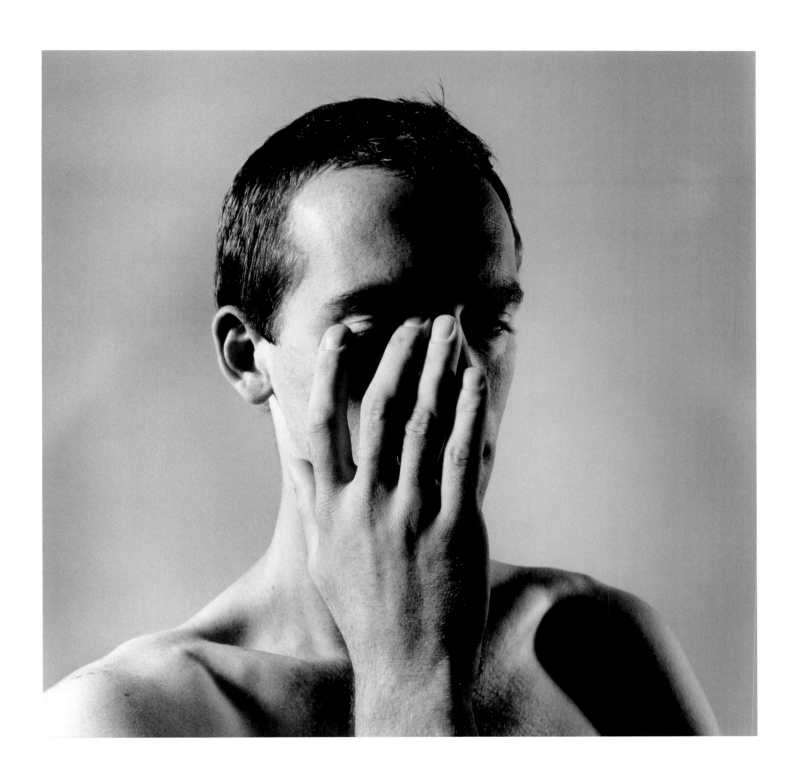

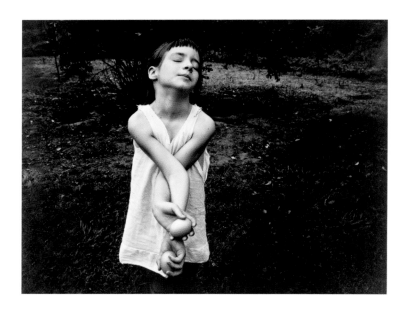

Diane Arbus *Child with a Toy Grenade, Central Park, New York*, 1962. Gelatin-silver print, 15 x 15 inches (38.1 x 38.1 cm)
Emmet Gowin *Nancy, Danville, Virginia*, 1969. Gelatin-silver print, 5 ¹/₂ x 7 inches (14 x 17.8 cm)

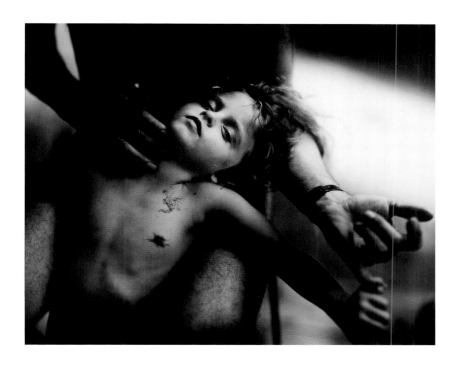

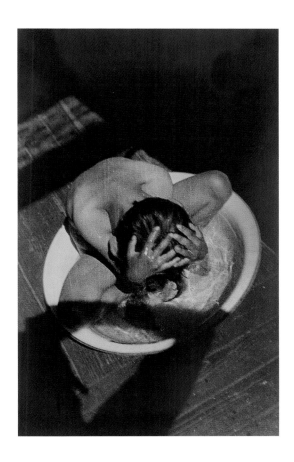

Sally Mann *Last Light*, 1990. Gelatin-silver print enlargement, 20 x 24 inches (50.8 x 61 cm)
Alexander Rodchenko *Morning Wash (Varvara Rodchenko)*, 1932. Gelatin-silver print, 6 ³/₄ x 4 inches (17.1 x 10.2 cm)

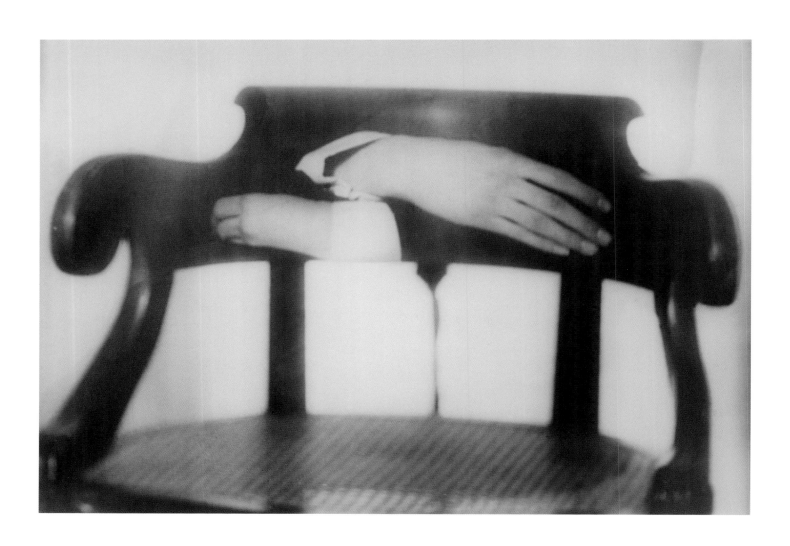

"Blond Hands over the Magic Fountain":
Photography in Surrealism's Uncanny Grip

KIRSTEN A. HOVING

Among the photographs by Man Ray that appeared in the inaugural issue of the French Surrealist magazine, *La révolution surréaliste*, in 1924, is a strange image of a wood armchair with two disembodied hands hovering on its back. The photograph challenges common assumptions about the documentary role of photography by offering Surrealist alternatives: The inanimate object is animate; the recognized place is alien; and, above all, the factual photograph is fantastic. The hands in Man Ray's photograph are the agents of these transformations. Indeed, throughout Surrealist art and literature, disembodied hands function as signifiers of psychic dislocation by being simultaneously familiar and disturbing. In Surrealist photographs in particular, hands are presented as independent entities: cut by the edge of the image, isolated from the body by photographic manipulation, or disrupted from their usual physical context to embody an alternate reality in which disembodiment is the norm. In their detached state such hands are uncanny: simultaneously living and ghostly, chaste and erotic, rational and dreamlike.

With its image of ghostly severed hands, Man Ray's armchair photograph encapsulates a broad range of issues central to Surrealism, as expressed in André Breton's first manifesto of Surrealism, published just a little over a month before the appearance of the first issue of *La révolution surréaliste*. Rather than setting out a specific aesthetic program, Breton enumerated those elements that seemed most important to Surrealism: freedom, imagination, madness, irrationality, the illogical, the dream, the marvelous. His goal was "the future resolution of these two states, dream and reality, which are seemingly so contradictory, into a kind of absolute reality, a *surreality*."[1] Although in his first manifesto Breton barely touched on the possibilities of visual Surrealism, he used hands to explain how the imagination could be liberated. Surrealism, he wrote, "will glove your hand, burying therein the profound M with which the word Memory begins."[2] It would circumvent conscious thought processes to engage the creative potential of the unconscious. Breton turned to the act of "gloving" to suggest Surrealism's negation of tactile surface reality in favor of a deeper connection with things that cannot be touched or consciously known. For Breton the hand needed to be figuratively disconnected to reveal a state of mind apart from the logic

Man Ray *Untitled*, 1924. Gelatin-silver print, 9 x 6 ¹/₂ inches (22.9 x 16.5 cm)

Some of the ideas explored here first appeared in my article Kirsten H. Powell, "Hands-On Surrealism," *Art History* 20, no. 4 (Dec. 1997), pp. 516–33.

1. André Breton, "Manifesto of Surrealism," in *Manifestoes of Surrealism*, trans. Richard Seaver and Helen R. Lane (Ann Arbor: The University of Michigan Press, 1972), p. 16. Originally published as "Manifeste du surréalisme," 1924.
2. Ibid., p. 32. The French is "Gantera votre main, y ensevelissant l'M profond par quoi commence le mot Mémoire." From Breton, "Manifeste du surréalisme," *Oeuvres complètes*, vol. 1 (Paris: Gallimard, 1988), p. 334.

of memory and time—the same mental condition implied by Man Ray's improbable floating hands.

In addition to using the gloved hand as a symbol for the superficial reality he wished to resist through Surrealism, Breton linked Surrealist literary production—with its desire to plumb unconscious thought through automatic writing and other antinarrative forms of expression—to photography. He observed: "The invention of photography dealt a mortal blow to old means of expression, as much in painting as in poetry, where automatic writing, which appeared toward the end of the nineteenth century, is a veritable photography of thought."[3] If Surrealist writing could be a photography of thought, Surrealist photography is a form of visual poetry. Man Ray's armchair with hands functions as a photographic ode to the surreal, offering a visual counterpart to the kind of chance encounters between body parts and objects featured in Surrealist writing. As J. H. Matthews has observed, Man Ray's photograph "offers an amalgam of pictorial elements which, taken separately, do not produce surprise but which, brought into proximity by photographic means, result in the visual counterpart of the *rapprochement de mots* (the bringing together of words) practiced by certain surrealist poets in their effort to resist rational language and to overturn its boundaries."[4]

Breton also used the act or idea of severing to describe Surrealism. To demonstrate the potency of Surrealist states of being, in his first manifesto he described the remarkable effect of a phrase that came to him one night before falling asleep: "There is a man cut in two by the window."[5] In this phrase, Breton encapsulated the experience of finding the marvelous in the commonplace, so that the reality of a man leaning out of a window could become a surreal evocation of body dislocation, fragmentation, or even amputation. Hands, photographs, severing—all these work together for Breton as vehicles to position Surrealism as an alternate mode of perceiving and conceiving the world. Man Ray, too, incorporated these elements to use the factual recording medium of the photograph to "document" the marvelous.

While on one level Man Ray may have intended the photograph of the chair and hands as a kind of English pun on the word "armchair," or as a French pun on his own assumed name—the "mains" (hands) of Man—in it he also presented a partial body whose materiality is far less important than its surreality.[6] The quirky appearance of phantom hands on the back of a hard, wood chair may seem odd in an age of mechanical reproduction, but those hands fit easily with the fascination with the supernatural that marked the early days of Surrealism. In his search for a superior form of reality, Breton often turned to strange sources of inspiration: the spiritualist world of the occult; the ghosts haunting ruined castles of gothic novels (he was especially fond of Horace Walpole's gigantic hand in armor in *The Castle of Otranto* [1764]); the phantoms

3. André Breton, "Max Ernst," in *The Lost Steps*, trans. Mark Polizzotti (Lincoln: University of Nebraska Press, 1996). Originally published in *Les pas perdus*, 1924.
4. J. H. Matthews, "Modes of Documentation: Photography in *La révolution surréaliste*," *Modern Language Studies*, no. 15 (summer 1985), p. 42.
5. Breton, "Manifesto of Surrealism," p. 21.
6. The partial body has traditionally been a source of inspiration for artists and writers. For example, see David Hillman and Carla Mazzio, eds., *The Body in Parts: Fantasies of Corporeality in Early Modern Europe* (New York: Routledge, 1997) and Linda Nochlin, *The Body in Pieces: The Fragment as a Metaphor of Modernity* (London: Thames and Hudson, 1995). For a brief discussion of the partial body in Surrealism, see Elza Adamowicz, "Part-Bodies: Crime or Miracle?" in Adamowicz, *Surrealist Collage in Text and Image: Dissecting the Exquisite Corpse* (Cambridge: Cambridge University Press, 1998), pp. 173–84.

that emerge from an individual in the act of automatic writing or recounting dreams; the lure of magic and alchemy; the juxtaposition of unrelated objects and ideas. All of these manifest the marvelous. Moreover, some of Breton's most startling literary images conjure up visionary hands. The opening line of the series of automatic writings collectively titled *Soluble Fish*, published with the first manifesto of Surrealism in 1924, calmly recalls: "The park, at this time of day, stretched its blond hands over the magic fountain."[7] Parks do not have hands, much less blond hands, unless there is magic afoot—the kind of magic that results from a willingness to put one's faith, as Breton put it in the manifesto, in "previously neglected associations, in the omnipotence of dream, in the disinterested play of thought."[8] Indeed, later in *Soluble Fish* there is evidence of just such thought-play, when he writes: "Hands to knead the air, to toast but once the bread of the air, to slam the great eraser of sleeping flags, of solar hands, finally, frozen hands!"[9]

For the Surrealists, and Man Ray and Breton in particular, disembodied hands were potent symbols of the liberated psyche. What was it about hands that enabled them to function in this way? As the body part that separates humans from other animals, hands are an identifiable symbol for the advanced reasoning capacities of the species—capacities for rationalism that Surrealists like Breton were anxious to bypass. As tools that respond to signals from the brain, our hands with their opposable thumbs enable us to engage in activities that define us as physical creatures who do practical things in the real world. For Surrealists, who wished to engage unconscious thought, severed hands symbolized a break from the physical body and a bridge to the dreaming mind. Thus Surrealists fragmented hands, dislocating them from the body and privileging them as independent body parts. In so doing, they negated the unity of the body and destabilized its logic.

To question why Surrealists were drawn to the fragmented body is to confront an issue as complex as Surrealism itself. The disintegrated body allowed Surrealist artists and writers to rethink received notions about the body and its realities, both anatomical and psychological. It permitted them to make revolutionary assaults on the idea of the rational whole, and to present the isolated parts as antireligious, nonredemptive relics of a new world view. It offered metaphors for human existence in which the part became whole, and the fragment—with its allusions to the battlefield, the dissecting table, the analyst's couch, and the history of art—was given privileged status. The origin of the modern conception of the body as the sum of its knowable parts has been traced to the Renaissance practice of dissection and the illustrations of body parts, known as "anatomies," that were published in anatomical texts.[10] One way to understand Surrealist photographers' presentations of the body is to think of their photographs as modern "anatomies" that examine the

7. André Breton, *Soluble Fish*, in *Manifestoes of Surrealism*, p. 51. Originally published as *Poisson soluble*, 1924.
8. Breton, "Manifesto of Surrealism," p. 26.
9. Breton, *Soluble Fish*, p. 66.
10. See Jonathan Sawday, *The Body Emblazoned: Dissection and the Human Body in Renaissance Culture* (London: Routledge, 1995). Literary historians have argued that a similar partitioning of the body found its way into literature of the sixteenth and seventeenth centuries, resulting in literary genres, such as the "blazon," that took as their poetic subjects the secular glorification of specific anatomical parts. For a discussion of the Renaissance blazon, see Nancy J. Vickers, "Members Only," in Hillman and Mazzio, eds., pp. 3–21. Michel Foucault has even looked at punitive practices of dismemberment at this time as a way of understanding cultural meanings of the whole and fragmented body. See Foucault, *Discipline and Punish*, trans. Alan Sheridan (New York: Vintage Books, 1979).

11. Wartime poets realized this, and the physical fragmentation of the body was a leitmotif in poems, such as one by Edgell Rickword that recounts the progressive rotting of a corpse until the closing line, "I had to leave him; then the rats ate his thumbs." Quoted in Paul Fussell, *The Great War and Modern Memory* (Oxford: Oxford University Press, 1975), p. 159.
12. The emphasis on the fragmented body in Surrealism was no doubt due in part to the carnage of World War I, whose mutilated and amputated veterans were visible reminders of the recent mass assault on humanity. Although direct references to the war are rare in Surrealist writing, the fragmented wartime body does appear in at least one poem published in *La révolution surréaliste*: "Epitaph for a Monument to the War Dead," by Benjamin Péret, who invokes cutoff hands and broken leg bones in this virulent antiwar diatribe. See Péret, "Epitaphe pour un monument aux morts de la guerre," *La révolution surréaliste*, no. 12 (Dec. 15, 1929), p. 51. For a further discussion of the impact of World War I on Surrealist imagery, see Sidra Stich, *Anxious Visions: Surrealist Art* (Berkeley: University Art Museum; New York: Abbeville Press, 1990). Hal Foster has explored the way in which the body might be thought of as armor in "Armor Fou," *October*, no. 56 (spring 1991), pp. 64–97.

ways the fragmented body can comment on the modern mind. Man Ray's *Anatomies* (1929), a photograph of a woman's neck that can also be read as a phallus, is a case in point. Instead of dissecting corpses, these modern anatomists dissected vision itself to propose a world of floating eyes, dismembered limbs, decapitated heads, independent torsos, and, above all, severed hands that function as emblems for the human psyche in turbulent modern times.

Having come of age during the Great War—as a medical student Breton worked as an intern in the neuropsychiatric wards of several military hospitals—these artists and writers understood the body as vulnerable and fragile: Amputation and dismemberment were all too common outcomes of military engagement.[11] However, in the wake of the war, Breton, Man Ray, and others appropriated dismemberment for their own creative purposes, finding convulsive beauty in what most people would associate with the horrific.[12] The disembodied hands of Surrealism offer an analysis of the meaning of "alive" in the postwar era. Man Ray's double exposure inscribes disembodied hands onto the "body" of an inanimate object, onto the "back" of the "arm" chair; Breton's park stretches out its blond hands. In such images, history imprints itself on

Man Ray *Anatomies*, 1929. Gelatin-silver print, 8 7/8 x 6 3/4 inches (22.6 x 17.2 cm). The Museum of Modern Art, New York, Gift of James Thrall Soby

the body through the inversion of the trope of the powerless, fragmented bloody arm or leg on the battlefield into a new postwar body, whose strength ironically lies in its fragmentary, visionary nature.

Strange encounters between fragmented hands and seemingly unrelated objects are also common in Surrealism. Man Ray, like Breton, was fascinated early in his career by the way hands could connect us to a rich world of dreams and the unconscious. The 1922 *Rayograph with Hand and Egg* suggests the kind of serendipitous meeting of unrelated elements pioneered in the writings of the Surrealist precursor the Comte de Lautréamont (Isidore Ducasse), who described beauty as, among other things, the chance encounter of a sewing machine and an umbrella on a dissecting table.[13] Lautréamont's delight in incongruous juxtapositions had a clear impact on Breton's poetic descriptions of such dreamlike body fragments as blond hands, and they find a ready parallel

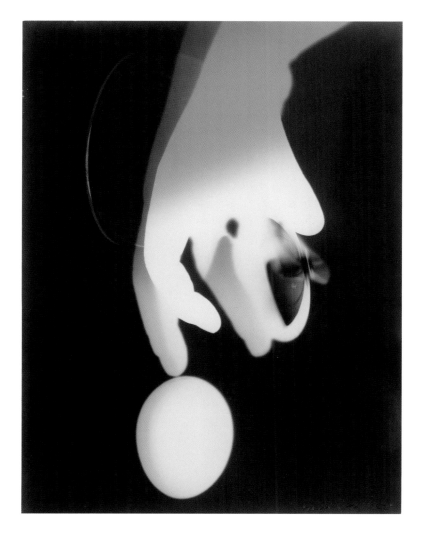

Man Ray *Rayograph with Hand and Egg*, 1922. Gelatin-silver print photogram, 9 ¹/₂ x 7 inches (24.1 x 17.8 cm)

13. Comte de Lautréamont (Isidore Ducasse), *Les chants de Maldoror*, in *Oeuvres complètes* (Paris: Gallimard, 1973). For a discussion of the influence of *Maldoror* on Breton's interest in the fragmented body, see Alexander Waintrub, "Crimes of Passion: Surrealism, Allegory, and the Dismembered Body," Ph.D. diss., University of California at Los Angeles, 1996.

in Man Ray's shadowy pairing of hand and egg.[14] The egg and a moving hand make the familiar new and strange: Produced without a camera by exposing the objects on light-sensitive paper, the image proposes a photographic alchemy in which representational reality is subordinate to a transforming experience and the hand is estranged from the body to become something else. The image is perhaps also an allusion to the "ovum philosophicum"—the alchemist's philosophical egg in which a substance goes through a symbolic death and rebirth.[15]

In addition to their roots in the prose of Lautréamont, Man Ray's and Breton's early visual and verbal investigations have affinities with Freud's conception of the uncanny.[16] "Dismembered limbs," Freud observed in his essay "Das Unheimliche" of 1919, "a severed head, a hand cut off at the wrist, as in a fairy tale of Hauff's, feet which dance by themselves . . . all these have something peculiarly uncanny about them, especially when . . . they prove capable of independent action in addition."[17] Although not articulated as such, Freud's emphasis on dismemberment was perhaps also a response to the physical horrors of the war. He linked dismemberment to the castration complex, emphasizing that the uncanny derives from repressed infantile complexes. Moreover, he argued that the uncanny can only be expressed in literature, stories, and "imaginative productions" in which the writer avoids obvious fantasy elements and creates the illusion of events happening in the world of everyday reality. That is, the more true to life the setting and details, the greater the potential for the uncanny.

Photographs, especially photographs of disembodied hands, are particularly good vehicles for expressing Freud's *unheimlich* because of their ability to be at once highly realistic and strangely fantastic, to simultaneously elicit feelings of familiarity and disruption in the viewer. It is not surprising that Breton illustrated his essay on convulsive beauty with photographs, or that, as Hal Foster suggests, Breton related beauty to photographic shock and ultimately to death.[18] Foster further argues that Breton's conception of convulsive beauty is closely related to Freud's notion of the uncanny. Convulsive beauty requires a frisson, that shudder of pleasure that borders on repulsion—a "physical sensation, like the feeling of a feathery wind brushing across my temples to produce a real shiver," arising from repressed sexual desire, in Breton's words.[19] Breton defines convulsive beauty as reciprocity between opposite states of being: fixed-explosive (arrested motion), animate-inanimate (mineral crystals that grow), veiled-erotic (hidden exposure), magic-circumstantial (unintended visual and verbal puns or dualisms). Its locus is most often the body, and in photographic form it implies both fragmentation, as in the faceless, disintegrating figure in Man Ray's *Fixed-Explosive (Explosante-fixe)*, and doubling, as in the second skin of

14. Breton published his first article on Lautréamont, "La note," in *Littérature*, no. 2 (April 1919), followed by "Les chants de Maldoror" in *La nouvelle revue française* (June 1, 1920). Man Ray's photograph of a sewing machine wrapped in a blanket and tied with rope, titled *The Enigma of Isidore Ducasse*, appeared in the December 1924 issue of *La révolution surréaliste*.

15. Man Ray may have become interested in alchemy through his associations with Marcel Duchamp and Breton, who were intrigued by the ideas of transformation inherent in alchemical science.

16. For a provocative discussion of the place of the uncanny in Surrealism. see Hal Foster, *Compulsive Beauty* (Cambridge, Mass.: The MIT Press, 1995).

17. Sigmund Freud, "The 'Uncanny'" ("Das Unheimliche," 1919), in *The Standard Edition of the Complete Psychological Works of Sigmund Freud*, trans. J. Strachey, vol. 17 (London: The Hogarth Press, 1955), p. 244. Freud refers to a story by Wilhelm Hauft entitled "The Severed Hand" (also known as "The Lost Hand of Zaleukos") in which a doctor mistakenly decapitates a corpse that turns out to be alive. As retribution, a judge demands the loss of one of his hands. Freud's essay was not translated into English until 1925 and French until 1933; the parallels between his ideas and the uses of disembodied hands in Surrealism are striking evidence of a common interest in the power of the fragmented body.

18. Foster, *Compulsive Beauty*, pp. 27–28.

19. André Breton, *Mad Love*, trans. Mary Ann Caws (Lincoln: University of Nebraska Press, 1987), p. 8. Originally published as *L'amour fou*, 1937.

ink applied to the model's hand and arm in his *Veiled-Erotic* (*Erotique-voilée*, p. 105), two photographs from a 1933 series also named, by Breton, *Veiled-Erotic*. Breton used both of these photographs to illustrate his essay "La beauté sera convulsive" (Beauty will be convulsive) in *Minotaure* in 1934.[20] In both, with their exploding and blackened bodies (wartime tropes) made desirable and beautiful, Man Ray accomplishes the conjunction of the aesthetically pleasing and the violently deforming that also informs Surrealism's severed hands.

In many Surrealist photographs, illusionistically severed hands resonate with Freud's thoughts on the uncanny and Breton's on convulsive beauty. Often the dismemberment derives from a selective narrowing of the visual frame, as in Berenice Abbott's 1927 photograph of the hands of Jean Cocteau. Perhaps having absorbed an interest in hands from her work as Man Ray's studio assistant between 1924 and 1926, or perhaps referring to Cocteau's own fascination with hands (in his 1930 film *The Blood of a Poet*, hands develop mouths and speak), Abbott reduced Cocteau to his hands. Brightly lit and artfully positioned on a hat, the hands seem independent from the body, as if cut from the whole

20. André Breton, "La beauté sera convulsive," *Minotaure* 2, no. 5 (May 1934), pp. 8–16. *Fixed-Explosive* is on p. 8; *Veiled-Erotic* is on p. 15.

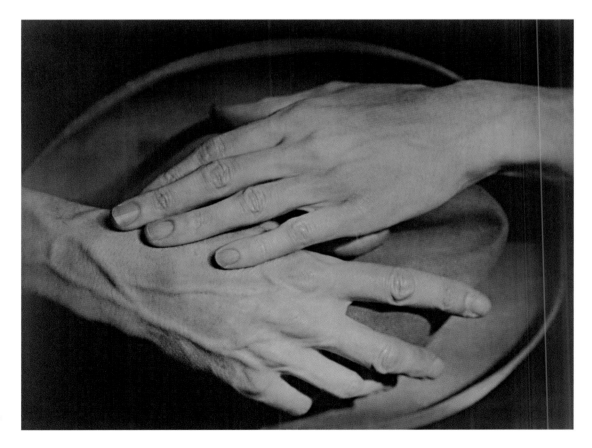

Berenice Abbott *Hands of Jean Cocteau*, 1927. Gelatin-silver-chloride print, 7 3/8 x 9 3/8 inches (18.7 x 23.8 cm)

and offered for consideration. The fact that the hands are "severed" from the body only by the frame of the photograph keeps us from fully accepting the illusion of dismemberment, paralleling Freud's argument that obviously crafted fantasies are not nearly as uncanny as strange stories that appear to be true.[21] Brassaï's *Cast of Picasso's Hand* (ca. 1943), a photograph of the artist's fist in plaster, seems to meet these criteria more exactly. The hand in Brassaï's photograph resonates with Freud's linking of severed hands and castration because of its materiality: The plaster seems like roughened flesh; the obvious three-dimensionality of the cast with its break at the wrist has more substance than flattened hands in photograms or photographed hands cropped by the edge of the frame; and the dark shadow it casts makes it seem all the more real. The hand's roughened wrist and mottled surface recalls the severed hand poked at by a man with a stick in Salvador Dalí and Luis Buñuel's film *Un chien andalou* (1928), itself perhaps a gruesome allusion to the rotting body parts seen on wartime battlefields.

The emphasis on substance and the consequent allusions to physical castration seen in Abbott's and Brassaï's photographs are countered by Surrealist photographs in which hands are insubstantial, even ghostly. Freud noted that many people experience the uncanny in its most powerful form in relation to death and to the idea of the return of the dead in spirit form. That is, when the body is not as we expect it to be, when it lacks the materiality of flesh and blood, the uncanny sets in. Surrealist photographers frequently used their medium to dematerialize substance, suggesting an uncanny, new reality that privileged the mental

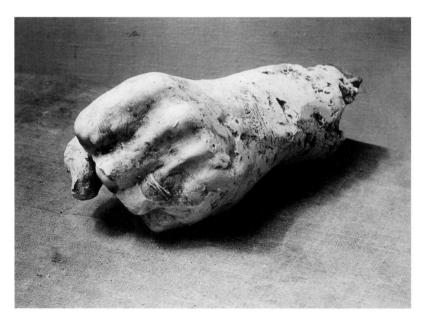

Brassaï *Cast of Picasso's Hand*, ca. 1943. Gelatin-silver print, 4 ³/₄ x 6 ³/₄ inches (12.1 x 17.1 cm)

21. Freud, p. 246.

over the physical. Maurice Tabard's solarized *Study* (1930, p. 102), for example, is an eerie, metallic hand that seems removed from commonplace reality. Like Man Ray, who used solarization to similar effect (see *Hands*, 1949, p. 103), Tabard chose a manipulation that subverted the realism of vision in favor of a surreal, visionary experience. The dark hand in Tabard's photograph glows slightly, suggesting an altered state of being in which the hand seems capable of merging with or emerging from the darkness that surrounds it. It oscillates between something immediately recognizable and something not like the body as we know it. Moreover, this hand seems capable of independent action or existence, an attribute that Freud believed made disembodied parts especially uncanny.

The sense of the body as incomplete, which is at the heart of Freud's correlation between the severed hand and the castration complex, was also central to Surrealist conceptions of disembodiment. However, the psychological charge implicit in Freud's linking of dismemberment and castration takes a different form in Surrealist verbal and visual discourses. Freud explored the unconscious to understand human behavior; the Surrealists believed that the unconscious was a source of creative inspiration that would lead to new ways of understanding the world. Accordingly, Surrealists were attracted to the idea of material objects made insubstantial and intangible. For Breton, this is apparent in his fascination with transparent hands, which he explored in a variety of texts. In *Soluble Fish*, for example, he relied on the topos of the transparent hand to conjure up the possibility of inner vision: "I took this hand in mine; raising it to my lips I suddenly noticed that it was transparent and that through it one could see the great garden where the most experienced divine creatures go to live."[22] While X-ray technology had indeed rendered flesh transparent at the end of the nineteenth century, Breton's dematerialization transformed the material facts of waking reality into the visionary stuff of dreams.

Transparency also inspired photographers working in the Surrealist mode, where transparent hands act as a code for the alternate reality represented by the unconscious. This is apparent in Osamu Shiihara's *Composition* (1938, p. 103).[23] A combination of positive, negative, and fragmented hands, Shiihara's photograph reduces the hand to a shadowy trace, partially opaque and partially translucent, that seems at once modern (it is a mechanical reproduction) and primitive (it harks back to the photograms of the early days of photography and even to the handprints found on the walls of prehistoric caves).[24] Although it is not clear how familiar Shiihara was with either Surrealist theory as articulated by Breton or Freud's writings on the uncanny, he surely sensed that transparency could suggest liberated states of mind. Transparency could

22. Breton, *Soluble Fish*, p. 90. Later in his poem "Les attitudes spectrales," published in 1932, Breton writes:"The hands that tie and untie love-knots and air-knots / Keep all their transparency for those who see / They see palms on hands / Crowns in eyes." Breton, "Ghostly Stances," in Breton, *Earthlight*, trans. Bill Zavatsky and Zack Rogow (Los Angeles: Sun & Moon Press, 1993), p. 102. Originally published in *Le revolver à cheveux blancs*, 1932. In "La forêt dans la hache," also published in 1932, Breton observes: "All I have left is a transparent body inside of which transparent doves hurl themselves on a transparent dagger held by a transparent hand." Breton, "The Forest in the Axe," in *Earthlight*, p. 110. Originally published in *Le revolver à cheveux blancs*, 1932.
23. Osamu Shiihara was a member of the avant-garde Tanpei Photography Club in Osaka, where he would have absorbed the lessons of modern European photography through such exhibitions as *Film und Foto*, which traveled to Osaka in 1931.
24. For further discussion of such photograms and prehistoric handprints, see my article: Powell, pp. 516–33.

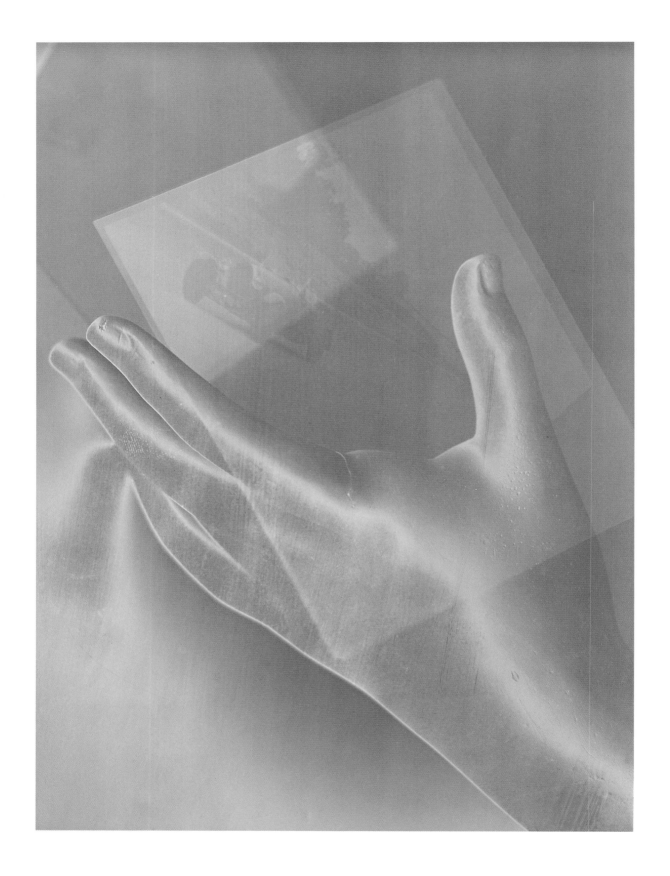

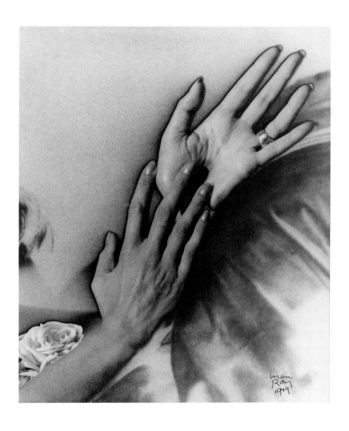

Maurice Tabard *Study*, 1930.
Gelatin-silver print, 7 x 5 inches
(17.8 x 12.7 cm)

Man Ray *Hands*, 1949. Solarized
gelatin-silver print, 10 x 8 inches
(25.4 x 20.3 cm)

Osamu Shiihara *Composition*,
1938. Solarized gelatin-silver
print, 12 x 10 ¹/₈ inches (30.5 x
25.7 cm)

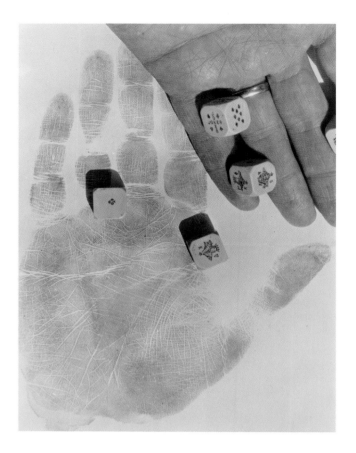

also suggest immaterial concepts such as chance, as in René-Jacques's photograph *Hand and Dice* (ca. 1928), which may allude to Stéphane Mallarmé's concrete poem "Un coup de dés jamais n'abolira le hazard" (A throw of the dice will never abolish chance), first published in 1914. René-Jacques juxtaposed a partial palm with a palm print, positioning the "real" hand and dice against the inky double of the "reproduced" hand. As a metaphor for something that cannot be controlled by conscious will, the dice are coupled with a palm print whose insubstantiality implies an alternative to physical presence.

In his essay on the uncanny, Freud theorizes that feelings of uncanniness may be vestiges of primitive beliefs in the power of thought, demonstrated by the prompt fulfillment of wishes, the efficacy of secret injurious spells, and the return of the dead. The uncanny, he argues, is thus a modern phenomenon, resulting from the clash between a rational world view and the residue of irrational animistic belief systems sometimes hidden in our psyches. He elaborates on this idea by noting the uncanny effects of doubling, describing the shock of momentarily thinking that his own reflection was another person.[25] In René-Jacques's photograph, the handprint offers a similar uncanny double, a mirror image of the original that, like primitive palm prints in prehistoric caves,

René-Jacques Hand and Dice, ca. 1928. Gelatin-silver print. 9 x 6 ½ inches (22.9 x 16.5 cm)

25. Freud, pp. 247–48.

seems invested with unknown powers. In addition to the fascination of the doubled subject—in René-Jacques's photograph, the hand and its palm print—photographs are themselves, as Rosalind Krauss has observed, doubles, copies, or multiples of an original exterior subject and thus are inherently uncanny.[26]

The uncanny doubling of palm printing also intrigued Man Ray. As Foster points out, in Breton's view the "veiled-erotic" implies a mixing of identities—a state, in Breton's words, in which "the animate is so close to the inanimate," and that Foster notes "brushes up against the uncanny."[27] As a former Dada artist, Man Ray understood the potential for disruption in the mixing of human and machine. For *Veiled-Erotic* he posed the artist Meret Oppenheim, creator of the infamous fur-lined teacup, nude in the studio of the printmaker Louis Marcoussis.[28] She stands beside the press, her inner forearm and palm covered with

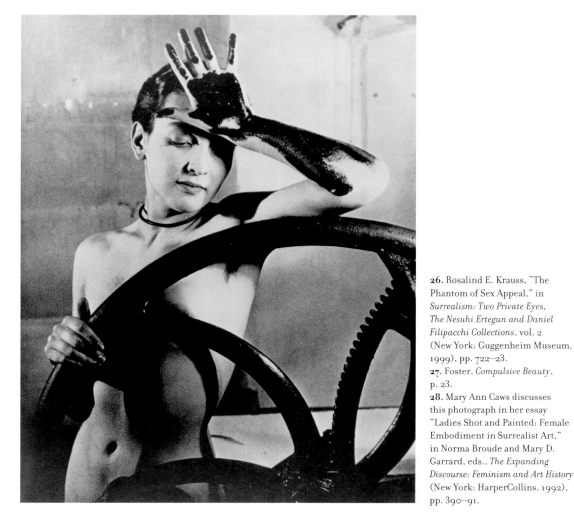

Man Ray *Veiled-Erotic* (*Erotique-voilée*), illustration to André Breton, "La beauté sera convulsive," *Minotaure* 2, no. 5 (May 1934), p. 15

26. Rosalind E. Krauss, "The Phantom of Sex Appeal," in *Surrealism: Two Private Eyes, The Nesuhi Ertegun and Daniel Filipacchi Collections*, vol. 2 (New York: Guggenheim Museum, 1999), pp. 722–23.
27. Foster, *Compulsive Beauty*, p. 23.
28. Mary Ann Caws discusses this photograph in her essay "Ladies Shot and Painted: Female Embodiment in Surrealist Art," in Norma Broude and Mary D. Garrard, eds., *The Expanding Discourse: Feminism and Art History* (New York: HarperCollins, 1992), pp. 390–91.

printer's ink. Her inked arm seems slightly scandalous in the context of her nudity: Stained and defiled, the arm and its matching shadow mimic the shiny, black metal of the printing press's wheel, while her fingers echo the shape of the cog mechanism. The ink also acts as a doubling device for the hand, marking it like a glove, like a shadow, and suggesting the print it could make if it were applied to another surface. Reproduction is the point: The erotically charged nude seems ready to mate with machine to produce a work of art suitable for the age of mechanical reproduction. The offspring of the process will be hand-prints, traces of the animate original possessing an inanimate identity all their own.

The uncanny erotic charge bestowed on the hand in Man Ray's *Veiled-Erotic* series can be found in other Surrealist works. Léon-Paul Fargue explored the erotic potential of the hand in a 1935 essay in *Minotaure*, writing: "Hand of woman, unique trance, extreme point of my life, ravishing arm of the sea where the tributaries of blood glisten, round and perfumed hand that climbs to the head, hand that looks for its place in the hollow, like a body surprised in a bed where one slips for the first time."[29] A photograph by Brassaï accompanying Fargue's article shows two clasped hands, mirroring the climax of the end of the article: "I see my hand become giant, and in each of my fingers I see myself minuscule. Rest. If I run to seek your secrets, if I continue, eyes shut, all that is planted begins, all that these flanges promise, these vibrations of the palm, these stifled cries, these jingles of the wrist, these fears of the ring finger, rest. My hand loves you."[30] Hans Bellmer's three photos of intertwining fingers are another drama of erotic hands. Like actors in a slightly pornographic puppet show, the hands in Bellmer's 1934 triptych touch and clutch in a parody of copulation.

Beyond their erotic possibilities, palm prints and palm reading held considerable fascination for the Surrealists for their visionary properties, recalling Freud's location of the uncanny in the persistence of so-called primitive, animistic beliefs such as divination.[31] The palm was a text to be read, whose lines could reveal not only the present but also the future and the past. In Breton's autobiographical novel, *Nadja*, published in 1928, hands act as a go-between between the real and surreal by taking on a visionary, prophetic role. Nadja sees a flaming hand over the Seine; later she tells Breton to follow a line being traced across the sky by a hand, and then shows him a hand on a poster:

> A red hand with its index finger pointing, advertising
> something. Nadja insists on touching this hand, which she
> jumps up to reach several times and which she succeeds in
> slapping with her own. "The hand of fire, it's all you, you

29. Léon-Paul Fargue, "Pigeondre," *Minotaure* 2, no. 6 (winter 1935), p. 29 (my translation). "Main de femme, unique transe, pointe extrême de ma vie, ravissant bras de mer où les affluents du sang se glissent, main ronde et parfumée qui monte à la tête, main qui cherche sa place dans le creux, comme un corps surpris dans un lit de voyage où l'on se glisse pour la première fois."

30. Ibid. (my translation). "Je vois ma main devenir géante, et dans chacun de mes doigts, je m'aperçois, minuscule. Repose. Si je cours à la recherche de tes secrets, si je continue, les yeux fermés, tout ce que ce grain commence, tout ce que promettent ces phalanges, ces vibrations de la paume, ces cris étouffés, ces cliquetis du poignet, ces peurs d'annulaires, repose. Ma main t'aime."

31. For Surrealist interest in palm reading see, for example, Lotte Wolff, "Les révélations psychiques de la main," *Minotaure* 2, no. 6 (winter 1935), pp. 38–44. Later a subject for Man Ray's camera, Wolff proposed a system of reading the psychic revelations in the lines of the palm in keeping with both traditional palmistry and the psychological theories of Carl Jung and William James. The article was illustrated with the palm prints of artists and writers, among them Breton, Duchamp, and Paul Eluard.

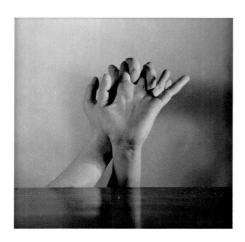 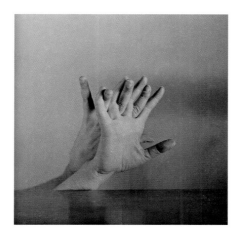 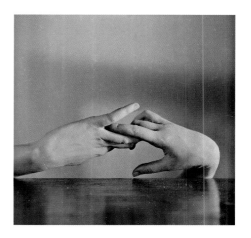

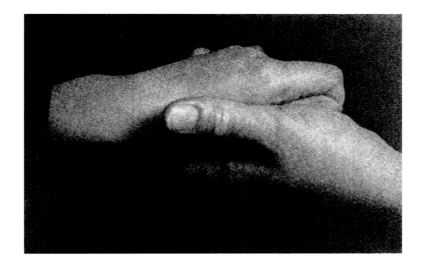

know, it's you." She remains silent, I believe that she has
tears in her eyes. Then suddenly, standing in front of me,
virtually stopping me, with that extraordinary way she has
of calling me, the way you might call someone from room to
room in an empty castle: "André? André? . . . You will write
a novel about me. I'm sure you will. Don't say you won't."[32]

32. André Breton, *Nadja*, trans.
Richard Howard (New York:
Grove Press, 1960), p. 100.
For further analysis of *Nadja*,
see Roger Cardinal, *Breton:*
Nadja (London: Grant and Cutler,
1986) and Carlo Passi, "Nadja ou
l'écriture erratique," *Pleine marge*,
no. 10 (Dec. 1989), pp. 83–99.

Hans Bellmer *Untitled*, 1934.
Three gelatin-silver prints, each
2.5 x 2.5 inches (6.4 x 6.4 cm)

Brassaï Untitled illustration
to Léon-Paul Fargue, "Pigeondre,"
Minotaure 2, no. 6 (winter 1935),
p. 29

Here the hand shifts from celestial vision to the touchable, printed
hand of the poster, where, despite its status as two-dimensional,
reproduced image, it takes on a tangibility that allows the visionary
to merge with the commonplace. The hand also has prophetic powers,
leading Nadja to predict the writing of the novel that the reader of
Nadja reads.

Walker Evans seems to have shared something of Breton's fascination for the apparitional and prophetic hand. In *East Entrance*, a photograph from around 1947, Evans shows a hand painted on the side of a board fence, delineated in the flattened graphic language of an advertising icon, but energized by the play of sun and shadow and pointing to something beyond the frame. Evans represents a hand that itself is a representation, like Nadja's "hand with its index finger pointing, advertising something" that she touches with her own. Yet for all its potential power as an uncanny apparition, Evans's hand remains deadpan, lacking the magical charge that Nadja imparts to the advertising hand in Breton's text. The same is true of a 1962 photograph by Evans, *Gypsy Storefront, 1562 Third Avenue, New York*, which also hints at an interest in hands and prophesy. Here, Evans offers up another advertising hand, this one on a storefront window, notifying passersby of the presence of a "reader advisor" who will unlock the secrets written in the lines of the palm. Unlike Breton, who allows Nadja—and by extension the reader—to interact with the advertising hand by circuitously investing it with meaning that exceeds its simple function as a sign to direct our gaze or impart information, Evans takes a straightforward approach. The strangeness in his photographs resides in the cold facts of these found hands, rather than in their ability to project a new level of understanding. The hands in Evans's photographs seem invested with mysterious powers—the pointing finger commanding attention and the open palm predicting the future—but Evans remains a bystander, presenting them as curiosities rather than making them seem marvelous.

Walker Evans *East Entrance*, ca. 1947. Gelatin-silver print, 6 ¹/₂ x 9 ¹/₄ inches (16.5 x 23.5 cm)

Walker Evans *Gypsy Storefront, 1562 Third Avenue, New York*, 1962. Gelatin-silver print, 11 ³/₄ x 9 ³/₄ inches (29.8 x 24.8 cm)

Severing the hand from the body separates the part from the whole and endows it with the sense of estrangement in which Breton claimed the marvelous resided. It also creates a kind of formlessness (what the Surrealist outcast Georges Bataille called *informe*) by declassifying and destabilizing the hand and its relationship to the body. Krauss has argued that the formless resides in acts of lowering and categorical blurring, and she observes that in many Surrealist photographs there is "deep, categorical blurring involving a transgression of boundaries."[33] Certainly this is the case in these images of severed hands that assume new identities. In this resistance to the logic of the intact body lies another kind of transgression, a resistance to narrative logic: Bodies that should be intact are disjointed; the body's boundaries are refigured, deforming the stories they customarily tell.

In Surrealist literary texts, disembodied hands move the reader from rational narrative to lists of types of hands that exceed the boundaries of reason. A case in point is Georges Hugnet's article, "Petite rêverie du grand veneur" (Little reverie of a master of the hounds), published in *Minotaure* in 1934. Hugnet's reverie, recalling Breton's early fascination with phantoms and the occult, is set in a gothic wonderland that provides a surreal taxonomy of uncanny hands. A fan is passed from hand to hand; mineral hands ripen under the eyes of alchemists; and there are fossil hands, root hands, hands of fish, hand-polished hands in marble and plaster. Inside the castle, gloves hang from ivory hands, and plush pedestals support transparent glass hands holding vases or stars. There are typographic hands, votive hands, sliced hands, happy hands, sad hands, wax hands, freak hands. A beautiful palm reader invokes "the Hand," the malignant, marvelous hand of blood, vengeance, love, and revolt, the hand that grips and lets go of the world in rags, of "all that can't be held in the hand."[34]

Above the title of Hugnet's article is a photograph of a series of hands by Louis Igout for the Calavas studio. The photograph is typical of many that appeared in Surrealist books and journals as examples of "found Surrealism"—images that were not intended to be Surrealist photographs but that were nevertheless seen as surreal. At first this grid of hands appears to be a study of the movement of a single hand over time, as in the photographs of Eadweard Muybridge. But this is not a narrative record. Rather, it is a classification of hands as thing and sign: Each hand is differently ornamented, with bracelets, cuffs, and rings, and each performs a discrete action. In two cases, the index finger points; one hand holds a pen poised above paper; and two hint at the sign of the cuckold. What is odd about these hands is their fragmentary nature and their obsessive repetition, which seems cinematic but is not. These

Louis Igout Untitled illustration to Georges Hugnet, "Petite rêverie du grand veneur," *Minotaure* 2, no. 5 (May 1934), p. 30

33. Rosalind E. Krauss, "Claude Cahun and Dora Maar: By Way of Introduction," in Krauss, *Bachelors* (Cambridge, Mass.: The MIT Press, 1999), p. 13.
34. Georges Hugnet, "Petite rêverie du grand veneur," *Minotaure* 2, no. 5 (May 1934), p. 30 (my translation). "Tout ce qui ne tient pas dans la main."

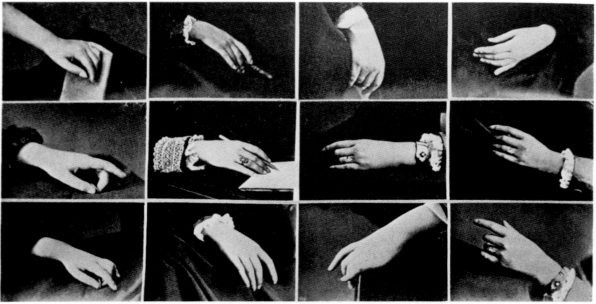

PETITE RÊVERIE DU GRAND VENEUR

par GEORGES HUGNET

DE la main au gant, de la main-mesure à l'ombre, de la main de mer à la main de poulie, de la main donnée à la main qu'on prête, il y a plus d'un pouce, plus d'une main, car il y a toute la main du destin, la main hiéromancienne, cette main de gloire qui sous la flamme de sa bougie tient toutes les mains mortes, la main qui est une racine convulsée comme le cri de son arrachement.

Avant d'arriver à ce sourd château qui apparaissait et disparaissait en un tournemain, la belle chiromancienne, — c'était une main masquée haut et court dans une mitaine d'araignée, — dut franchir un sous-bois où passait de main en main un éventail. Là, tout un peuple avait la main légère : mains minérales qui mûrissent sous les yeux des alchimistes, mains fossiles, mains de racines, mains de madrépores dépaysés, de champignons à la chair d'ombre, mains de poissons, et d'autres en bois ou en marbre, en plâtre, polies à la main.

D'une grande salle où on accédait par un hall à éclairage marin rempli de gants accrochés à des mains d'ivoire, partaient des couloirs dans les cinq directions des doigts. Une main harmonique avait présidé à cette disposition que précisait une main courante. Tout au long des couloirs, des socles en peluche supportaient des mains de verre tenant des vases ou des étoiles, des mains typographiques, des mains votives, des mains tranchées, des mains heureuses, des mains malheureuses, des mains de cire, des mains phénoménes.

On y déjeunait d'une main d'oublies.

I. Dans le pouce était aménagé un théâtre d'ombres pour que les mains pussent devenir des biches, des oiseaux, des paysages.

II. Dans l'index la main de Cléopâtre tournait, d'une blancheur de craie, à la confusion de l'histoire.

III. Le médius abritait des mains qui halaient main sur main le câble du destin.

IV. Pour l'annulaire, il contenait une main hiéroglyphique dont les symboles miroitaient comme des bagues de fatalité.

V. Restait l'auriculaire la main chaude attrapait des mains et des mains, à pleine main, des mains fines qui s'appelaient fascinations.

A la place de la paume se trouvait donc la grande

salle. Des mains s'y distrayaient, nonchalantes, ou y jouaient à des poursuites. Mains droites et mains gauches en venaient aux mains. Ici, des mains imitaient des monstres dans les velours. Là, des mains dans un cône de lumière jouaient au billard. Une harpe marchait toute seule, un peigne dans une chevelure, et bien d'autres objets encore, entourés de mains volantes. Un peu partout dormaient des mains. Mains longues, couchées comme des peaux de Suède, mains de sirènes dans des eaux de fuchsine, mains aux ongles bleus de nuit, mains de jour, mains foudroyées par leurs lignes, mains d'agate, mains modèles, mains battues et mains à fouet, mains abandonnées comme une algue jetée sur le sable, mains, plutôt des caresses en forme de mains, endormies sur des conques de Vénus, mains dédaigneuses de gel et de fougère, mains aimées, mains de rêve et de pluie relâchées de fraîcheur, mains brûlées de la fièvre, mains comme des corps de femmes couchées, aux hanches saillantes, mains hantées semblables aux mains de diable des mers chaudes, mains sur la bouche, mains, mains... Et à l'écart, comme mue par le silence d'une tour dans le passé, une main hautaine, oublieuse de ses dentelles, caressait, on eût dit sans savoir, une statue attiédie par un long, précis, savant envoûtement, de la façon dont elle aurait flatté la tête d'un lévrier.

C'est alors que, mystérieuse des mystérieuses parmi ces mains sans nom, la belle chiromancienne quitta sa robe de filoselle et fit glisser une tenture qui semblait ne devoir cacher qu'une fenêtre. Or, à travers un rideau de fumée que dissipaient des mains de bois tourné, apparut la Main, la Main qui en met sa main au feu, la Main maléfique, la merveilleuse, la Main de sang, la main nue de Vengeance, la main nouée sur l'amour et la révolte, la main lourde, la Main Noire, la main qui étreint et relâche des mondes en loques, la Mandragore :

tout ce qui ne tient pas dans la main.

Georges HUGNET.

MASQUE ZUNI DE ANAHOHO (NOUVEAU MEXIQUE). LA MAIN PEINTE SUR LE VISAGE REPRÉSENTE UNE CONSTELLATION. L'OREILLE EST FIGURÉE PAR LA FLEUR D'UNE HERBE NARCOTIQUE

hands, like those in the text with which they are paired, comprise a collection of strangely displaced body parts that suggest a language and purpose beyond our comprehension, as though they speak a sign language for the deaf that has yet to be translated. The temporal narrative is missing. The juxtapositions are illogical, and these multiplied, severed hands are uncanny.

Disjointed at the elbow or wrist, floating freely in space, materializing in unusual places and endowed with unexpected traits, the hands in Surrealist visual and literary imagery are almost always independent entities. They are a body part parted from the body. Their conceptual power emerges from the objects or actions with which they are juxtaposed or from the new bodies onto which they are grafted. Near the end of *Soluble Fish*, we find Breton "remembering" how "an ivory file that I picked up on the floor instantly caused a certain number of wax hands to open up around me, remaining suspended in the air until alighting on green cushions."[35] In these texts and images, hands are in the air, on cushions, everywhere but where we expect them to be and doing everything except the logical handiwork of waking reality. They are disconnected from the body, from reality, from logic, from time, and given new meaning as fragments that remind us both of how things usually are and of how things might be in the truncated, fragmentary world of Surrealist experience.

Breton's verbal acrobatics derived from his willingness to experiment with images that emerged through the process of automatic writing, which tapped the imagery of the unconscious. Photographers who wished to approximate this approach faced the challenge of finding ways to circumvent the conscious decisions that typically determine the final appearance of a photograph.[36] They did so in a variety of ways: by using techniques such as multiple exposure, montage, and unorthodox lighting to give the photograph the look of an image that emerged automatically from the artist's unconscious, and by actually trying to work in an automatic fashion with processes, such as solarization or the making of cameraless photograms, that had an inherent spontaneity and thus led to less predictable results. It could be argued that there is no such thing as "Surrealist photography," since the photographers who moved in the orbit of Surrealism were not as directly engaged with Surrealist practice and polemics as the more well-known artists and writers of the movement. Yet the importance of photography in Surrealism cannot be denied. From illustrations in Surrealist books and journals to inclusion in Surrealist exhibitions, photography played a central role in the visual culture of Surrealism. Especially in their images of hands, photographers overcame the limitations of their medium to give visual form to many of the ideas that were being explored in other Surrealist venues. More than

35. Breton, *Soluble Fish*, p. 108.
36. The most important discussions of the stylistic devices used by photographers in the context of Surrealism remain three essays by Rosalind E. Krauss: "The Photographic Conditions of Surrealism," *October*, no. 19 (winter 1981), pp. 3–34; and "Photography in the Service of Surrealism" and "Corpus Delicti," in Krauss, *L'Amour Fou: Photography and Surrealism* (Washington, D.C.: Corcoran Gallery of Art; New York: Abbeville Press, 1985), pp. 13–42, 55–100.

in painting or poetry, in photography artists were forced to chart the boundaries between fact and fantasy, between vision and conception, between the real and the surreal. In so doing, they offered a new definition of the body as seen through its parts, caught in the disembodied hands of Surrealism's grip.

Pierre Dubreuil *Gernod!! (Crevettes)*, ca. 1929. Oil print, 9 $^1/_2$ x 7 $^1/_2$ inches (24.1 x 19.1 cm)

André Kertész *Arm and Ventilator*, 1937. Gelatin-silver print, 8 ¹/₂ x 7 ³/₄ inches (21.6 x 19.7 cm)

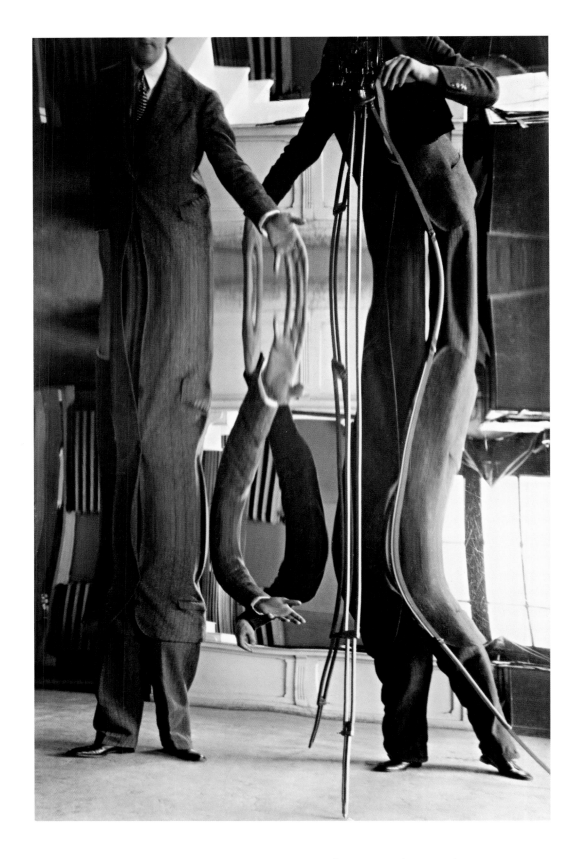

André Kertész *Distortion Portrait of Carlo Rim and André Kertész*, 1930. Gelatin-silver print, 8 ³/₄ x 5 ¹/₂ inches (22.2 x 14 cm)

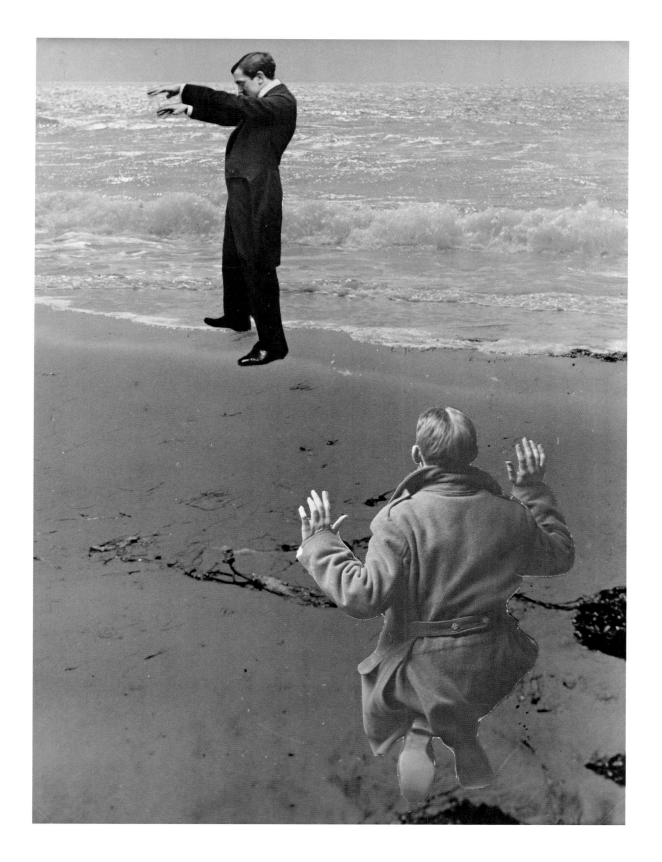

Dora Maar *Danger*, 1936. Photocollage, 9 ³/₄ x 7 ¹/₄ inches (24.8 x 18.4 cm)

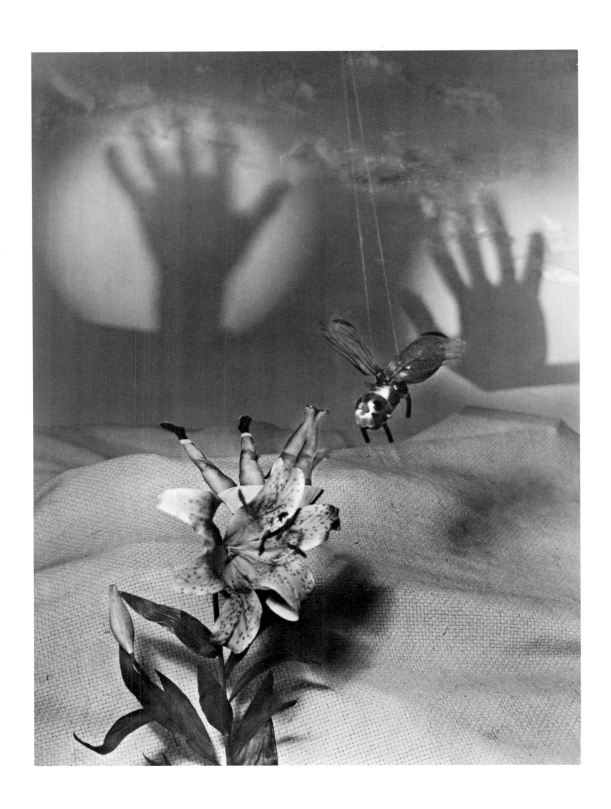

Robert Disraeli *Love's Triumph*, 1932. Gelatin-silver print, 9 ¹/₂ x 7 inches (24.1 x 17.8 cm)

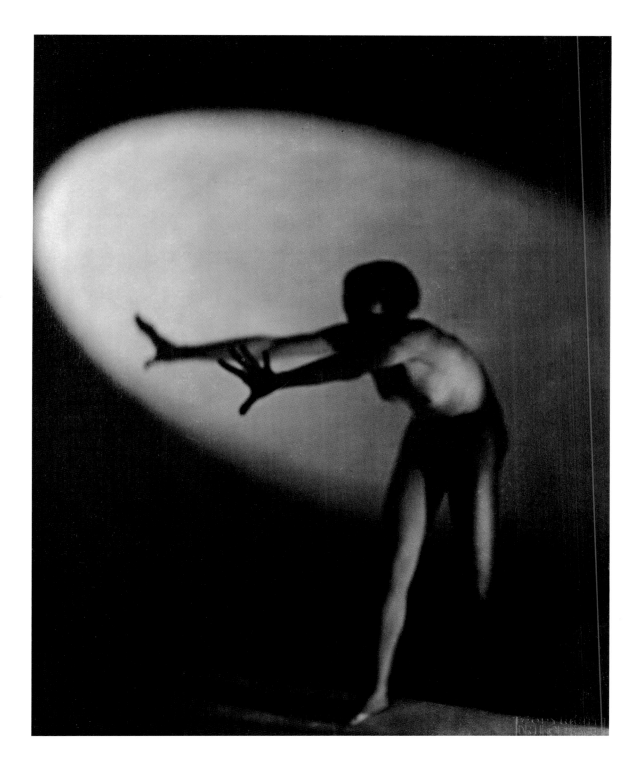

František Drtikol *Horror*, 1927. Pigment print, 11 ½ x 9 inches (29.2 x 22.9 cm)

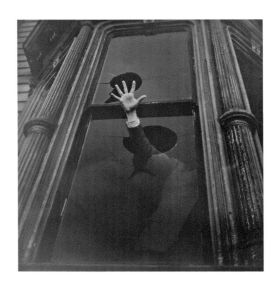

John Gutmann *The Cry*, 1939. Gelatin-silver print, 2 ¹/₂ x 2 ¹/₂ inches (6.4 x 6.4 cm)

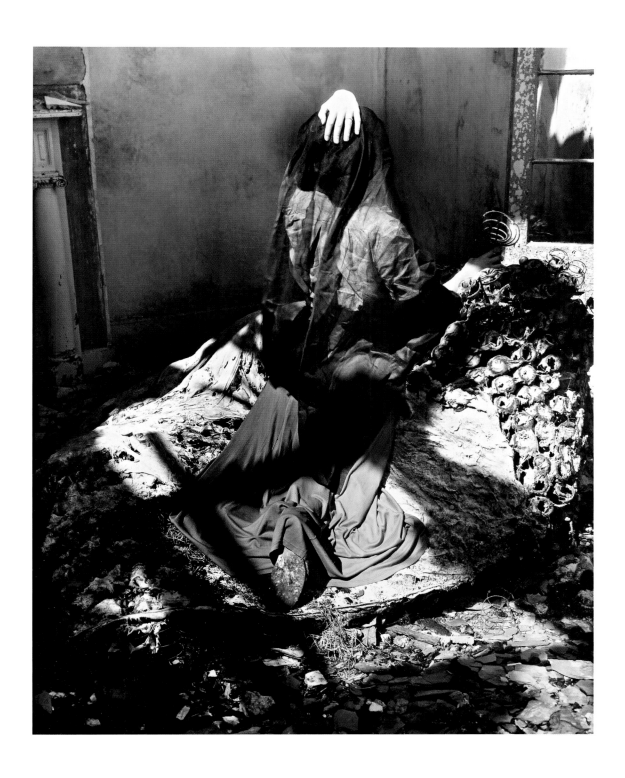

Clarence John Laughlin *The Auto-Eroticists*, 1941. Gelatin-silver print, 13 ¹/₂ x 10 ¹/₂ inches (34.3 x 26.7 cm)

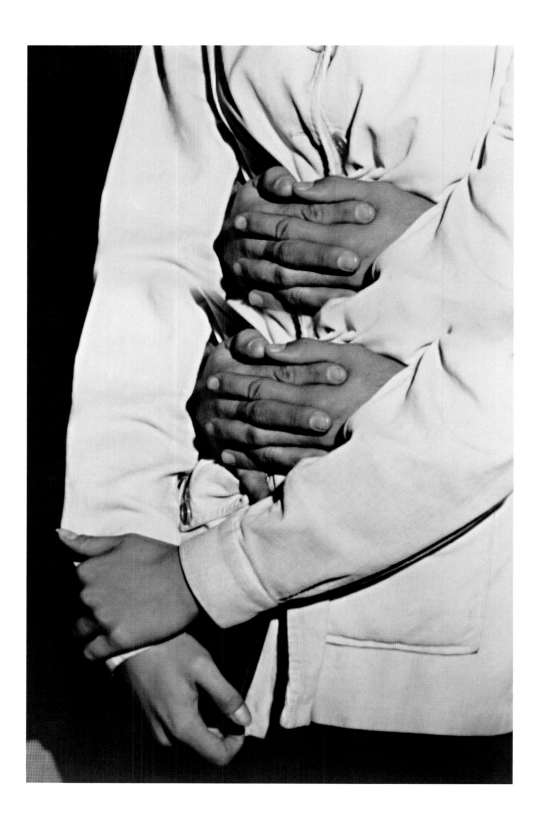

Weegee *Hands*, early 1950s. Gelatin-silver print, 6 x 4 inches (15.2 x 10.2 cm)

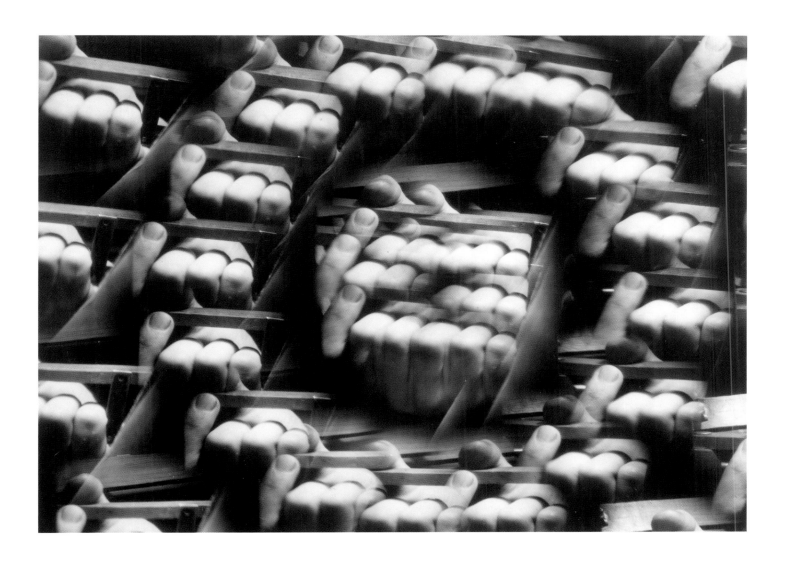

Raymond Hains *Hand Multiplied by a Play of Mirrors*, 1947. Gelatin-silver print, 11 $^7/_8$ x 16 inches (30.2 x 40.6 cm)

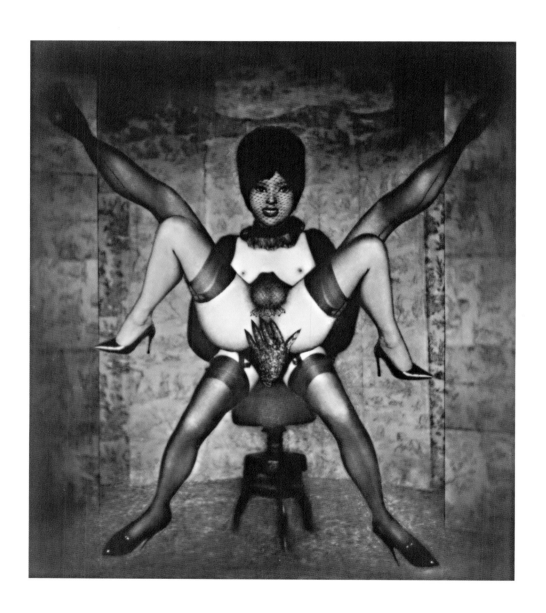

Pierre Molinier *Untitled*, 1969. Gelatin-silver print photomontage, 9 ½ x 7 inches (24.1 x 17.8 cm)

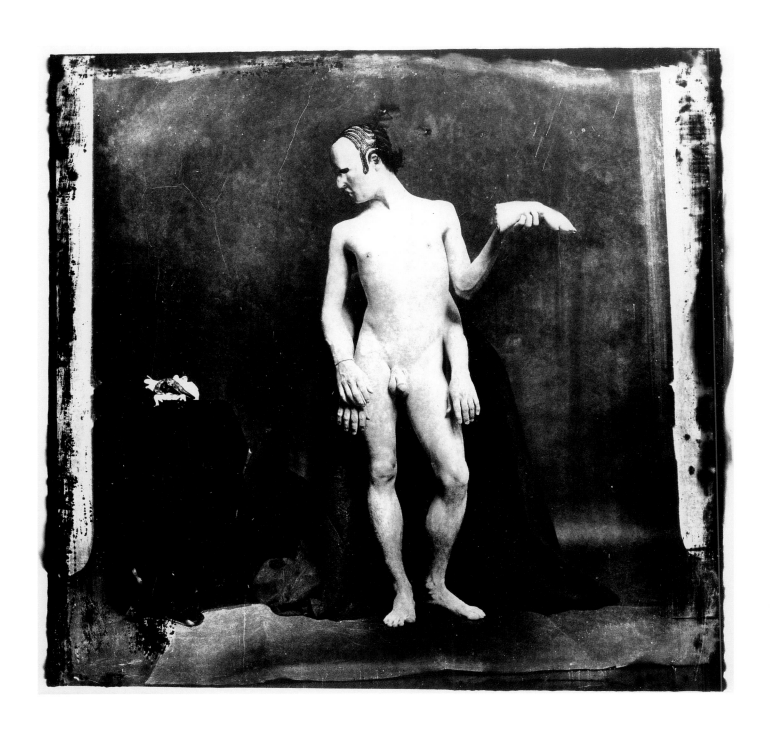

Joel-Peter Witkin *The Boy with Four Arms*, 1984. Toned gelatin-silver print, 20 x 16 inches (50.8 x 40.6 cm)

Tina Modotti *Hands of a Marionette Player*, 1929. Gelatin-silver print, 9 x 5 ¼ inches (22.9 x 13.3 cm)

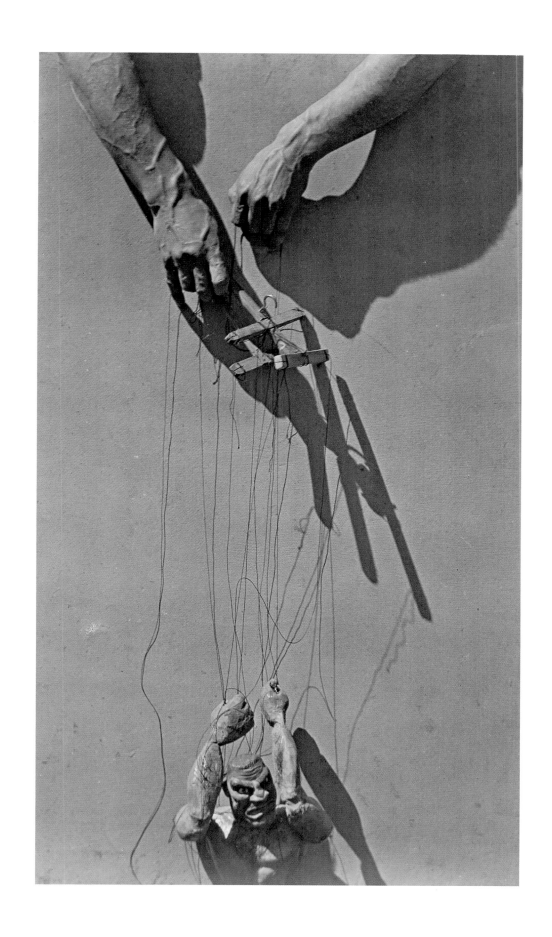

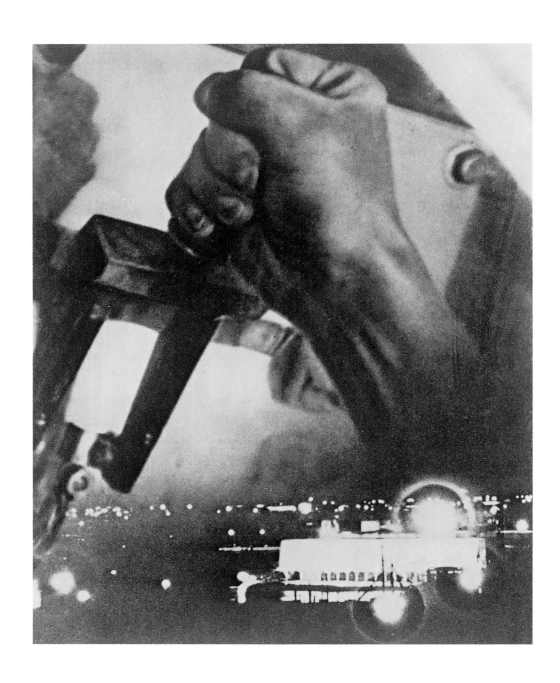

El Lissitzky *The Current Is Switched On*, 1932. Gelatin-silver print photomontage, 5 ³/₄ x 4 ³/₄ inches (14.6 x 12.1 cm)

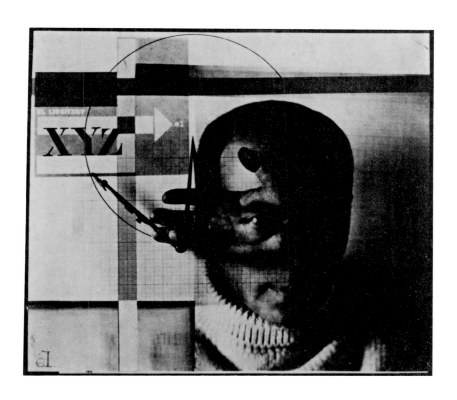

El Lissitzky *The Constructor*, 1924. Gelatin-silver print photomontage, 3 x 3 ¹/₂ inches (7.6 x 8.9 cm)

Richard Avedon *Palermo, Sicily, September 3, 1947*, 1947. Gelatin-silver print, 20 x 16 inches (50.8 x 40.6 cm)

Irving Penn *Mud Glove, New York*, 1975. Four-part platinum-palladium print, overall 50 x 42 inches (127 x 106.7 cm)

Walker Evans *Untitled*, 1929. Gelatin-silver print photogram, 11 x 7 inches (27.9 x 17.8 cm)

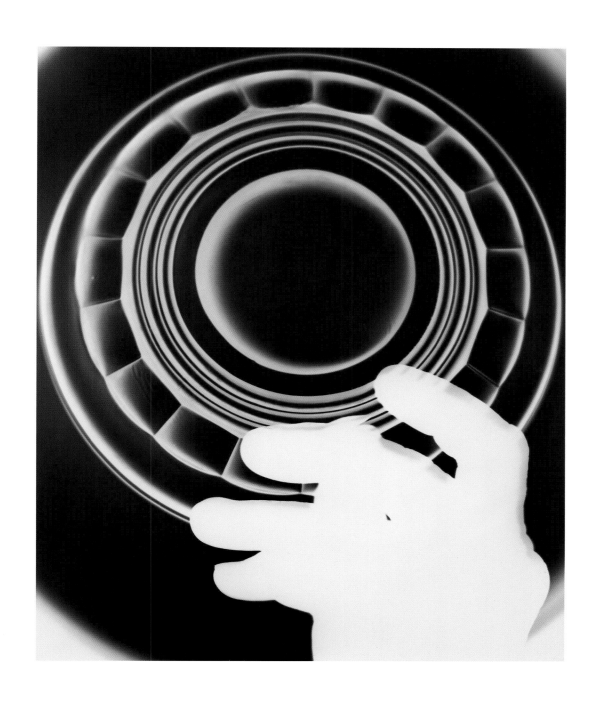

August Sander *Advertising Photogram for a Glass Manufacturer, Cologne*, ca. 1932. Gelatin-silver print photogram, 8 ¹/₂ x 7 ¹/₄ inches (21.6 x 18.4 cm)

Vik Muniz *Dürer's Praying Hands*, 1993. Toned gelatin-silver print, 34 x 30 inches (86.4 x 76.2 cm)

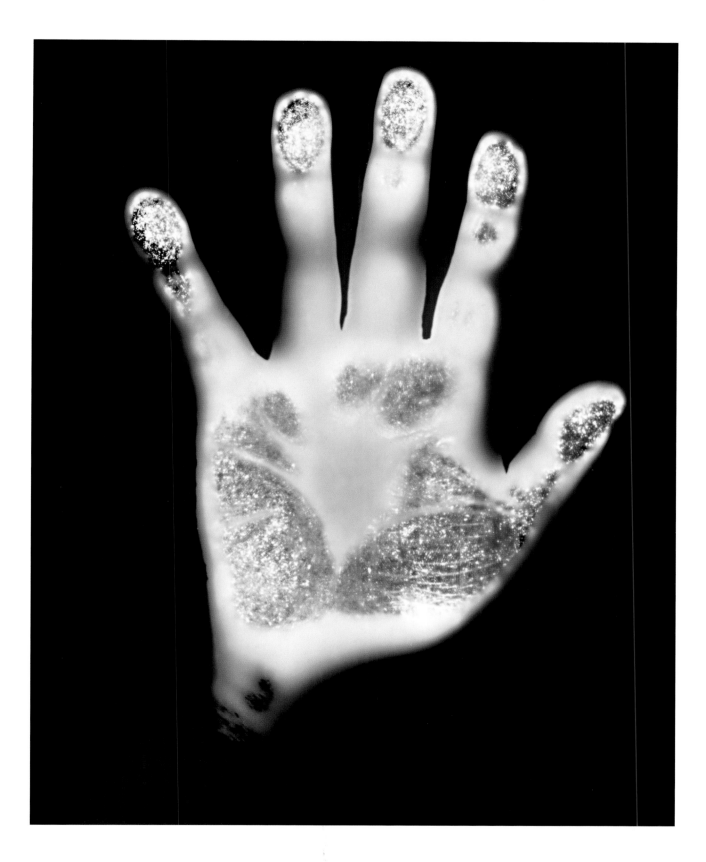

Gary Schneider *Henry*, 2000. Toned gelatin-silver print, 36 x 29 inches (91.4 x 73.7 cm)

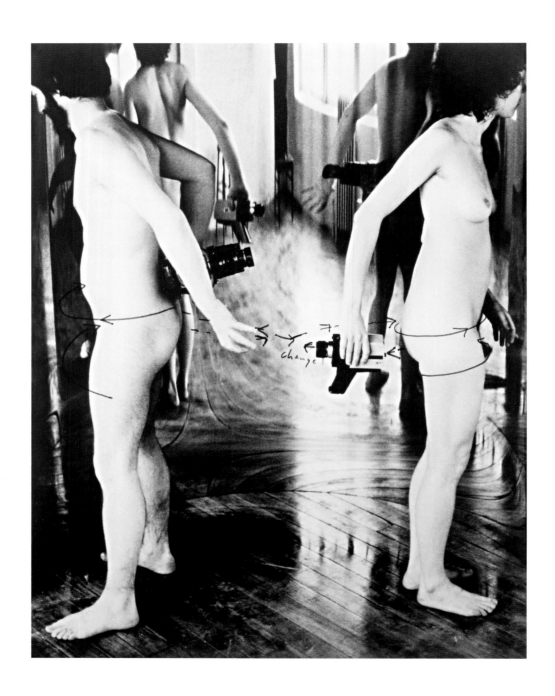

Dan Graham *Body Press*, 1970. Gelatin-silver print, 10 x 8 inches (25.4 x 20.3 cm)

Sam Taylor-Wood *Travesty of a Mockery*, 1995. Two C-prints, each 15 x 23 inches (38.1 x 58.4 cm)

Bruce Nauman *Studies for Holograms (a–e)*, 1970. Five screenprints, each 26 x 26 inches (66 x 66 cm)

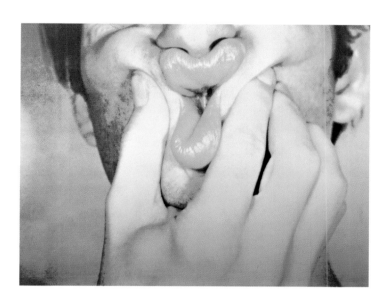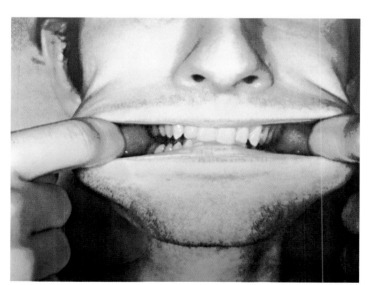

Gilbert and George *Bottle Bar*, 1973. Five gelatin-silver prints, each 6 ¹/₂ x 8 ³/₄ inches (16.5 x 22.2 cm)

Sigmar Polke *Untitled*, 1972. Solarized gelatin-silver print, 7 x 9 inches (17.8 x 22.9 cm)

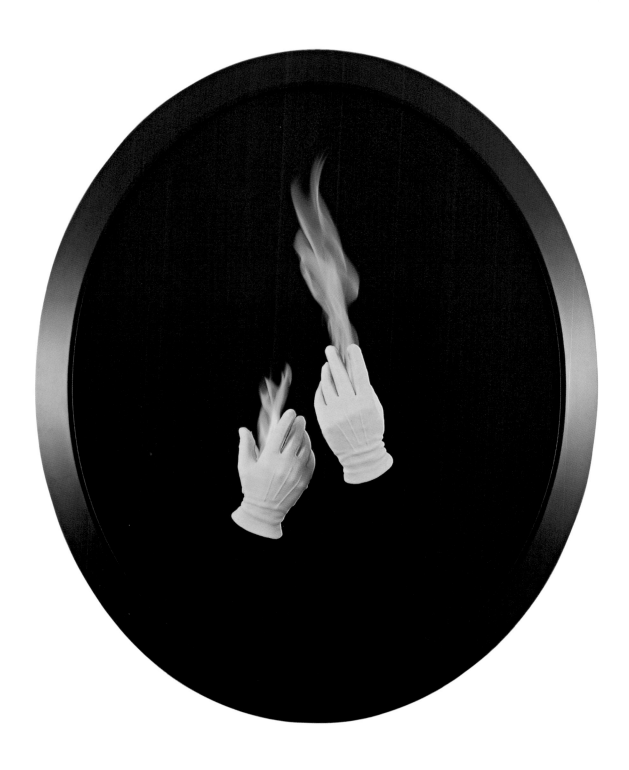

Sarah Charlesworth *Trial by Fire*, 1993. Laminated Cibachrome, 36 x 28 inches (91.4 x 71.1 cm)

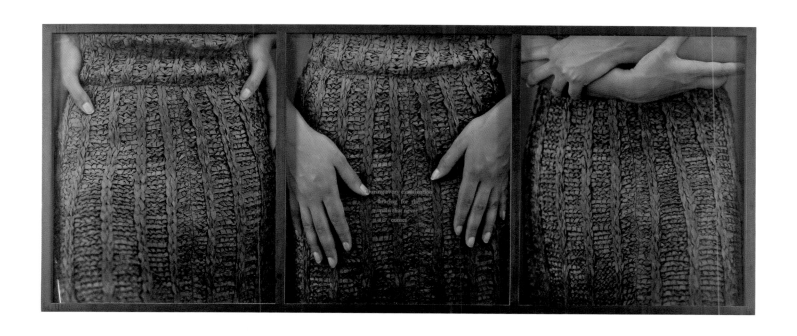

Lorna Simpson *Lower Region*, 1992. Three color Polaroid prints and engraved Plexiglas, overall 26 x 60 inches (66 x 152.4 cm)

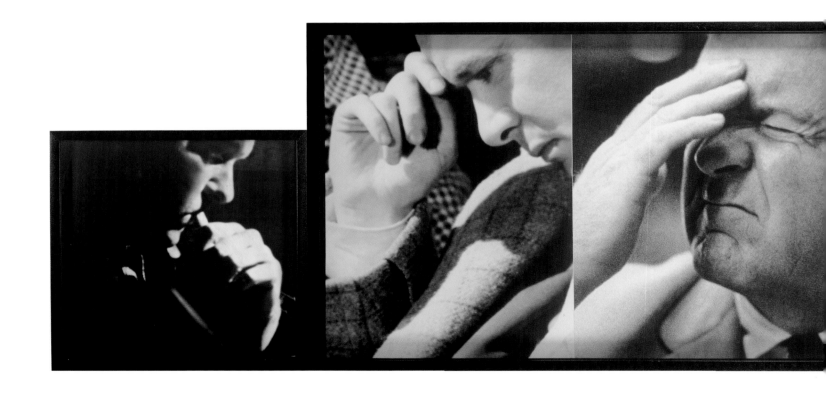

John Baldessari *Five Male Thoughts (One Frontal)*, 1990/1996. Photomontage, overall 25 x 78 inches (63.5 x 198.1 cm)

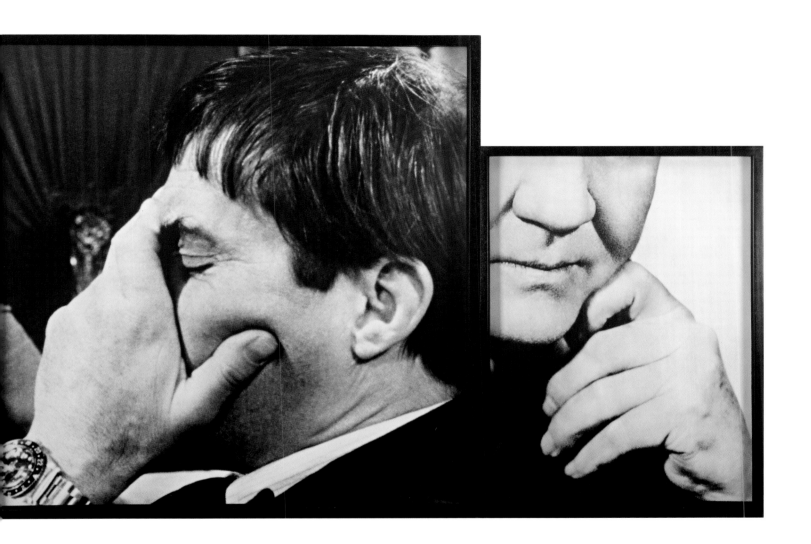

Jeff Wall *Rear, 304 East 25th Avenue, Vancouver, 9 May 1997,*
1:14 & 1:17 p.m., 1997. Gelatin-silver print, 97 x 143 inches
(246.4 x 363.2 cm)

Gilbert and George *Black Gargoyles*, 1980. Twelve hand-colored gelatin-silver prints, overall 71 ½ x 79 ½ inches (181.6 x 201.9 cm)

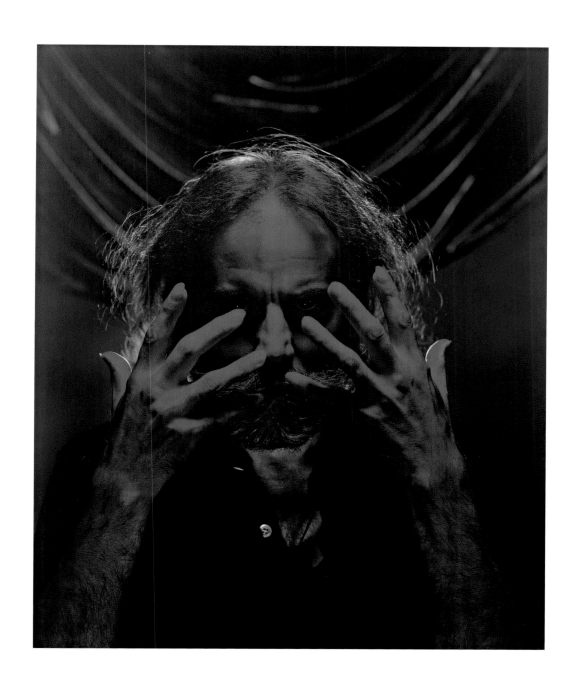

Lucas Samaras *Self-Portrait*, 1990. Polaroid Polacolor II print, 24 x 20 inches (61 x 50.8 cm)

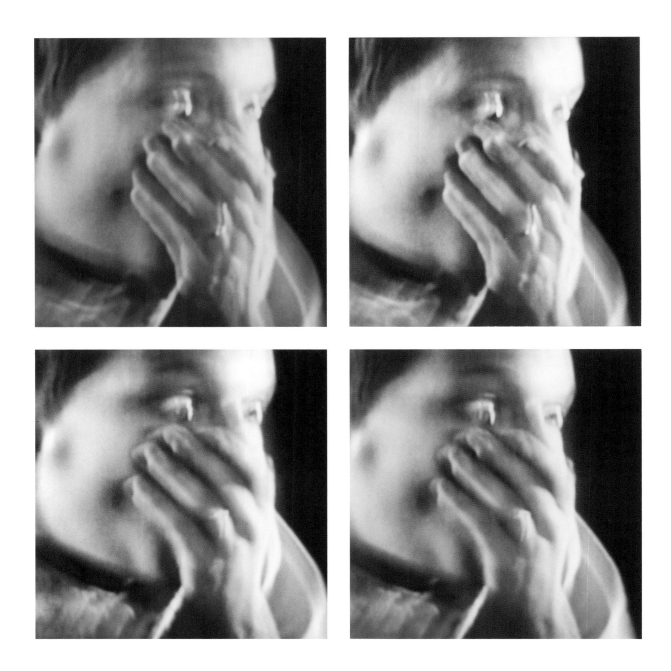

Cornelia Parker *Blue Shift*, 2002. Four Polaroid prints, each 3 ¹/8 x 3 ³/8 inches (7.9 x 8.6 cm)
Rachel Harrison *Untitled (Perth Amboy Series)*, 2001. C-Print, 26 x 20 inches (66 x 50.8 cm)

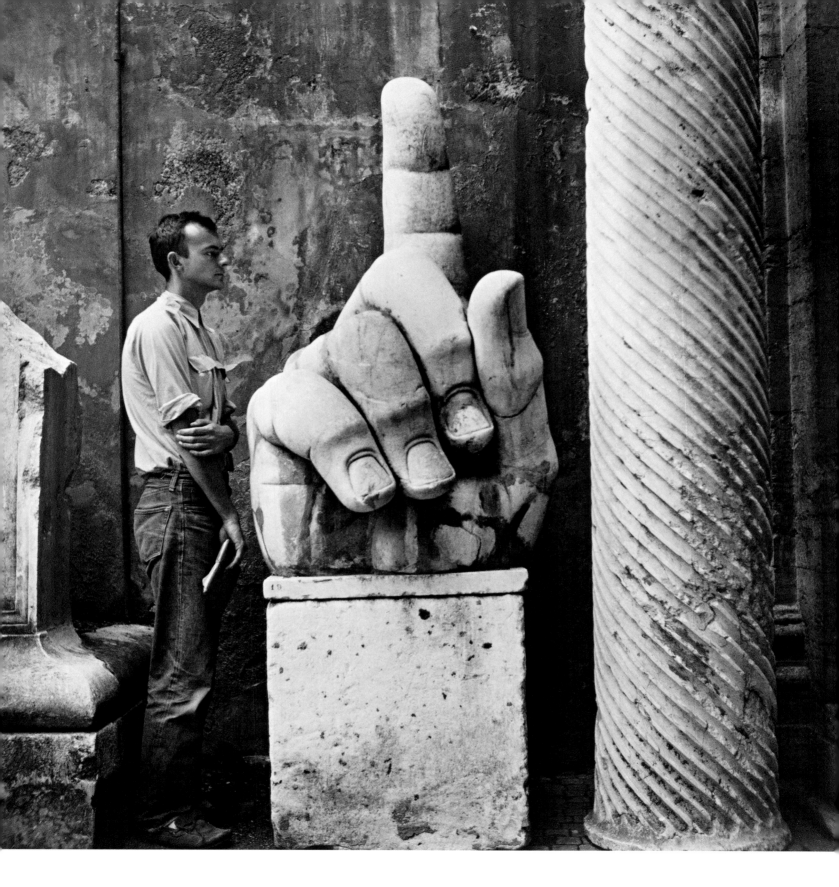

The Telltale Hand

Taken as a whole, The Buhl Collection addresses us less as
a statement than as a question. By its mere existence it prompts us to
wonder why so many photographers over the years have made work that
focuses on hands. Whether portraying them in isolation or as significant,
often scene-stealing elements in larger scenarios, the images in The
Buhl Collection—both by their quantity and quality—suggest that this
humble if invaluable body part occupies an unexpectedly important
position in photography's symbolic universe. The same claim could
not be made with regard to painting, where the hand has hardly been
a pervasive or popular subject (although its telling gestures are crucial
components of some of art history's greatest hits, such as Leonardo
da Vinci's *The Last Supper*). How, then, can we account for photography's
peculiar and enduring relationship—an attraction that continues to
be elaborated in works by contemporary artists—with our hands?

Without wishing to sound like a public relations agent for our prehen-
sile extremities, I think it can be argued that the hand is almost inherently
photogenic. The definition of this term, of course, is somewhat tautolog-
ical: Anything that looks good when it is photographed, after all, qualifies
as being photogenic. Yet with its expressive capacities and its archipelago
of distinct and distinctive features, the hand appeals to the precision
of photography in a manner unmatched by any other area of the body
except for the face. Its articulated joints, intricate structure, and ornate
landscape of creases and wrinkles comprise a compelling topography
for the camera's detail-catching eye.

Above all, what commands the photographer's attention is the hand's
fluidity and flexibility, its endless possibilities of composing and recom-
posing itself. This capacity is evident in the range of emphatic gestures—
from shaking a fist or flipping someone the bird to seductively beckoning
a loved one—that play such a vivid role in our everyday communication.
Compared to the relatively passive features of the face—when was the last
time you saw a nose or an ear convey emotion dramatically?—our hands
constitute a whirling theater of nuance. They are salutary subjects for
photography's unique ability to capture movement that would otherwise
escape our sustained attention.

That said, I suspect there is a more potent, perhaps even compulsive,
motivation underlying the pictures that are assembled in this exhibition.
Perhaps this reason can be construed as a compensatory reaction—or in

Robert Rauschenberg
Cy + Relics, Rome, 1952. Gelatin-
silver print, 20 x 16 inches
(50.8 x 40.6 cm)

more romantic terms as a kind of haunting. It springs from the fact that the hand is precisely what is missing from, and what is obviated by, the photographic process. Mechanical in nature, photography excludes and suppresses the realm of touch. In drawing and painting, we speak of cool colors or hard edges—terms that directly conjure our sense of handling. But tactility and all traces of direct, physical contact are absent from film's smooth surfaces. Referring to its machine-produced perfection, the art historian Henri Focillon once memorably observed: "Even when the photograph represents crowds of people, it is the image of solitude, because the hand never intervenes to spread over it the warmth and flow of human life."[1]

Could it be, then, that the hand haunts the house of photography as a figment of its bad conscience? Certainly, for many of the contributors to this exhibition, hands seem to exercise that slightly morbid fascination that draws us, almost involuntarily, toward repressed content. Given the inevitable return of the repressed, the hand's recurring role in such a wide range of images could hardly be considered surprising.[2]

In any case, it is striking how many of the works by contemporary artists in The Buhl Collection depict their subject as a more or less uncanny entity. There are, of course, other influences to consider in this regard. The uncertain nature of touch in a technological age potentially imbues our subject with a ghostly or fugitive demeanor, and hands— as both cultural artifacts and body parts—have long been linked to the uncanny, from their associations with esoteric practices like palmistry or legerdemain to their status as asymmetrical twins, suspect mirror images. Allusions to these motifs routinely crop up in many of the contemporary photographs in this phantasmagoric collection, in which we also find images where hands are rendered strange or alien in appearance; where they engage in ambiguous activities and esoteric communications; or where they seem to possess an odd life all their own.

A pair of humorously eerie photographs from 1952 set the stage for much of the later work in the collection, while indirectly invoking an almost oedipal hostility toward traditions of handmade art. In Robert Rauschenberg's *Cy + Relics, Rome* (p. 152), we see the painter Cy Twombly confronted by an ancient sculptural fragment of a gigantic hand. Yet rather than offering a portrait of aesthetic reverence, Rauschenberg's image conveys something slightly comical about the way Twombly is dwarfed by this enormous hand. Was Rauschenberg gently poking fun at the painter's enthrallment not only with classical traditions, but with the practice of a kind of art that places central importance on the artist's touch? Rauschenberg, by contrast, with his interest in mechanical reproduction, views the ghosts of art history—and their potentially overbearing legacy—with cool detachment.

1. Henri Focillon, *The Life of Forms in Art*, trans. George Kubler (New York: Zone Books, 1989), p. 174.
2. It is worth noting in this regard that, as both Sigmund Freud and the makers of horror movies insist, the repressed usually returns in an altered and unfamiliar form.

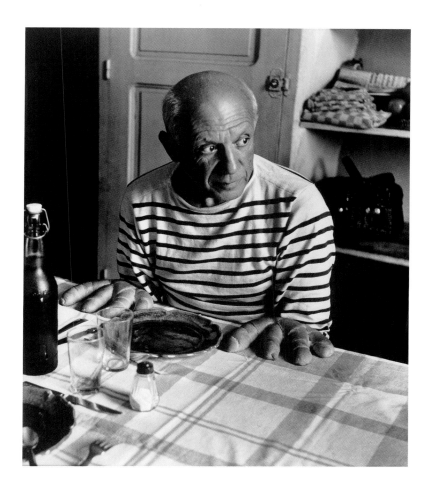

Made the same year, Robert Doisneau's portrait of Pablo Picasso shows his famous subject seated at a table, where a pair of four-fingered loaves of bread stand in as surrogates for the artist's hidden hands. In endowing his sitter with clumsy-looking and freakish digits, Doisneau playfully subverts the myth of Picasso's physical and technical virtuosity. Like Rauschenberg's portrait of Twombly, his photograph drolly challenges the heroic construction of the hand as the vehicle through which artistic genius is channeled.

In the early 1950s, when these portraits were made, photography had not yet fully refashioned our definitions of "high" art. That process was kick started in earnest by Andy Warhol's work in the 1960s. Yet in these postwar images by Rauschenberg and Doisneau, the hand is already coded as something outdated or displaced, as a symbol of bygone conventions. By the time contemporary art had completely absorbed and accommodated a machine-made aesthetic—not only through various photographic practices that emerged in the 1960s and early 1970s, but also through the industrial approach of Minimalist sculptors—the image of the hand was almost completely severed from its classical associations.

Robert Doisneau *Picasso's Breads, Vallauris*, 1952. Gelatin-silver print, 46 ¹/₂ x 39 inches (118.1 x 99.1 cm)

Indeed, a number of contemporary photographs in The Buhl Collection examine the hand as though it were a quasi-autonomous object, a subject deserving of portraiture in and of itself, rather than treating it as a sign of artistry and manual skill. These images play on our sense of the hand's double identity as a part that is at once attached to the body yet also somehow separate. Located at our extremities, hands appear at times to possess a life and intelligence of their own. "Hands are almost living beings," notes Focillon, "eyeless and voiceless faces that nonetheless see and speak."[3] This vaguely unnerving impression of self-sufficiency has fostered a range of pop-culture fictions featuring hands that exist as independent, self-willed creatures. (This tradition, which could be said to begin with the gigantic, armored hand in Horace Walpole's *The Castle of Otranto* [1764], finds a memorable, latter-day example in the character of Thing in *The Addams Family*.)

Warhol's *Self-Portrait* (1983), for example, depicts the artist's hand as though it were a sovereign entity. Isolated against a monochrome background, it "faces" the camera from the center of the frame, perched atop a pale, necklike band of wrist and forearm. Despite the mildly phallic diagonal thrust of the forearm, and of the thumb sticking out in the opposite direction, Warhol's hand and arm ultimately look as static as a mannequin's. It is a hand that seems to exist outside the realm of touch—a photographic hand, as it were. By contrast, John Coplans's black-and-white *Self-Portrait* (1986)—a monumental vertical image of the back of the artist's hand—exudes a dense, meaty presence. While Warhol's hand is surrounded by empty space, Coplans's fills most of the frame, presenting us with a strange, landscapelike expanse that is utterly alien yet undeniably familiar.

To some degree, each of these poker-faced "self-portraits" focuses our attention on what is so conspicuously missing from them: a conventional intimation of a psychological individual. In traditional portraiture, of course, the sitter's dress and environment are used to convey information about personality and social position. Warhol and Coplans, however, deprive us of these cues, and in both photographs the artist's solitary hand ultimately seems insufficient as an emblem of selfhood; it fails to function, in other words, as a metonymic representation of the whole person. Instead, despite—or perhaps because of—their curiously compelling characters, the hands in these pictures stubbornly retain their identity as mere parts. Warhol's deadpan Polaroid, in particular, addresses us less as a portrait than as another ironic commentary on the myth of the artist's touch as a hallmark of genius. (As the crown prince of mechanical reproduction, Warhol was surely being ironic when he dubbed this picture of his hand a self-portrait.)

3. Focillon, p. 157.

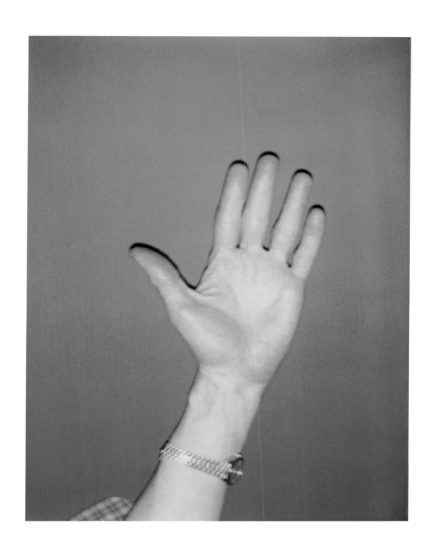

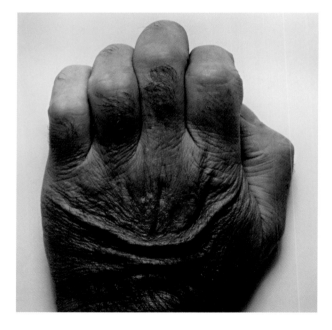

Andy Warhol *Self-Portrait*, 1983.
Polaroid Polacolor print, 4 ¼ x
3 ½ inches (10.8 x 8.9 cm)

John Coplans *Self-Portrait*,
1986. Gelatin-silver print,
41 x 39 inches (104.1 x 99.1 cm)

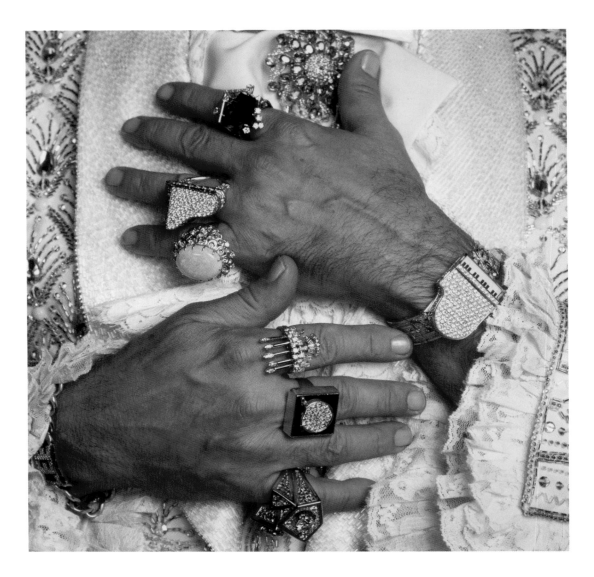

In these and other images of seemingly autonomous hands, we encounter photography's ability to isolate and dislocate its subjects, to transform them by presenting them out of context. In some instances, this approach can leave us in doubt as to whether the solitary body part we behold is alive or dead. Such is the case in Annie Leibovitz's *Liberace, Las Vegas* (1981), which offers a close view of the back of the entertainer's hands, shown lying across a small square of his frilly jacket and shirt. The lifeless manner in which Liberace's hands rest on his body, his fingers weighed down by ungainly rings, suggests a corpse laid out for viewing.

If Leibovitz's image somewhat mischievously exploits the way that photography can confuse the difference between the living and the dead, Andres Serrano's paired portraits *The Morgue (Knifed to Death I and II)* (1992) deliberately reek of mortality and violence. Borrowing their dramatic memorial lighting from the history of painting, Serrano's somber

Annie Leibovitz *Liberace, Las Vegas*, 1981. Cibachrome, 13 ¹/₂ x 13 inches (34.3 x 33 cm)

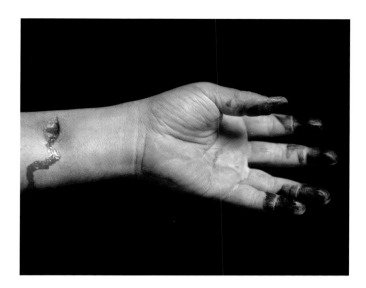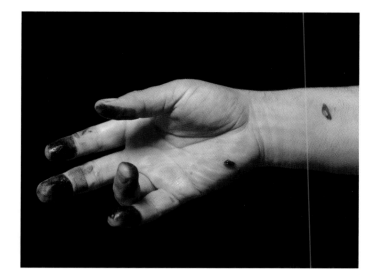

photographs portray the left and right hands of a murder victim. Scars are visible across the horizontal line of each forearm, and the ink blackening the fingertips gives each hand a disconcertingly truncated appearance. Conjuring a tragic transformation, these marks prompt our vain attempts to imagine the damage inflicted on the rest of the body. Yet a different kind of violence also haunts these hands: namely, the violence of photography, which can sever our corporeal parts from one another in unsettling ways.

Serrano's portraits present a damaged yet still intact object. In Cindy Sherman's *Untitled, #240* (1991, p. 160), we encounter an almost inchoate sliver of hand composed of a thumb and a couple of fingers. Stretched across the upper third of a dimly lit composition, forefinger and thumb are posed in a form that strongly suggests a gaping mouth, and they rest on what appears to be bloodstained ground. Sherman's photograph, part of her *Civil War* series, asks us to engage with a kind of theatricalized abjection. Yet however stylized, its evocation of form-lessness and dissolution is viscerally unsettling—perhaps because the fragment depicted so insistently refuses to resolve itself into anything suggesting a larger whole.

In Sherman's photograph, we encounter the epitome of what I would call (at the risk of using a term past its sell by date) a postmodern hand. In modernist aesthetics, the fragment or part is traditionally treated as a poetic microcosm that is complete in and of itself, even as it serves as a metonymic index of a larger whole. In postmodern aesthetics, however, the fragment remains just that: It is intractably partial and incomplete, and consequently unstable and without fixed identity. In choosing to make portraits of isolated hands, then, the contemporary artists in The Buhl Collection almost inevitably take on fundamental questions about

Andres Serrano The Morgue *(Knifed to Death I and II)*, 1992. Cibachrome, silicone, Plexiglas, and wood, two prints, each 32 ½ x 40 inches (82.6 x 101.6 cm)

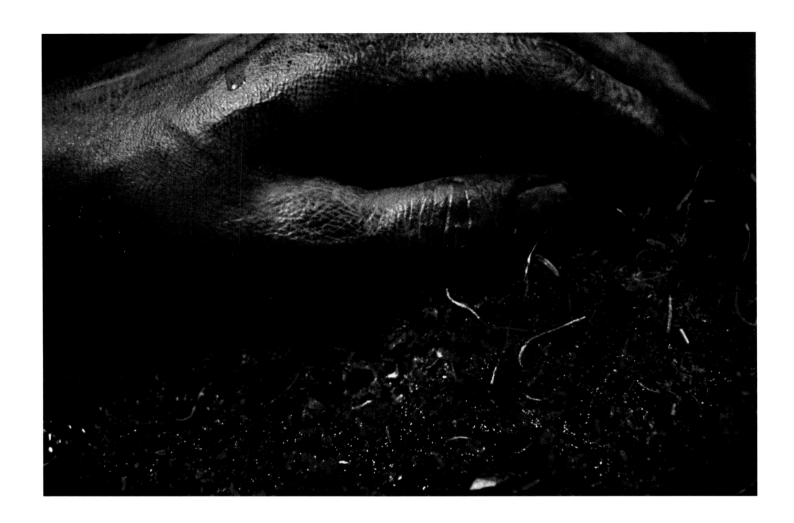

Cindy Sherman *Untitled, #240*,
1991. Color photograph,
49 x 72 inches (124.5 x 182.9 cm)

Jeanne Dunning *Long Hole*,
1994–96. Cibachrome, 15 ³/₄ x
24 ¹/₂ inches (40 x 62.2 cm)

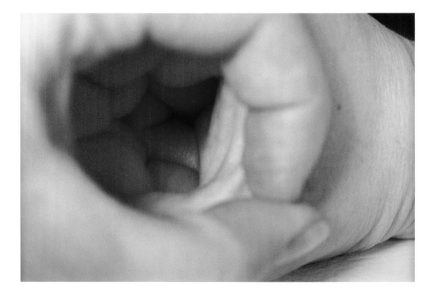

how we represent ourselves. As an example of portraiture, Sherman's photograph—and to a lesser extent, those of Warhol and Coplans—insinuates a model of a self comprised of separate and potentially incompatible components. As such, it is a self that remains resistant to iconic representation, since no single image is capable of capturing its shifting complexity.

The hand's ability to mimic other parts of the body or otherwise transform its appearance inspires a good many of the contemporary photographs in this exhibition. These works are not individual portraits but images that elaborate on the hand's protean powers. As in Sherman's *Untitled, #240*, Jeanne Dunning's *Long Hole* (1994–96) depicts a finger and thumb that provocatively form a shape reminiscent of a bodily orifice. Not a mouth, in this case, but an interior canal of some kind—something deep, fleshy, and dark. Indeed, we might think we were looking into an open wound or a hollow, corporeal stump were it not for the easily identifiable thumbnail and finger in the foreground. Dunning's image invites us to confuse the exterior and interior of the body, and confronts us with the contradictory excitement and repulsion we feel at the thought of what lies under our own skin.

Janine Antoni's *Ingrown* (1998, p. 162) and Maurizio Cattelan's *Black Star* (1996, p. 163) also evoke the dissolving of bodily boundaries. Both photographs depict fingers joined together in bizarre and disquieting ways. *Ingrown* portrays two female hands whose fingers have seemingly merged, fastened together by their elongated and painted nails. What is normally a cosmetic accessory has here mutated into an imprisoning device, implying that conventions of feminine beauty can fatally constrain a woman's freedom to act and create. Cattelan's *Black Star* also alludes to ideological entrapment, making indirect reference to the members of a Swiss-based cult who, in committing mass suicide, laid their bodies out to form a star, a key symbol of their church. Cattelan's image shows five hands floating over a dark void, their fingers touching to form the outline of a five-pointed star. The hands' somewhat contorted shapes and their eerie, collective metamorphosis hint at a distortion and dissolution of individual identity.

If a slightly sinister atmosphere inflects these photographs of trans- formed hands, we might well recall that there is almost always something suspect or vaguely alarming about objects we cannot identify clearly. The hand, with its shape-shifting faculty, is precisely such an object. It engages in a multitude of activities, and with each one its meaning seems to change. But there is also a more direct motive for associating the hand with a sense of dread or ominous threat: One of its oldest and most cele- brated uses, after all, has been to violently seize, crush, and strike. The cultural historian Elias Canetti has even argued that the tip of the finger

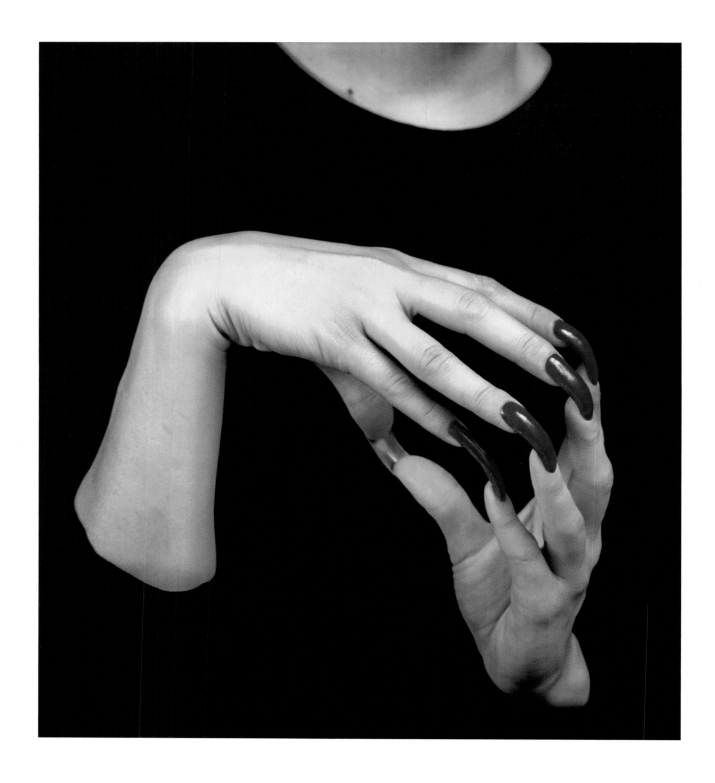

Janine Antoni *Ingrown*, 1998.
C-print, 18 ¹/₈ x 16 ³/₈ inches
(46 x 41.6 cm)

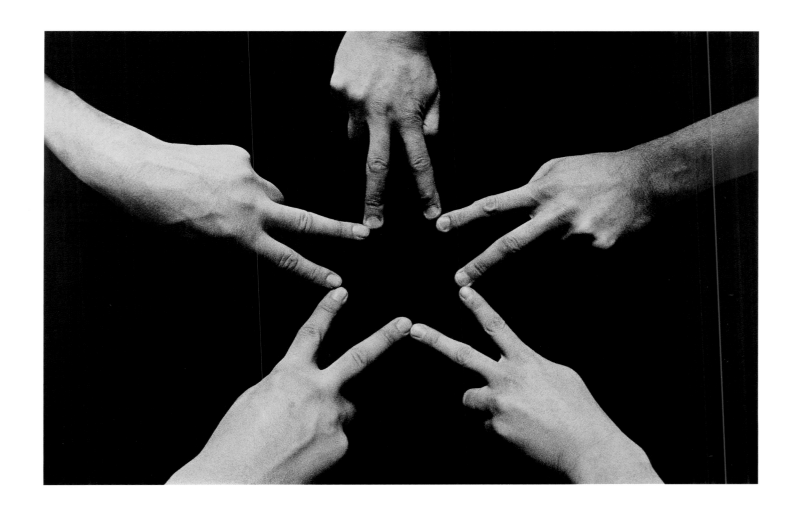

Maurizio Cattelan *Black Star*,
1996. Gelatin-silver print, 40 ¹/₄ x
60 ¹/₄ inches (102.2 x 153 cm)

is the prototype for the dagger and arrow; pointed and armored with a nail, it first provided man with the sensation of stabbing.[4]

We find an echo of this idea in Douglas Gordon's *Three Inches Black (no. 9)* (1997). An almost mundane image not unlike a mug shot, it depicts two hands whose thumbs appear to touch. The photograph is oddly cropped so that we see only three fingers on each hand, but what immediately catches our attention is the black tattoo that covers three inches of one forefinger. It is a strange and portentous mark, and it imbues the whole hand with a shady and threatening character. Indeed, Gordon's photograph suggestively conjures up the hand's identity as a potential weapon. The blackened digit it depicts was inspired by a memory from Gordon's youth. When the artist was growing up in Scotland, local police prohibited anyone from carrying a pointed object longer than three inches, because that is the distance from the surface of the chest to the heart.

The violent hand trespasses and penetrates. It crosses the space we carefully maintain between one another, violating our physical autonomy. As such, it is yet another manifestation (albeit in an extreme form) of the hand's role as exploratory agent linked to touch and physical contact. We find the hand performing these functions in Vito Acconci's photographic series *Passes* (1971), only reconfigured in the vocabulary of Conceptual performance. These images partially document a twenty-minute performance in which the artist extended his arm in front of his face, then gradually brought it closer while passing his hand up and down and back and forth, until his hand pushed into the skin of his face. As in works by other conceptually motivated artists in this period, the hand appears here as both a key instrument in the work's creation and a

Douglas Gordon *Three Inches Black (no. 9)*, 1997. Color photograph mounted on PVC, 31 ¹¹/₁₆ x 41 ⁵/₁₆ inches (80.5 x 105 cm)

4. Elias Canetti, *Crowds and Power*, trans. Carol Stewart (New York: Farrar, Straus & Giroux, 1962), p. 219.

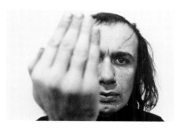

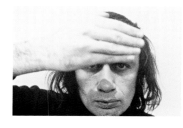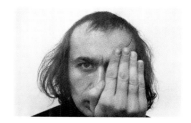

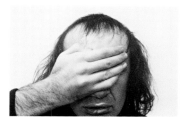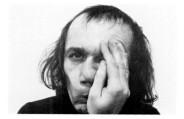

tool for surveying the relationship of self and environment. At the same
time, these photographs hint at paranoia and aggression: Acconci's
gestures conceal his face as if defending it from the touch of our intrusive
gaze, pushing the viewer away even as they eventually evoke a simple,
physical affirmation of self.

While our own touch offers solace, that of an unknown stranger is
almost universally feared; it is only in crowds, as Canetti has argued,
that we lose this fear through becoming one with the mass.[5] Shot from
a God's-eye perspective, Andreas Gursky's *May Day II* (1998, p. 166)
conveys a powerful sense of this phenomenon with its image of anony-
mous hands floating above a sea of dancers at a massive rave event. Like
a late 1990s response to Acconci's *Passes*, it shows us a scene where the

Vito Acconci *Passes*, 1971.
Six gelatin-silver prints, each
3 1/2 x 5 inches (8.9 x 12.7 cm)

5. Ibid., p. 16.

hand's role as delimiter of personal space is surrendered in exchange for an experience of abandonment. Yet Gursky's photograph is also disquieting: With their uncannily uniform gestures, the dancers appear as an army of marionettes, their movements controlled by the invisible hands of a DJ spinning music from an unseen stage.

The hand, of course, cannot only touch, it can also reach out across physical distance; as a communications device capable of sending coded signals, it can exercise enormous power from afar. (Think of the infamous "thumbs down" gesture made by crowds at gladiatorial events in ancient Rome.) No clearer example of this capacity exists than that provided by the conductor of an orchestra. In order to rouse or silence every instrument on stage, the conductor needs make only the slightest gesture with his hand and baton. Members of the audience, meanwhile,

Andreas Gursky *May Day II,* 1998. C-print, 73 x 88 ¹/₂ inches (185.4 x 224.8 cm)

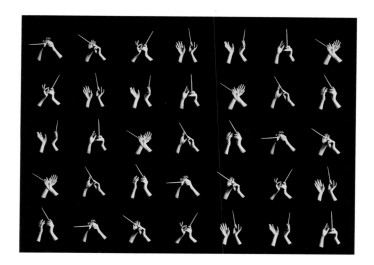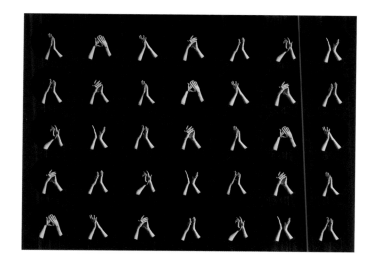

must experience the music while remaining motionless. It is only at the performance's end that they can find physical release by gesturing with their own hands, sending a message of praise back to the stage by clapping.

This situation provides the ostensible subject of Annette Lemieux's *Transmitting Sound* (1984), a diptych that features sequential images of a pair of hands. In the first panel, the hands are shown making the gestures of an orchestra conductor; in the second, they appear to be applauding. With their subjects isolated against a black background, Lemieux's photographs seem to project a quasi-scientific aura that recalls the nineteenth-century motion studies of Eadweard Muybridge. Yet beyond capturing the elastic gestures of the hands, whose curious and compelling poses suggest a strange semaphore, Lemieux's work focuses on the contrast between different systems of transmitting sound: the somewhat abstract (and silent) code employed by the conductor, and the immediate means offered by clapping. In other words, we find here yet another work in which the hand possesses a kind of conceptual dual identity that cannot be conveyed in a single photograph.

With his diptych *My Hands Are My Heart* (1991, p. 169), Gabriel Orozco offers yet another viewpoint on the powers of hands. Against the background of the artist's naked chest, Orozco's hands are shown squeezing a lump of clay, and then, in a second image, openly holding the resulting sculpture of his "heart." Together these photographs comprise a portrait of the artist engaged in a primordial act of creation: making an object in a purely tactile manner, with sightless hands, rather than proceeding from visually based aesthetic decisions. It is a practice of modeling, needless to say, long considered anachronistic in contemporary art.

Still a circular logic informs Orozco's piece. It is, after all, a portrait of hands producing an indirect portrait of themselves. And in producing

Annette Lemieux *Transmitting Sound*, 1984. Gelatin-silver prints, two parts, each 26 x 36 inches (66 x 91.4 cm)

this negative image by pressing into the clay, the artist mimics the photographic process in which light leaves an impression on the negative film. Likewise, his sequential gestures of closing his hands to make the imprint and then opening them to unveil the result call to mind the snapping of a camera's aperture. But *My Hands Are My Heart* is also a conceptual work about the value of hands. Sight slips over the world's surfaces, while a more intensive knowledge of things requires a tangible exploration; indeed, our perception would be greatly impoverished without the information we glean from touching and holding. Orozco's work reminds us of all this, while also insinuating the crucial role of the hand in the formation of culture. His shirtless chest, beyond suggesting a primitive backdrop to his hand's activity, invites us to compare the warm tones of his skin with that of the pale orange clay, as if invoking the idea of the divine potter whose skilled hands gave shape to human life. Orozco is saying that at the very heart of civilization we find the hand. Not only does the hand make things, but its shape-forming talents, as Orozco implies, are inextricably linked to the origins of our symbol-making and hence to our development of language and memory. As Canetti has observed: "It is the quiet, prolonged activities of the hand which have created the only world in which we care to live."[6]

In the course of this essay, it seems that I have also followed a somewhat circular logic, returning again to consider an image of the artist's hands. Only here it is no longer employed as an icon of individual creativity, but as a generalized symbol of the construction of culture—including, surprisingly enough, that photographic process that so definitively denies the hand a part in producing images of our world. In the end, however, the hand exacts a symbolic revenge. With its numerous uses and far-flung associations—its links with intimacy and analysis, tenderness and brutality, communication and concealment—the hand seems destined to endlessly haunt and inspire photography's collective imagination.

6. Ibid., p. 213.

Gabriel Orozco My Hands Are My Heart, 1991. Two Cibachromes, each 9 x 13 ³/₄ inches (22.9 x 34.9 cm)

Unknown photographer *The Faith Healer (or Hypnotist)*, ca. 1855. Sixth-plate daguerreotype, 3 x 3 ½ inches (7.6 x 8.9 cm)
Unknown photographer *Scene of Medical Hypnosis (?)*, 1856. Quarter-plate ambrotype, 4 x 3 inches (10.2 x 7.6 cm)

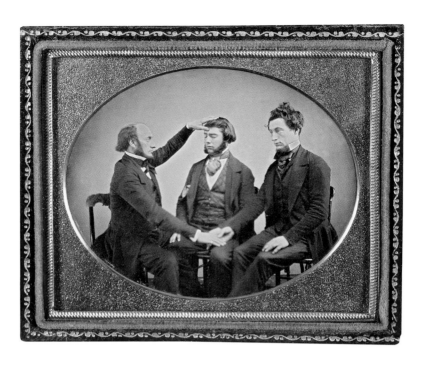

Henri Cartier-Bresson *The Visit of Cardinal Pacelli, Montmartre*, 1938. Gelatin-silver print, 6 ¹/₂ x 9 ³/₄ inches (16.5 x 24.8 cm)

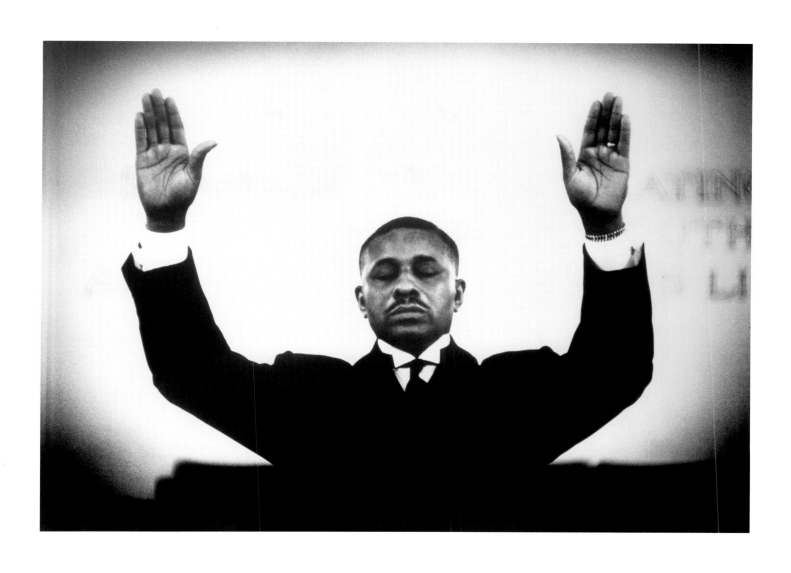

Gordon Parks *Pastor Ledbetter, Metropolitan Baptist Church, Chicago,* 1953. Gelatin-silver print, 20 x 28 inches (50.8 x 71.1 cm)

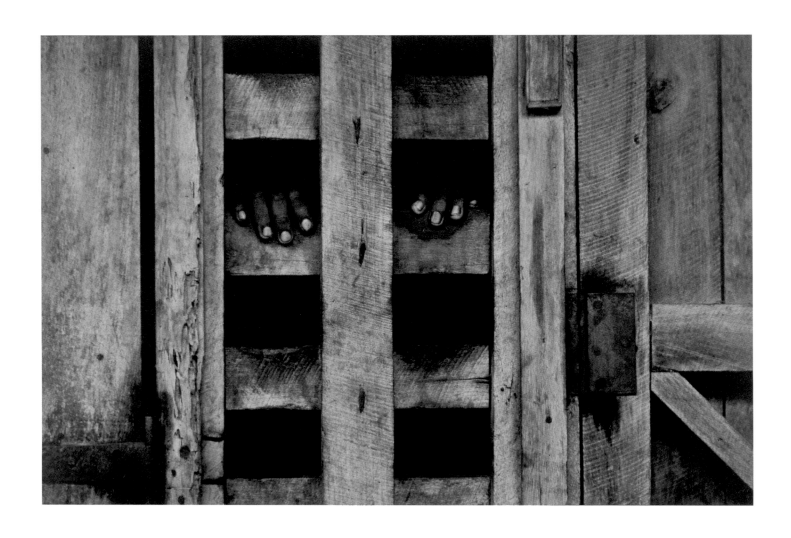

W. Eugene Smith *Stockade*, 1954. Gelatin-silver print, 9 x 13 ¼ inches (22.9 x 33.7 cm)

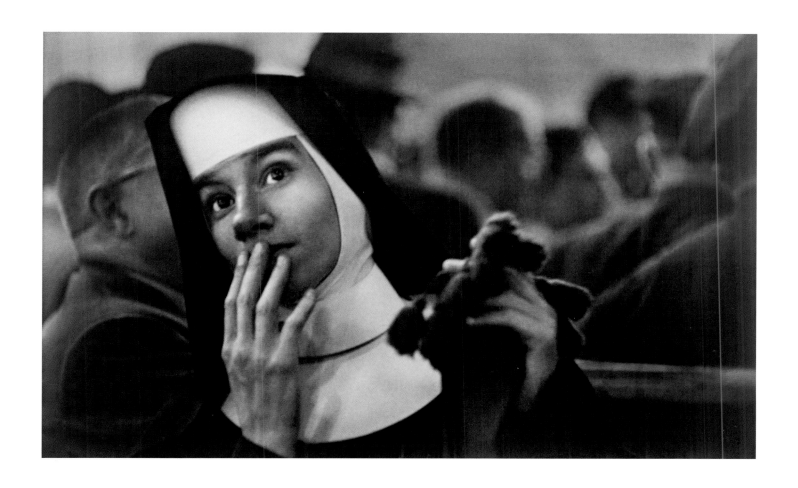

W. Eugene Smith *Waiting for Survivors: The Andrea Doria Sinking*, 1956. Gelatin-silver print, 8 ¼ x 13 ⅜ inches (21 x 33.9 cm)

Elliott Erwitt *Vice President Nixon and Soviet Premier Khrushchev during the "Kitchen Debate"* *at the U.S. Exhibition in Moscow*, 1959. Gelatin-silver print, 8 x 12 inches (20.3 x 30.5 cm)

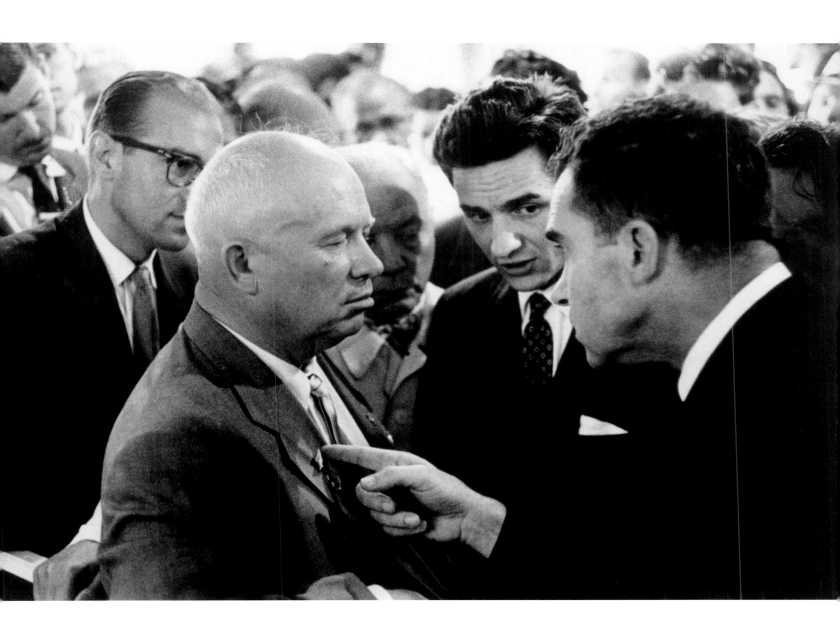

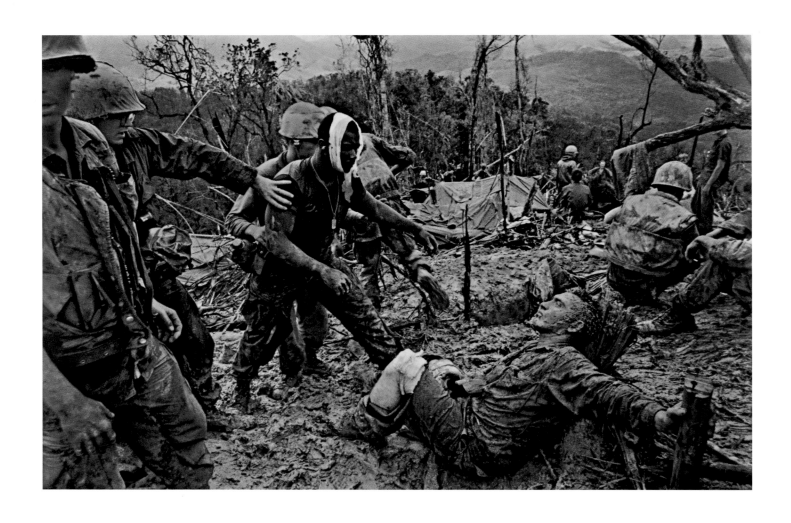

Larry Burrows *Reaching Out, Battle of Hill 484, South Vietnam*, 1966. Dye-transfer print, 15 x 22 ¹/₂ inches (38.1 x 57.2 cm)

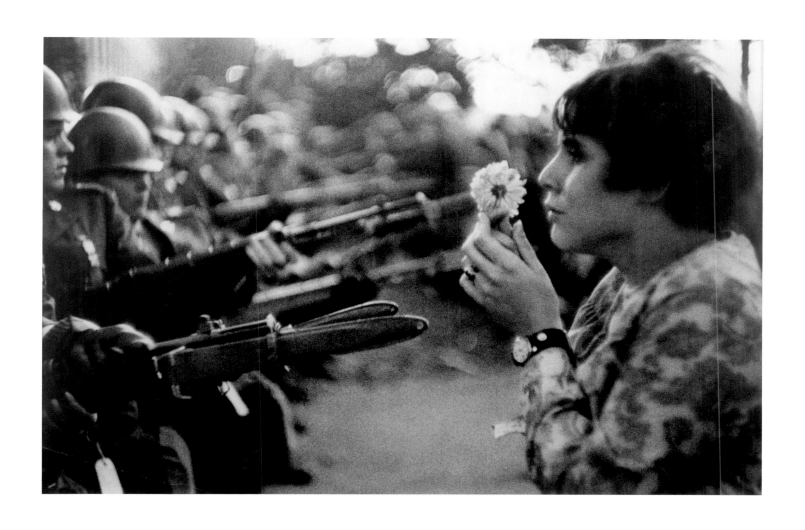

Marc Riboud *Jan Rose Kasmir at a Demonstration against the Vietnam War, Washington, D.C.*, 1967. Gelatin-silver print, 10 x 15 inches (25.4 x 38.1 cm)

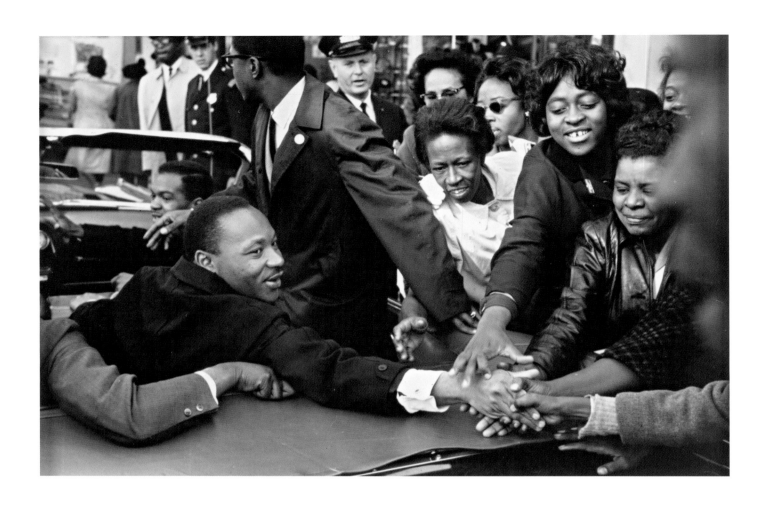

Leonard Freed *Martin Luther King Being Greeted on His Return to the United States after Receiving the Nobel Peace Prize, Baltimore, 1963.*
Gelatin-silver print, 5 x 7 ¼ inches (12.7 x 18.4 cm)

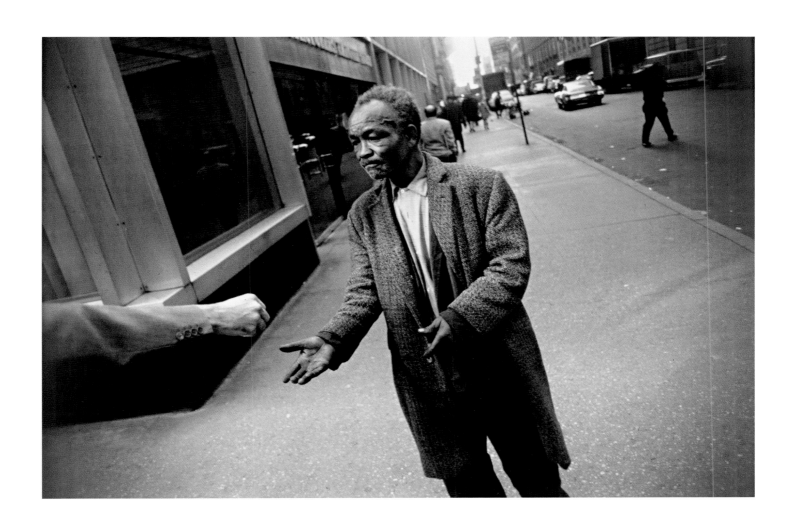

Garry Winogrand New York City, 1969. Gelatin-silver print, 11 x 14 inches (27.9 x 35.6 cm)

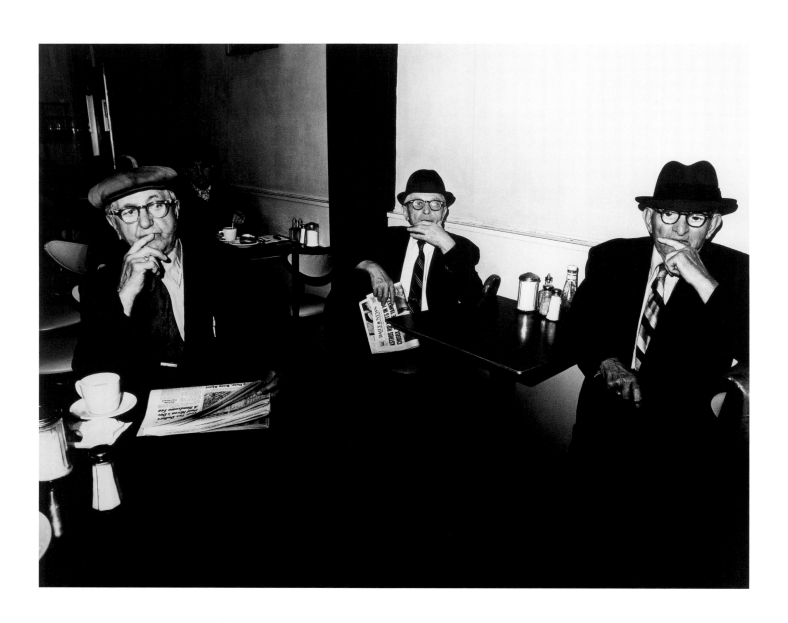

Bruce Davidson *Three Men in Garden Cafeteria, New York City*, 1976. Gelatin-silver print, 20 x 24 inches (50.8 x 61 cm)

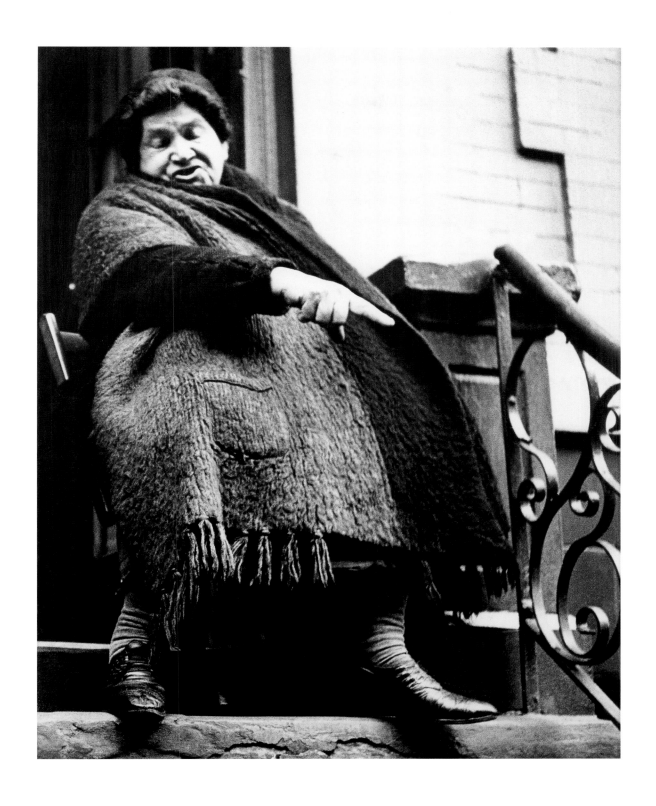

Lisette Model *Lower East Side, New York*, 1942. Gelatin-silver print, 13 ¼ x 10 ½ inches (33.7 x 26.7 cm)

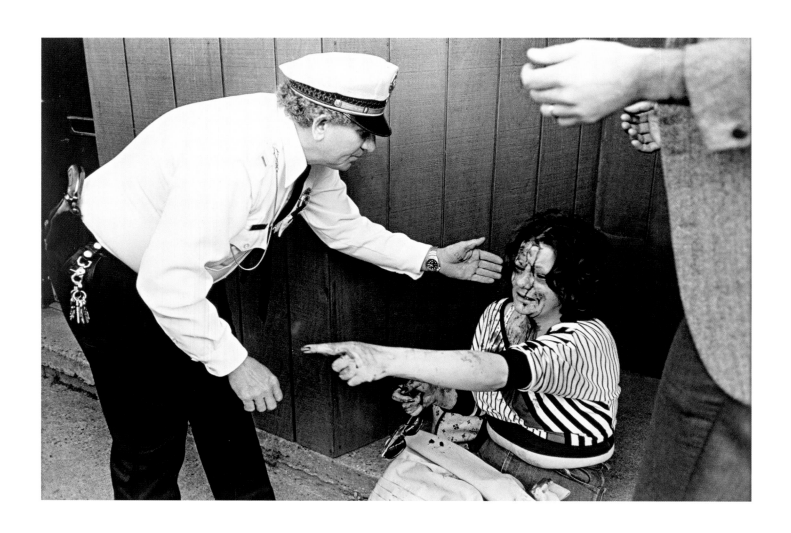

Donna Ferrato *Injured Woman on the Street—McKeesport, Pennsylvania*, 1983. Gelatin-silver print, 12 ³/₄ x 25 ³/₄ inches (32.4 x 65.4 cm)

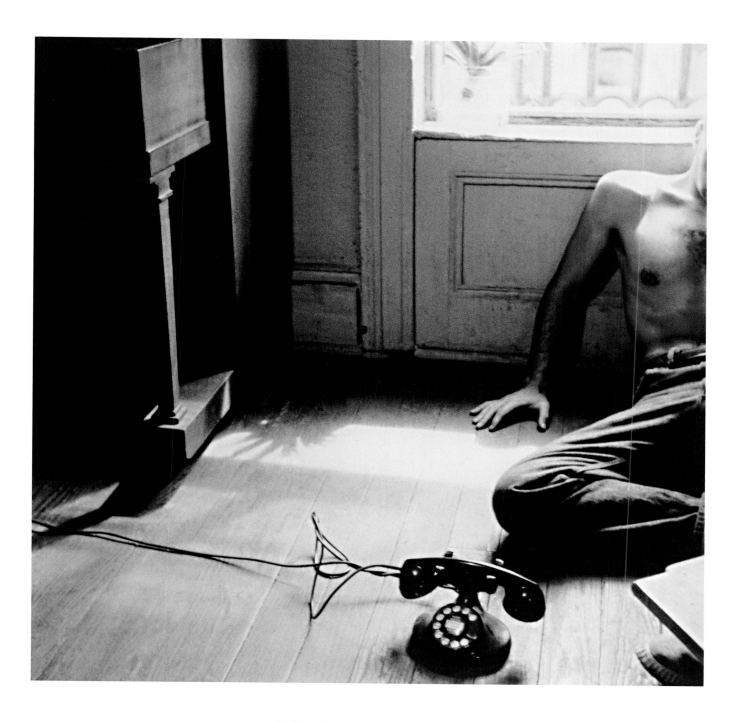

Robert Rauschenberg *Norman's Place #2*, 1955. Gelatin-silver print, 20 x 16 inches (50.8 x 40.6 cm)

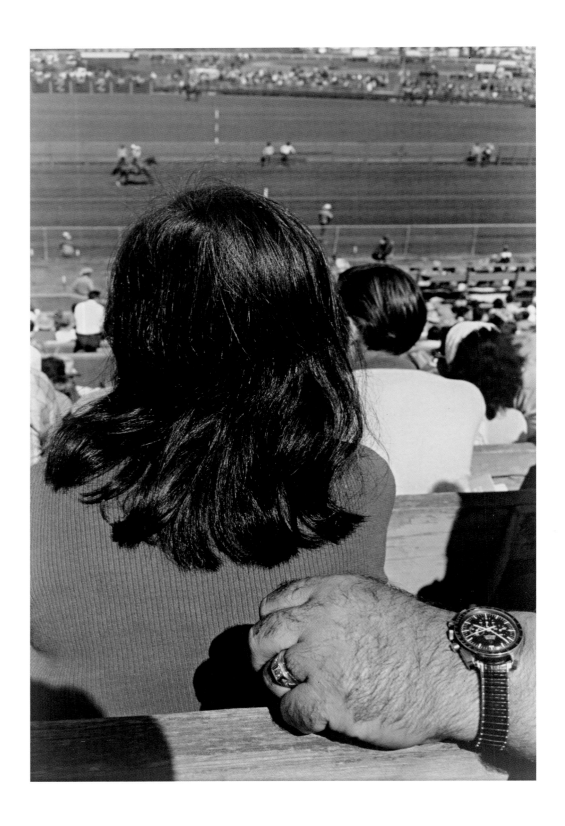

Lee Friedlander *Salinas*, 1972. Gelatin-silver print, 13 ⁷/₈ x 11 inches (35.2 x 27.9 cm)

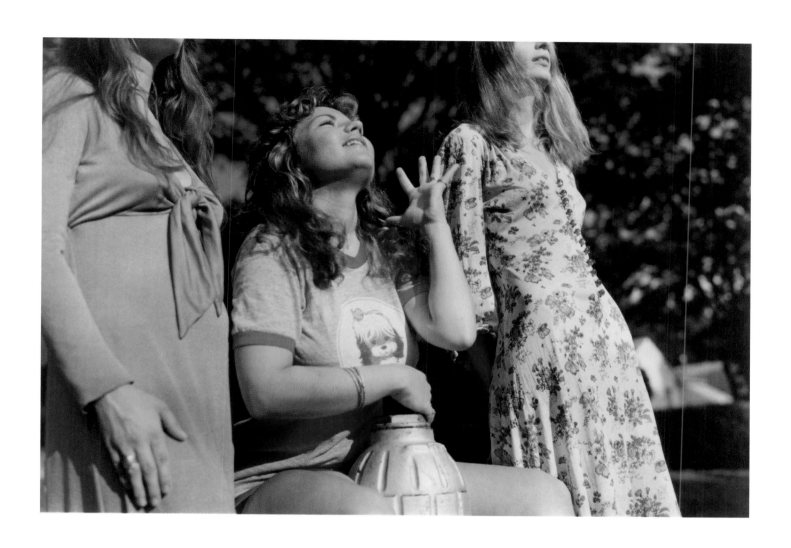

William Eggleston *Untitled*, ca. 1975. Dye-transfer print, 12 x 18 inches (30.5 x 45.7 cm)

Nan Goldin *Joey in my mirror, Berlin*, 1992. Cibachrome, 25 $^{7}/_{8}$ x 38 $^{5}/_{8}$ inches (65.7 x 98.1 cm)

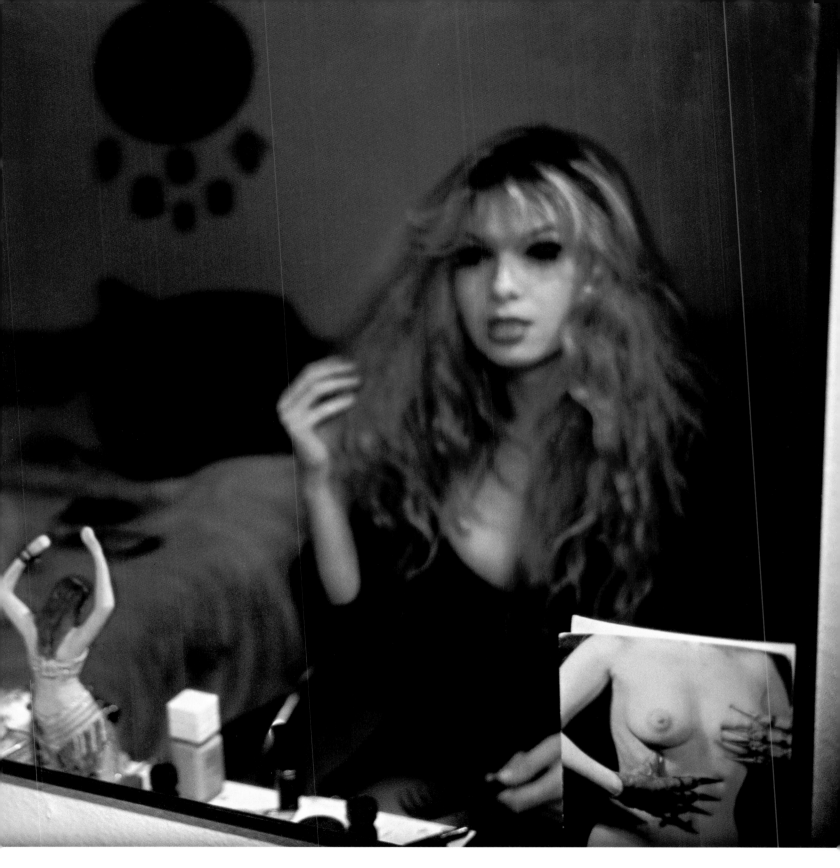

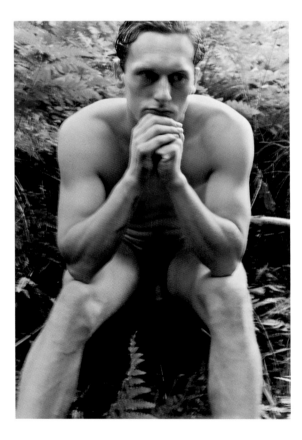

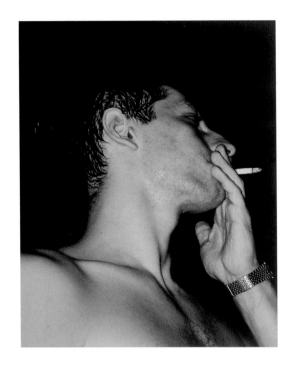

Wolfgang Tillmans *Arndt Sitting Nude*, 1991. C-print, 16 x 12 inches (40.6 x 30.5 cm)
Wolfgang Tillmans *Smoker (Chemistry)*, 1992. C-print, 16 x 12 inches (40.6 x 30.5 cm)
Wolfgang Tillmans *Cornel, Zurich*, 1993. C-print, 12 x 16 inches (30.5 x 40.6 cm)

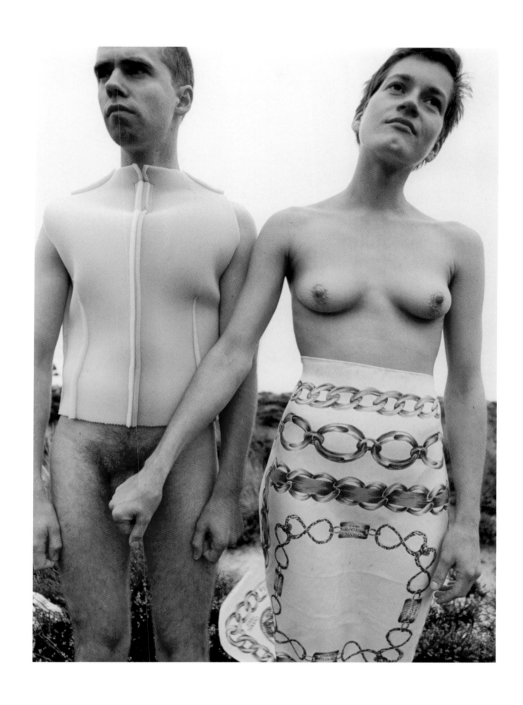

Wolfgang Tillmans *Lutz & Alex holding cock*, 1992. C-print, 23 ⅝ x 19 ⅝ inches (60 x 49.8 cm)

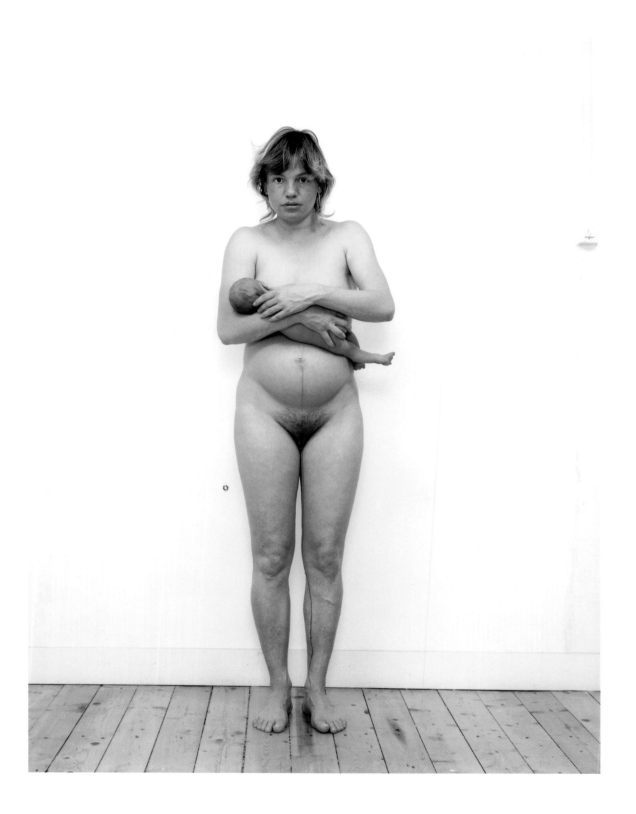

Rineke Dijkstra *Tecla, Amsterdam, the Netherlands, May 16, 1994*, 1994. C-print, 60 ¹/₄ x 50 ³/₄ inches (153 x 129 cm)

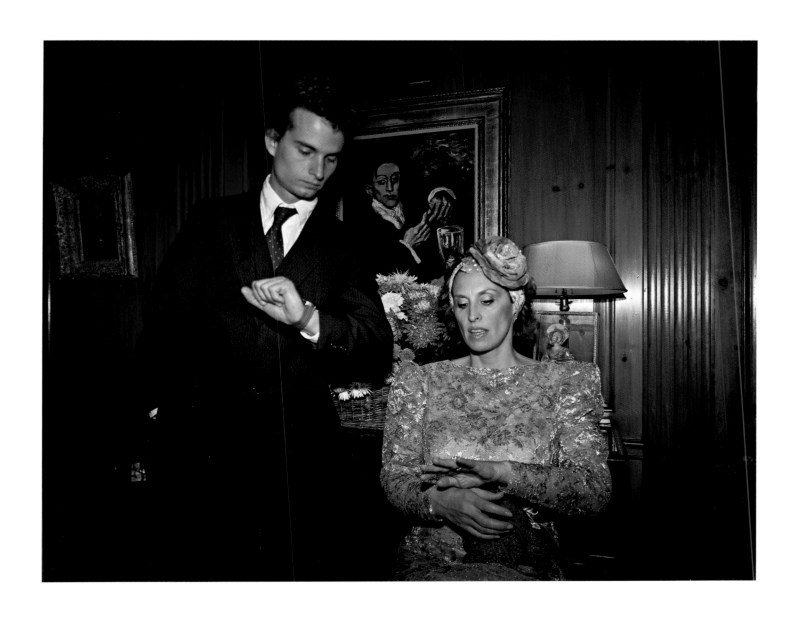

Tina Barney *The Watch*, 1985. C-print, 48 x 60 inches (121.9 x 152.4 cm)

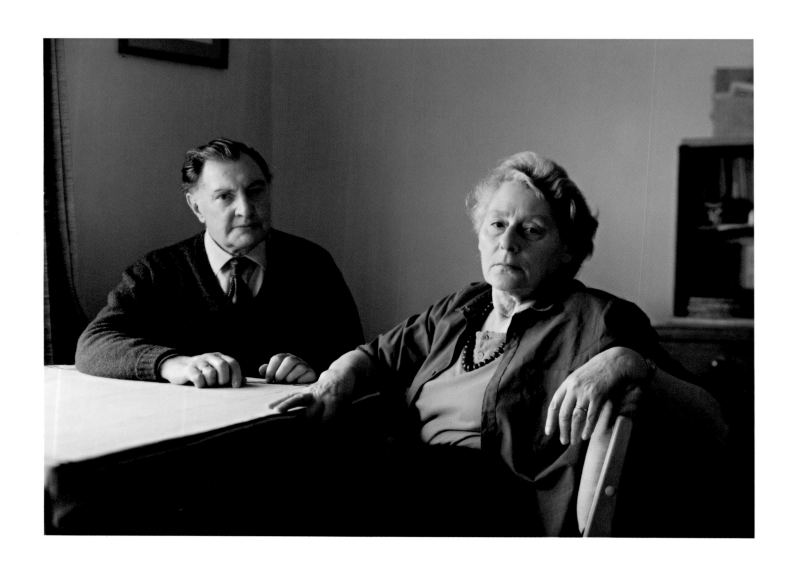

Thomas Struth *Anci and Harry Guy, Groby, Leicestershire*, 1989. C-print, 26 x 33 inches (66 x 83.8 cm)

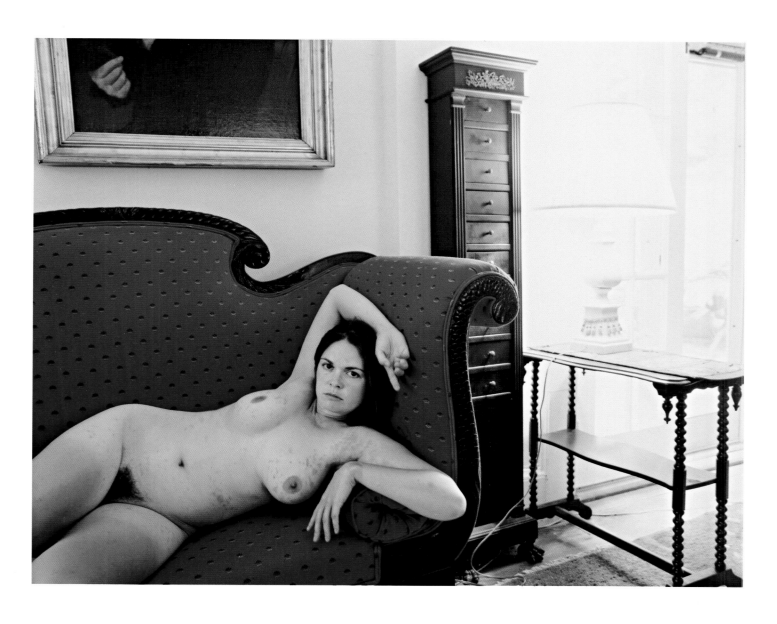

Tracey Baran *Ivy*, 2001. C-print, 30 x 40 inches (76.2 x 101.6 cm)

William Klein *School Out, Dakar*, 1963/printed and painted ca. 1995. Gelatin-silver print with enamel paint, $19^{3}/_{4}$ x $23^{5}/_{8}$ inches (50.2 x 60 cm)

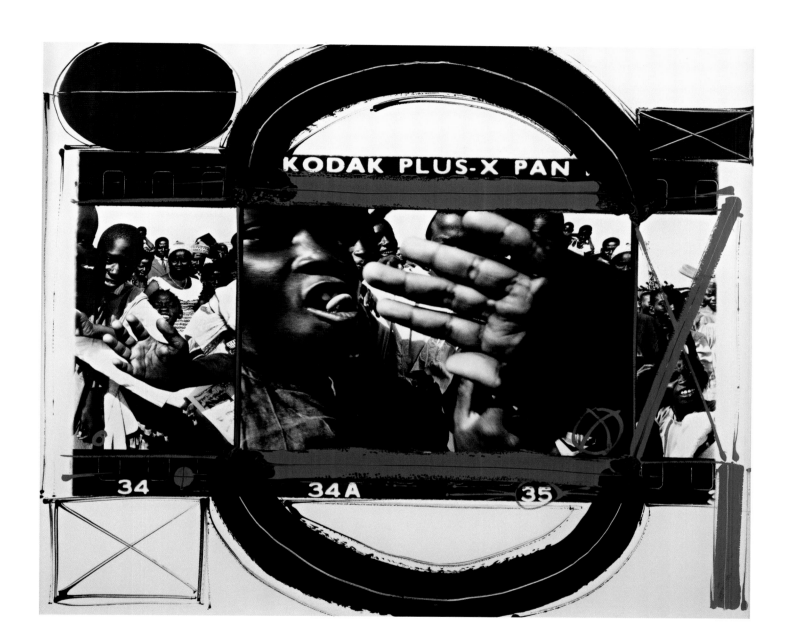

Catalogue Entries

MATTHEW S. WITKOVSKY
with MELANIE MARIÑO and NAT TROTMAN

The entries that follow represent the artists and works featured in the exhibition. For historical, journalistic photographs, the titles used are those by which the images are now known. Print dates and edition numbers have been ascertained whenever possible; print dates are only indicated when they differ by more than five years from the date the image was recorded. Polaroid prints and photograms are presumed to be unique. Dimensions indicate sheet size, although only the image itself is reproduced; thus, there may appear to be a discrepancy between the dimensions given (height x width) and the orientation of the photograph. Initials indicate authors of the texts on artists and artworks: MSW (Matthew S. Witkovsky), MM (Melanie Mariño), and NT (Nat Trotman).

Berenice Abbott
b. 1898, Springfield, Ohio; d. 1991, Monson, Maine

Berenice Abbott made her American reputation as
a documentary photographer, particularly with her
ambitious chronicle *Changing New York* (1929–39).
During her formative years in Paris, however, Abbott
apprenticed with Man Ray in 1923–25, and she opened
her own Paris studio for portraiture in 1926. Abbott's
shift to urban documentary work has been attributed
to her discovery of the archive of photographer
Eugène Atget. Abbott purchased the massive Atget
estate in 1928, one year after his death, and brought it
to New York, where she later sold the entire collection
to the Museum of Modern Art. As a teacher at the
New School for Social Research from 1934 to 1958, an
author of handbooks on photographic technique and
aesthetics, and a commercial as well as an indepen-
dent photographer, Abbott promoted the "straight"
photograph as modern fine art throughout a long and
prolific career.

Hands of Jean Cocteau, 1927. Gelatin-silver-chloride
print, 7 3/8 x 9 3/8 inches (18.7 x 23.8 cm)

One way to identify this modernist close-up is as
a synecdochic portrait of Cocteau: hands and a
hat (head), the two body parts essential for a poet.
But Janet Flanner, Paris correspondent for *The New
Yorker* saw the matter differently. She called Abbott's
photographs of Cocteau "faceless," and noted of a
different image: "Only his hands . . . are poetic and
brief. The poet himself has been eliminated." The true
echo of Cocteau's hands, this photograph suggests, is
the visual object of the hat itself: elongated, ribbed,
precious. —MSW

SUGGESTED READINGS
Mileaf, Janine. *Constructing Modernism: Berenice Abbott
 and Henry-Russell Hitchcock*. Middletown, Conn.:
 The Davison Art Center, Wesleyan University, 1993.
O'Neal, Hank. *Berenice Abbott: American Photographer*.
 New York: McGraw-Hill, 1982.
Van Haaften, Julia. *Berenice Abbott*. New York:
 Aperture, 1988.

Vito Acconci
b. 1940, New York

Vito Acconci's early work used the body as an instrument
of communication, testing the boundaries between
Conceptual and performance art. After graduating
from the writing program at the University of Iowa in
1964, Acconci moved back to New York, where his
poetry appeared in *Art and Literature* and *The Paris
Review*. In 1969, the young writer re-created himself;
moving his work from the page to the street, he began
to use a camera to record repetitive physical actions such
as jumping and throwing. Throughout the following
decade, Acconci also employed performance, film, and
video to construct "reflexive sentences" that depicted
the artist circling in on his own body. *Trademarks*
(1970) is a close-up view of the bite marks on the artist's
knees, legs, and arms, dripping with saliva and ink.
At the same time, Acconci turned outward to track the
effect of his physical presence on others. In *Proximity
Piece* (1970), he targeted randomly chosen visitors at a
museum exhibition, edging closer until they moved away.

Passes, 1971. Six gelatin-silver prints, each 3 1/2 x
5 inches (8.9 x 12.7 cm)

Originally in videotape, this work now exists only as
photographic documentation. Shot at the time of the
video's production, this sequence of six photographs
documents a system of hand movements that accom-
panied the gradual retraction of Acconci's extended
arm. Each image features a frontal view of the artist's
face partially blocked by the back of his hand, which
"passed" up and down and back and forth over his
blurred visage. That action demarcated the space sur-
rounding the body, while identifying that space as a
bodily extension. But as the body (the hand) claimed
that space, that space also invaded the body (the face).
The performance concluded when the artist pulled
his arm in so far that his hand pressed into his skin,
disfiguring his face. —MM

SUGGESTED READINGS
Linker, Kate. *Vito Acconci*. New York: Rizzoli, 1994.
Vito Acconci: A Retrospective, 1969–1980. Chicago:
 Museum of Contemporary Art, 1980.

Ansel Adams
b. 1902, San Francisco; d. 1984, Monterey, California

One of the most famous American photographers, Ansel Adams was also a dedicated educator and conservationist. During his long career, he cofounded the Museum of Modern Art's photography department with Beaumont Newhall and David McAlpin; directed the Sierra Club for thirty-seven years; tested new technologies for the Polaroid Corporation; taught annual workshops at Yosemite National Park; and wrote many instructional texts on photography. Adams is best known, however, for his stunning landscape photography and for the zone system of film exposure and development that he invented to create his prints. By the time of his death, Adams's photographs had been included in over five hundred exhibitions. Mount Ansel Adams, an 11,760-foot mountain at the edge of Yosemite, was named in his honor the next year.

Georgia O'Keeffe, 1976. Gelatin-silver print, 10 x 8 inches (25.4 x 20.3 cm)

Adams first met O'Keeffe in 1929 through her husband, photographer Alfred Stieglitz. By that time O'Keeffe already lived apart from Stieglitz, in New Mexico, as she would for the rest of their marriage. Her love of the West appealed to Adams, and over the years they met occasionally for photography treks. In his autobiography, Adams describes taking this photograph, claiming that O'Keeffe had "the most impressive physical presence of anyone" he had met. Here, Adams highlights that presence by concentrating on O'Keeffe's face and hands, two of her most expressive features—all the more distinctive in her old age (O'Keeffe was eighty-nine)—and those most bound up with her identity as a painter. —NT

SUGGESTED READINGS
Adams, Ansel, with Mary Street Alinder. *Ansel Adams: An Autobiography*. Boston: Little, Brown and Company, 1985.
Ansel Adams: Fiat Lux. Irvine, California: The Regents of the University of California, 1990.
Hammond, Anne. *Ansel Adams: Divine Performance*. New Haven: Yale University Press, 2002.

Janine Antoni
b. 1964, Freeport, Bahamas

Janine Antoni's public career began three years after she obtained her M.F.A. at the Rhode Island School of Design in 1989, with an exhibition titled *Gnaw*. The show consisted of two five-hundred-pound cubes—one made of chocolate, the other of lard—eaten away by the artist, and the sculptures she produced using the masticated removings. The chewed lard was mixed with pigment and beeswax to make 150 lipsticks, while the chocolate was cast into 40 heart-shaped packages for chocolate candy. Antoni generates her work through performance and the operations of her own body on objects frequently chosen from the universe of conventionally feminine products and activities, such as lipstick, weaving, mascara, or cradling. Her work has been featured in many group shows and a recent museum retrospective, and earned Antoni a John D. and Catherine T. MacArthur Fellowship in 1998.

Ingrown, 1998. C-print, edition 8/8, 18 1/8 x 16 3/8 inches (46 x 41.6 cm)

This photograph of paralyzing, hypertrophic fingernails is rich with associations. It calls to mind vampires, hydras, or werewolves—monsters perched on the far side of sex appeal. At the same time, long nails are often a sign of beauty and distinction, and have served as status symbols in working-class America, imperial China, and Buddhist India (where it is men who cultivate them). The soft appearance of the fingers and hands here emphasizes a distance from manual labor (ironic for a sculptor), while the high-gloss, scarlet finish of the nails conventionalizes the image of women as idle, sensual objects. Clearly, the artist could not both make or photograph the work and wear them, and removing these narcissistic manacles requires further help or an act of wrenching pain. *Ingrown* encapsulates a renunciation of creative agency and, beyond that, the seductive attractions of human bondage. —MSW

SUGGESTED READINGS
Janine Antoni. Küsnacht, Switzerland: Ink Tree, 2000.
Janine Antoni: Slip of the Tongue. Glasgow: Centre for Contemporary Arts, 1995.

Diane Arbus
b. 1923, New York , d. 1971, New York

Diane Nemerov came from a family in the fur trade, owners of what became Saks Fifth Avenue. With her husband Allan Arbus, she established a business partnership in the early 1950s working for fashion magazines. After they separated in 1959, she continued to work freelance for *Vogue*, *Esquire*, and other publications. In the mid-1950s, Arbus found an important mentor in photographer Lisette Model, with whom she cultivated her talent for frank, direct portraits of ordinary people and social misfits; her own interest in what she called "freaks," however, greatly surpassed that of her teacher. In 1967, four years after receiving a John Simon Guggenheim Memorial Foundation fellowship for a project to inventory "American rites, manners, and customs," Arbus was included in the important *New Documents* exhibition at the Museum of Modern Art, New York. Following her suicide, that museum also held a large retrospective exhibition of her work in 1972.

Child with a Toy Grenade, Central Park, New York, 1962 (printed 1970s). Gelatin-silver print, edition 40/75, 15 x 15 inches (38.1 x 38.1 cm)

Arbus took this early picture for a planned series on rich children. The boy in this candid close-up stands squarely before the camera, slightly knock-kneed, his summer outfit awry and hands and face contorted to simulate a manic frustration. His mock anguish (which may correspond to a real sentiment he does not yet know how to express) suggests that the child is performing for the world, while also pursuing an inner fantasy. The (self-)destructiveness of this fantasy, meanwhile, is symbolized by the object he clutches—a toy hand grenade. With this relatively transparent subject, Arbus honed her feel for the potentially dangerous gap between awareness of self and perceptions of others that makes her work so compelling. —MSW

SUGGESTED READINGS
Arbus, Doon, et al. *Diane Arbus Revelations*. New York: Random House, 2003.
Armstrong, Carol. "Biology, Destiny, Photography: Difference According to Diane Arbus," *October*, no. 66 (fall 1993), pp. 28–54.
Sontag, Susan. "America, Seen Through Photographs Darkly." In Sontag, *On Photography*. New York: Doubleday, 1977, pp. 25–48.

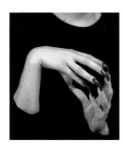

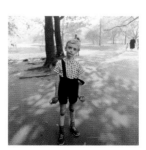

Eve Arnold
b. 1913, Philadelphia

One of the most significant women photojournalists of her time, Eve Arnold reshaped the genre of reportage with her intrepid yet empathic vision. The daughter of Russian immigrant parents, Arnold received little professional training in photography. In 1948, she studied for six weeks with Alexey Brodovitch at the New School for Social Research, New York. With the celebrated art director's encouragement, she photographed fashion shows in Harlem, creating the pictures that earned her first publication, in the British *Picture Post*. Winning recognition for her bold visual style, Arnold joined Magnum Photos as its first woman member in 1955. She has traveled widely, documenting white supremacists in America, peasants in Inner Mongolia, and hospital-interned dissidents in the Soviet Union, and has also produced probing portraits of diverse political and religious figures, Hollywood luminaries, and working-class people.

Malcolm X, 1961 (printed ca. 1992). Gelatin-silver print, 20 x 16 inches (50.8 x 40.6 cm)

In 1960, on assignment for *Life* magazine, Arnold journeyed from Washington, D.C. to New York and then to Chicago, following Malcolm X, then the emerging head of the Black Muslim movement. This iconic image captures the smiling profile of the young leader sporting a smart hat, his hand (adorned with gold watch and Masonic ring) raised behind his neck. Arnold described Malcolm X as a "brilliant, silent collaborator" who enlisted her assistance in orchestrating his public image. The hand of the charismatic orator, which we might think of as accompanying rhetorical flourishes, here also suggests this flair for self-construction. "What I learned was not technique," Arnold once reflected. "If the photographer cares about the people before the lens and is compassionate, much is given. It is the photographer, not the camera that is the instrument." —MM

SUGGESTED READINGS
Arnold, Eve. *Eve Arnold, in Retrospect*. New York: Knopf, 1995.
Magna Brava: Magnum's Women Photographers. Edinburgh: National Galleries of Scotland, 1999.

Richard Avedon
b. 1923, New York

Richard Avedon began photographing professionally in 1944 after leaving the Merchant Marine, where he served in the photography department. His military work led to a position at *Harper's Bazaar*, which he kept until the mid-1960s. Though Avedon initially made a name for himself in fashion photography, he is most famous for his portraiture. In his signature style, he places subjects before a blank white background and photographs them at close range—a stark aesthetic that refuses idealization and uses the sitters' self-consciousness to reveal their inner selves. His oeuvre also includes an early body of street photography, which displays much of the psychological and compositional complexity he would later bring to fashion and portrait photography.

Palermo, Sicily, September 3, 1947, 1947 (printed 1994). Gelatin-silver print, edition 2/6, 20 x 16 inches (50.8 x 40.6 cm)

The pictures taken by Avedon in Palermo in 1947 are some of the best examples of his early street photography. In this image, the background almost totally disappears in the glaring Sicilian sunlight. A sign in the shape of a glove hangs by a cord from a balcony above, dangling off-center, its darkness contrasting with the building behind it. Decontextualized as it is, the sign feels like a real glove animated and controlled by a ghostly body. This tension between stasis and energetic movement pervades much of Avedon's work, and here lends meaning to an otherwise banal and inanimate object.

Joe Louis, Prize Fighter, New York City, 1963. Gelatin-silver print, edition 3/6, 20 x 16 inches (50.8 x 40.6 cm)

For his portrait of legendary boxer Joe Louis, Avedon departs from his usual full frontal pose to focus on a significant detail: Louis's fist. Still, as in many of his portraits, the photographer isolates that fist against a neutral background—here gray rather than white. The effect is a metaphorical substitute of the fist for the man. Here, Louis's identity equals his profession: With its shallow depth of field and tight framing, this photograph sums up a man who works with his hands as a blunt, monistic fist, and makes the subject present in a way that a conventional portrait could not. —NT

SUGGESTED READINGS
Avedon, Richard. *Portraits*. London: Thames and Hudson, 1976.
Livingston, Jane. *The New York School: Photographs 1936–1963*. New York: Stewart, Tabori & Chang, 1992.
Richard Avedon: Evidence 1944–1994. New York: Random House, 1994.

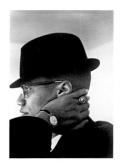

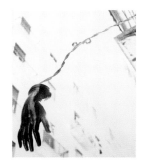

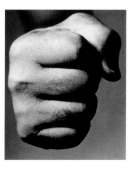

John Baldessari
b. 1931, National City, California

John Baldessari turned increasingly in the 1960s from landscape painting to found photographic imagery or casually made snapshots as readymade visual material. His goal was not so much to create art as to cause art to exist, and at the same time to prompt reflection on what makes the art object meaningful in an aesthetic or a phenomenal sense. From 1968 on, Baldessari moved among the twin communities that shared his interests: the loosely knit, international network of artists and galleries involved in the Conceptual art movement, and the art-school classroom. He has shown regularly since 1970 (including retrospectives in 1981, 1989, 1990, and 1996) and teaches in the studio art program at the University of California, Los Angeles.

Five Male Thoughts (One Frontal), 1990/1996. Photomontage, overall 25 x 78 inches (63.5 x 198.1 cm)

Hands and hand gestures have long been important to Baldessari, as evidenced in his *Commissioned Paintings* series of 1969, in which slides of a friend pointing at sundry objects were copied by hired portrait painters in oil on canvas. In his photomontages in particular, the ostensible legibility of body language is a key variable in a multilevel game that Baldessari plays with communication and meaning. The hackneyed poses in *Five Male Thoughts (One Frontal)*, which might aptly be called allegorical shorthand, provide a summary catalogue of various states of mind—from rumination, despair, and relative confidence to the sudden realization of a blunder. Apparently arbitrary aesthetic decisions, such as the use of color filters or variations in size, suggest additional nuances in decoding these "sound bites" of masculine behavioral conventions. —MSW

SUGGESTED READINGS
van Bruggen, Coosje. *John Baldessari*. Los Angeles: Museum of Contemporary Art; New York: Rizzoli, 1990.
Davies, Hugh M., and Andrea Hales, eds. *John Baldessari: National City*. San Diego: Museum of Contemporary Art, 1996.

Tracey Baran
b. 1975, Bath, New York

Tracey Baran emerged in the late 1990s with the wave of young female photographers that included Anna Gaskell, Justine Kurland, and Malerie Marder. Unlike her contemporaries, however, Baran creates autobiographical, even confessional, pictures. Rather than constructing fantastic tableaux, she has chosen to focus on herself and her family, sketching scenes filled with tension and unease. The photographs in her 1998 debut show examined the disordered life of her home in upstate New York. The 1999 series *Give and Take* infused a steely sexuality into her aesthetic. In *Still* (2001), her purview widened to encompass surreal scenes of her hometown. In these groups of photographs, Baran makes her presence felt whether she appears or not—a strategy that at once diffuses the judgment of her gaze and strengthens the emotional impact of her work.

Ivy, 2001. C-print, edition 2/5, 30 x 40 inches (76.2 x 101.6 cm)

In this photograph, a self-portrait, Baran reclines nude on a sumptuous red sofa, like a classical odalisque or André Kertész's *Satiric Dancer* (1926). Her hands, in particular, suggest her languor, one dangling from the edge of the sofa, the other stretched out above her head (and releasing the camera shutter). Indeed, Baran's hands echo those of the severely truncated figure in the painting above her, tying the image together gracefully. Her poison-ivy-splotched body, however, undermines these traditional signs of beauty and resists consumption as an aesthetic object. Baran's documentation of her rash thus becomes a gesture of defiance that aggressively reasserts her unidealized reality. —NT

SUGGESTED READINGS
Kostabi, Mark. "Mark Kostabi on Tracey Baran." *Shout* 5, no. 5 (May 2001), p. 11.
Schwabsky, Barry. "Tracey Baran: LiebmanMagnan." *Artforum* 38, no. 5 (Jan. 2000), p. 112.
———. "Tracey Baran: The Museum of Contemporary Photography, Chicago." *Art on Paper* 7, no. 5 (March 2003), p. 64.
Volk, Gregory. "Tracey Baran at LiebmanMagnan." *Art in America* 89, no. 11 (Nov. 2001), pp. 147–48.

Tina Barney
b. 1945, New York

Tina Barney was born into New York society, and it is this culture on which she has turned her camera for over twenty years. Barney discovered photography as a member of the Museum of Modern Art's Junior Council, through which she worked as a volunteer in the institution's photography department. She did not take up the medium herself, however, until moving to the relative isolation of an Idaho ski town in 1975, after which she began photographing her family during summers back east. By the early 1980s, she was enlarging her color prints to the grand dimensions of four by five feet. With these nearly life-size images, which hover between snapshot and staged production, Barney has captured the subtle anxieties running through her family and its milieu.

The Watch, 1985. C-print, edition 4/10, 48 x 60 inches (121.9 x 152.4 cm)

This image portrays two members of Barney's circle of friends and family; the man and woman are not identified in the title, as they are in many of her photographs. The subjects' blithe disregard for the camera typifies much of Barney's work, as does the moneyed setting. The two figures seem caught in the midst of their own introspective actions: Frozen in midspeech, the woman (Barney's sister) looks down at her gesticulating hands, while the man (Barney's nephew) glances at the eponymous watch. Between them, in the background, a painting by Pablo Picasso emblematizes the opulence of their surroundings; its prominently displayed hands also highlight the gestures below. —NT

SUGGESTED READINGS
Barney, Tina. *Friends and Relations: Photographs*. Washington, D.C.: Smithsonian Institution Press, 1991.
———. *Photographs: Theater of Manners*. Zurich: Scalo, 1997.

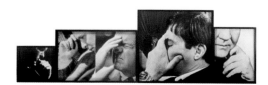

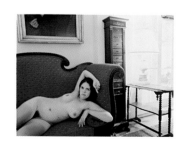

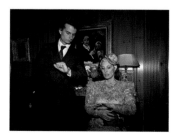

Herbert Bayer

b. 1900, Haag, Austria; d. 1985, Montecito, California

Herbert Bayer's experimentation with photography began during his tenure at the Bauhaus, where he often used others' photographs in his graphic design work. Upon leaving the Bauhaus in 1928, he made documentary photographs influenced by his colleague László Moholy-Nagy, but he found little to interest him in the technical aspects of straight photography. Rather than using the camera to document external reality, Bayer wanted to frame that reality within his subjective vision. After moving to Berlin in 1929, he began to focus on photomontage, a practice that allowed him to reconfigure photography's indexical bond to the world within his own highly personal, autonomous works of art.

The Lonely Metropolitan (Einsamer Großstädter), 1932. Gelatin-silver print photomontage with gouache and airbrush, 16 ⅛ x 11 ¾ inches (41 x 29.8 cm)

Bayer's photomontage borrows its visual vocabulary from Surrealism, particularly in its correlation of eyes and hands. Yet while the image flirts with the psychological—having been included in Bayer's series of *Dream Montages*—it also recounts its own construction. The photomontage assembles images as discrete yet fragmentary objects, arranged by the artist's hands and eye. How appropriate, then, that the hands floating against the Berlin apartment facade and the eyes airbrushed into their palms belong to Bayer himself. We can therefore read *The Lonely Metropolitan* as a self-portrait of an artist permeated by mechanical reproduction, and as alienated by it as he is liberated. —NT

SUGGESTED READINGS
Bach, Otto Carl. *Herbert Bayer: A Total Concept*. Denver: Denver Art Museum, 1973.
Bayer, Herbert. *Herbert Bayer*. Essay by Ludwig Grote. London: Marlborough Fine Art, 1968.
Cohen, Arthur A. *Herbert Bayer: The Complete Work*. Cambridge, Mass.: The MIT Press, 1984.

Hans Bellmer

b. 1902, Kattowitz, Germany (now Katowice, Poland); d. 1975, Paris

Hans Bellmer was perhaps the most extreme adherent of canonical Surrealism. In 1933, having practiced design and typography for a decade in the political crucible of interwar Berlin, Bellmer declared his refusal to do anything that could be of service to the state. He meant the Nazi Reich but also the coercions of society in general. That year Bellmer built his first "doll," with the help of his brother Fritz, and his photographs of this homemade plaything dismembered or in erotic contortions were published by the Surrealists the following year. Bellmer quickly found his way to Paris, and in 1938 he relocated permanently to France. Although his work was kept at the margins of exhibitions on Surrealism during the postwar decades, it now figures centrally in studies of that movement.

Untitled, 1934. Three gelatin-silver prints, each 2 ½ x 2 ½ inches (6.4 x 6.4 cm)

Sue Taylor explains that the choice of subject in these three photographs, unique to Bellmer's oeuvre, derives from a treatise on bodily awareness by psychoanalyst Paul Schilder. Schilder discussed an exercise wherein a person twists his or her arms and hands into a knot and can then no longer coordinate the movement of individual fingers by sight; only if someone else touches the fingers will they move as commanded. The subject is thus alienated from a part of his or her own body. As Taylor makes clear, Bellmer was obsessed with the relation of sight to touch and with the experience of the body as a sum of parts. This set of erotic or autoerotic images suggests an encounter with oneself as an other. —MSW

SUGGESTED READINGS
Foster, Hal. *Compulsive Beauty*. Cambridge, Mass.: The MIT Press, 1993.
Lichtenstein, Therese. *Behind Closed Doors: The Art of Hans Bellmer*. Berkeley: University of California Press; New York: International Center of Photography, 2001.
Taylor, Sue. *Hans Bellmer: The Anatomy of Anxiety*. Cambridge, Mass.: The MIT Press, 2000.

Mel Bochner

b. 1940, Pittsburgh

Mel Bochner studied painting in his hometown, at the Carnegie Institute of Technology, then undertook a peripatetic route through several cities and vocations (painting, philosophy, and art instruction) before settling in New York in 1964. A series of exhibitions in the late 1960s established him as a formative participant in Conceptual art, a loosely bounded tendency that privileged mental activity and questions of cognition over the production of tangible objects. Bochner is best known for a series of early 1970s installations in which spaces, shadows, or surfaces were marked out by a series of measurements in order to provoke viewers' awareness of the relation of linguistic and mathematical conventions to phenomenal experience.

Actual Size (Hand), 1968. Gelatin-silver print, 23 x 15 inches (58.4 x 38.1 cm)

Beginning in 1966, Bochner made several projects intended to cast doubt on the photograph as a repository of truthful information. For *Actual Size (Hand)*, a photograph of Bochner's hand and forearm measured against a foot-long line was printed at 1:1 scale, so that the image might be considered a literal record. Its indexical trace, however, has more in common with the twelve-inch measurement it depicts than with the artist's physical body. Bochner included a reproduction of a print of the negative for this photograph—an image several times removed from the "original"—in another piece, *Misunderstandings (A Theory of Photography)* (1970). Taken together with its companion piece, a similarly scaled photographic view of Bochner's head and back, *Actual Size (Hand)* forms a skeptical retort to El Lissitzky's self-portrait *The Constructor* (1924, p. 229), in which the creative faculties of head and arm are conjoined optimistically as tools to redesign the human universe. —MSW

SUGGESTED READINGS
Field, Richard S., et al. *Mel Bochner: Thought Made Visible 1966–1973*. New Haven: Yale University Art Gallery, 1995.
Rothkopf, Scott. *Mel Bochner Photographs, 1966–1969*. Essay by Elisabeth Sussman. New Haven: Yale University Press; Cambridge, Mass.: Harvard University Art Museums, 2002.

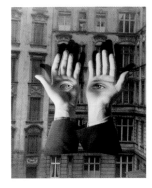

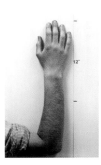

Margaret Bourke-White
b. 1904, New York; d. 1971, Darien, Connecticut

A pioneer in the emergent field of photojournalism in the 1930s, Margaret Bourke-White popularized the documentary photo-essay that formed the staple of the mass picture magazine. Bourke-White attended several universities throughout the United States before graduating from Cornell University in 1927. She began her professional career as an industrial photographer, taking pictures of the Otis Steel Company in Cleveland. Her work commanded the attention of Henry Luce, who hired her in 1929 as the first photographer at *Fortune* magazine and six years later as one of four members of the elite photographic staff of *Life*. In 1937, Bourke-White's and Erskine Caldwell's collaborative documentation of the lives of sharecroppers in the American South was published in the landmark book *You Have Seen Their Faces*.

Untitled (Hands Playing Violin and Cello), ca. 1940s. Gelatin-silver print, 6 ³/₄ x 4 ³/₄ inches (17.1 x 12.1 cm)

Following Bourke-White's predilection for broad and flat patterns, this image is organized around the linear intersections and superimposed planes of a violin and a cello. The cello's strings multiply the vertical tug of the violin's bow, while the slender strings of the violin find their echo in the horizontal movement of the cello bow. The hands that dominate the image enforce this play of rhyme and contrast. Each constructs a perpendicular extension, with the fingers of the hand at left sloped down on its clasped bow and the hand at right straining upward to reach the strings. Softly yet dramatically illuminated by multiple synchroflash, the musician's hands also emblematize the way the photographer's hand, unseen, intervenes—releasing the shutter or the flash to capture the desired expression or movement. —MM

SUGGESTED READINGS
Callahan, Sean, ed. *The Photographs of Margaret Bourke-White*. Greenwich, Conn.: New York Graphic Society, 1972.
Goldberg, Vicki. *Bourke-White*. New York: Harper and Row with the International Center of Photography, 1988.

Brassaï (Gyula Halász)
b. 1899, Brassó, Transylvania (now Brasov, Romania); d. 1984, Beaulieu-sur-Mer, France

Gyula Halász took up the pseudonym Brassaï in 1932, around the time that his first photographs, which showed the streets and clubs of Paris after dark, were exhibited. Brassaï's focus on the city, as well as his personal engagement in the Paris avant-garde scene, brought him to the heart of the Surrealist movement. Thus, some of his first published pictures appeared in the journal *Minotaure* and included disorienting images of everyday objects, graffiti, and female nudes. It was through the Surrealists, too, that Brassaï met Pablo Picasso, with whom he maintained a lifelong friendship. After World War II, Brassaï, who had been an expatriate in France since the age of twenty-five, became a respected memoirist of Paris in the 1930s, publishing several books on the era.

Cast of Picasso's Hand, ca. 1943 (printed ca. 1960). Gelatin-silver print, 4 ³/₄ x 6 ³/₄ inches (12.1 x 17.1 cm)

This photograph first appeared in Brassaï's 1964 memoir *Conversations with Picasso*. It was taken during the height of the German occupation of Paris, when Brassaï, having refused to apply for a Nazi license, had been forbidden to work as a photographer. In Brassaï's words, Picasso made this cast, "a closed fist at the end of a strong wrist, as if he wanted to seize all its concentrated power." Such power—the incarnation of the artist's romanticized genius—was what Brassaï sought to capture by depicting both Picasso's hand and his then little-known sculptural prowess. —NT

SUGGESTED READINGS
Brassaï. *The Artists of My Life*. Trans. Richard Miller. New York: The Viking Press, 1982.
———. *Conversations with Picasso*. Trans. Jane Marie Todd. 1964. Reprint, Chicago: The University of Chicago Press, 1999.
Picasso vu par Brassaï. Paris: Musée Picasso, 1987.
Sayag, Alain, and Annick Lionel-Maire, eds. *Brassaï: "No Ordinary Eyes."* London: Thames and Hudson, 2000.

Helen Pierce Breaker
b. ca. 1895; d. ca. 1939

An American salon photographer active during the 1920s and 1930s, Helen Pierce Breaker is best known for her portraits and nude studies. In the early 1920s, Breaker lived in St. Louis, Missouri, but she set up a studio in Paris toward the end of that decade. There she created a celebrated publicity photograph of Ernest Hemingway. Breaker exhibited at the international Pictorialist salons in Los Angeles in the mid-1920s and at the twenty-seventh Salon International d'Art Photographique de Paris in 1932. During that time, her work was also included in *The Little Review*, the influential modernist magazine of the arts that published the work of such avant-garde artists and writers as André Breton, Marcel Duchamp, T. S. Eliot, James Joyce, and Ezra Pound.

India Ramosay's Hand, 1935. Gelatin-silver print, 7 ⁷/₈ x 6 ¹/₄ inches (20 x 15.9 cm)

This enigmatic photograph centers on a dramatically illuminated upright hand, its palm turned diagonally toward the viewer, with middle finger and thumb looped together. The evocative treatment of light and atmosphere exemplifies the tonalist style of American Pictorialism, and the reference to the mudra hand gesture incorporates Buddhist iconography. Derived from the Sanskrit word for "seal" or "mystery," mudra designates a series of hand and finger postures that express and preserve the performer's inner state, which either represents an aspect of divine nature or embodies a given deity. This highly symbolic form of gestural communication also contributed to the development of specific movements in East Indian classical dance. The hand's position here may thus indicate the subject's occupation. —MM

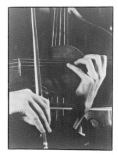

Anton Bruehl
b. 1900, Hawker, Australia; d. 1982, San Francisco

A protégé of the prominent Photo-Secessionist Clarence H. White, Anton Bruehl was celebrated in his time as one of the leaders of early magazine photography. Trained in electrical engineering at the Christian Brothers' School in Melbourne, Bruehl was already a skilled amateur portraitist when he emigrated to the United States in 1919. He settled in New York, and in 1925 embarked on a career as a professional photographer, creating the Weber and Weilbroner advertisements known as the Fabric Group, which featured geometric compositions of socks, scarves, ties, and fedoras. Bruehl regularly contributed celebrity portraits and editorial features to *Vogue*, *Vanity Fair*, and *House and Garden*, and it was with Condé Nast's support that he pioneered the use of color. Increasingly identified with commercial color photography, Bruehl was also acclaimed within the realm of fine art photography, especially for his 1933 monograph *Mexico*.

Threading the Needle, 1929. Gelatin-silver print, 20 x 16 inches (50.8 x 40.6 cm)

This photograph appeared in an advertisement for Town Series Suits posted in the June 15, 1929 issue of *The New Yorker*. The image offered a visual icon of the tailor's deference to the "thousands of New Yorkers who insist that only ten fingers working with needle and thread can produce a subtly curving shoulder line, a properly accented waist or a lapel with the right degree of roll." Elegantly illuminated, the photograph renders a pair of hands with fingers delicately poised to insert the slender filament of thread, which arcs from the lower-right corner into the eye of an upright needle. The subtle, atmospheric composition, tonality, and mood reflect the precepts of Pictorialist photography. However, the photograph's subject appears needle sharp, paradoxically aligning the objective precision of straight photography with the ad's promotion of hand tailoring in the age of the machine. —MM

SUGGESTED READINGS
Anton Bruehl. New York: Howard Greenberg Gallery, 1998.
Yochelson, Bonnie. *Pictorialism into Modernism: The Clarence H. White School of Photography*. New York: Rizzoli, 1996.

Larry Burrows
b. 1926, London; d. 1971, Ban Alang, Laos

In 1942, at the age of sixteen, Larry Burrows began working for *Life* magazine. By the end of World War II, he was receiving full-fledged assignments, mostly photographing personalities like Winston Churchill and Ernest Hemingway. His life's work, however, focused on wars and conflicts in places far from his native England. In the late 1950s, he covered the Congo uprising and the Anglo-French invasion of Egypt, among other events, taking not just battlefield photographs but humanistic images conveying the tolls of war. Burrows began photographing the Vietnam conflict in the early 1960s; in 1971, a helicopter carrying him and three other photojournalists was shot down in Laos. His body was never recovered.

Reaching Out, Battle of Hill 484, South Vietnam, 1966 (printed 1993). Dye-transfer print, 15 x 22 ½ inches (38.1 x 57.2 cm)

As an Englishman documenting an American war, Burrows avoided outright patriotism and absolute cynicism or protest in his Vietnam photojournalism. Instead, he concentrated on the sadness and suffering that the war brought to all sides. This photograph is perhaps the greatest example of his humanism under fire, conveying the hellish disorder and pain of the battlefield. At its center—both compositional and moral—one wounded soldier extends his hand to another, either in grief or assistance. Burrows encapsulates war's intersection of tragedy and hope in a simple communicative gesture whose ambiguity symbolizes the world's uncertainties about Vietnam. —NT

SUGGESTED READINGS
The Editors of *Life*. *Larry Burrows: Compassionate Photographer*. New York: Time-Life Books, 1972.
Faas, Horst, and Tim Page, eds. *Requiem: By the Photographers Who Died in Vietnam and Indochina*. London: Jonathan Cape, 1997.
Frizot, Michel. *A New History of Photography*. Cologne: Könemann, 1998.

Claude Cahun (Lucy Renée Mathilde Schwob)
b. 1894, Nantes, France; d. 1954, Saint-Hélier, Jersey, English Channel Islands

At the age of twenty-three, Lucy Schwob, who was born into a family of well-known publishers and writers, took on the pseudonym Claude Cahun. In doing so she not only established an independent artistic identity but, given her new name's androgyny, challenged gender norms. Cahun spent her life as a writer and an artist, publishing a book of prose poetry and photomontage entitled *Aveux non avenus* in 1930 and associating with the Surrealists, in several of whose exhibitions she participated. An avowed leftist, she helped found the Contre-Attaque group with André Breton and Georges Bataille in 1934 and wrote against Fascism throughout the war years. Her many photographic self-portraits, for which she is best known today, were most likely personal objects, never exhibited during her lifetime.

Self-Portrait ("I Am in Training Don't Kiss Me"), ca. 1927. Gelatin-silver print, 4 ⅛ x 3 inches (10.5 x 7.6 cm)

In this image, as in many others, Cahun sports a boyishly short haircut, thick makeup, and an elaborate outfit complete with a barbell prop—all signs, like her pseudonym, of her dedication to playing with her identity. She has placed herself on a stage, thematizing both her self-display and her lifelong interest in theater. Leaning against the curtained backdrop, with one hand spread out, Cahun emphasizes the masquerade that for her signifies her identity. The words "I am in training, don't kiss me," written on the front of her costume, suggest that she is not yet fully formed; they also echo the sensuality of the curtains' texture and of Cahun's baby-doll lips. —NT

SUGGESTED READINGS
Claude Cahun photographe. Paris: Musée d'Art Moderne de la Ville de Paris, 1995.
Leperlier, François. *Claude Cahun: L'écart et la métamorphose*. Paris: Jean-Michel Place, 1992.
Monahan, Laurie J. "Radical Transformations: Claude Cahun and the Masquerade of Womanliness." In M. Catherine de Zegher, ed. *Inside the Visible: An Elliptical Traverse of 20th Century Art*. Cambridge, Mass.: The MIT Press, 1996.

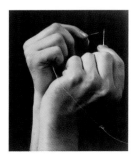

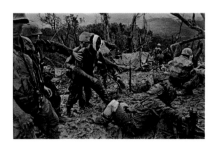

Julia Margaret Cameron
b. 1815, Calcutta; d. 1879, Kalutara, Ceylon
(now Sri Lanka)

The daughter of a prominent colonial family, Julia
Prattle married a founding member of the Supreme
Council of India. In 1846, the two left for England
with their four (later five) children. At age forty-eight,
Cameron turned to photography as an artistic pastime
that might also balance dwindling revenues from her
husband's estates in Ceylon. She joined two prestigious
British photographic societies within months of making
her first print, in early 1864, and sold her works at
exhibitions in London beginning the next year. Posing
family acquaintances, relatives, and above all her maid,
Mary Hillier, Cameron staged scenes from classical
mythology and old master painting in emulation of
contemporary fine art. Her most ambitious and costly
project was the illustration of an edition of *Idylls of the
King*, the suite of Arthurian poems by Alfred Tennyson,
with whom Cameron shared a deep Christian longing
and a despondency over the state of modern civilization.

Vivien and Merlin, 1874. Albumen print, 12 $^3/_4$ x
10 $^3/_4$ inches (32.4 x 27.3 cm)

This is the second of two images of the enchantress
Vivien, who has lured Merlin into relinquishing a
charm, which she is now using to imprison him in a
tree. She dominates the defeated magician with an
upraised arm, rendered the more commanding in
contrast to his own arms, which hang low at his side.
If this scene of amour betrayed by evil appears less
than utterly horrible, it is partly because Cameron's
husband, Charles, who posed as Merlin, could barely
restrain his laughter during shooting. —MSW

SUGGESTED READINGS
Cox, Julian, Colin Ford, et al. *Julia Margaret Cameron:
 The Complete Photographs*. Los Angeles: Getty
 Publications, 2003.
Lukitsch, Joanne. *Julia Margaret Cameron*. London:
 Phaidon Press, 2001.
Oliphant, Dave, ed. *Gendered Territory: Photographs
 of Women by Julia Margaret Cameron*. Austin:
 University of Texas Press, 1996.
Wolf, Sylvia. *Julia Margaret Cameron's Women*. Chicago:
 The Art Institute of Chicago; New Haven: Yale
 University Press, 1998.

Robert Capa (Endre Friedman)
b. 1913, Budapest; d. 1954, Hanoi

Robert Capa arrived in Berlin at age eighteen, exiled
from his native Hungary for leftist activism. He took a
job with the Dephot news agency and soon convinced
its director, Simon Guttmann, to make him a field
photographer, despite his lack of prior experience.
Guttmann sent him to cover the Spanish Civil War in
1935, and Capa made his reputation there by memori-
alizing a partisan fighter at the instant he was struck
by an enemy bullet. In 1936, Capa invented the name
by which he is now known and the character of an
American photojournalist to go with it; he made this
fictional identity a reality in 1939, when he took a job
with *Life* magazine. In 1947, Capa, along with Henri
Cartier-Bresson and others, founded the Magnum
Photos collective for photojournalists. In the early
1950s, Capa presided over the agency's rapid success.
Capa died after stepping on a land mine while on
assignment to cover the French retreat in Vietnam.

*Leon Trotsky Lecturing Danish Students on the History
of the Russian Revolution, Copenhagen, Denmark,
November 27, 1932*, 1932 (printed 1960s). Gelatin-
silver print, 8 $^3/_4$ x 13 $^1/_2$ inches (22.2 x 34.3 cm)

This image was published in Capa's first news story.
The passion of the speaker overwhelms his visibility,
with grasping hands that seem to claw at the air
around his face. Blotchy discolorations—the visual
equivalent of static during a radio address—further
heighten the tone. Capa chose this image deliberately,
favoring it over other negatives from the same roll
with a more even exposure that show Trotsky's face
fully and his right hand in a tightly controlled fist.
—MSW

SUGGESTED READINGS
Capa, Cornell, and Richard Whelan, eds. *Robert Capa:
 Photographs*. New York: Knopf, 1985.
Capa, Robert. *Robert Capa: Photographs*. Foreword by
 Henri Cartier-Bresson. New York: Aperture, 1996.
Kershaw, Alex. *Blood and Champagne: The Life and
 Times of Robert Capa*. New York: St. Martin's Press,
 2003.

Henri Cartier-Bresson
b. 1908, Chanteloup, France

Born into an affluent mercantile family, Henri
Cartier-Bresson turned his back on business and the
bourgeoisie. He studied painting in the 1920s and
spent years on the fringes of the nascent Surrealist
movement. Somewhat interested in photography
by 1930, Cartier-Bresson turned to this medium
full-time in 1932 after purchasing a Leica, the rapid-
focus portable camera that revolutionized street
photography and photojournalism. Long stays in Spain,
Mexico, and New York followed, during which he made
his images and his life among the down-and-out. He
spent three years at hard labor in a German prisoner-
of-war camp, in 1939–42, then entered the French
resistance; for many years after World War II he con-
centrated on socially committed reportage. Widely
traveled, Cartier-Bresson has cultivated broad creative
interests for seventy years, while retaining photography
as his primary medium of expression.

The Visit of Cardinal Pacelli, Montmartre, 1938
(printed 1940s). Gelatin-silver print, 6 $^1/_2$ x 9 $^3/_4$ inches
(16.5 x 24.8 cm)

Cartier-Bresson took this shot as a staff photographer
for the leftist current events magazine *Ce soir*, where
he worked with his friends and Magnum Photos
cofounders Robert Capa and David Seymour (Chim).
Cartier-Bresson was often asked to use a heavy view
camera fitted with large glass negatives instead of his
compact Leica, because the glass plates were easier to
retouch before printing than thirty-five millimeter roll
film. Cartier-Bresson captured this intricate crowd
scene, dense with the faces of devout supplicants and
anxious officials surging around the future Pope
Pius XII, by holding the cumbersome equipment aloft
and releasing the shutter "blind." —MSW

SUGGESTED READINGS
Cartier-Bresson, Henri. *A Propos de Paris*. Texts by
 Vera Feyder and André Pieyre de Mandiargues.
 Boston: Bulfinch Press, 1994.
Galassi, Peter. *Henri Cartier-Bresson: The Early Work*.
 New York: The Museum of Modern Art, 1987.

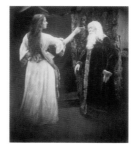

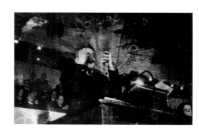

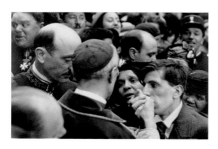

Maurizio Cattelan
b. 1960, Padua, Italy

"I am not an artist," Maurizio Cattelan once declared, "I am a project-maker, a situation maker." Since the late 1980s, the artist has devised sculptural jokes and theatrical tableaux and performances that disrupt the operations of the institutional spaces they inhabit, releasing a narrative that the viewer must complete. Merging the roles of clown and saboteur, Cattelan mines the rich Italian tradition of the commedia dell'arte, while extending the institutional critique of art initiated by Marcel Duchamp and developed more recently by artists like Hans Haacke and Louise Lawler. A tragicomic sensibility infuses Cattelan's provocations, undermining figures and symbols of authority and elaborating thematics of absurdity and failure.

Black Star, 1996. Gelatin-silver print, edition 2/3, 40 ¼ x 60 ¼ inches (102.2 x 153 cm)

This image captures five splayed hands, each with middle and index finger outstretched to delineate the outline of a star against a black background. Shot in the artist's studio, the photograph was made during a period when Cattelan often alluded to Italian politics in his work. The picture's iconic star bears comparison with the emblem of the Red Brigade, an extreme left terrorist group formed in 1969. But the star simultaneously reproduces the idea of photography as a process of drawing with "the pencil of light." Layering political allusion and aesthetic self-reference, Cattelan's image elliptically associates art with terrorist transgression.

Mother, 1999. Gelatin-silver print, edition 10/10, 45 ½ x 40 ¾ inches (115.6 x 103.5 cm)

Mother presents a photographic record of a theatrical tableau created by the artist for the 1999 Venice Biennale, for which he employed a fakir to bury himself in the sand. Only his hands, clasped in prayer, are exposed to view. The absence of the body is balanced by the presence of a synecdoche, the hands. Their curious posture of worship—or is it supplication?—is emblematic of the devotion we associate with motherhood. The hands also allegorize the artist's desire for the viewer's adulation, even as they parody that yearning. —MM

SUGGESTED READINGS
Spector, Nancy, Francesco Bonami, and Barbara Vanderlinden. *Maurizio Cattelan*. London: Phaidon Press, 2000.
Zahm, Olivier. "Openings: Maurizio Cattelan." *Artforum* 33, no. 10 (summer 1995), pp. 98–99.

Sarah Charlesworth
b. 1947, East Orange, New Jersey

Throughout the 1980s, Sarah Charlesworth was identified with artists such as Barbara Kruger, Sherrie Levine, Richard Prince, Cindy Sherman, and Laurie Simmons, whose deconstructive analyses of cultural signs signaled the advent of postmodern photography. Charlesworth was deeply influenced by the critique of representation variously articulated by Conceptual art and the theories of subjectivity that increasingly reshaped that legacy. A 1969 graduate of Barnard College, she founded *The Fox* magazine with Joseph Kosuth in 1974 and contributed to the pioneering feminist art publication *Heresies*. In 1977, Charlesworth began the photo-based serial *Modern History*, for which she photocopied the front pages of newspapers and blocked out all the text, leaving only the masthead, photographs, and layout. This abstracted sequence of images reframed the news, questioning its construction of information.

Trial by Fire, 1993. Laminated Cibachrome, edition 4/6, 36 x 28 inches (91.4 x 71.1 cm)

In 1992, Charlesworth turned away from the strategy of appropriation to create her own photographs. This Cibachrome picture is drawn from the series *Natural Magic* (1992–94), which uses photography as medium and subject to explore the image's much vaunted transparency to the real. Suspended in the lower center of an oval black ground, two white gloves spontaneously emit flames, as if performing a magic trick. This picture likens photography to a form of charlatanry and conjures the artifice that has always surrounded the medium—from the mysterious chemistry associated with its nineteenth-century beginnings to the mass media simulations of its twentieth-century incarnations. —MM

SUGGESTED READINGS
Charlesworth, Sarah. *Sarah Charlesworth: A Retrospective*. Santa Fe: SITE Santa Fe, 1998.
Linker, Kate. "Sarah Charlesworth: Artifacts of Artifice." *Art in America* 86, no. 7 (July 1998), pp. 74–79, 106.

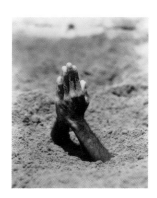

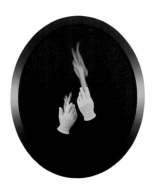

Larry Clark
b. 1943, Tulsa, Oklahoma

In the 1990s, Larry Clark came into his own as a filmmaker, with the pseudo-documentary *Kids* (1995) and *Another Day in Paradise* (1998). He has said that he thought of his earlier projects as films even though they appeared as still photographs. Clark learned photography from his mother, who went door-to-door making portraits of babies, and he found his initial subjects equally close to home. Outtakes from the drug- and sex-filled lives of his hometown buddies formed a loose narrative in his first book, *Tulsa* (1971). For his second publication, *Teenage Lust* (1983), Clark enlisted the participation of the next generation, and he has continued since then to keep his focus on the behavior of teenagers.

Untitled, 1972 (printed 1990). Gelatin-silver print, edition 25/25, 8 ¼ x 12 ½ inches (21 x 31.8 cm)

This image from *Teenage Lust* typifies the candid impropriety of Clark's approach to image-making, which has influenced a generation of artists who use the camera to document their personal lives (the most famous of whom is Nan Goldin). While the faces of the teenagers in this photograph seem to meet with the nervousness of a first kiss, their hands take full possession of each other's bodies, particularly the girl's as it wraps around her partner's erection. With its sunlit, car-seat setting, the scene seems allegorical rather than documentary, and it reminds us that where sex is concerned every depiction is an ideal. —MSW

SUGGESTED READINGS
Clark, Larry. *Teenage Lust*. New York: Larry Clark, 1983.
Kelley, Mike. "Larry Clark: In Youth Is Pleasure." *Flash Art*, no. 164 (May–June 1992), pp. 82–86.
Larry Clark. Groningen: Groninger Museum, 1999.

Chuck Close
b. 1940, Monroe, Washington

For over four decades, Chuck Close has renovated the genre of portraiture, adapting the model of photography to the format and motifs of painting. After graduating magna cum laude from the University of Washington in 1962, Close went on to study at Yale University's School of Art and Architecture, receiving his B.F.A. in 1963 and his M.F.A. in 1964. In the mid-1960s, Close turned away from the virtuoso gestures of Abstract Expressionism and, influenced by the antisubjectivism and process of Minimalism, began to use photography as the matrix for his monumental, iconic portraits. For these early photorealist works, the artist began by overlaying a grid onto a black-and-white Polaroid. He then transposed the details of the sitter's head onto a large canvas using acrylic paint and airbrush. Reconstituting the dots of mechanical printing into pictorial image, these portraits refute both the individuality of the painterly mark and the veracity of the photographic document.

Mark Morrisroe, 1984. Two Polaroid prints, each 80 x 40 inches (203.2 x 101.6 cm)

In 1984, Close employed a forty-by-eighty-inch Polaroid camera to create nude studies devoted primarily to dance professionals in the Boston area. This photograph, derived from that collection, takes as its subject Mark Morrisroe, the "Boston School" photographer known for his diaristic self-representations. Split along a vertical axis, the portrait delivers a frontal, close-up view of the genitals of the standing artist. Artfully lit and slightly misaligned, its explicit depiction of the artist's sexuality is also concerned with doubling—the splayed hands that dominate the image emblematize the medium's duplicating operations. Here, repetition yields difference—between the two prints, the two sides of the body—thematizing the unstable nature of identity. —MM

SUGGESTED READINGS
Lyons, Lisa, and Robert Storr. *Chuck Close*. New York: Rizzoli, 1987.
Storr, Robert. *Chuck Close*. New York: The Museum of Modern Art, 1998.

Charles M. Conlon
b. Albany, New York, 1868; d. Troy, New York, 1945

Widely regarded as the greatest baseball photographer of all time, Charles Conlon worked by day as a newspaper proofreader, taking pictures in his spare time and printing them in his home darkroom. He made his first official photographs in 1904, and within two years was carrying his camera and glass-plate negatives onto the field to capture the players in the course of games. Conlon so excelled at this brand of action photography that by the early 1920s his images dominated all the national baseball magazines and cards, though almost always without credit. He continued to document baseball into his seventies, finally retiring just a few years before his death.

Eddie Cicotte, ca. 1913. Gelatin-silver print, 6 ⅞ x 5 ¼ inches (17.5 x 13.3 cm)

Though best known for portraiture and fieldside action shots, Conlon also produced studies of particular baseball moves. Here, Eddie Cicotte demonstrates the knuckleball, which he invented in 1906. The knuckleball got its name not because the ball touched the knuckles, but because the knuckles were raised away from the ball during the pitch. Conlon's photograph dwells on the manual contortions in which Cicotte, a star pitcher, excelled. Cicotte is best remembered today for conspiring with six other White Sox players to throw the 1919 World Series, an offense for which he was banned from the game for life. —NT

SUGGESTED READINGS
Buckley, James, Jr., and Jim Gigliotti. *Baseball: A Celebration!* New York: DK, 2001.
Honig, Donald. *Baseball: The Illustrated History of America's Game*. New York: Crown Publishers, 1990.
McCabe, Neal, and Constance McCabe. *Baseball's Golden Age: The Photographs of Charles M. Conlon*. New York: Harry N. Abrams, 1993.

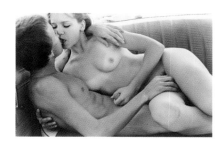

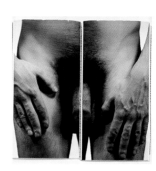

John Coplans
b. 1920, London; d. 2003, New York

Following multiple careers as a painter, editor, critic, and museum director, John Coplans returned at the age of sixty to the production of art. Resident in the United States since 1960, Coplans worked over the following two decades as editor in chief of *Artforum*, which he cofounded in 1962, and as a museum director (of the Art Gallery of the University of California at Irvine, the Pasadena Art Museum, and the Akron Art Museum). In 1981, he returned to New York, where he began to create photographs of couples; three years later he arrived at his ongoing project of nude *Self-Portraits*. These monumental black-and-white pictures display detailed views of the artist's aging body parts, informed by his earlier painterly articulations of frontality, scale, and edge, as well as by feminist critiques of the body and gender.

Self-Portrait, 1986, Gelatin-silver print, 41 x 39 inches (104.1 x 99.1 cm)

Coplans's weighty, unflinchingly graphic photographs depict the flaws of a vulnerable male body, reversing customary expectations of the idealized nude and the potent male. This image belongs to the artist's early experimental representations of his hands. It isolates and magnifies one hand against a solid-white background, the fingers folded at the knuckles, the wrinkled skin crinkling into flabby folds just above the wrist. If such intimate minutiae coalesce into a generalized landscape, that topography also summons associations to the human face—the loose creases of flesh recall the form of a smiling mouth—the part of the body that has traditionally defined the self-portrait. For the artist, such metonymies encode "a personal sign language of a nonverbal confessional." —MM

SUGGESTED READINGS
A Body: John Coplans. New York: Powerhouse Books, 2000.
Coplans, John. *Provocations: Writings by John Coplans*. London: London Projects, 1966.

Jules Courtier
active 1894–1927, Paris

Jules Courtier, general secretary of the Institut Général Psychologique in Paris in the early part of the twentieth century, is known for his parapsychological experiments with the medium Eusapia Palladino. During séances, the authenticity of Palladino's psychic abilities was questioned; scientists like Courtier hoped that the objectivity of the photograph could provide certifiable evidence of psychic phenomena. Photographs also "proved" the presence of auras and especially of spirits, who exposed themselves onto film but remained invisible to the eye. Palladino herself was best known for acts of psychokinesis, in which the unassisted movements of objects were recorded by the camera.

Cast Hands of Eusapia Palladino, 1908. Two gelatin-silver prints, each 4 ½ x 7 inches (11.4 x 17.8 cm)

The most common of Palladino's numerous psychic phenomena included levitations of the séance table, movements of curtains or the medium's dress, and raps or bangs on the table's surface—all essentially manual acts. Thus reports of her séances repeatedly note the location of her hands during the occurrence of each phenomenon. These images, however, pertain to the alleged ability of many psychics, including Palladino, to materialize the hands of spirits in bowls of hot wax, from which observing scientists could make casts. The impressions shown here were formed from both Palladino's hands and the hands of spirits contacted during a séance, and were used by Courtier and his colleagues as a basis of comparison in examining the medium's paraphenomena. —NT

SUGGESTED READINGS
Carrington, Hereward. *Eusapia Palladino and Her Phenomena*. New York: b. W. Dodge & Company, 1909.
Courtier, Jules. "Rapport sur les séances d'Eusapia Palladino à l'Institut général psychologique." *Bulletin de l'Institut général psychologique* (Paris) nos. 5 and 6 (1908).
Fielding, Everard. *Sittings with Eusapia Palladino and Other Studies*. New Hyde Park, New York: University Books, 1963.

Gregory Crewdson
b. 1962, New York

Growing up in Brooklyn, Gregory Crewdson was always fascinated by suburbia's single-family homes and discrete yards. When he began photographing in the late 1980s while pursuing his master's degree at Yale University, he turned to this American archetype as his subject, staging family tableaux not of friends but of strangers. Crewdson maintains this depersonalized, fictional mood in all his work, constructing elaborate sets for each image and keeping narrative just out of reach, like a repressed trauma. Along with Cindy Sherman and others, Crewdson contributed to the resurgence of the tableau photograph in the 1990s. But the particular air of the uncanny that he develops in his highly produced scenes of horrific and strange rituals sets Crewdson's art apart.

Untitled, 1995. C-print, edition 3/6, 40 x 50 inches (101.6 x 127 cm)

In this photograph, from the *Natural Wonder* series, the audience seems to assume the viewpoint of a forest creature, like the stuffed bird in the upper-right corner. A corpse—or, even more horribly, a part of a corpse—looms in the foreground, yet to be discovered by the absent denizens of the houses in the distance. The central position of the hand, with its curled yet motionless fingers, insists on the natural decay that awaits us all. Death takes the form of nature itself, literally surrounding the signs of civilization in the picture, waiting to take over. —NT

SUGGESTED READINGS
Crewdson, Gregory. *Dream of Life*. Essay by Darcey Steinke. Salamanca: Ediciones Universidad de Salamanca, 1999.
———. *Twilight*. Essay by Rick Moody. New York: Harry N. Abrams, 2002.
Schorr, Collier. "Close Encounters." *Frieze*, no. 21 (March–April 1995), pp. 44–47.

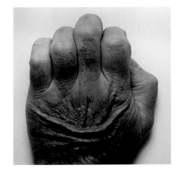

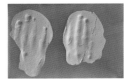 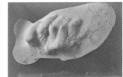

Imogen Cunningham
b. 1883, Portland, Oregon; d. 1976, San Francisco

A highly determined woman, Imogen Cunningham made her career in photography against the odds of her background and upbringing. After earning a degree in chemistry at the University of Washington in 1907, she trained in the Seattle portrait studio of Edward Curtis and studied further in Dresden, then a great center for photographic craft and industry. Cunningham exhibited regularly from the early 1910s in amateur salons and regional art museums. Except for several years as a homemaker, she maintained a portrait studio most of the time after 1910. She is remembered in the company of Edward Weston and Ansel Adams as a participant in f/64, the 1930s photography group that advocated "clean," unmanipulated imagery—yet she also tested photographic special effects throughout her career.

Martha Graham, Dancer, 1931. Gelatin-silver print, 7 1/4 x 9 3/4 inches (18.4 x 24.8 cm)

This photograph, published in *Vanity Fair* in December 1931, marked Cunningham's first appearance in that prestigious magazine. A recent but close acquaintance, Graham had agreed to pose for what became an all-day session unconnected with any performance. Cunningham concentrated repeatedly on the dancer's hands, which were fundamental to conveying the primal, searching emotions that Graham sought to express onstage. Cunningham photographed hands often, and *Vanity Fair* treated the theme as well—an illustrated feature on "Hands That Rule the World of Art" had appeared the previous May. This particular image may have been shown at the M. H. de Young Memorial Museum, San Francisco, in a 1932 survey of hands in art and photography, a precursor to the present exhibition, which met with great praise: "Hands! Hands! Hands! Coarse hands, efficient hands, creative hands . . . reach out to attract you . . . [to] one of the most engaging exhibitions that has ever been offered."

Hands and Aloe Plicatilis, 1960. Gelatin-silver print, 7 3/4 x 7 inches (19.7 x 17.8 cm)

Cunningham is best known for tightly cropped, semi-abstract studies of two subjects: human bodies and plants. In this work, she superimposed negatives of her two preeminent themes to make what is known as a "sandwich montage." The notion of suggesting an identity between two apparently disparate phenomena has a long history in photography and modern art, ranging from the Symbolist-inspired *Equivalents* of Alfred Stieglitz and Minor White to Surrealist practices before and after World War II. This montage by Cunningham proposes with innocent delight that our hands possess a potential for autonomous generation—indeed that our fingers might take root outside our body. —MSW

SUGGESTED READINGS
Lorenz, Richard. *Imogen Cunningham: On the Body*. Boston: Bulfinch Press, 1998.
Rule, Amy, ed. *Imogen Cunningham: Selected Texts and Bibliography*. Boston: G. K. Hall, 1992.

Bruce Davidson
b. 1933, Oak Park, Illinois

Throughout his troubled teenage years, Bruce Davidson explored his native Chicago with his camera, taking pictures of down-and-out subjects that resonated with his own disconsolate youth. On the strength of these images he was accepted to the Rochester Institute of Technology, from which he graduated in 1954. Going on to Yale University, Davidson created his first photo-essay for *Life* later that year, a behind-the-scenes view of the university football team. The essay became his preferred form; Davidson's first major body of work, on a Brooklyn street gang, was completed in 1959, the year he joined Magnum Photos. Later projects include studies of the civil rights movement in the 1960s, life on East 100th Street in New York's Spanish Harlem, the New York subway system, and Central Park.

Three Men in Garden Cafeteria, New York City, 1976. Gelatin-silver print, 20 x 24 inches (50.8 x 61 cm)

In 1976, Davidson took on a freelance assignment about New York's Garden Cafeteria on East Broadway. Though less expansive than many of his more famous essays, this project bears Davidson's hallmarks. An in-depth, up-close look at a waning subculture of the city, it focuses as much on individual emotion as sociological survey. In this photograph, three elderly men sit at separate tables, each wearing a suit, tie, and hat, an outfit that in 1976 must have already felt like a relic of a bygone era. Each of them raises a hand to his mouth, as if lost in thought; each stares through similar black-rimmed glasses, but in a different direction. These men seem adrift and alone yet almost unconsciously bound together; they are already a part of the city's history that, like the cafeteria in which they sit, will soon disappear. —NT

SUGGESTED READINGS
Davidson, Bruce. *Bruce Davidson*. New York: Pantheon Books, 1986.
Davidson, Bruce, and Henry Geldzahler. *Bruce Davidson Photographs*. New York: Agrinde Publications and Summit Books, 1978.
Vanderbilt, Tom. "The Picture Man." *The New York Times*, Jan. 19, 2003, sec. 14, p. 1.

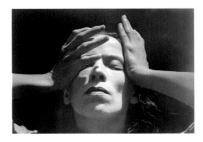

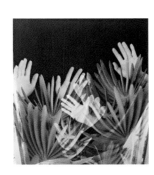

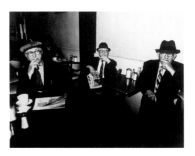

Rineke Dijkstra
b. 1959, Sittard, the Netherlands

First exhibited in 1992, Rineke Dijkstra's photographs coordinate documentary observation with intimate psychological description. The Dutch-born artist studied at the Gerrit Rietveld Academie in Amsterdam, then worked as a freelance photographer for magazines such as *Elle* and *Avenue*. Dijkstra achieved international acclaim with the exhibition of her *Strandportretten* series (1992–94). Shot with flash lighting, these large-format color photographs posed preadolescent bathers against nondescript seascapes. Distinguished by their rigorous clarity and artificial character, these portraits frame the off-register moment, bracketing slight bodily gestures and facial expressions of unease and vulnerability. Dijkstra continued to probe such moments in subsequent series that seem to carry August Sander's detached typological comparisons into the uncanny "gap between intention and effect" cultivated by Diane Arbus.

Tecla, Amsterdam, the Netherlands, May 16, 1994, 1994. C-print, edition 4/6, 60 ¼ x 50 ¾ inches (153 x 129 cm)

In 1994, Dijkstra initiated the series *New Mothers*, which portray Dutch mothers with their babies immediately after delivery. This full-length nude study isolates the standing figure of Tecla, centered and frontally posed before a plain, white wall. Its austere setting heightens various marks of physical exertion—the "linea nigra" that scores her distended stomach; the placental blood that trickles down her leg; the rosy glow that flushes her cheeks; her left shoulder raised awkwardly to balance the red infant swaddled in her arms. But it is above all the young mother's hands—gently clasping the ruddy newborn to her breast—that puncture the sterility of this rigorously classical composition, drawing a parallel between maternal vulnerability and infantile helplessness. —MM

SUGGESTED READINGS
Rineke Dijkstra: Beaches. Zurich: Codax Publisher, 1996.
Rineke Dijkstra: Portraits. Boston: Institute of Contemporary Art, 2001.

André Adolphe-Eugène Disdéri
b. 1819, Paris; d. 1890, Paris

In the history of photography, André Adolphe-Eugène Disdéri is renowned for his production and marketing of the third application of the collodion technique, whereby a glass plate was coated with guncotton dissolved in ether and alcohol and exposed in the camera while still wet. He began his career as a daguerreotypist in Brest. Disdéri settled in Paris in the early 1850s, and in 1854 received a patent for the *carte-de-visite* that rendered the daguerreotype obsolete. Employing a camera equipped with four lenses and a movable plate-holder, he generated a wet-plate negative that could expose up to eight different images. The resulting positive paper print was then split into individual portraits, each glued to a calling-card-sized mounting board, measuring approximately four by two and a half inches. Labor-efficient and inexpensive, Disdéri's system of mass-produced portraiture simultaneously signaled the onset of photography's industrialization and commercialization, and was an index of the Second Empire's cult of speed and progress.

Comte de Stroganoff, ca. 1860. Albumen print, 7 ½ x 9 inches (19.1 x 22.9 cm)

In 1861, Disdéri was appointed official photographer to the imperial courts of England, France, Russia, and Spain. The subject of this image is Count Stroganoff, whose family had long been legendary for their patronage of the arts. Comprised of a sequential arrangement of eight portraits, stacked in two rows, this print shows the standing figure of the count—from the front and in profile—variously posed against a virtual space. Each gesture is distinguished by the position of his hands—soberly hung at his sides or clasped behind his back, discreetly tucked into his pockets or inside his lapel. But these compositions reveal little about the Count's personality. For while its rapid exposure time made Disdéri's technique economical—opening studio portraiture to the middle classes and rendering images of the aristocratic or upper classes available for collection—the democratization of the medium also depleted its potential to render each sitter's individual identity. —MM

SUGGESTED READING
McCauley, Elizabeth Anne. *A. A. E. Disdéri and the Carte-de-Visite Portrait Photograph*. New Haven: Yale University Press, 1985.

Robert Doisneau
b. 1912, Gentilly, France; d. 1994, Paris

Robert Doisneau came into his prime as a professional photographer in the two decades after World War II, taking fashion plates, celebrity portraits, and well-timed snapshots of Parisian life. Doisneau grew up near the "zone," a ribbon of poverty and homelessness encircling the French capital, and his sympathies remained always with the politics and habits of urban, working-class people. He rarely portrayed misery or hardship, however, preferring whimsy and elegance to despair. Doisneau published his work in illustrated magazines such as *Life* through the photo agency Rapho, which he joined in 1939. Beginning in the late 1940s, he worked on contract for *Vogue*. In the 1970s and after, he recorded changes to his childhood suburb and successive generations of cultural figures, with the gentility of a visitor from another era.

Picasso's Breads, Vallauris (Les pains de Picasso, Vallauris), 1952 (printed 1975). Gelatin-silver print, 46 ½ x 39 inches (118.1 x 99.1 cm)

The magazine *Le point* sent Doisneau to take a series of photographs of Pablo Picasso at home with his wife Françoise Gilot. This image was made soon after Doisneau arrived, just as the couple were sitting down to lunch. The bread that provided Doisneau with his fortuitous, punning image (*pains* rhymes in French with *mains*, or hands) came from a local baker, who according to Picasso made these four-fingered creations as a house specialty. The clumsiness of the substitute digits is endearing—and funny when one thinks of Picasso's legendary dexterity with brush and pencil. The photograph also slyly grafts a local, artisanal product onto the body of this world-famous painter, giving to the loftiest fine art an eminently popular dimension. —MSW

SUGGESTED READINGS
Hamilton, Peter. *Robert Doisneau: A Photographer's Life*. New York: Abbeville Press, 1995.
Roumette, Sylvain. *Robert Doisneau*. London: Thames and Hudson, 1991.

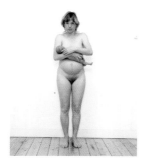

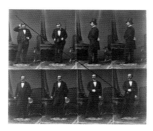

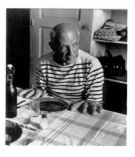

František Drtikol
b. 1883, Příbram, Bohemia (now Czech Republic);
d. 1961, Prague

František Drtikol trained as a studio photographer in his hometown, then from 1901 to 1903 at the Lehr- und Versuchsanstalt für Photographie in Munich, where apprentices were schooled in Art Nouveau aesthetics as well as photographic technique. Drtikol opened a portrait studio in Prague in 1910, which soon gained cachet with leading cultural and political figures. During the 1920s, he shifted toward a more angular, expressionist stylization often identified with Art Deco. Along with his portrait work for prominent individuals, Drtikol created a series of nude studies with theatrical settings that evolved over the 1920s to images of abstract bodies and geometric forms. In 1935, after nearly two decades of prosperity and worldwide renown, Drtikol renounced his career to devote himself to yoga and Buddhism.

Horror (Hrůza), 1927. Pigment print, 11 ½ x 9 inches (29.2 x 22.9 cm)

In characteristic soft focus, surrounded in shadow and stage light, a nude woman allegorizes a state of raw emotion. To lend the gesture a primal force, Drtikol has hidden the model largely in darkness; indeed, although her out-thrust arms and open palms work to stave off the invading blackness, it seems to have already begun swallowing her. The erotic charge of this photograph lies in the tension between this pose of ostensible resistance and the absorptive hold on viewers of a body half-hidden from the light. —MSW

SUGGESTED READINGS
Birgus, Vladimír. *The Photographer František Drtikol*. Prague: Kant, 2000.
Fárová, Anna. *František Drtikol: Art Deco Photographer*. Munich: Schirmer Art Books, 1993.

Pierre Dubreuil
b. 1872, Lille, France; d. 1944, Grenoble, France

Throughout the first half of the twentieth century, Pierre Dubreuil enjoyed an international reputation as one of France's leading photographers. Dubreuil launched his artistic career in 1896 and joined the Photo-Club de Paris the following year. In 1903, he was elected to the Linked Ring, an elite photographic society, and seven years later his work was included in Alfred Stieglitz's important exhibition of international art photography at the Albright Art Gallery in Buffalo, New York. Dubreuil experimented with carbon, platinotype, and gum-bichromate processes before settling on the oil print in 1904. If the soft focus of his early images reflected the crucial influence of Pictorialist photography, his work throughout the 1920s also assimilated more avant-garde experiments in modern art—notably Cubism, De Stijl, and Surrealism—which played with the techniques of montage and the effects of incongruous scale and odd juxtapositions.

Gernod!! (Crevettes), ca. 1929. Oil print, 9 ½ x 7 ½ inches (24.1 x 19.1 cm)

This image frames a pair of hands sorting through an inchoate mass of small shrimp. Spliced abruptly by the print's edges, the fingers are enlarged by the use of extreme close-up. The photograph's dynamic composition, which cultivates the off-kilter fragment, reinforces the disorder of the scene. Its fine tonalities also conjoin the techniques of Pictorialism to the idiom of New Vision photography. The manual application of pigment enhances the structural manipulations that figure the camera's extension of normal human vision, deftly demonstrating how the human hand might collaborate with the mechanical camera to rewrite the reality they represent. —MM

SUGGESTED READINGS
Pierre Dubreuil: Photographies 1896–1935. Paris: Centre Georges Pompidou with Dubroni Press, 1987.
Zingg, Jean-Pierre. *Pierre Dubreuil*. Papeete: Editions Avant et Après, 1991.

Eugène Ducretet
b. 1844, Paris; d. 1915, Paris

Eugène Ducretet, with an assistant named Ernest Roger, founded one of the first supply houses for electromagnetic equipment in France in 1864. The firm furnished material for the development of telegraphic and radio communication for at least the first two decades of the twentieth century. After the discovery of X rays, a high-frequency form of electromagnetic radiation, by Wilhelm Conrad Röntgen in December 1895, Ducretet was asked by the Sorbonne to make several X-ray (radiographic) studies of humans. He also undertook the first successful wireless transmission from the top of the Eiffel Tower, in 1898.

X-ray Study of a Hand (Etude radiographique d'une main), 1897. Albumen print, 9 ½ x 7 inches (24.1 x 17.8 cm)

The discovery of X rays created an overnight sensation. Dr. Röntgen's experiments were soon repeated in laboratories across Europe and in North America, and their photographic results entered the popular imagination through newspapers, lectures, and fairground attractions. While pictures of whole bodies (human and animal) and of ordinary objects such as wallets grew increasingly common, X rays of the hand had an iconic status. Röntgen mailed copies of a radiograph of his wife's bejeweled hand to leading scientists in Europe with his first explanatory treatise. The human hand, Adamic instrument of labor and industry, seemed to have definitively yielded its primacy to the machine; it was no longer possible to say that one knew something "like the back of my hand" when that most familiar body part could be rendered new and strange. —MSW

SUGGESTED READINGS
Holtzmann Kevles, Bettyann. *Naked to the Bone: Medical Imaging in the Twentieth Century*. New Brunswick, N.J.: Rutgers University Press, 1997.
Montagné, Jean-Claude. *Eugène Ducretet: Pionnier français de la radio*. Paris: Jean-Claude Montagné, 1998.
Thomas, Ann. *Beauty of Another Order: Photography in Science*. Ottawa: National Gallery of Canada; New Haven: Yale University Press, 1997.

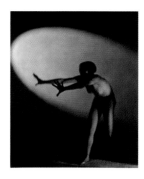

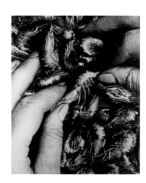

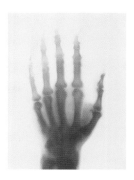

Jeanne Dunning
b. 1960, Granby, Connecticut

Jeanne Dunning began to make photographs in 1987 to question optically and socially conditioned perceptions of the human body. Extreme close-ups of skin, fingers, and nostrils; portraits of women's hair, whether on the head, the thighs, or the upper lip; corporeally allusive comestibles such as peeled tomatoes—these are some of the transformations of perceptual reality effected by her detailed prints. For the last several years, Dunning has created videos, photographs, and sculpture that set her human subjects in an ambivalent or unsettling relationship to food. Her work has been presented at the Hirshhorn Museum and Sculpture Garden, Smithsonian Institution (1994), and the Malmö Konstmuseum, Sweden (2000), as well as in group shows on gender issues in contemporary art.

Long Hole, 1994–96. Cibachrome, edition 3/3, 15 ³/₄ x 24 ¹/₂ inches (40 x 62.2 cm)

Dunning made her first series of *Holes* in 1988, photographs of disconcertingly magnified orifices that turned out to be inverted close-ups of nostrils. In the second series, from which this image is taken, cupped hands suggest a variety of interior spaces that have been likened to warm caves or to moist and vulnerable bodily passages, such as the vagina and the esophagus. The feelings provoked in the viewer range from comfort to desire to revulsion. At the same time, *Long Hole*, which shows more of the outside surface of the hands than many pictures in this series, evokes the child's game in which two hands held end to end become a makeshift telescope. Those crude tunnels, like Dunning's photographs, imitate an instrument that brings the faraway world closer; their effect, however, is to make that which is close by harder to apprehend. —MSW

Suggested Readings

Holliday, Taylor. "Nude Awakenings," *Artnews* 98, no. 2 (Feb. 1999), pp. 94–95.
Jeanne Dunning. Text by Mimi Thompson. New York: Feigen Contemporary, 1997.
Jeanne Dunning: Bodies of Work. Normal, Ill.: University Galleries of Illinois State University, 1991.

Harold Eugene Edgerton
b. 1903, Fremont, Nebraska; d. 1990, Boston

In 1926, shortly after entering the Massachusetts Institute of Technology, Harold Eugene Edgerton (known as "Doc") made a remarkable discovery: By using a precise electronic flash of light, he could make moving parts of machinery appear to stand still. Within a few years, he had perfected the means of recording this arrest of motion on film, revolutionizing flash photography in all its applications. Throughout the rest of his life, Edgerton brought his discoveries to many fields of knowledge. During World War II, he applied his strobes to nighttime, aerial reconnaissance photography. In 1953, he began a lifelong association with Jacques Cousteau, later pioneering many developments in deep-sea imaging.

Champagne Bottle, ca. 1939 (printed 1960s). Gelatin-silver print, 10 x 8 inches (25.4 x 20.3 cm)

Edgerton is best remembered for his images of everyday events that, when photographed at shutter speeds as short as one ten-millionth of a second, reveal the bizarre phenomena constantly escaping the human eye. In this image, a hand uncorks a bottle of champagne, triggering Edgerton's high-speed camera with the wire seen at the top of the frame. This photograph, like Edgerton's famous image of a milk-drop coronet, exposes the actual dynamics of a common occurrence, in this case the path of foam and the shape of the cork. The picture also functions as an aesthetic object, showing darkly silhouetted forms against a light background. As Edgerton said, "The object is to find out what's going on, and if you happen to get a good picture, why, it doesn't hurt anything."—NT

Suggested Readings

Brown, David E. *Inventing Modern America: From the Microwave to the Mouse*. Cambridge, Mass.: The MIT Press, 2002.
Edgerton, Harold Eugene. *Stopping Time: The Photographs of Harold Edgerton*. New York: Harry N. Abrams, 1987.
Roberts, David. "Doc." *American Photographer* 13, no. 3 (Sept. 1984), pp. 40–48.

William Eggleston
b. 1939, Memphis, Tennessee

William Eggleston is a product of the American South. He was raised on his family's plantation in rural Mississippi; sporadically attended Vanderbilt University, Delta State College, and the University of Mississippi; and has resided in Memphis for many years. The South, in fact, provided the subject matter for his first mature body of work, presented by Eggleston in the late 1960s to the Museum of Modern Art's John Szarkowski, to whom he had been introduced through his friends Garry Winogrand and Lee Friedlander. Eggleston's resulting debut exhibition at that New York institution in 1976 was both disdained and widely influential, pioneering a vividly colorful and seemingly spontaneous aesthetic that later inspired photographers such as Nan Goldin.

Untitled, ca. 1975. Dye-transfer print, edition 1/5, 12 x 18 inches (30.5 x 45.7 cm)

Like so many of Eggleston's images, this photograph looks like a quickly composed snapshot. The frame slices unevenly through the faces of the two standing women, obscuring their identities, and none of the figures seems aware of the camera. The seated woman, who apparently straddles a fire hydrant (again the framing denies us information), occupies the center of the image and offers the only clues to its meaning. Her gaze, upward toward the source of light, and her outstretched fingers suggest some sort of reverie, even an ecstatic revelation. While her clothing and her less-than-religious surroundings might seem too mundane for such a vision, the vibrant blues, reds, and yellows suffusing the scene nevertheless speak to the power of divine beauty. —NT

Suggested Readings

Eggleston, William. *The Democratic Forest*. Introduction by Eudora Welty. London: Secker & Warburg, 1989.
———. *William Eggleston's Guide*. Essay by John Szarkowski. New York: The Museum of Modern Art, 1976.
Eggleston, William, et al. *The Hasselblad Award 1998*. Göteborg, Sweden: Hasselblad Center, 1999.

Elliott Erwitt
b. 1928, Paris

Born in Paris of Russian parents, Elliott Erwitt emigrated to the United States in 1939 to escape the coming war. He studied photography at Los Angeles City College and film at the New School for Social Research in New York, then produced images for *Collier's*, *Look*, and *Life* magazines. In 1954, he became a full member of Magnum Photos, and served as president of the agency's New York office for three terms beginning in 1968. Since the 1970s, Erwitt has become best known for his humorous photographs of dogs, in collections such as *Son of Bitch* (1974). In 2003, he published *Elliott Erwitt's Handbook*, a collection of his photographs featuring hands.

Vice President Nixon and Soviet Premier Khrushchev during the "Kitchen Debate" at the U.S. Exhibition in Moscow, 1959 (printed 1995). Gelatin-silver print, 8 x 12 inches (20.3 x 30.5 cm)

Erwitt took this picture while covering the first exhibition of American products in Moscow for Magnum Photos. Nixon and Khrushchev had become embroiled in an argument over economic policy in front of a model American kitchen display. Erwitt's photograph quickly came to symbolize the entire Cold War conflict. Nixon's hand, aggressively pointing at and touching the Soviet premier's chest, represented the United States as fearlessly and powerfully standing up against the alleged Communist threat. The photograph was so striking that Nixon used it (without Erwitt's permission) in publicity for his 1960 campaign for the presidency. —NT

SUGGESTED READINGS
Erwitt, Elliott. *Elliott Erwitt's Handbook*. New York: The Quantuck Lane Press, 2003.
———. *Snaps*. New York: Phaidon Press, 2001.
Goldberg, Vicki. *The Power of Photography: How Photographs Changed Our Lives*. New York: Abbeville Press, 1991.
Kismaric, Susan. *American Politicians: Photographs from 1843 to 1993*. New York: The Museum of Modern Art, 1994.

Frederick H. Evans
b. 1853, London; d. 1943, London

Frederick Evans was making his living as a well-regarded bookstore owner when, at the age of thirty, he bought his first camera. He began by photographing landscapes and microscopic organisms; later, he turned to portraits of his literary and artistic friends, including Aubrey Beardsley, William Morris, and George Bernard Shaw. Evans spent most of his time, however, photographing the many Gothic churches of England and France. For him, architecture offered the most expressive possibilities for the medium: He preached and practiced "the straightest of straight photography," in contrast to the Pictorialist work then dominant. By the time of his death, Evans was celebrated as a great forefather of modernism's "pure" photography.

Portrait of Aubrey Beardsley, 1894. Platinum print with ink-on-paper border by Beardsley, 4 7/8 x 3 3/4 inches (12.4 x 9.5 cm)

Beardsley, at the time only eighteen years old, was a frequent visitor to Evans's bookshop. Evans owned over forty of Beardsley's drawings and sold platinum-print reproductions in his shop. It was Evans who in 1893 recommended that Beardsley illustrate Thomas Malory's *Le morte d'Arthur*, his first major commission. The following year, when Beardsley sat for Evans, the photographer pictured him as a famous gargoyle from Notre Dame in Paris. This choice both betrays Evans's obsession with architecture and reflects Beardsley's own grotesque reinterpretations of medieval form. It also accentuates the artist's hands—effectively the tools of his trade. This portrait, with a border drawn by Beardsley, was reproduced in *Le morte d'Arthur*, which was issued in twelve parts from June 1893 to November 1894. —NT

SUGGESTED READINGS
Hammond, Anne, ed. *Frederick H. Evans: Selected Texts and Bibliography*. Oxford, England: Clio Press, 1992.
Newhall, Beaumont. *Frederick H. Evans: Photographer of the Majesty, Light and Space of the Medieval Cathedrals of England and France*. New York: Aperture, 1973.
Photography: The First Eighty Years. London: P. & D. Colnaghi & Co., 1976.

Walker Evans
b. 1903, St. Louis, Missouri; d. 1975, New Haven, Connecticut

Although he always resisted the term "art photographer," Walker Evans was instrumental in establishing photography as an artistic profession in the United States. Ten years after making his first serious photographs, Evans had published three books with noted writers and had had as many solo shows at the Museum of Modern Art, New York. The last of these, *American Photographs* (1938), established a lineage—characterized by the ironic documentation of this country's sights and mores—continued by Robert Frank, Lee Friedlander, and others. Evans photographed in Tahiti (1932), Cuba (1933), and (on assignment to the Farm Security Administration) the American South (1935–37). In 1945, he became associate editor at *Fortune*, retiring twenty years later to take a teaching position at Yale University. Two further books, *Many Are Called* and *Message from the Interior*, followed in 1966, as did another retrospective in 1971.

Untitled, 1929. Gelatin-silver print photogram, 11 x 7 inches (27.9 x 17.8 cm)

This early image, which appears to be a photogram (a hand was placed directly on photosensitive paper and exposed to light), is extremely unusual for Evans. A few other works prior to 1930, most famously a view of hand-shaped votive candles hanging from a Manhattan storefront, suggest the passing influence of Surrealist fetishism on Evans. (He made a trip to Paris in 1926–27, and took his first pictures then as well.) The ghostly appendage in this composition, irradiated with negative light, recalls the photograms of Man Ray and artists working in Germany such as László Moholy-Nagy and El Lissitzky.

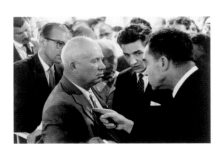

East Entrance, ca. 1947. Gelatin-silver print, 6 ½ x 9 ¼ inches (16.5 x 23.5 cm)

The sideways, disembodied hand, clothed in a section of shirt sleeve and jacket, was a common typographic device in advertising of the later nineteenth century, used as a flourish that suggested the traveling salesman calling attention to his wares. Many avant-garde movements, from Dada, Surrealism, and the Czech group Devětsil in the 1920s to Fluxus artists in the 1960s and 1970s, reproduced this advertising sign to symbolize their rebellious flirtation with consumer culture. The giant, outstretched thumb and index finger painted on this fence form a gesture that hovers midway between a cartoon and a commandment. It is as though the hand of God had descended to earth in the guise of a dignified, elephantine gentleman, politely yet firmly indicating the path we should travel.

Gypsy Storefront, 1562 Third Avenue, New York, 1962. Gelatin-silver print, 11 ¾ x 9 ¾ inches (29.8 x 24.8 cm)

Painted and mechanically produced signage is an enduring theme in Evans's work, one that built to an obsession during his later years. This palm reader's storefront was photographed as part of a photo-essay project for *Fortune* (never published) that proposed to describe the small-time commercial character and rapid changes taking place on Manhattan's Third Avenue. Like the pointing hand, the hand of the palmist has a long and varied history in advertising, whether for businesses or for traveling entertainments such as the circus or local fairs, and it has attracted the attention of many artists as well. —MSW

SUGGESTED READINGS
Greenough, Sarah. *Walker Evans: Subways and Streets*. Washington, D.C.: National Gallery of Art, 1991.
Rosenheim, Jeff L., and Douglas Eklund. *Unclassified: A Walker Evans Anthology*. New York: The Metropolitan Museum of Art, 2000.
Trachtenberg, Alan. *Reading American Photographs: Images as History, Mathew Brady to Walker Evans*. New York: Hill and Wang, 1989.
Walker Evans: Signs. Essay by Andrei Codrescu. Los Angeles: The J. Paul Getty Museum, 1998.

Andreas Feininger

b. 1906, Paris; d. 1999, New York

The son of American painter and Bauhaus instructor Lyonel Feininger, Andreas Feininger grew up in Berlin and studied carpentry and architecture in the 1920s before turning to photography. Feininger made architectural and advertising photographs in the years around 1930, while pursuing a career as an architect. Hampered by visa troubles, he moved to Sweden in 1934, where he decided to pursue photography full-time; in December 1939, he took advantage of his American passport to relocate to New York. Feininger worked for twenty years with *Life* magazine, specializing in cityscapes of New York. He also authored numerous technical books on photography and picture books celebrating the beauty and wonder of the natural world.

Untitled (Finger Printing), 1942. Gelatin-silver print, 13 ½ x 10 ¾ inches (34.3 x 27.3 cm)

Before joining the staff at *Life* in 1943, Feininger worked for a time at the newly created Office of War Information in Washington, D.C. This government agency, eliminated in 1945, had the task of promoting the war effort at home and overseas. Fingerprinting, introduced as a method of criminal identification around 1900 to supplement photographic mug shots, is presented here through photography as an emblem of governmental omniscience. The purpose of this image is not to identify an individual, still less a criminal, but to inspire ordinary citizens to serve, and to identify themselves with, their government. With two hands deployed to guide each one proffered, this message of protection can also be considered a definitive image of manipulation. —MSW

SUGGESTED READINGS
Andreas Feininger: A Retrospective. New York: International Center of Photography, 1976.
Police Pictures: The Photograph as Evidence. San Francisco: San Francisco Museum of Modern Art and Chronicle Books, 1997.

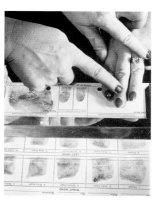

Donna Ferrato
b. 1949, Waltham, Massachusetts

The international photojournalist Donna Ferrato is widely acclaimed today for her documentation of the complex commingling of love and violence. While employed as a legal secretary, Ferrato was enrolled at the San Francisco Art Institute from 1976 to 1977. Following her studies, she worked as a camerawoman for KREX-TV news in Grand Junction, Colorado, and as a staff photographer for Media People in New York. She then turned successfully to photojournalism, traveling widely throughout Europe, Africa, and the Persian Gulf and publishing her work in *Life*, *Time*, *Fortune*, *The New York Times*, and the *Washington Post*. In the 1980s, Ferrato was critically commended for her photographic work on domestic violence (collected in the award-winning book *Living with the Enemy*), a subject the photographer described as "America's best-kept secret."

Injured Woman on the Street—McKeesport, Pennsylvania, 1983 (printed 1995). Gelatin-silver print, 12 ³/₄ x 25 ³/₄ inches (32.4 x 65.4 cm)

Ferrato is well known for her extraordinarily intimate approach to her subjects—she lives with them in their homes and visits women's shelters and maximum-security prisons—and for her sensitive portrayals of their physical and psychological traumas. This image was recorded at night after Ferrato accompanied the police on a "ten-four" call. It depicts a battered woman slumped against a wall on the street, her face and sweater splattered with blood. A web of crisscrossed hand gestures organizes the scene—the victim points her finger in accusation against a "friend" long gone; a policeman extends his arm toward her solicitously; and a faceless third party exposes a pair of nondescript hands. The hand of brutality is absent from this picture, which maps the presence of abuse through these multiplied signs of pain and horror, kindness and witness. —MM

SUGGESTED READINGS
Ferrato, Donna. "Donna Ferrato's Women: Under the Skin." *Aperture*, no. 121 (fall 1990), pp. 36–41.
———. *Living with the Enemy*. New York: Aperture, 1991.

Robert Filliou
b. 1927, Sauve, France; d. 1987, Les Eyzies, France

In 1959, after ten years as an economist in the United States and South Korea and several more years of peripatetic existence as a writer, Filliou befriended the artist Daniel Spoerri and soon joined the loosely knit movement later known as Fluxus. The tenor of this freewheeling, international group may be gauged from Filliou's Galerie Légitime (1961), a showcase for art located in his hat. Creation is a constant activity, Filliou maintained, and as such an equivalence obtains between things that are well made, badly made, or not made at all. In 1965–68, Filliou ran a "store" in southern France—really a site for performances and the distribution of Fluxus book editions. He later took part in the Düsseldorf art scene connected with Joseph Beuys. Filliou died shortly before completing a thirty-nine-month period of seclusion with his wife at a Tibetan monastery in France.

Hand Show (cover), 1967. Portfolio of twenty-four photolithographs, edition 31/150, portfolio 11 ⁷/₈ x 9 ¹/₂ x 1 ¹/₂ inches (30.2 x 24.1 x 3.8 cm); each sheet 11 x 8 ¹/₂ inches (27.9 x 21.6 cm). Photos by Scott Hyde

In April 1967, Filliou curated a display at Tiffany's in New York of photographs showing the left hands of five artists. The venue, suggested by Andy Warhol (one of the participants), circumvented regular gallery channels, while the subject was chosen to short-circuit mediation by critics: "Anybody by reading the lines of our hands could see what we are doing." This tongue-in-cheek explanation refers partly to palmistry, the art of telling one's character and fate from one's hand, and partly to the belief that hands are the key to authorial identity (hence the importance of signatures in art). For the portfolio *Hand Show*, Filliou selected twenty-four artists, including himself and the photographer Scott Hyde, and intended to use the resulting images to form a "hand clock," but the idea never went beyond a prototype. Daniel Spoerri remarked amusingly that the project suited Filliou, because he was extremely maladroit. —MSW

SUGGESTED READINGS
Hendricks, Jon. *Fluxus Codex*. Detroit: The Gilbert and Lila Silverman Fluxus Collection; New York: Harry N. Abrams, 1988.
Robert Filliou. Nimes: Musée d'Art Contemporain, 1990.

Marc Foucault
b. 1902, Rome; d. 1985, Paris

Marc Foucault, who was primarily an architectural photographer, launched his career in 1937, when he collaborated on an encyclopedic guide to the Louvre for the Paris publishing house Editions Tel. This same company later published the architectural series *Collection des cathédrales et des sanctuaires du moyen age*, for which Foucault photographed many French monuments, including Mont-Saint-Michel and the cathedrals of Strasbourg, Sens, and Amiens. In these folio editions, Foucault used a clean, detailed style that demonstrated his technical and compositional acumen, perhaps developed during his years as an assistant to film director Jean Dréville. Yet Foucault also worked in a radically different idiom, producing manipulated images of everyday subjects, as evidenced in his contribution to the German exhibition *Subjektive Fotografie 2* in 1954.

Untitled, 1946. Photocollage, 11 ¹/₂ x 9 inches (29.2 x 22.9 cm)

One technique for manipulating pictures used by Foucault (and reported on by *Life* magazine in 1954) involved melting his negative's emulsion in hot water in order to warp and stretch areas of the image—a method no doubt adopted from the Surrealist Raoul Ubac's *brulage* process. Though this picture is a photographic collage, its effects resemble those achieved by Foucault several years later. Here, the distinction between flora and fauna is ready to collapse: An elongated hand seems literally to sprout from a plant, assisting another pair of hands that tend to the plant's care. Foucault evokes a dreamlike alternate reality mediated by the technical possibilities of photography, and signals the influence on his work of Surrealism that is scarcely evident in his architectural photographs. —NT

SUGGESTED READINGS
Deschamps, Paul, ed. *Le Mont-Saint-Michel*. Paris: Editions Tel, 1941.
"Speaking of Pictures: Hot Water Trick Makes Madman's World." *Life* 37, no. 18 (Nov. 1, 1954), pp. 10–11.
Subjektive Fotografie 2: Ausstellung moderner Fotografie. Saarbrücken: Staatliche Schule für Kunst und Handwerke, 1954.

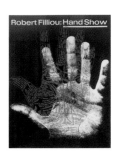

Robert Frank
b. 1924, Zurich

Robert Frank has had several artistic careers. A commercial photographer beginning in the late 1940s, he worked for *Harper's Bazaar*, *Life*, *Vogue*, and other magazines sporadically throughout the 1950s, meeting important mentors such as Alexey Brodovitch and Walker Evans. The publication in French and English of *The Americans* in 1958–59 established his reputation as an outsider in America with a keen feel for this country's anomie and disparities of race and class. Frank kept company in those years with Beat writers Allen Ginsberg and Jack Kerouac, and began to make films inspired by that milieu. In 1970, he withdrew from the cultural moment in which he matured by moving to a remote corner of Nova Scotia, where he continues to spend much of his time today.

Pablo and old man—New York City 2, 1958. Gelatin-silver print, 7 ³/₄ x 11 ¹/₂ inches (19.7 x 29.2 cm)

This snapshot of Frank's son, Pablo, listening to an old man telling a story, was one of many diaristic observations Frank showed Pablo and his daughter Andrea during a reunion with them ten years after they were taken. The ensuing, tense exchange between the artist and his partly estranged children—over issues of privacy, parenting, love, and trust—was itself recorded by Frank for his first openly autobiographical film, *Conversations in Vermont* (1968). Similar reflections came to dominate his work in the 1970s, and this focus intensified after Andrea was killed in a plane crash in 1973. This early image cannot, on its own, tell the story of mortality and alienation in Frank's own life. However, its telescopic contrast of life experiences through gestures—the man's hand large, aged, and tremulous; those of the child small and closed in rapt attention—nevertheless creates a powerful narrative device. —MSW

Suggested Readings
Greenough, Sarah, and Philip Brookman. *Robert Frank: Moving Out*. Washington, D.C.: National Gallery of Art, 1994.
Robert Frank. New York: Pantheon Books, 1985.

Leonard Freed
b. 1929, New York

A self-taught photographer, Leonard Freed has earned his living since the late 1950s as a freelance photojournalist. From his earliest work on Jewish culture in New York, Freed has used the camera to explore and attempt to rectify social injustice. His first two books portrayed post-Holocaust Jewish life in Amsterdam (1959) and Germany (1965). He then devoted himself to African American society, working through fundamental aspects of race relations during and just prior to the civil rights era in his film *The Negro in America* (1966) and the book *Black in White America* (1969). Since 1970, Freed has belonged to the socially committed cooperative Magnum Photos.

Martin Luther King Being Greeted on His Return to the United States after Receiving the Nobel Peace Prize, Baltimore, 1963. Gelatin-silver print, 5 x 7 ¹/₄ inches (12.7 x 18.4 cm)

Freed included this image in *Black in White America* at the point where his narrative begins to address the hopes and difficulties of the civil rights movement. Dr. King stretches his arm to connect with a radiant stream of well-wishers, forming a knot that triumphantly upstages the white police officers looking on from the edges of the picture. Here, the euphoria of solidarity in struggle and the benediction gained by touching the reverend's hand combine with the traditional political significance of pressing the flesh with one's supporters. In this nonreligious setting, the "laying on of hands" operates in both directions, since King derives strength from his constituents even as they look to him for guidance. —MSW

Suggested Readings
Freed, Leonard. *Black in White America*. New York: Grossman Publishers, 1969.
Kasher, Steven. *The Civil Rights Movement: A Photographic History, 1954–68*. New York: Abbeville Press, 2000.
Leonard Freed Photographs, 1954–1990. Introduction by Stefanie Rosenkranz. Manchester, England: Cornerhouse, 1991.

Lee Friedlander
b. 1934, Aberdeen, Washington

In the mid-1950s, Lee Friedlander began photographing jazz musicians for Atlantic Records, a professional assignment that fused with his own interest in creative improvisation. His dry, deceptively casual shots of contemporary America—store windows, signs, pedestrians, himself—earned Friedlander a solo exhibition at the George Eastman House, Rochester, in 1963. Four years later, he joined Garry Winogrand and Diane Arbus in *New Documents*, an exhibition at the Museum of Modern Art, New York, that consecrated them as successors to Robert Frank and Walker Evans. Friedlander has since explored subjects as varied as the California desert, small-town monuments across America, and the female nude—in each case with an apparently slovenly disregard for composition that masks an ascetic rigor.

Salinas, 1972. Gelatin-silver print, 13 ⁷/₈ x 11 inches (35.2 x 27.9 cm)

As in many of Friedlander's images, the conventional attraction of this scene, a horse race, is rendered pictorially unimportant. In its place, we are treated to banal details: the back of an anonymous woman's head, and a short section of beefy forearm set on the back of her seat. This wall-like foreground is completed by a shadow in the lower left corner, likely cast by the photographer. Friedlander's photograph takes its strength from the personalities suggested by these fragments, particularly the swarthy male arm with its signet ring and thick watchband. The shadow to the left suggests a tension that involves Friedlander as well; one has the sense that he and the owner of that stout limb have both laid claim to the woman, each one introducing something of himself to mark the territory. —MSW

Suggested Readings
Like a One-Eyed Cat: Photographs by Lee Friedlander 1956–1987. Text by Rod Slemmons. New York: Harry N. Abrams in association with the Seattle Art Museum, 1989.
Rosler, Martha. "Lee Friedlander's Guarded Strategies." *Artforum* 13, no. 8 (April 1975), pp. 46–53.

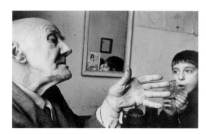

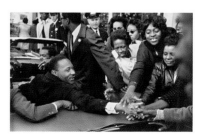

Anna Gaskell
b. 1969, Des Moines, Iowa

Anna Gaskell's work offers an extended, sometimes sinister, meditation on childhood. Her first photographs, taken while she was earning her B.F.A. degree at the School of the Art Institute of Chicago in the early 1990s, took her three younger brothers as subjects. After graduating, she spent a year as Sally Mann's assistant before enrolling at the Yale University School of Art. In 1995, with an M.F.A. in hand, Gaskell began her first series of mature work, *wonder*, in which she used adolescent girls in a deconstructed retelling of *Alice in Wonderland*. In later works, Gaskell has continued to stage girls in radical revisions of literary narratives, achieving an aesthetic rife with mystery.

Untitled #84 (resemblance), 2001. C-print, edition 3/3, 19 1/8 x 23 3/4 inches (48.6 x 60.3 cm)

Resemblance, one of Gaskell's most recent series, occupies the territory of late-nineteenth-century horror stories, in which monsters and automatons abound. The loose narrative driving the series revolves around an endless group of identical girls, who are not simply creations of some mastermind but instead are actively building their creator. In this photograph, Gaskell seems to pay tribute to E. T. A. Hoffmann's tale of automatons, "The Sandman," which notably provided Sigmund Freud with a prime example of the uncanny in his essay of that title. Here, a hand reaches toward an idyllic girl's face—but is it inserting or plucking out her eye? This sort of narrative ambiguity provides the tension in much of Gaskell's work. —NT

SUGGESTED READINGS
Gaskell, Anna. *by proxy*. Aspen, Colo.: Aspen Art Museum, 2000.
———. *resemblance*. Andover, Mass.: Addison Gallery of American Art, Phillips Academy, 2002.
Squiers, Carol. "Anna in Wonderland." *American Photo* 10, no. 1 (Jan.–Feb. 1999), pp. 34–36.

Mario Giacomelli
b. 1925, Senigallia, Italy; d. 2000, Senigallia

The two salient facts of Mario Giacomelli's life, he said, were the abject poverty he experienced as a child and the loss, at age nine, of his father. Giacomelli then dropped out of school and entered a local printing firm. This work remained his principal source of income; as an artist, he avoided most career obligations. He began to photograph in 1953, working from the start in narrative series, the titles of which he frequently chose from his own and others' poems. Giacomelli produced candid, sometimes shocking pictures of his native region with an apparently careless technique of grainy blacks and yellowed whites, which made his lyrically morbid scenes all the more affecting. Well known in Italy but largely ignored abroad until the mid-1980s, Giacomelli's work has gained increasing international recognition in recent years.

My Head Is Full, Mama (Ho la testa piena, mamma), 1985–87. Gelatin-silver print, 11 3/4 x 15 3/4 inches (29.8 x 40 cm)

This is the final photograph in a series compiled from work made in Italy and at Lourdes, France, between 1957 and 1987. The title comes from a poem that reads in part, "Give me a sharp knife / And as I cut the stars / Cover the sky with a grey cloth / And tell the flowers I do not want perfume." These bittersweet lines match the elegiac feel of the photographs, three of which feature a handsome young man in a wheelchair. His right hand, which hangs limply above a blanket spread over his legs, seems fixed and numb. It can be disconcerting to try to read the feelings of a person whose gestures have been immobilized. On its own, this hand is elegant and attractive, and seems capable of refined, sensual action. Attached to a body (which can also be seen as a metaphor for our own limited body of awareness), it becomes achingly beautiful in its impotence. —MSW

SUGGESTED READING
Crawford, Alistair. *Mario Giacomelli*. London: Phaidon Press, 2001.

Ralph Gibson
b. 1939, Los Angeles

On his seventeenth birthday, Ralph Gibson enlisted in the United States Navy and was assigned to the Naval School of Photography, where his duties included aerial, documentary, and portrait photography. After his discharge, Gibson enrolled in the San Francisco Art Institute, but perhaps his most important artistic training came from his assistantship to Dorothea Lange in 1960–61, and his work with Robert Frank in New York later in the decade. In 1970, Gibson published his first independent book, *The Somnambulist: Photographs*, through his own Lustrum Press. He has published some eighteen monographs, including recent photographs of sculptures by Eric Fischl.

From *The Somnambulist*, 1967 (printed 1974). Gelatin-silver print, edition 19/25, 16 x 20 inches (40.6 x 50.8 cm)

This image from *The Somnambulist* features Gibson's friend and fellow photographer Mary Ellen Mark. Far from simply being a portrait, the photograph originally appeared in an ambiguous narrative scheme that betrayed Gibson's early debts to Surrealism. As the book's title suggests, Gibson was exploring the intrusion of dream states into waking life. Indeed, a thread of fantasy runs though most of his work. Here, Mark seems lost in reverie as she enmeshes her fingers with those of an unseen person, presumably the photographer himself. The hand in the foreground contrasts with Mark's, as if ready to pull her out of the darkness of the subconscious into the light. —NT

SUGGESTED READINGS
Gibson, Ralph. *Deus ex machina*. Cologne: Taschen, 1999.
———. *The Somnambulist: Photographs*. New York: Lustrum Press, 1970.
Weiermair, Peter, ed. *Ralph Gibson: Light Years*. Zurich: Edition Stemmle, 1996.

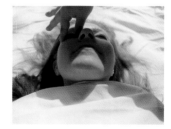

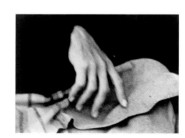

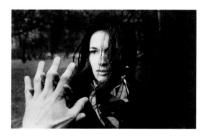

Gilbert and George
Gilbert Proesch: b. 1943, San Martino, Italy
George Passmore: b. 1942, Devon, England

George met Gilbert at Central St. Martin's School of Art in London in 1967; everything prior to that moment, they say, is unimportant. The pair share an irrepressible drive to fuse life and art as closely as they have joined their own lives. Their mural-size photographic pieces, drawings, and live performances concentrate exuberantly on themselves and their radiantly decadent visions. Gin bottles, sunflowers, penises, feces, vulgar words, and Christian crosses have paraded through their works over the decades, frequently bathed in Day-Glo tints. Fastidiously dressed and seemingly inseparable, Gilbert and George have accompanied their exhibitions to cities around the world, bringing unfailing good humor and a keen sense of publicity to their cause: to reach people everywhere with an art that is modern, accessible, and devilishly divine.

Bottle Bar, 1973. Five gelatin-silver prints, each 6 ¹/₂ x 8 ³/₄ inches (16.5 x 22.2 cm)

For several years in the 1970s, Gilbert and George applied themselves with cheerful discipline to the consumption of hard liquor. The works from this period feature a protean arrangement of bottles, glasses, and barroom interiors, photographed at crazy angles or with deliberate crudeness, as if the camera itself had been leading the revelry. The two protagonists remain impeccably attired throughout, so it is left to their surroundings and accessories to convey the atmosphere of inebriation. Blinding flashes of light penetrate the first two photos in *Bottle Bar* with the force of a throbbing hangover. That sensation is immediately transferred to the pair of hands—even more blinding in their whiteness—that toast each other with a pair of ghostly cocktail glasses in the center image. The artists have been snuffed out by their debauchery—their own hands take their place at the table, delightedly conspiring to eclipse them with booze.

Black Gargoyles, 1980. Twelve hand-colored gelatin-silver prints, overall 71 ¹/₂ x 79 ¹/₂ inches (181.6 x 201.9 cm)

Gargoyles and other premodern monsters occupy a notable place in the Gilbert and George cosmology. Hell, they claim, is not a nether region but a space of elemental fears and base, carnal longings within ourselves. Their aim is to express these terrors and passions by exteriorizing them as "living sculpture." That goal is succinctly achieved in these impersonations of gargoyles, the demons that commonly grace waterspouts on Gothic cathedrals. Spooky hand gestures are key to the cartoonlike effectiveness of the poses. The posture, typically for Gilbert and George, is both insane and ecstatic, with the result that the piece comes across as both sheer camp and inspired vision. —MSW

SUGGESTED READINGS
Farson, Daniel. *Gilbert and George: A Portrait*. London: HarperCollins, 1999.
Gilbert and George. Paris: Musée d'Art Moderne de la Ville de Paris, 1997.

Nan Goldin
b. 1953, Washington, D.C.

Nan Goldin grew up in Boston, where after a tempestuous adolescence she became friends with the drag queens who featured in her first photographs. Her engagement with the fringes of society was not merely voyeuristic. Her portrayal of a small group of friends over the years included herself and had the feel of a diary. After more formal training at the School of the Museum of Fine Arts in Boston, she moved to New York in 1978, and soon began presenting her work as ever-shifting slide shows with musical accompaniment. In the 1990s, Goldin expanded her purview to include scenes from Europe and Southeast Asia, always maintaining an intimate, snapshot-style relationship with her subjects.

Joey in my mirror, Berlin, 1992. Cibachrome, edition AP 1, 25 ⁷/₈ x 38 ⁵/₈ inches (65.7 x 98.1 cm)

By the early 1990s, the gay and transsexual communities of which Goldin was part had been ravaged by the AIDS epidemic, and her pictures of her drag queen friends became not only celebrations of gender play but harrowing portraits of survival and sometimes death. Here, Goldin's friend Joey looks into a mirror in a moment of literal self-reflection, toying with her long, womanly hair with one hand. A hula girl and a Paul Outerbridge photograph of a nude female torso at the bottom corners of the mirror frame Joey's image, foregrounding the differences and similarities, seen and unseen, between these three figures of femininity. —NT

SUGGESTED READINGS
Emotions and Relations. Hamburg: Hamburger Kunsthalle; Cologne: Taschen, 1998.
Goldin, Nan. *The Other Side*. Zurich: Scalo, 1995.
Goldin, Nan, David Armstrong, and Hans Werner Holzwarth, eds. *Nan Goldin: I'll Be Your Mirror*. New York: Whitney Museum of American Art; Zurich: Scalo, 1996.

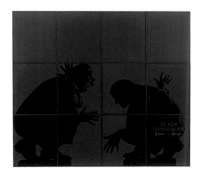

Douglas Gordon
b. 1966, Glasgow, Scotland

Raised in a working-class, mostly Protestant family, Douglas Gordon left home after four years at a local art school to attend the Slade School of Art in London, from 1988 to 1990. Three years later, Gordon achieved overnight acclaim with *24 Hour Psycho*, in which the film by Alfred Hitchcock was projected so slowly that it stretched over a full calendar day. Moving freely through popular cinema and literature for his inspiration, Gordon has since created video installations, photographs, and texts that conjure a world of violence and fractured identities. In 1996, he was awarded the Turner Prize, given annually in Britain to a prominent artist under the age of fifty.

Three Inches Black (no. 9), 1997. Color photograph mounted on PVC, edition 3/3, 31 11/16 x 41 5/16 inches (80.5 x 105 cm)

Inspired by a police crackdown on gang violence in his native Glasgow that involved a public ban on objects three inches or longer, Gordon arranged to have a man's index finger tattooed in black to the length of a potential weapon. This "simple yet extreme" idea, as Gordon has written, appealed to him because of how it joined an amorous metaphor—"touching someone's heart"—with the literal threat of a fatal cardiac puncture. Choosing the left or "sinister" hand for his staining operation, Gordon also marked it as distinct from the right, rehearsing themes of Manichaean struggle and schizophrenia that are evident in much of his work. Among many similar pieces is *A Divided Self*, a video from 1996 in which Gordon shaved one of his arms, then had his clean and hairy appendages do battle to see which one would gain the upper hand. —MSW

SUGGESTED READINGS
Douglas Gordon. Los Angeles: Museum of Contemporary Art; Cambridge, Mass.: The MIT Press, 2001.
Francis, Mark, ed. *Douglas Gordon: Black Spot*. Liverpool: Tate Gallery Liverpool, 2000.

Emmet Gowin
b. 1941, Danville, Virginia

Emmet Gowin began photographing his family in 1964, when he married and began to visit his wife's family homestead. Shortly thereafter, Gowin studied for his M.F.A. at the Rhode Island School of Design under Harry Callahan, whose photographs of his own wife and family were a source of inspiration. In the mid-1970s, under the influence of Walker Evans and Frederick Sommer, Gowin began to photograph landscapes around the world. These landscapes have been his dominant mode of expression for the past twenty years and have increasingly thematized ecological concerns. Gowin's deep engagement with his social and physical environment is the hallmark of both his family portraits and his landscapes.

Nancy, Danville, Virginia, 1969. Gelatin-silver print, 5 1/2 x 7 inches (14 x 17.8 cm)

Gowin's niece Nancy was one of his most enthusiastic subjects in Danville. In this photograph he documents her youthful play acting and finds within it an evocative lyricism. Nancy's entangled arms seem both flexible and as fragile as the egg she holds in each hand. Her face is lost in reverie amidst the horizonless landscape that surrounds her. Like the child Diane Arbus photographed in Central Park (p. 200) or Sally Mann's child (p. 231), Nancy acknowledges her surveillance and tries to impress herself upon the photograph through her performance. The image reflects on the representational power of photography and on the pose of the pictured subject—both held, like Nancy's eggs, in a delicate, intertwined balance. —NT

SUGGESTED READINGS
Bunnell, Peter C. *Emmet Gowin: Photographs 1966–1983*. Washington, D.C.: Corcoran Gallery of Art, 1983.
Emmet Gowin: Photographs. Boston: Bulfinch Press, 1990.
George, Alice Rose, et al. *Flesh and Blood: Photographers' Images of Their Own Families*. New York: Picture Project, 1992.

Dan Graham
b. 1942, Urbana, Illinois

Dan Graham matured among the New York artists who defined Conceptual art in the later 1960s. Anti-establishment convictions led him to work outside the gallery system for many years, purchasing magazine spots to "show" works made with deliberately cheap materials. In Graham's films and videos from the 1970s, viewers and performers were asked to think about the experience of watching others and being watched simultaneously. Beginning in the late 1970s, Graham extended the issues of intersubjectivity, bodily awareness, and consciousness of surveillance raised by these works into an architectural dimension, with a series of pavilions in two-way glass that he designed. Graham's work, which has been the subject of numerous monographs and exhibitions, constitutes an elegant invitation to explore one's sense of physical and social place.

Body Press, 1970. Gelatin-silver print, 10 x 8 inches (25.4 x 20.3 cm)

In the film from which this photograph is taken, a naked man and woman stand back to back inside a cylindrically shaped mirror. Without turning around, they each hold a Super-8 movie camera, pointed outward, and move it in a slow spiral around their bodies upward from legs to face, then back down again. Whenever the spiral leads behind their backs, as in this image, the performers exchange cameras. The roving machines effect an ersatz physical communion, caressing two sets of skin and interweaving alternate bodily identities on film. They are made to act like disembodied hands, but provide a kind of embodied viewing, since the resulting film sequences, showing flesh either distorted by anamorphic reflection or suspended in midair, project a disoriented carnality that Graham has wryly called a "very good skin flick." —MSW

SUGGESTED READINGS
Graham, Dan. *Rock My Religion, 1965–1990*. Ed. Brian Wallis. Cambridge, Mass.: The MIT Press, 1993.
Pelzer, Birgit, Mark Francis, and Beatriz Colomina. *Dan Graham*. London: Phaidon Press, 2001.
Wagner, Anne. "Performance, Video, and the Rhetoric of Presence." *October*, no. 91 (winter 2000), pp. 59–80.

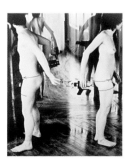

Joseph Grigely
b. 1956, East Longmeadow, Massachusetts

Joseph Grigely's art threads speech with writing to produce a kind of acoustical image. Deafened in a childhood accident, the artist was educated at the National Technical Institute for the Deaf, New England College, and Oxford University in England. He began to exhibit in the 1990s, creating assemblages and installations out of scraps of paper that record scribbled names, notes, and conversations with interlocutors unfamiliar with American Sign Language. While invoking the grid and the monochrome, these works also use language to undermine the autonomy and opticality preserved by those cherished modernist devices. At the same time, these hybrid arrangements refer to the still life, redirecting the genre's attention to the throwaway odds and ends of everyday life.

Josephine P., Rotterdam, 1996, 1997. R-print, edition 1/3, 3 x 4 ³/₄ inches (7.6 x 12.1 cm)
Amy V., Ghent, January 30, 1997, 1997. R-print, edition 1/3, 3 x 4 ¹/₂ inches (7.6 x 11.4 cm)
Wassily Z., Vienna, June 9, 1997, 1998. R-print, edition 2/3, 3 x 4 ¹/₂ inches (7.6 x 11.4 cm)

These three photographic portraits record the hand at rest and in the process of scribbling and doodling on white sheets of paper. The inscribed texts are not consistently legible, but they identify a particular individual; their idiosyncratic graphic marks also visualize the inflections of speech. The hand serves as the conduit for the translation of auditory event into visual representation. The manual production of that representation also draws out the condition of writing that structures photographic reproduction: The photograph not only transcribes but recodes the artist's conversations as an exchange between the languages of quotidian communication and of aesthetic practice. —MM

SUGGESTED READINGS
Joseph Grigely: Matrix 140. Hartford: Wadsworth Atheneum, 1999.
Kimmelman, Michael. "Bits and Pieces from the Intersection Where a Deaf Man Meets the Hearing." *The New York Times*, Aug. 31, 2001, p. E28.

Jan Groover
b. 1943, Plainfield, New Jersey

For Jan Groover, "Formalism is everything." Groover received a B.F.A. in painting from Pratt Institute, Brooklyn, in 1965 and an M.A. in Art Education from Ohio State University in 1970. For the next three years, she taught at the University of Hartford, where she also took up photography. Using color film and a thirty-five millimeter camera on a stationary tripod, Groover created serial diptychs and triptychs of street traffic. Their balance of form and color echoed the artist's abstract Minimalist paintings. In 1978, she turned to the close-up still lifes of kitchen utensils, vegetables, and plants that earned her wide public acclaim as a proponent of "new" color photography. These artful compositions heighten our perceptual experience of everyday objects through their exaggerated scale and rich contrasts of light, color, and texture, while courting comparison to the abstract arrangements of Alfred Stieglitz, Paul Strand, and Edward Weston.

Untitled, 1990. Palladium print, edition 4/15, 12 x 9 inches (30.5 x 22.9 cm)

In 1979, Groover began to experiment with platinum-palladium printing techniques. Introduced in 1873, this process depends on the reaction of iron salts with platinum or palladium salts to form a metal image that is absorbed into the paper's fibers, yielding a rich and delicate tonal range. In this print, the blurred details and warm sepia tones of drapery and flesh induce an almost mystical aura that enhances the scene's implied narrative. Emerging from a differentially focused field of cloth, the curved hand of an infant, cupped by the less distinct hand of the mother, stretches out toward the viewer. This tender image of support and offering condenses the Christian iconography of mother and child, elaborating a Pictorialist tradition of domestic photography that extends from Julia Margaret Cameron to Gertrude Käsebier. —MM

SUGGESTED READINGS
Jan Groover: Photographs. Purchase, New York: Neuberger Museum, State University of New York at Purchase, 1983.
Kismaric, Susan. *Jan Groover*. New York: The Museum of Modern Art, 1987.

Pedro E. Guerrero
b. 1917, Casa Grande, Arizona

Pedro Guerrero grew up in Mesa, Arizona, just twenty-four miles from the future site of Frank Lloyd Wright's Taliesin West. Upon graduating high school, he impulsively decided to become a photographer and studied for two years at the Art Center School in Los Angeles. He returned to Mesa in 1939 and was introduced to Wright, who hired him at his first interview. Guerrero worked as Wright's staff photographer until the architect's death in 1959. He then continued to work as an architectural photographer, and developed significant photographic relationships with Alexander Calder and Louise Nevelson.

Frank Lloyd Wright's Hands, Illustrating Architectural Concepts, 1953. Twelve gelatin-silver prints, edition 24/25, each 5 ³/₈ x 5 ³/₈ inches (13.7 x 13.7 cm)

In an early 1950s television interview with Hugh Downs, Wright demonstrated key differences between conventional and organic architecture with his hands. When the conversation was published in Wright's book *The Future of Architecture*, the publisher decided to include a photographic reenactment with the text; thus Guerrero was called in. The first six images demonstrate the concepts of traditional post-and-beam construction. The rest illustrate Wright's ideal organic architecture: His hands are clasped to signify the new system's strength in the next four images, whereas they are joined to illustrate its application in his Unitarian Meeting House in Madison, Wisconsin, in the final two. In support of his new technique, Wright said, "You see one thing merging into another and being of another rather than this old cut, butt and slash." —NT

SUGGESTED READINGS
Boyle, Bernard Michael, ed. *Wright in Arizona: The Early Work of Pedro E. Guerrero*. Tempe: Herberger Center for Design Excellence, Arizona State University, 1995.
Guerrero, Pedro E. *Picturing Wright: An Album from Frank Lloyd Wright's Photographer*. San Francisco: Pomegranate Art Books, 1994.
Wright, Frank Lloyd. *The Future of Architecture*. New York: Horizon, 1953.

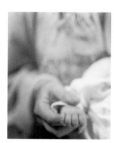

Andreas Gursky
b. 1955, Leipzig, East Germany

Andreas Gursky enrolled at the Folkwangschule in Essen and studied with Otto Steinert in the late 1970s. He then went on to the Kunstakademie in Düsseldorf in the early 1980s, where he worked with Bernd and Hilla Becher. He began to draw critical attention in the latter part of the 1980s as the most prominent member of a new generation of Düsseldorf-trained artist-photographers. Gursky's photographic tableaux are indebted to the Neue Sachlichkeit tradition exemplified by August Sander's physiognomic compendium of Weimar Germany's social types, and are renovated by the Bechers' typologies of anonymous, industrial-era architecture. The artist's digitally montaged "fictive constructions," however, are highly pictorial. They distill an aestheticized vision of our global image-world—its international spaces of politics, finance, and industry; habits of leisure and recreation; scenes of travel and transport; and fetishized objects of art and consumption.

May Day II, 1998. C-print, edition 3/6, 73 x 88 ¹/₂ inches (185.4 x 224.8 cm)

As in Gursky's other May Day pictures documenting rave parties, there is no single vantage point from which to view the frenzied celebration in *May Day II*. Teeming crowds cluster into abstract patterns in this sweeping panorama. Its expansive horizontality is reinforced by an illuminated yellow wave that bisects the image laterally, leading into the blue haze that emanates from an invisible stage on the central-right framing edge. Within an otherwise dark and dispersed field of bodies, the moving golden light picks out swarms of hands. Their homogeneous movement evokes the experience of losing oneself in the mass, adroitly conveying the principle of deindividualization that structures Gursky's representations of social formation. —MM

SUGGESTED READINGS
Galassi, Peter. *Andreas Gursky*. New York: The Museum of Modern Art, 2001.
Syring, Mary Louise, ed. *Andreas Gursky: Photographs from 1984 to the Present*. Munich: Schirmer Art Books, 1998.

John Gutmann
b. 1905, Breslau, Germany (now Wrocław, Poland);
d. 1998, San Francisco

John Gutmann sailed to San Francisco in 1933, when he was prevented as a Jew in Germany from using his advanced degrees in art and philosophy to teach or to exhibit his paintings. Shortly before his voyage, Gutmann purchased a Rolleiflex camera and arranged to send photographs of American popular culture to German illustrated magazines. After he joined the New York-based Pix agency in 1936, his photographs began to appear in American periodicals as well, including *Life* and the *Saturday Evening Post*. The same year, Gutmann began to teach at San Francisco State College, where he remained until his retirement in 1973. His activities in photography, which Gutmann had never considered to be art, diminished after the 1930s, although he toured the Pacific as a military photographer during World War II.

The Cry, 1939. Gelatin-silver print, 2 ¹/₂ x 2 ¹/₂ inches (6.4 x 6.4 cm)

Gutmann's penchant for morbid and erotic symbolism aligns his work of the 1930s with Surrealism, although he made no contact with the official Surrealist movement. The symbolic substitution of one body part for another—in this case a tense, outstretched hand standing in for what the title implies is a desperate throat—was a common Surrealist trope. The Freudian implications of that switch (principally castration anxiety) are doubled in this picture by the psychologizing conceit of the house as a prison of mental anguish, styled after the Surrealists' elected predecessor, Edgar Allan Poe. For all its schematic allusions, *The Cry* nevertheless seems heartfelt in its abrupt simplicity. It may also readily be interpreted as an allegory of existential despair in the year of the Nazi blitzkrieg. —MSW

SUGGESTED READINGS
The Photography of John Gutmann: Culture Shock. Essay by Sandra S. Phillips. London: Merrell Publishers in association with the Iris and B. Gerald Cantor Center for Visual Arts at Stanford University, 2000.
Thomas, Lew, ed. *The Restless Decade: John Gutmann's Photographs of the Thirties*. 1984. Reprint, New York: Harry N. Abrams, 1996.

Raymond Hains
b. 1926, St. Brieuc, France

Raymond Hains rose to prominence in the 1950s when he, with Jacques Villeglé, formed the Affichistes group, who produced works of art by strategically tearing through sections of deeply layered street posters. The heart of his projects has always been the manipulation and abstraction of found concrete reality, arrived at through experimentation and chance. By relying on technical processes, Hains creates a tension between social meaning and a pure formalism empty of the artist's personality. Whereas his *affichiste* works manifest these goals physically, by literally destroying a chosen section of the streetscape, his earliest pieces did so optically, through the photographic medium itself.

Hand Multiplied by a Play of Mirrors (*La main multipliée par un jeu de miroirs*), 1947. Gelatin-silver print, 11 ⁷/₈ x 16 inches (30.2 x 40.6 cm)

In the late 1940s, Hains created a series of "hypnagogic photographs," using specially made, fluted lenses to distort reality into a patterned wash of imagery. In referencing dream states, the series wore its Surrealist allusion on its sleeve, but the pictures themselves were less psychological than purely optical. In this example, the special camera's mechanics have arranged the image of a hand in concentric circles. The thumb and forefinger seem to be holding something, but any possible meaning of the act has been voided by fragmentation and repetition. As a result, the hand, the body's most functional part, has been rendered effectively useless—converted to a purely aesthetic form. —NT

SUGGESTED READINGS
Hains, Raymond. *Décollage: Les Affichistes*. Essay by Benjamin H. D. Buchloh. New York: Zabriskie Gallery, 1990.
———. *J'ai la mémoire qui planche*. Paris: Editions du Centre Pompidou, 2001.
Hains, Raymond, et al. *Raymond Hains*. Essays by Blandine Chavanne et al. Poitiers, France: Editions Musée de la Ville de Poitiers et de la Societé des Antiquaires de l'Ouest, 1989.

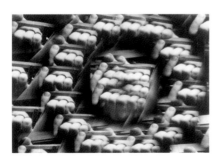

Rachel Harrison
b. 1966, New York

Since her first New York exhibition, in 1991, Rachel Harrison has seemed determined to confound the categories with which modern art has traditionally been understood. A graduate of Wesleyan University, Harrison combines kitschy, often humorous found objects with deliberately manufactured, minimal sculptural elements to form blank assemblages that deny any obvious reading. Many of her works incorporate photographs. On several occasions, she has produced full photographic series, although these are often installed with other objects. Harrison's use of these two modes of expression signals the centrality of photographic themes (the act of looking, states of presence and absence) in her work. In these installations, the relay race between scavenged tchotchkes and indexical images offers her audience a compelling opportunity for exploration.

Untitled (Perth Amboy Series), 2001. C-Print, edition 5/6, 26 x 20 inches (66 x 50.8 cm)

This photograph comes from an installation named after Perth Amboy, the New Jersey town where, late in 2000, an apparition of the Virgin Mary allegedly appeared in a house window. The images depict this window from the outside, with reflections of suburban trees and power lines obscuring all but the hands of pilgrims, who hope to draw closer to the Holy Mother by touching the panes of glass. For Harrison this two-fold communion (through sight and touch) mirrors spectators' relation to her art—a relation also encapsulated in the accompanying sculpture of a wheelchair-bound doll gazing at a photo of a Hollywood blue screen. —NT

SUGGESTED READINGS
Anton, Saul, and Bruce Hainley. "Bear Necessities." *Artforum* 41, no. 3 (Nov. 2002), pp. 162–69, 202, 210.
Arning, Bill. "The Harrison Effect." *Trans*, no. 7 (2000), pp. 168–73.
Hunt, David. "Rachel Harrison." *Arttext*, no. 74 (Aug.–Oct. 2001), p. 80.
Whitney Biennial 2002. New York: Whitney Museum of American Art, 2002.

D. O. Hill and Robert Adamson
Hill: b. 1802, Perth, Scotland; d. 1870, Edinburgh, Scotland
Adamson: b. 1821, Burnside, Scotland; d. 1848, Edinburgh

David Octavius Hill, an established painter and secretary of the Scottish Academy, first met Robert Adamson in 1843, shortly after Adamson, an engineer, had set up one of the first professional photographic studios in Scotland. Almost immediately, they formed a working partnership that was cut tragically short after only four and a half years by Adamson's waning health. That short time, however, was marked by the men's ambition, and they produced thousands of images using the calotype process invented by William Henry Fox Talbot just a few years earlier. Adamson provided technical knowledge, while Hill guided their pictures' artistic direction. Subjects included architectural studies, portraits of the residents of Edinburgh, and documentary images of the nearby fishing village, Newhaven.

The Misses Grierson, ca. 1845. Salt print from calotype negative, 8 x 5 ½ inches (20.3 x 14 cm)

This image shows two daughters of a Scottish reverend possibly connected with the formation of the Free Church of Scotland, whose ministers Hill and Adamson photographed systematically. The patterns and range of tones in the girls' locks of hair and dresses exhibit the rich chiaroscuro effects for which the calotype was frequently praised. The sisters' downcast eyes, along with the seated girl's folded hands, lend them an air of proper demureness; the pose also allows the bright sunlight to reflect off their hair, and their eyes to fall into rich shadow. The girls' nearly identical appearances and tender touch signal another youthful virtue—their delicate affection for one another. —NT

SUGGESTED READINGS
Stevenson, Sara. *David Octavius Hill and Robert Adamson: Catalogue of Their Calotypes Taken between 1843 and 1847 in the Collection of the Scottish National Portrait Gallery*. Edinburgh: National Galleries of Scotland, 1981.
———. *The Personal Art of David Octavius Hill*. New Haven: Yale University Press, 2002.

E. O. Hoppé
b. 1878, Munich; d. 1972, London

The German-born Emil Otto Hoppé was one of the most renowned and successful stage and society portraitists in London in the first half of the twentieth century. Discouraged from pursuing a career as a painter, Hoppé entered the family profession of banking, but began to practice photography in London after meeting the well-known amateur photographer J. C. Warburg. In 1903, he joined the Royal Photographic Society, which hosted his first solo exhibition seven years later. He won general public recognition with the publication in *The Illustrated London News* of sixteen portraits from the show. Commissioned by individuals and the popular press, Hoppé's portraits were distinguished by their keen psychological insight, their stylish design and composition, and their subjects—who included eminent figures in literature (Henry James), science (Albert Einstein), society (King George V and Queen Mary), and politics (Benito Mussolini).

"Snakes": *The Sinuous Arms of the Famous Dancer Roshanara*, ca. 1918. Gelatin-silver print, 9 ¾ x 7 ¼ inches (24.8 x 18.4 cm)

The subject of this image is Roshanara, the dancer who was born Olive Craddock in Calcutta, India, and moved to London at the age of sixteen. There, she enhanced a celebrated production of *Kismet* with her background in ethnic dance. Unlike the photographer's *Book of Fair Women* (1922), which consolidated Hoppé's reputation as a connoisseur of female beauty, this informal, dramatic, and unconventional portrait does not represent the dancer's face but focuses instead on her light, gracefully undulating arms. Hands frequently played an important part in Hoppé's compositions. Here, dark rings adorn Roshanara's hands, suggesting the eyes of the snakes to which the title alludes and reinforcing the exoticism of the sitter's dance specialty. —MM

SUGGESTED READINGS
E. O. Hoppé: 100,000 Exposures. New York: Photo Center Gallery, New York University School of the Arts, 1982.
Pepper, Terence. *Camera Portraits by E. O. Hoppé: 1878–1972*. London: National Portrait Gallery, 1978.

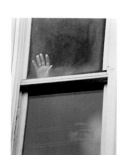

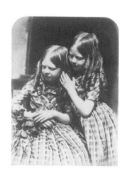

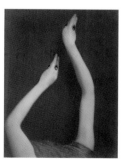

Peter Hujar
b. 1934, Trenton, New Jersey; d. 1987, New York

From the early 1950s through the mid-1970s, Peter Hujar made his living as a magazine photographer, working principally in fashion. The photographic subjects that most interested him, however, came from his memories and his immediate world: animals such as the ones he had known as a child on his grandparents' farm, and artists, transvestite performers, and friends in the downtown New York art scene. His 1976 book, *Portraits in Life and Death*, memorialized these subjects, many of whom Hujar had photographed in intimate, classicizing poses at his East Village studio, opened in 1969. With frankness and elegance, Hujar presented the gay community of lower Manhattan to a local and international art audience, with shows in Paris (1980), Basel (1982), and, after his death, in Amsterdam and Winterthur (1994).

David Wojnarowicz, 1981. Gelatin-silver print, 14 1/2 x 14 1/2 inches (36.8 x 36.8 cm)

Hujar met artist David Wojnarowicz the year this photograph was taken, and the two remained intimate companions and soul mates thereafter. As in much of Hujar's work, stateliness vies with sensuality in this portrait. Wojnarowicz's hand presses gently and inquiringly against his face, so that he seems to be caressing himself like a tender lover, while warm light spills across his upper body. Hujar took several photographs of himself and others in autoerotic positions, and, although he did not show people having sex, his portraits have been described as postcoital. The raised hand that Wojnarowicz holds between himself and the camera reinforces the idea of Hujar's style as one of languid phallicism. —MSW

SUGGESTED READINGS
Peter Hujar: Animals and Nudes. Text by Klaus Kertess. Santa Fe, N.Mex.: Twin Palms, 2002.
Stahel, Urs, and Hripsimé Visser, eds. *Peter Hujar: A Retrospective*. Zurich: Scalo, 1994.

Louis Igout
b. 1837, Paris?; d. after 1881, Paris

Louis Igout operated a photographic studio in the Montparnasse area of Paris from the 1860s, specializing in nudes and figure studies for artists as well as an ever-increasing clientele of voyeurs. The publishing house of A. Calavas, which produced the plate shown in this exhibition, had entered the market for photographic albums only a few years before with a similar specialty. Calavas soon branched out, however, into textiles and decorative arts of all periods, producing an annual series for the Union Centrale des Arts Décoratifs in Paris (1888–98), among other volumes. By the interwar years, when it produced memorial albums for the Exposition Coloniale (1931) and the Exposition de Paris (1937), the Maison Calavas had become a venerable relic of early photographic book publishing.

Set of Hands (Jeu de mains), ca. 1880. Albumen print, 7 1/2 x 5 1/4 inches (19.1 x 13.3 cm)

This collection of disembodied, variously attired hands was intended for artists, who could choose an image and use it to piece together a pose without recourse to a model. However, the sheet as an object also matches the classificatory photographs, recording body parts in various positions, used by Parisian authorities from the early 1870s to advance a putatively exact knowledge of human nature. In these images, aesthetic examination dovetailed with criminological, psychiatric, and other scientific and pseudoscientific ambitions, the common goal being "apprehension" of the subject. Poet and collage artist Georges Hugnet deformed this positivist ideology to irrational purposes, when he reproduced the plate by Igout with his mock chronicle "Petite rêverie du grand veneur" (Little reverie of a master of the hounds) in the Surrealist journal *Minotaure* in 1934. In that changed context, as Kirsten Powell observes, Igout's hands became "strange, bodiless forms," speaking "a sign language for the deaf that has yet to be translated." —MSW

SUGGESTED READINGS
Powell, Kirsten H. "Hands-On Surrealism." *Art History* 20, no. 4 (Dec. 1997), pp. 516–33.
Rouillé, André. *Le corps et son image: Photographies du dix-neuvième siècle*. Paris: Contrejour, 1986.

Pierre Jahan
b. 1909, Amboise, France

Pierre Jahan is best known for *La mort et les statues* (Death and statues), the book he published with Jean Cocteau in 1946. Jahan's images of statuary shattered during the occupation of Paris bridged the Surrealist urban vision of André Breton's *Nadja* (1928) and the humanist photojournalism of the 1950s. Appropriately, Jahan was an early member of the Groupe des XV, an ensemble of documentary photographers dedicated to evoking deeper meanings and emotions through their images. Like other members of this group, Jahan has embraced many venues for his work—from art galleries to magazines to photo-essays in book form—while taking up as many styles, including urban realism, promotional advertising, and late Surrealism.

Hand with Five Eyes (Main aux cinq yeux), 1947. Gelatin-silver print, 11 1/2 x 15 3/8 inches (29.2 x 39.1 cm)

As a late Surrealist work, this photograph hearkens back to that movement's attempts to shock its viewers out of complacent assumptions about reality. Unlike Man Ray or Raoul Ubac, however, Jahan does not overtly manipulate the image. Instead, he relies on selective cropping and strong references to Surrealist iconography. Both eyes and hands recur in the psycho-sexual imagery adopted by Surrealism—fingers in particular often symbolize the phallus. Thus, when Jahan severs this hand's most powerful member, the thumb, he suggests oedipal castration anxiety—an allusion doubled by the five plucked-out eyeballs that signify Oedipus's own fate of blindness.—NT

SUGGESTED READINGS
Cocteau, Jean. *La mort et les statues*. Photographs by Pierre Jahan. Paris: Editions du Compas, 1946.
Frizot, Michel. *A New History of Photography*. Cologne: Könemann, 1998.
Lionel-Marie, Annick. *Collection de photographies du Musée national d'art moderne*. Paris: Editions du Centre Pompidou, 1996.

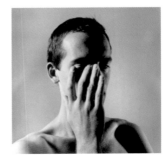

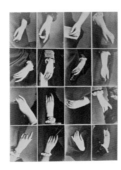

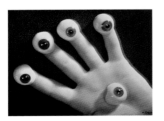

György Kepes
b. 1906, Selyp, Hungary; d. 2001, Cambridge, Massachusetts

Part of the Hungarian diaspora between the world wars, György Kepes went to Berlin in 1930 to work with his country's most famous representative on the international art scene, László Moholy-Nagy. Kepes was trained as a painter, but he became an all-purpose designer, working in advertising, theatrical set design, and exhibition installation. Kepes followed his teacher-employer to London in 1936. When Moholy-Nagy was offered a position in Chicago the following year, he followed him there as well, to what came to be called the Institute of Design. As head of the Light and Color Department in Chicago, and later as founding director of the Center for Advanced Visual Studies at the Massachusetts Institute of Technology in the 1960s, Kepes experimented with a wide range of technologies in the utopian realm where science, art, and visual communication intersect.

———

Hand, ca. 1939. Gelatin-silver print photogram, 14 x 11 inches (35.6 x 27.9 cm)

Like many people who experimented with photography during the 1930s, Kepes used the human hand to symbolize the wedding of originality and individual creativity to a thoroughly mechanical medium—an example of what Kepes saw as the beneficial symbiosis between humans and machines. This particular image, however, does not appear to be the precise, controlled work one might expect of a designer and technician. It suggests instead the flourish of a magician's wave, that instant when the palm opens to reveal that a hidden object has disappeared. Here, however, it is the hand itself that seems to have taken leave of its physical existence—the fingers wafting away like fading smoke signals. —MSW

SUGGESTED READINGS
Coke, Van Deren. *Avant-Garde Photography in Germany, 1919–1939*. New York: Pantheon Books, 1982.
Kepes, György. *Language of Vision*. Chicago: P. Theobald, 1944.
Neusüss, Floris M., et al. *Experimental Vision: The Evolution of the Photogram since 1919*. Niwot, Colo.: Roberts Rinehart Publishers in association with the Denver Art Museum, 1994.

André Kertész
b. 1894, Budapest; d. 1985, New York

André Kertész adopted his gallicized first name, previously Andor, after moving to Paris in 1925, having decided to change his profession from stockbroker to photographer. He worked freelance there for illustrated magazines, and showed his work in exhibitions of the "new photography" such as *Film und Foto* in Stuttgart, Germany (1929). Kertész, who was Jewish, emigrated to New York in 1936, where he slowly became integrated into a new establishment of magazines (thanks to Alexey Brodovitch, the influential art director at Condé Nast) and art institutions. In 1946, Kertész had his first museum exhibition, at the Art Institute of Chicago; a full retrospective was mounted by the Museum of Modern Art in 1964. Kertész has also been the subject of posthumous retrospective exhibitions in 1985 (Chicago and New York) and 1994 (Paris).

———

Distortion Portrait of Carlo Rim and André Kertész, 1930. Gelatin-silver print, 8 ¾ x 5 ½ inches (22.2 x 14 cm)

In 1930, caricaturist Carlo Rim was appointed editor at the illustrated magazine *Vu*. The owner, Lucien Vogel, planned a promotional article, and asked Kertész for portraits capturing Rim's energetic spirit; the result was a series of images made in fun-house mirrors at the Parisian fairgrounds of Luna Park. As he would explore further in his famous *Distortion* series three years later, Kertész recorded limbs that had squeezed themselves into independent bodily entities, like runaway globules of quicksilver. When he lent his free arm, alongside Rim's, to the center of this photograph, their two hands appeared to be doubled, oozing from the corporeal originals into a figure eight suspended in midair. In their mercurial liquidity, these multiplied limbs echo the sinuously elongated shutter wire attached to Kertész's camera.

Arm and Ventilator, 1937. Gelatin-silver print, 8 ½ x 7 ¾ inches (21.6 x 19.7 cm)

Kertész has often been assimilated into French Surrealism, although he never collaborated with the movement. In response to later questions on this subject, the photographer called himself a "naturalist Surrealist." This fortuitously recorded view of a workman repairing a drugstore ventilator shares an anticipatory violence with certain Surrealist sculptures of Alberto Giacometti—scenes that herald an imminent, ghastly accident. Where the disembodied forearms in *Distortion Portrait of Carlo Rim and André Kertész* provoke chuckles and delight, this practically severed limb instills feelings of dread, unease, and suspense. The history of the industrial workplace is filled, after all, with horrible accidents of this nature. *Arm and Ventilator* seems to lend itself to psychological (even psychoanalytic) and political captioning, but as in much of Kertész's work its reticence makes it resistant to definitive interpretation. —MSW

SUGGESTED READINGS
Borhan, Pierre. *André Kertész*. Boston: Little, Brown and Company, 1994.
Phillips, Sandra S., et al. *André Kertész: Of Paris and New York*. Chicago: The Art Institute of Chicago, 1985.

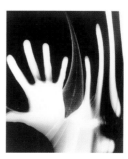

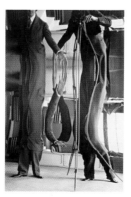

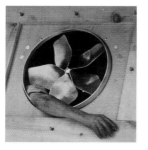

William Klein
b. 1928, New York

William Klein moved to Paris in 1946 to pursue abstract painting. From 1952, however, he worked steadily as a magazine photographer, primarily doing fashion spreads for *Vogue*. In 1954, Klein turned to photographic books, publishing a tetralogy of visual memoirs on cities, from New York (1956) to Tokyo (1964), that share a brash, edgy subject matter and a willfully anti-aesthetic look. Klein then switched his energies to independent cinema. Among his more than one dozen satirical and documentary films are a trio on African American celebrities Eldridge Cleaver (1970), Muhammad Ali (1964/1974), and Little Richard (1980). In the 1970s, he branched out into commercials and feature films for television. Since 1989, Klein has reinvented himself as an artist-photographer, with a series of poster-size enlargements of his camera work marked off in brightly colored paint.

School Out, Dakar, 1963/printed and painted ca. 1995. Gelatin-silver print with enamel paint, 19 ³/₄ x 23 ⁵/₈ inches (50.2 x 60 cm)

Klein's usual impudent proximity was matched in this instance by the subjects themselves, who as he put it tried to "squeeze into [my] camera," using their hands to help climb inside. An outstretched palm in front of the lens usually indicates censorship, by an official or by the subject of the photograph. Here, the hand has been put forward as a substitute for one child who could not manage to thrust his face into the frame. The snapshot, no doubt cropped by the photographer, balances that fortuitously inserted hand with the tongue-wagging antics of another pupil to create a graphic symmetry. The composition is neatly anchored at the center through the pose of a third schoolboy, who offers his smiling face and half-raised hand in echo of his more brazen peers. —MSW

SUGGESTED READINGS
Dieckmann, Katherine. "Raging Bill." *Art in America* 78, no. 12 (Dec. 1990), pp. 71–79.
William Klein: Photographs, Etc. Text by John Heilpern. New York: Aperture, 1981.

Gustav Klutsis (Gustavs Kluces)
b. 1895, Livonia, Latvia; d. 1938, near Moscow

An ethnic Latvian, Gustav Klutsis changed his name when he arrived in Moscow in 1918, as a soldier and an art graduate from Riga. For most of the 1920s, Klutsis studied and taught at Vkhutemas, a school for fine and applied arts that stood at the center of avant-garde involvement with the Soviet Revolution. Klutsis came to specialize in photomontage, initially designing book and magazine covers in the dynamic, fragmentary styles of Futurism and Dada. A loyal follower of Stalin, Klutsis shifted around 1928 to more seamless work, and throughout the 1930s he created posters that exemplified the public face of Stalinist directives. To be outstanding in that climate, as Klutsis was, meant in the end simply to stand out: Despite his fervent glorification of Soviet state policy, Klutsis ultimately paid for his visibility with his life.

Let Us Fulfill the Plan of the Great Projects (*Vypolnin plan velikikh rabot*), 1930. Gelatin-silver print photomontage, 8 ¹/₂ x 5 ¹/₂ inches (21.6 x 14 cm)

Klutsis used this image for two different posters in 1930. The other poster, enhanced with the number "100%" and other small additions, bears the title *Workers, Everyone Must Vote in the Election of Soviets*. A raised palm, in other words, symbolized affirmation and solidarity, a sign to "count me in," whether at the election booth or, in this image, at the factory. Klutsis literally identified himself "100%" with this representation, as he used photographs of his own outstretched palm to create all the hands in the image. *Us* and *Everyone* thus acquire a common identity as a proliferating yet indivisible superorganism. The hand, often considered an index of individuality (as suggested by fingerprinting and palmistry), appears here, with its signature lines smoothed or hidden, as the consummate emblem for the faceless mass. —MSW

SUGGESTED READINGS
Dickerman, Leah, ed. *Building the Collective: Soviet Graphic Design, 1917–1937: Selections from the Merrill C. Berman Collection*. New York: Princeton Architectural Press, 1996.
Gassner, Hubertus, and Roland Nachtigäller. *Gustav Klucis: Retrospektive*. Ostfildern-Ruit, Germany: Gerd Hatje, 1991.
Teitelbaum, Matthew, ed. *Montage and Modern Life, 1919–1942*. Cambridge, Mass.: The MIT Press, 1992.

Barbara Kruger
b. 1945, Newark, New Jersey

In the early 1980s, Barbara Kruger earned widespread critical acclaim with provocative photocollages that played language against image to intervene in the discourse of sexual politics. After attending Syracuse University and New York's School of Visual Arts and Parsons School of Design, where she studied with Diane Arbus, Kruger was variously employed as graphic designer, art director, and picture editor for Condé Nast. Exploiting the techniques of graphic design, her early artistic work enlarges and crops found media photographs, which are stamped with laconic texts in trademark black letters against a red background. Set in Futura bold type, these captions declare, "Your body is a battleground," "We won't play nature to your culture," and "I am your almost nothing." Kruger's aggressive juxtapositions intercept the stereotypes circulated by the signs of advertising, compelling the viewer "to determine who we are, what we want to be, and what we become."

Untitled, 1985. Nine color photolithographic and silk-screen prints, edition 1/50, each 20 ¹/₂ x 20 ¹/₂ inches (52.1 x 52.1 cm)

Splintering the sentence, "We will no longer be seen and not heard," this nine-panel work re-presents old magazine photographs of hands—clasped in prayer, cupped to the ear, pointing to the eye—striated with one-word connotative messages: *be, heard, seen*. Both photography and gesture communicate by analogy. Here, however, linguistic fragments puncture the self-evidence of such analogical representations. For instance, the profile view of a child thumbing her nose is superimposed with the declarative rebuttal *no*, reconstituting playful expression as emphatic rebellion. Such montages revise our cultural stock of poses, redoubling the transformation of the body into picture and converting its seemingly natural denotation into culturally coded connotation. —MM

SUGGESTED READINGS
Barbara Kruger: Thinking of You. Cambridge, Mass.: The MIT Press, 1999.
Barbara Kruger: We Won't Play Nature to Your Culture. London: Institute of Contemporary Arts, 1983.

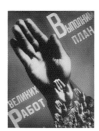

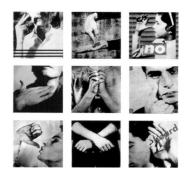

Dorothea Lange
b. 1895, Hoboken, New Jersey; d. 1965, San Francisco

Born Dorothea Nutzhorn to an immigrant German couple, Lange took her mother's maiden name after her father abandoned the family in 1907. Lange trained with society portraitist Arnold Genthe and opened her own photography studio in San Francisco in 1918. Her documentary career began in 1932–33, at the height of the Depression, when she exhibited scenes of social protest in the Bay Area. Several government assignments followed, particularly from the propaganda wing of the Farm Security Administration, which fostered many photographic talents. Lange and her second husband, economist Paul Taylor, concentrated on the condition of migrant workers, coauthoring the picture book *An American Exodus* in 1939. Lange's work pace slowed in the late 1940s, when she became seriously ill. She died during preparations for a 1966 retrospective exhibition.

Migratory Cotton Picker, Eloy, Arizona, 1940 (printed 1940s). Gelatin-silver print, 13 ½ x 10 ½ inches (34.3 x 26.7 cm)

The cracked, blistered, weathered hands of manual laborers were regularly featured in documentary photographs of the 1930s, because they highlighted one of the cruelest ironies of the so-called machine age: people forced to work like machines to keep pace with the mercantile demands of industrialized society, but themselves barely surviving physically. Lange gave basic information to this effect in this picture's full caption: "Resting at cotton wagon before returning to work in the field. He has been picking cotton all day. A good picker earns about two dollars a day working, at this time of the year, about ten hours. This is in an area of rapidly expanding commercial cotton culture." —MSW

SUGGESTED READINGS
Levin, Howard M., and Katherine Northrup, eds. *Dorothea Lange: Farm Security Administration Photographs, 1935–1939: From the Library of Congress.* Glencoe, Ill.: Text-Fiche Press, 1980.
Partridge, Elizabeth, ed. *Dorothea Lange: A Visual Life.* Washington, D.C.: Smithsonian Institution Press, 1994.
Phillips, Sandra S., et al. *Dorothea Lange: American Photographs.* San Francisco: San Francisco Museum of Modern Art and Chronicle Books, 1994.

Jacques-Henri Lartigue
b. 1894, Courbevoie, France; d. 1986, Nice, France

Widely regarded as a child prodigy, Lartigue began making photographs at the age of seven, when his father, himself an amateur photographer, gave him his first camera. These earliest pictures would set a standard for his lifelong career as a photographer, painter, and writer: Lartigue captured the affects of his own life and those around him with consistent freshness and a joie de vivre that maintained formal excellence without sinking into pretentiousness. In 1963, John Szarkowski gave Lartigue his first solo show, at the Museum of Modern Art, New York, which along with a twelve-page spread in *Life* magazine brought him almost instant fame and influenced the era's new wave of art fashion photographers, including Richard Avedon and Helmut Newton.

Florette in Cannes (*Florette à Cannes*), 1942. Gelatin-silver print, 2 x 2 ¼ inches (5.1 x 5.7 cm)

Lartigue met Florette Orméa, his third wife, early in the year this photograph was taken; he described her as "a funny little country girl with the hands of a vamp." Women's hands, especially their fingernails, had always been objects of fascination for Lartigue. On the Riviera, where Lartigue lived for most of his life, brightly painted nails, like glossy lips and increasingly risqué bathing suits, symbolized the joyous luxury of beachside life. In this photograph, Lartigue's soft-focus emphasis on Florette's polished and bejeweled hand captures the passion of the photographer's newfound love and brings to mind the almost desperate obliviousness of life in a resort town during a time of war. —NT

SUGGESTED READINGS
Goldberg, Vicki. *Jacques-Henri Lartigue: Photographer.* London: Thames and Hudson, 1998.
Lartigue, Jacques-Henri. *Jacques-Henri Lartigue.* Introduction by Jacques Damade. New York: Pantheon Books, 1986.
———. *Lartigue's Riviera.* Essay by Mary Blume. Paris: Flammarion, 1997.

Clarence John Laughlin
b. 1905, Lake Charles, Louisiana; d. 1985, New Orleans

Clarence John Laughlin regarded himself as a writer first, a book collector second, and a photographer third. That said, he still produced over seventeen thousand negatives between 1930 and 1967, when he retired from photography for health reasons. The majority of these images exhibit his literary tendencies in allegorical conceptions accompanied by complex, didactic captions and arranged in ambiguous, narrative sequences. Laughlin strongly believed that the fusion of image and text produced the greatest artistic statement, a credo that cast him as a renegade during an era of modernist, purist aesthetics. By the 1970s, however, several nationally touring solo exhibitions hailed him as a predecessor to the high-concept, sociological emphasis of much postmodernist photography.

The Auto-Eroticists, 1941. Gelatin-silver print, 13 ½ x 10 ½ inches (34.3 x 26.7 cm)

This photograph was part of Laughlin's extended series *Poems of the Interior World*, which comprise the core of his symbolic work. The series illustrated what Laughlin termed the "third world of photography"—poetic work, as opposed to the first two worlds of documentary and "pure" photography. In fact, this image was produced in direct contrast to Edward Weston's photographs of the same house, also made that year. Laughlin emphasized the hand as a symbol of the erotic self-gratification that he saw resulting from the emotional decay of modern life. He also explicitly used the hand as a reference to the iconography of Surrealism, whose potential Laughlin first realized the year he made this photograph. —NT

SUGGESTED READINGS
Davis, Keith F. *Clarence John Laughlin: Visionary Photographer.* Kansas City, Mo.: Hallmark Cards, 1990.
Edward Weston and Clarence John Laughlin: An Introduction to the Third World of Photography. New Orleans: New Orleans Museum of Art, 1982.
Lawrence, John H., and Patricia Brady, eds. *Haunter of Ruins: The Photography of Clarence John Laughlin.* Boston: Little, Brown and Company, 1997.

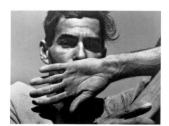

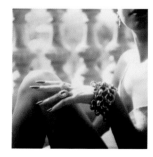

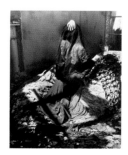

Annie Leibovitz
b. 1949, Waterbury, Connecticut

Annie Leibovitz's career as a photographer began in 1970, while she was a student of painting and photography at the San Francisco Art Institute. She sent a portfolio of her work to Jann Wenner, founder and editor of *Rolling Stone*, who subsequently invited her to New York to attend an interview with John Lennon. Leibovitz's photographs of Lennon appeared on two subsequent covers of the magazine. By 1973, she was the official photographer for *Rolling Stone*, but it was not until around 1980, when she left for *Vanity Fair* and shifted to color film, that she began to hone her distinctive style, placing subjects in narrative scenarios saturated with color. Leibovitz is best known for her pictures of celebrities, though her recent work in *Women* suggests a more democratic turn.

Liberace, Las Vegas, 1981. Cibachrome, edition 3/40, 13 ½ x 13 inches (34.3 x 33 cm)

In her portrait of Liberace, Leibovitz focuses not only on her subject's hands but on how they are adorned. Liberace's hands were, of course, key to his success as a pianist; the jewelry with which they are bedecked and the gilt satin clothing against which they are placed were another important aspect of his iconicity, signifying his luxurious, public lifestyle. The composition of the photograph also conveys the subject's opulence, its square format rife with rich colors that play off one another. Under Leibovitz's direction, the shallow surfaces filling the frame read as commentary both on this particular celebrity and on the broader effects of fame. —NT

SUGGESTED READINGS
Leibovitz, Annie. *Photographs: Annie Leibovitz 1970–1990*. New York: HarperCollins, 1990.
———. *Women*. Essay by Susan Sontag. New York: Random House, 1999.
Stardust: Annie Leibovitz 1970–1999. Humlebaek, Denmark: Louisiana Museum of Modern Art, 2000.

Annette Lemieux
b. 1957, Norfolk, Virginia

Since the 1980s, Annette Lemieux has worked with diverse mediums, including painting, drawing, sculpture, and installations, to create works that refuse to conform to any traditional notion of style. Lemieux received her B.F.A. in 1980 from Hartford Art School at the University of Hartford, where Jack Goldstein and David Salle were teaching. She moved to New York at the beginning of the 1980s, when the contemporary art scene was dominated by Neo-Expressionism. Eschewing this return to the figure and to artisanal modes of production, Lemieux marshaled the techniques and strategies of Conceptual art. While more finely crafted, her work continued to debate the rhetoric of the visual image, favoring the combination of simple forms (such as a brick wall or a shoe sole) to scrutinize art's capacity to function simultaneously as perceptual object and linguistic instrument.

Transmitting Sound, 1984. Gelatin-silver prints, two parts, each 26 x 36 inches (66 x 91.4 cm)

This large diptych constructs a type of alphabet of music. Comprised of five rows of seven photographs, each gridlike panel repeats the image of a pair of hands gesticulating animatedly—in one panel they are wielding a baton; in the other they are clapping. The silence of these works belies their title; here, the viewer is invited not so much to hear as to see the music. Set against a black background, the picture's mixed repertoire of distilled hand gestures operates quietly, like an arbitrary sign language. Together, they form a system that relays abstract sound through the syncopations of the image. —MM

SUGGESTED READINGS
Annette Lemieux: The Appearance of Sound. Sarasota: John and Mable Ringling Museum of Art, 1989.
Pincus-Witten, Robert. "Entries: Annette Lemieux, an Obsession with Stylistics: Painter's Guilt." *Arts Magazine*, no. 63 (Sept. 1988), pp. 32–37.

Helen Levitt
b. 1918, New York

Helen Levitt came to photography early; she was in her late teens when she trained with a commercial photographer and began seeking out the work of Henri Cartier-Bresson, Ben Shahn, and Walker Evans in New York galleries showing photographs. Levitt started taking her own pictures in 1936, following in her heroes' footsteps by documenting life on the streets of New York. Her first solo exhibition was held at that city's Museum of Modern Art in 1943. It consisted of her photographs of city children, a theme for which she became famous and to which she has returned many times in her long career. Other projects have included several films and a book produced with James Agee.

New York, ca. 1939. Gelatin-silver print, 6 x 9 inches (15.2 x 22.9 cm)

Although for some of her photographs Levitt used an angled lens to capture her subjects surreptitiously, in this image her quarry deliberately mugs for—even accosts—her camera. Each of the four boys shows a remarkably individual expression: looking at us patiently, gesticulating in mock indignation, basking in the camera's attention, and looking off at an angle as though slightly confused. But it is the hatless boy to whom one's attention returns, frozen in midspeech, hand Napoleonically inserted into his vest. Levitt catches his direct gaze and dramatic gesture in one of Cartier-Bresson's "decisive moments," and delicately shows the adult postures lurking in adolescent play. —NT

SUGGESTED READINGS
Levitt, Helen. *Crosstown*. Introduction by Francine Prose. New York: Powerhouse Books, 2001.
Livingston, Jane. *The New York School: Photographs 1936–1963*. New York: Stewart, Tabori & Chang, 1992.
Phillips, Sandra S., and Maria Morris Hambourg. *Helen Levitt*. San Francisco: San Francisco Museum of Modern Art, 1991.

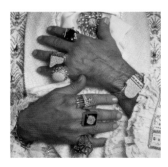

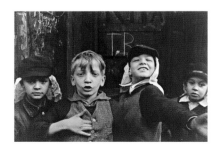

Alexander Liberman
b. 1912, Kiev; d. 1999, Miami Beach, Florida

Alexander Liberman was a man of many lives and artistic styles. As an abstract painter, he helped pioneer an aesthetic of simply colored geometric forms ten years before the advent of Minimalism. He also received numerous commissions for large-scale, outdoor, abstract sculpture. And throughout his life he worked by day in the magazine industry, eventually as art director for Condé Nast. Liberman did not consider photography art, as he found it too impersonal. True to his magazine roots, he favored paparazzi photography, which provided information simply and journalistically. He considered himself an amateur photographer, but insatiably documented the many arenas and personalities with which he engaged.

The Hands of Marcel Duchamp, 1959. Gelatin-silver print, 16 x 20 inches (40.6 x 50.8 cm)

In 1960, Liberman published a collection of photographs titled *The Artist in His Studio*. Throughout the previous decade, he had visited a number of world-renowned artists, occasionally publishing the resulting photographs in his magazines. This photograph of Duchamp is one of four Liberman included in his book, accompanied by his own reflections on the artist. Duchamp had legendarily given up painting for chess, a myth debunked in Liberman's text. Nevertheless, the game was Duchamp's great obsession, and in this image Liberman captured the artist's hands not in the act of creation but at play, a fitting tribute to one who did so much to remove the artist's hand from the work of art. —NT

SUGGESTED READINGS
Kazanjian, Dodie, and Calvin Tomkins. *Alex: The Life of Alexander Liberman*. New York: Knopf, 1993.
Liberman, Alexander. *The Artist in His Studio*. Rev. ed. New York: Random House, 1988.
Rose, Barbara. *Alexander Liberman*. New York: Abbeville Press, 1981.

El Lissitzky (Lazar Lissitzky)
b. 1890, near Smolensk, Russia; d. 1941, Moscow

El Lissitzky left Russia to study architecture and drawing in Germany in 1909; he subsequently divided his life and career between those two countries. In the early 1920s, Lissitzky designed graphics for everyone from the nascent Soviet government and poets of the Russian avant-garde to a Swiss advertising firm. He also vigorously promoted advanced art and Soviet revolutionary values in books and a series of influential exhibition installations. These designs, particularly for the Soviet section of the *Pressa* propaganda exhibition in Cologne (1928) and for the *Film und Foto* exhibition in Stuttgart (1929), made innovative use of photography and photomontage. In the 1930s, Lissitzky worked in design cooperatives on projects such as *USSR Building Socialism* (1933) and *Industry of Socialism* (1935), as well as Soviet pavilions at World's Fairs in Paris (1937) and New York (1939).

The Constructor, 1924. Gelatin-silver print photomontage, 3 x 3 1/2 inches (7.6 x 8.9 cm)

One of a series of self-portraits made in this year, *The Constructor* became an emblematic image for Lissitzky and remains a compelling symbol of his era. With unwavering confidence, head, hand, and instruments are conjoined in a condensed proclamation of the world's constructive future. Insight, passing through the eye, is transmitted instantaneously to the hand and through it into the marks of a new language. Lissitzky repeated the image of a hand holding a compass several times in the 1920s, in advertisements for modern manufacture and modern revolution alike. Here, the compass has traced an arc that inadvertently recalls the halo on a Russian icon, strengthening the impression of this unshakable visionary as a saint or prophet of the new world order.

The Current Is Switched On, 1932. Gelatin-silver print photomontage, 5 3/4 x 4 3/4 inches (14.6 x 12.1 cm)

This photomontage was prepared for a poster to celebrate the fifteenth anniversary of the Soviet Revolution, which had advanced with real and symbolic "electrification"—dynamism, industry, modernization—as its goal. The anonymous, allegorical worker's hand now completes that process, lifting the switch to fulfill Lenin's revolutionary slogan, "Let us electrify the country!" The reality in 1932 was rather different: Lissitzky himself had to hook up a line from a nearby factory in order to get power at his house outside Moscow. In his final poster, a second photomontage appeared to the right of this one with a benevolent Joseph Stalin looking at the viewer, his bust scaled in such a way that he seems to be the head guiding the hand of industrial progress. —MSW

SUGGESTED READINGS
Dickerman, Leah. "El Lissitzky's Camera Corpus." In Nancy Perloff and Brian Reed, eds. *Situating El Lissitzky: Vitebsk, Berlin, Moscow*. Los Angeles: Getty Research Institute, 2003.
El Lissitzky: Architect, Painter, Photographer, Typographer, 1890–1941. Eindhoven: Municipal Van Abbemuseum, 1990.
Tupitsyn, Margarita. *El Lissitzky: Beyond the Abstract Cabinet*. Munich: Schirmer und Mosel, 1999.

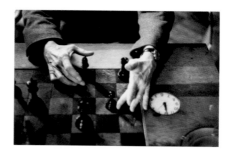

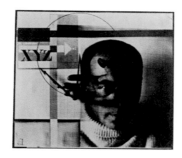

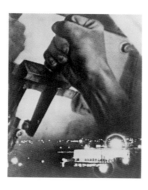

Dora Maar (Henrietta Theodora Markovitch)
b. 1907, Paris; d. 1997, Paris

The daughter of a French Croatian couple, Dora Maar was raised until the age of nineteen in Buenos Aires. After the family returned to Paris in 1926, Maar studied painting and photography, then worked as a photographer. Maar entered the Surrealist orbit in 1933 and demonstrated her affinity for the movement with a number of haunting, lonely photomontages and contemplative portraits of artists and their works. She is perhaps best remembered as the mistress of Pablo Picasso for nearly a decade beginning in 1936, and for his obsessive renderings of her face in the so-called *Weeping Woman* series. Maar showed photographs in several Surrealist exhibitions during the 1930s, and continued to make and exhibit paintings into her final years.

Nusch Eluard, Paris, 1936. Gelatin-silver print, 10 5/8 x 7 1/2 inches (27 x 19.1 cm)

The German-born Nusch (Maria Benz) met Surrealist poet Paul Eluard when she was just seventeen and a dancer in a Parisian music hall. Like Maar and other women of Surrealism, she served as a muse to male artists; unlike Maar, she did not make art herself, except for a few photomontages in the mid-1930s. Maar took several portraits of Nusch that portray her great beauty with much of the spellbound sensuality evident in work by Maar's male colleagues. In this close-up view, Nusch's slender fingers, lit softly from the side, give her visage the fragile allure of porcelain. She appears not to rest her face but to let it float, suspended, within her hands—or one may imagine that her hands are presenting that ethereal mask as a kind of trophy.

Danger, 1936. Photocollage, 9 3/4 x 7 1/4 inches (24.8 x 18.4 cm)

In 1935 and 1936, Maar created a series of photomontages that exemplify a Surrealist sensibility. With evident theatricality this work stages a mysterious drama on an isolated beach, using two figures transported from an altogether different reality. Although neither of the protagonists faces outward, their gestures implicate us as participants in this dreamscape. Like the squatting witness, we might throw up our hands in horror at the power of the hypnotist, who meanwhile conjures another spectator into his domain. Streams of energy flow from his outstretched arms with the force of an ocean current, pulling the spellbound toward the sea. The fact that we stand outside the picture does not mean we are safe, for in this mesmerizing world of illusions the tide is always advancing. —MSW

SUGGESTED READINGS
Caws, Mary Ann. *Dora Maar: With and Without Picasso*. London: Thames and Hudson, 2000.
Dora Maar and Picasso: A Dangerous Love Affair. Texts by Victoria Combalía and Hubertus Gassner. Munich: Haus der Kunst; Marseilles: Musées de Marseille, 2001.

Adrien Majewski
active late nineteenth–early twentieth century, Paris

Little is known about Adrien Majewski, but it is clear that his experiments typify the wave of mid- to late-nineteenth-century investigations that employed photographic processes to research paranormal phenomena. Following the theory of animal magnetism developed by Dr. Franz Anton Mesmer (1734–1815), many scientists came to believe that psychic emanations—variously called auras, odic forces, or effluvia—radiated from all living things. However, these waves were perceptible to only a few individuals, whose reports were often regarded skeptically. At the end of the nineteenth century, scientists attempting to discover an objective device for recording these phenomena turned to photography. In fact, photography and parapsychology rose to prominence during the same period, and their histories are intertwined.

Mr. Majewski's Hand (Main de M. Majewski), ca. 1900–10. Gelatin-silver print, 7 1/8 x 5 1/8 inches (18.1 x 13 cm)

Many scientists regarded the hands as focal points for human auratic emissions. In his 1896 treatise on the subject, Dr. Hippolyte Baraduc located the right and left hands as the paths by which, respectively, positive and negative energy flowed into and out of the body. Majewski produced this photograph by placing his hand onto an unexposed photographic plate without light. The resulting image is meant to follow Baraduc's theories, showing the presence of psychic radiations from the hand; yet, as critics pointed out at the time, heat from the hand alone can cause a negative's emulsion to develop. By blurring its possible chemical, physical, and psychic causes, Majewski's photograph hauntingly evokes photography's seemingly supernatural power during its early years. —NT

SUGGESTED READINGS
"Emanations." In Leslie Shepard, ed. *Encyclopedia of Occultism and Parapsychology*. 3rd ed. Detroit: Gale Research, 1991, pp. 517–23.
Im Reich der Phantome: Photographie des Unsichtbaren. Ostfildern-Ruit, Germany: Cantz, 1997.
Krauss, Rolf H. *Beyond Light and Shadow: The Role of Photography in Certain Paranormal Phenomena: An Historical Survey*. Munich: Nazraeli Press, 1995.

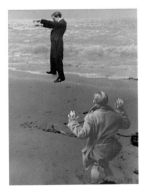

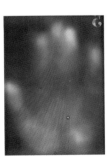

Sally Mann
b. 1951, Lexington, Virginia

In her long career, Sally Mann's subjects have included architectural details, local girls, and most recently landscapes, using homemade glass-plate negatives. Her best known pictures, however, taken throughout the 1980s and into the 1990s, document the childhoods of her son and two daughters. Instead of capturing sunny, stereotypical moments, her images emphasize emotional intensity, unease, and even pain. An often sexualized or violent theatricality replaces the blithe innocence normally attributed to children. While evoking a rich, Southern-gothic atmosphere tinged with Victorian notions of childhood, Mann reworks the vernacular genre of family photography and raises questions about cultural constructions of youth and maternal responsibility.

Last Light, 1990. Gelatin-silver print enlargement, edition 10/25, 20 x 24 inches (50.8 x 61 cm)

Like so many of Mann's photographs, this image uses ambiguity to heighten its emotional impact. Virginia, Mann's five-year-old daughter, lies back against an only partially visible man, whose hand plays with her hair and at her neck. Is this her father or some more ominous figure? Virginia's sultry, half-open eye gleams back at the camera, and her left pinkie finger pulls down on the man's hand as if demanding something of him. It is Virginia who seems to be in control of this scene; the photograph's title may therefore refer not only to the dim twilight of the picture itself, but to the rapid disappearance of youthful purity. —NT

SUGGESTED READINGS
Apter, Emily. "Just Because You're a Man." *Make*, no. 75 (April–May 1997), pp. 3–8.
Mann, Sally. *Immediate Family*. Afterword by Reynolds Price. New York: Aperture, 1990.
Redd, Chris. "Interview: Sally Mann." *Art Papers* 13, no. 2 (March–April 1989), pp. 17–21.

Robert Mapplethorpe
b. 1946, Floral Park, New York; d. 1989, Boston

Robert Mapplethorpe took up photography in 1971, two years after leaving Pratt Institute in Brooklyn, where he studied graphic arts and design and concentrated on mixed-media collage. At first, Mapplethorpe used Polaroid cameras primarily to take self-portraits, with frames often articulated as sculptural elements. By the mid-1970s, however, he had turned to black-and-white prints, focusing as much on society portraits, still lifes, and figure studies as on self-portraiture. Mapplethorpe also became interested in making explicitly sexual photographs, often relating to the increasingly visible gay subculture in his native New York. These images incited much controversy and became the center of the late-1980s debate around censorship and First Amendment rights in the arts.

Lowell Smith, 1981. Gelatin-silver print, edition 11/15, 20 x 16 inches (50.8 x 40.6 cm)

As notorious as much of Mapplethorpe's subject matter was, the most consistent aspect of his oeuvre is its formal, even classicist, quality. Mapplethorpe's images often feature carefully considered lighting and composition that bring out a range of tones without obscuring the idealized physicality of his models. For this piece, the photographer chose dancer Lowell Smith as an exemplar of perfect human form. The rich, dark tones of Smith's hands and arm play off the rigorous geometry of gray and white squares, offering carefully selected contrasts in value and line. As in his best pictures, Mapplethorpe's formal attentiveness sexualizes even his less explicit, everyday subjects. —NT

SUGGESTED READINGS
Celant, Germano. *Mapplethorpe*. London: Hayward Gallery; Milan: Electa, 1992.
Danto, Arthur C. *Playing with the Edge: The Photographic Achievement of Robert Mapplethorpe*. Berkeley: University of California Press, 1996.
Mapplethorpe, Robert. *Black Book*. Foreword by Ntozake Shange. New York: St. Martin's Press, 1986.

Mary Ellen Mark
b. 1940, Philadelphia

Mary Ellen Mark is one of the most influential contemporary practitioners of concerned documentary photography. She studied painting and art history at the University of Pennsylvania (1958–62) and went on to pursue a master's degree in photojournalism there, in the Annenberg School for Communication. In 1966, Mark moved to New York, and two years later attracted the attention of *Look* editor Pat Carbine, who assigned and published her studies of Federico Fellini and of London's pioneering methadone program for heroin addicts. Influenced by the black-and-white photography of Henri Cartier-Bresson, Marion Post Wolcott, and W. Eugene Smith, Mark's documentary work is characterized by its compassionate, straightforward approach to its dispossessed subjects—including women prisoners at an Oregon mental institution in the 1970s, runaway children in Seattle in the 1980s, and homeless families in New York City shelters in the 1990s.

Mother Teresa, Meerut, 1981. Gelatin-silver print, edition 1/75, 6 ½ x 9 ½ inches (16.5 x 24.1 cm)

This image is derived from Mark's two-part documentary project on Mother Teresa's Missions of Charity, which she initiated toward the end of 1979 on assignment for a *Life* magazine feature, "Teresa of the Slums: A Saintly Nun Embraces India's Poor," and resumed again on her own for two months beginning in January 1981. The photograph's monochrome record of Mother Teresa departs from dramatic and sentimental mass media representations of her charity work. Spare and contemplative, it focuses on the compassionate leader's hands, wrinkled and clasped as though in prayer. This icon of Mother Teresa's humanity—her frailty—is also an image of the tools of her altruistic ministrations; the single, simple gesture tells the story of a lifetime devoted to the dispensation of food, medicine, and support to those in need. —MM

SUGGESTED READINGS
Fulton, Marianne. *Mary Ellen Mark: 25 Years*. Boston: Little, Brown and Company, 1991.
Mary Ellen Mark: American Odyssey. Philadelphia: Philadelphia Museum of Art, 1999.

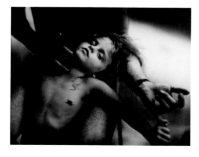

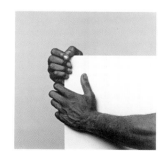

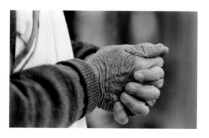

Paul McCarthy
b. 1945, Salt Lake City, Utah

Paul McCarthy has put it bluntly: "My work deals with trauma." In the early 1970s, following his studies at the University of Utah, the San Francisco Art Institute, and the University of Southern California, the Los Angeles-based artist began to present performances and photographs of the body subjected to abject immolations, like swallowing a urine-soaked hot dog or walking over glass shards. In the 1980s, McCarthy created figurative sculpture that meshed the confrontational body theater of those early performances with an updated Pop vocabulary that twisted popular childhood icons. Besmirched, grotesquely outfitted, deranged, and obscene, McCarthy's characters defile cherished children's fables and family sitcoms. These infantilized personae—clowns, stuffed toys, and Disney characters—loop childhood trauma into adult dysfunction to stage a spectacle of regression.

#14 Untitled (Taking Photo), 1999. Cibachrome, edition 3/6, 70 x 48 inches (177.8 x 121.9 cm)

This image documents a performance and installation executed at the Tomio Koyama Gallery in Tokyo, which featured McCarthy dementedly drawing and painting with chocolate syrup inside a claustrophobic stage set. Here, the artist is shown wearing a mask with Asian features and dressed in a monstrous Santa costume that prominently displays his genitals. Partially obscured by the camera held over his face, McCarthy turns toward the viewer as though to snap his or her picture. At once exhibitionist and voyeur, this "Tokyo Santa" transforms the sentimental icon of childhood innocence into a caricature of sexual perversion.

Right Hand (Propo Series), 2001. Cibachrome, edition 3/3, 70 x 48 inches (177.8 x 121.9 cm)

This photograph is taken from the *Propo* series, which is made of objects from McCarthy's performances from 1972 through 1984. He stored and later photographed them beginning in the 1990s. It displays the stump of a right hand, hung on a hook like a piece of butcher's meat. The hand's scabbed and dirty appearance contrasts with the sky-blue background, mingling the suggestion of bodily mutilation with that of bright cheer. As such, this "prop" routes the sexual fetishism of the body part—in which a foot, for instance, might figure an entire erotic body—into a synecdoche for a violated subject. —MM

SUGGESTED READINGS
Paul McCarthy. Introduction by Lisa Phillips; essays by Dan Cameron et al. Ostfildern-Ruit, Germany: Hatje Cantz; New York: Distributed Art Publishers, 2000.
Rugoff, Ralph, et al. *Paul McCarthy*. London: Phaidon Press, 1996.

Ralph Eugene Meatyard
b. 1925, Normal, Illinois; d. 1972, Lexington, Kentucky

An optician by profession, Ralph Meatyard practiced photography for twenty years exclusively as an amateur. Meatyard studied camera technique and the history of photography with a local chapter of the Photographic Society of America in Lexington, to which he moved in 1950. He became its president in 1959. Eight years later, he opened his own store, Eyeglasses of Kentucky, where he hung work by friends such as Emmet Gowin and Judy Dater. Meatyard was one of the first Americans to make staged photographs, now a reigning artistic tendency. An adept at Zen, he used the conflict between photographic clarity and theatrical ambiguity to evoke a complex vision that partook of "a truth of illusion and the illusion of truth."

Untitled (Hand in Doorway), 1961. Gelatin-silver print, 10 x 8 inches (25.4 x 20.3 cm)

Although Meatyard frequently worked in series, this particular image does not belong to a larger cycle. It does relate, however, to other photographs from the same year, such as an image of a boy holding a prosthetic hand in front of the same doorway that is depicted here. In both cases, the setting, like the severed limb, is eerily unnatural and incomplete, and suggests the irruption of other states of being into a banal reality headed steadily toward entropy. —MSW

SUGGESTED READINGS
Keller, Judith. *Ralph Eugene Meatyard*. London: Phaidon Press, 2002.
Tannenbaum, Deborah, ed. *Ralph Eugene Meatyard: An American Visionary*. Akron: Akron Art Museum; New York: Rizzoli, 1991.

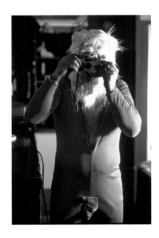

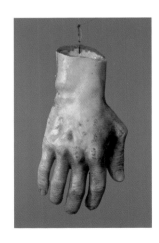

Annette Messager
b. 1943, Berck-sur-Mer, France

In three decades of installations, Annette Messager has filled a parallel universe with her stuffed creatures, photographic fragments, and reworked truisms, creating constellations of daydreams and nightmares that appear infantile but are despairingly mature. Beginning in 1973, Messager deployed invented identities—collector, trickster, and so on—to address issues of feminism and power relations in a personal, even disquietingly intimate, way. The level of violence increased in later installations such as *Chimeras* (1982–84) and *Spikes* (1991–93), the latter a room of drawings of corpses, frantic scribblings, and pointed weapons stuck into rag doll-animal hybrids. The interchange between individual trauma and historical catastrophe remains a guiding preoccupation in Messager's work.

Lines of the Hand ("Fear") (Les Lignes de la main ["Peur"]) (detail), 1987. Gelatin-silver print with acrylic, charcoal, and pastel, framed in wood, and colored pencil on wall; installation variable, photograph 5 x 3 ½ inches (12.7 x 8.9 cm)

This work is one of a series of image-text combinations inspired by the chiromantic value of creases in our palm. Complexities of personality are distilled into discrete emotional states, manifested through a word attached to each photograph: *tolerance*, *trust*, *hesitation*, *fear*, and so on. The chosen word is repeated, obsessively, to form a column at least six feet high below the image. It is as if the depicted hand had leaked its inmost essence to the ground. That flow has congealed into lines of writing, and the hand's own telltale marks have been effaced by the figure of a death's-head, like a face on a tarot card. Messager's palm readings operate at the nexus of bodily awareness, visual art, and language; all three, she suggests, are sign systems we use to codify our sense of our own fatedness. —MSW

SUGGESTED READINGS
Conkelton, Sheryl, and Carol S. Eliel. *Annette Messager*. New York: The Museum of Modern Art; Los Angeles: Los Angeles County Museum of Art, 1995.
Grenier, Catherine. *Annette Messager*. Trans. David R. Howell. Paris: Flammarion, 2001.
Hall, Donald. *Corporal Politics*. Cambridge, Mass.: The MIT List Visual Arts Center, 1992.

Lee Miller
b. 1907, Poughkeepsie, New York; d. 1977, Chiddingly, East Sussex, England

In 1927, Lee Miller was literally rescued from an oncoming bus by publisher Condé Nast, who subsequently hired her as a model and put her on the cover of *Vogue*. Almost two decades later, this same magazine ran her powerful photographs of the liberation of France and the horrors of Nazi concentration camps. Between these achievements, Miller frequented the avant-garde circles of Paris, starred in Jean Cocteau's first film, and most famously became the student and muse of Man Ray, with whom she discovered the process of solarization in 1929. Miller was as much a force behind the camera as before it, working in a Surrealist and then a journalistic idiom before renouncing her work for a postwar life of domesticity with her husband, the painter and collector Roland Penrose.

Condom, 1930. Gelatin-silver print, 9 x 6 ¾ inches (22.9 x 17.1 cm)

Miller made this photograph during her years with Man Ray, and it exhibits typical Surrealist characteristics. The everyday object of the title has been deliberately misused—inflated and nearly punctured by a contorted hand. Because of its precise framing, the photograph obscures the identity of the person shown as well as of the condom itself, disrupting the banality of its everyday meaning and opening up what André Breton might have called its "convulsive beauty." At the same time, the erotic associations of the condom, shown literally about to break under tension, evoke the air of destructive sensuality for which the Surrealists, not least Man Ray and Miller, were known. —NT

SUGGESTED READINGS
Calvocoressi, Richard. *Lee Miller: Portraits from Life*. New York: Thames and Hudson, 2002.
Livingston, Jane. *Lee Miller Photographer*. New York: Thames and Hudson, 1989.
Penrose, Antony. *The Lives of Lee Miller*. New York: Holt, Rinehart and Winston, 1985.

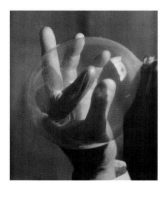

Lisette Model
b. 1901, Vienna; d. 1983, New York

Like those of her contemporary Weegee, Lisette Model's dark, disquieting street portraits paved the way to the practice of urban documentary vérité. Born into a wealthy Jewish family in prewar Vienna, Model trained as a pianist, studying with the composer Arnold Schoenberg in the early 1920s. After discovering photography by chance a decade later in Paris, she created the pictures of the French bourgeoisie on the Promenade des Anglais in Nice that Ralph Steiner published in *PM* magazine in 1941 under the title "Why France Fell." Model settled in 1937 in New York, where she trained her lens on marginalized inhabitants of the city, often rendered grotesque and ominous by her unusually low camera angles and close cropping. In 1950, Model began teaching at the New School for Social Research in New York, deeply influencing such notable photographers as Diane Arbus.

Lower East Side, New York, 1942. Gelatin-silver print, 13 ¼ x 10 ½ inches (33.7 x 26.7 cm)

Derived from the photographic series *Lower East Side* (1939–42), this image pictures an elderly woman, obese, sedentary, and shabbily shod, overflowing a chair balanced precariously on a stoop. Shot from up close and below, her foreshortened figure bulges toward us, generating a sense of spatial compression that evokes the immigrant populations crammed into the neighborhood's tenements. Unflatteringly depicted with eyes shut and mouth agape, the anonymous woman stretches her arm diagonally across the coarsely grained print (following the movement of the banister railing beside her), while her hand gestures toward the street beyond the photograph's framing edge. If the subject's outstretched index finger bitingly condenses her daily vocation of gossip, it also shows how the photograph itself operates deictically, like an arrow whose referent is made visible by the action of pointing. —MM

SUGGESTED READINGS
Lisette Model. Millerton, N.Y.: Aperture, 1979.
Thomas, Ann. *Lisette Model*. Ottawa: National Gallery of Canada, 1990.

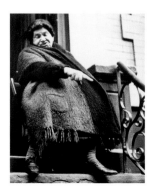

Tina Modotti
b. 1896, Udine, Italy; d. 1942, Mexico City

Actress, model, photographer, revolutionary, spy, enigma—these are common descriptions of the talented polyglot Tina Modotti. Raised in Italy and Austria, Modotti followed her father to California in 1913, where for several years she starred in immigrant theater productions. She switched careers after meeting photographer Edward Weston in Los Angeles. The two moved to Mexico in 1923, where Modotti developed from Weston's apprentice into an independent partner. She took portraits and made an increasing number of political images for publication in left-wing journals such as *The New Masses* (New York), *Arbeiter illustrierte Zeitung* (Berlin), and *El machete* (Mexico City). Deported to Europe in 1930, she tried briefly to continue with photography in Berlin, then became a relief worker in Moscow, Paris, and Civil War-era Spain. Modotti returned in 1939 to Mexico City, living a semiclandestine existence there that culminated in her death under mysterious circumstances in January 1942.

Flor de manita, 1925. Platinum print, 4 3/4 x 3 3/4 inches (12.1 x 9.5 cm)

This curiously shaped succulent was described by Weston as a witch's claw, and Modotti's photograph has since been termed an allegory of wretched desperation. The latter characterization seems more to the mark, because for all its supposed hideousness the diminutive plant looks fragile rather than frightening. Most interesting, however, is our impulse to ascribe human traits to natural elements, reflected already in the local name for this floral oddity: "little-hand flower." Such an object appears to need no further introduction, and indeed Modotti has framed it simply and with level directness. Its evocative shape addresses us of its own accord—"speaking in hands," it is an emblematic emissary for the current exhibition.

Hands of a Marionette Player, 1929. Gelatin-silver print, 9 x 5 1/4 inches (22.9 x 13.3 cm)

Modotti made a number of photographs in 1929 of Mexico's left-wing puppet-theater movement, and she became particularly friendly with artist Louis Bunin, whose hands may be depicted in this photograph. Like the plays, Modotti's works functioned as allegorical exposés of power—attacks on the manipulation of people and events by usually unseen higher forces. The hands of the demonic figure below possess their own force as well, such that the puppet and puppeteer seem to pull at each other in a contest of wills. The struggle is nevertheless asymmetrical; little fists of wood cannot match the relaxed, nimble forearms above. The hands of a faceless human cast ominous shadows in this perpetual tug-of-war, while "the people" raise their arms aloft with a grimace that suggests strength and impotence simultaneously. —MSW

Suggested Readings
Armstrong, Carol. "This Photography Which Is Not One: In the Gray Zone with Tina Modotti." *October*, no. 101 (summer 2002), pp. 19–52.
Lowe, Sarah M. *Tina Modotti: Photographs*. New York: Harry N. Abrams in association with the Philadelphia Museum of Art, 1995.
Tina Modotti: Una nueva mirada/A New Vision, 1929. Morelos: Universidad Autónoma del Estado de Morelos, 2000.

László Moholy-Nagy
b. 1895, Bácsbársod, Hungary; d. 1946, Chicago

László Moholy-Nagy is most closely associated with the Bauhaus in Germany, where he taught from 1923 to 1928. He played a fundamental role at that school of art and design, propagating the values of international Constructivism: research and experimentation with new technologies, active engagement with the modern world, and furtherance of utopian abstraction. Forced by right-wing political pressure to leave the Bauhaus, Moholy continued a transnational existence that had begun when he emigrated from his native Hungary in 1919. He worked as an exhibition designer, a typographer, and an art director for companies and publications in Berlin (1928–33), Amsterdam (1934), and London (1935–37), before landing in Chicago as director of the New Bauhaus, known from 1944 as the Institute of Design.

Photogram (Fotogram), 1925. Gelatin-silver print photogram, 10 x 8 inches (25.4 x 20.3 cm)

Moholy-Nagy praised the photogram, or cameraless photograph, as an arena for experimental composition "in which light must be sovereignly handled as a new creative means, like color in painting and sound in music." The idea of "handling light" comes through with literal force in this work, in which fingertips (probably the artist's) glow with a brilliant, luminous energy. Two hands have been brought together from opposite directions to leave this ghostly double imprint, such that the shadowy hand serves as a picture frame in which to view its whitened counterpart. It is as if the first hand were not only a tool for working with light but itself a photosensitive surface. Within this utopian circuit, hands appear as both the source of creative emanations and the means to fix them in visible form. —MSW

Suggested Readings
Fiedler, Jeannine. *László Moholy-Nagy*. Trans. Mark Cole. London: Phaidon Press, 2001.
Hight, Eleanor M. *Picturing Modernism: Moholy-Nagy and Photography in Weimar Germany*. Cambridge, Mass.: The MIT Press, 1995.
Passuth, Krisztina. *László Moholy-Nagy*. London: Thames and Hudson, 1985.

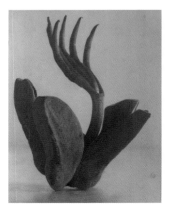

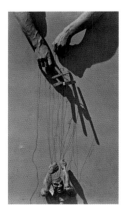

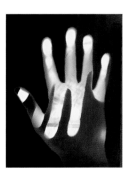

Pierre Molinier

b. 1900, Agen, France; d. 1976, Bordeaux, France

Pierre Molinier was a painter for most of his life, taking up photography only at age fifty. Having been influenced by Surrealism for many years, in 1955 Molinier formally introduced himself to André Breton, who gave him a solo show. Thereafter, photomontage was of central importance for Molinier. In 1967, he began collaborating with the Vienna Actionist Hanel Koeck, and his work became popular among European artists of the time. After his death by suicide in 1976, Molinier was honored with a retrospective at the Musée National d'Art Moderne, Centre Georges Pompidou, Paris.

Untitled, 1969. Gelatin-silver print photomontage, 9 ¹⁄₂ x 7 inches (24.1 x 17.8 cm)

Molinier's lifelong obsessions with sex and death manifested themselves in his work as body fragments and fetishes, sex toys and sadomasochistic gear, legs and genitals in transsexual panoply. In fact, many of his images began as self-portraits, upon which the artist used photomontage to pile successive layers of masquerade, playing out his own fantasies on the mirror image of his body. In this photograph, Molinier sits in garters on a piano stool, bearing a veiled woman's head and four extra gartered legs. In spite of this demonstrative profusion, a gloved hand demurely covers the central locus of the bodies' genitals, fending the viewer off from that most defining of intimacies. —NT

SUGGESTED READINGS

Durant, Mark Alice. "Lost (and Found) in a Masquerade: The Photographs of Pierre Molinier." *Exposure* 29, nos. 2–3 (1994), pp. 27–35.
Molinier, Pierre. *Pierre Molinier*. Winnipeg: PlugIn Editions, 1997.
Petit, Pierre. *Molinier, une vie d'enfer*. Paris: Editions Ramsay/Jean-Jacques Pauvert, 1992.
Pierre Molinier. Valencia, Spain: IVAM Centre Julio González, 1999.

Vik Muniz

b. 1961, São Paulo

From the moment of his New York debut in 1989, Vik Muniz has been known for his combination of technical virtuosity, wry humor, and complex conceptual underpinnings. Much of his work consists of art historical references realized with everyday materials like chocolate syrup, dirt, and string. Muniz often uses photography to document his elaborate and ephemeral constructions. Like the Dadaists, he employs multimedia to engage debates on high and low culture, but in his postmodern approach the results are less affronts to aesthetics than witty, sophisticated, and ultimately accessible jokes on the history of art and culture.

Dürer's Praying Hands, 1993. Toned gelatin-silver print, edition 2/3, 34 x 30 inches (86.4 x 76.2 cm)

In the late 1920s, Alfred Stieglitz photographed a number of clouds in a series titled *Equivalents*, which carved out a conceptual use for photography, atmospherically emblematizing man's essential freedom. Some sixty-five years later, Muniz undermined Stieglitz's metaphysical investment in clouds in a series of the same name. In this photograph, cotton balls mimic a cloud, which in turn mimics an image of praying hands drawn by Albrecht Dürer (which are themselves a mimetic representation of reality). Each layer fails to adequately copy the next, yet their very equivalence also undermines the system of representation itself. Meaning spirals into absurdity, glossed over by the apparent simplicity of the photograph and the sheer ordinariness of seeing shapes in clouds. —NT

SUGGESTED READINGS

Collins, Tricia, and Richard Milazzo. *Vik Muniz, the Wrong Logician, or, Cats and Dogs Fighting Like Clouds*. New York: Grand Salon; Verona, Italy: Ponte Pietra, 1993.
Grundberg, Andy. "Sweet Illusion." *Artforum* 36, no. 1 (Sept. 1997), pp. 102–05.
Vik Muniz: Seeing Is Believing. Sante Fe, N.Mex.: Arena Editions, 1998.

Eadweard Muybridge (Edward James Muggeridge)

b. 1830, Kingston upon Thames, England; d. 1904, Kingston upon Thames

Eadweard Muybridge is best known for his motion studies of people and animals, beginning with his 1872–73 photographic proof that a horse takes all four of its hooves off the ground while running. The son of a coal merchant, Muybridge sailed for America in 1851 expressly to make a name and fortune for himself. He first became a landscape photographer based in San Francisco, taking pictures of Yosemite and the Pacific Northwest. Then in the 1870s, he developed multiple-camera photography to record sequential movement. His mammoth achievement, *Animal Locomotion*, was published in 1887, after three years of research supported by the University of Pennsylvania. Muybridge lectured widely to publicize his results, and beginning in 1879 gave presentations of his images projected in rapid sequence that count among the first motion-picture shows.

Movement of the Hand; Drawing a Circle, plate 532 of *Animal Locomotion*, 1887. Collotype, 7 ¹⁄₂ x 15 inches (19.1 x 38.1 cm)

Muybridge's stated aim for the nearly eight hundred studies he made of people and animals in motion was to catalogue patterns of movement in a way valuable to scientists and artists alike. Recent historians have called into question the presumption of scientific method in these photographic sequences, and their value for artists turned out to be inspirational rather than observational. Muybridge's project has, however, secured a lasting place as a work of art in its own right. This print is unusual, for most plates in *Animal Locomotion* show full-figure subjects. The level of abstraction attained here (through repetition of the hand as an autonomous object) was consciously pursued in art over two decades later. —MSW

SUGGESTED READINGS

Braun, Marta. *Picturing Time: The Work of E. J. Marey, 1830–1904*. Chicago: University of Chicago Press, 1992.
Mileaf, Janine. "Poses for the Camera: Eadweard Muybridge's Studies of the Human Figure." *American Art* 16, no. 3 (fall 2002), pp. 30–53.
Muybridge, Eadweard. *Muybridge's Complete Human and Animal Locomotion*. 1887. Reprint, with introduction by Anita Ventura-Mozley, New York: Dover Publications, 1979.

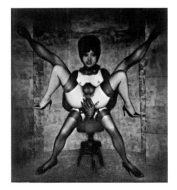

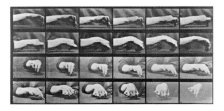

Nadar (Gaspard-Félix Tournachon)
b. 1820, Paris; d. 1910, Paris

Gaspard-Félix Tournachon lived and worked at the intersection of bohemian elitism and popular stardom. He took Nadar as his nom de plume in 1838, when he began associating with the free-spirited, starving Parisian literati later immortalized in Giacomo Puccini's *La Bohème* (1896). By 1854, when he learned photography and entered the failing business of his younger brother Adrien, Nadar had become famous as a caricaturist. Portraits of important friends such as Charles Baudelaire and Théophile Gautier enhanced the studio's reputation considerably. Within five years, his success seemed assured, yet Nadar showed an aversion to stability and prosperity. Massively in debt, he nevertheless preferred testing new photographic techniques and subjects to memorializing the bourgeoisie. Despite this aloofness and chronic financial setbacks, the Nadar studio continued in Paris into the 1940s, three decades after its founder's death.

Paul Legrand, ca. 1855. Salt print, 8 ½ x 6 ¼ inches (21.6 x 15.9 cm)

Paul Legrand studied under Jean-Baptiste (Gaspard) Deburau, the most famous mime of the nineteenth century, whose invention of the poetic, misunderstood Pierrot (in previous tradition a lazy servant known as Pedrolino) created a mass attraction during Nadar's youth. Legrand is shown here as Pierrot, "frozen" in surprise and shock. Pantomime, a form of mime that concentrates on specific situations and personalities, depends enormously on the expressivity of face and hands, and Deburau and Legrand made those parts of the body all-important—the rest of Legrand's body has practically disappeared under its costume. Without uttering a sound, the pantomimist uses his hands to describe things and events—to "talk" about them. Legrand makes this clear in an exaggeratedly communicative pose that recalls both newspaper caricatures and Baroque statuary. —MSW

SUGGESTED READING
Hambourg, Maria Morris, Françoise Heilbrun, and Philippe Néagu. *Nadar*. New York: The Metropolitan Museum of Art, 1995.

James Nasmyth
b. 1808, Edinburgh, Scotland; d. 1890, London

Photography was but one of James Nasmyth's many interests. He drew prolifically, and many of his works were made into lithographs, circulating mostly among his friends and acquaintances. Nasmyth's greatest historical contribution, however, was in the field of engineering: In 1842, he patented his steam hammer, which radically transformed the practice of casting metal and was a key development in Britain's industrial revolution. Nasmyth retired from engineering in 1856, and spent the last thirty-four years of his life pursuing another great love: astronomy. In 1874, he published *The Moon: Considered as a Planet, a World, and a Satellite*, which he coauthored with James Carpenter.

Back of Hand & Shrivelled Apple. To Illustrate the Origin of Certain Mountain Ranges by Shrinkage of the Globe., 1874. Two Woodburytypes, each 4 ½ x 3 ¼ inches (11.4 x 8.3 cm)

These images appeared in *The Moon* as illustrations of a theory advanced by Nasmyth and Carpenter to explain its rough surface. They suggested that the moon had once been actively volcanic, but eventually lost energy and began to cool. As this occurred, its core contracted, leaving its crust loose and hanging, much like the skin of an aging body or a desiccated apple. This idea of contraction was a variation of the widely held nineteenth-century view of terrestrial geology—the theory of plate tectonics was devised only in the 1960s—but Nasmyth's and Carpenter's metaphoric leap to the physiology of the hand was entirely their own. —NT

SUGGESTED READINGS
Elderfield, John, et al. *Modern Starts: People Places Things*. New York: The Museum of Modern Art, 1999.
Nasmyth, James. *James Nasmyth, Engineer: An Autobiography*. Ed. Samuel Smiles. London: John Murray, 1883.
Stevenson, Sara. *Light from the Dark Room: A Celebration of Scottish Photography*. Edinburgh: National Galleries of Scotland, 1995.

Bruce Nauman
b. 1941, Fort Wayne, Indiana

Bruce Nauman came of age in California in the 1960s, and his ideas were formed in a climate of social protest, free bodies, and increasing fluidity in definitions of art. By the time of his first museum show in 1972, Nauman had developed influential work in photography, performance, object art, and installations, as well as the new medium of video. Nauman used his own body frequently as material for temporary sculptures, bunching up and manipulating his flesh or contorting his face in live or taped performances that tested the limits of creativity and artistic identity. His work continues to range over many mediums and to treat an exceptionally broad set of interests. He is especially well known for a series of neon signs that present apparently simplistic yet perspicacious analyses of the circuits of power, desire, and violence encoded in conventional language and gestures.

Studies for Holograms (a–e), 1970. Five screenprints, four: edition 95/150, one: edition 48/150, each 26 x 26 inches (66 x 66 cm)

In 1968, Nauman made his first set of holograms—images that are contained in flat surfaces yet appear to float in three-dimensional space. A separate set of poses was captured on infrared film and used to make this set of screenprints two years later. Nauman frequently referred to drawings and prints as "studies" in these years, even when they postdated the work in question. Nearly all of his experiments in various mediums address the body as an ersatz sculptural material, and are intended to prompt questions about the source of artistic creativity and to deflate rhetoric about artistic genius. —MSW

SUGGESTED READINGS
van Bruggen, Coosje. *Bruce Nauman*. New York: Rizzoli, 1988.
Simon, Joan, ed. *Bruce Nauman*. Minneapolis: Walker Art Center, 1993.

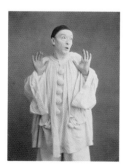

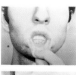
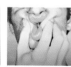

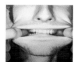

Charles Nègre
b. 1820, Grasse, France; d. 1880, Grasse

Charles Nègre hails from the first generation of painters turned photographers. Around 1839, Nègre moved to Paris, where he entered the studios of Paul Delaroche, Michael Drolling, and J. A. D. Ingres with the ambition of becoming a history painter. In 1844, after attending a demonstration of the daguerreotype process at the Institut de France, he started to work in this medium. But improvements in the calotype process, which enabled the production of multiple prints from one negative, soon inspired the artist to work instead with paper photography. Nègre recorded picturesque genre scenes—of ragpickers, organ-grinders, and chimney sweeps—and architectural monuments of Paris and the Midi, manipulating his negatives to achieve the atmospheric effects of painting and drawing through the light and dark of photography.

Hand Study (*Etude de main*), 1850s. Waxed-paper negative, 11 x 8 ¼ inches (27.9 x 21 cm)

A hand surfaces like a ghostly presence in this waxed-paper negative study—virtually skeletal, fingers splayed, cropped below the wrist. The details of its form are obscured, its outlines partially dissolved into the misty aureole of light that floods its open background. Nègre is known for drawing directly on his negatives with a pencil, delineating the elongation of the fingers, for instance, or darkening the recess between index finger and thumb or the patch of flesh just above the wrist bone. In this work, the hand functions both as subject and as instrument, modifying tonal values to accord with painterly conventions and exploiting the qualities of the waxed paper to enhance its textured surface. —MM

SUGGESTED READINGS
Borcoman, James. *Charles Nègre: 1820–1880*. Ottawa: National Gallery of Canada, 1976.
Heilbrun, Françoise. *Charles Nègre, photographe, 1820–1880*. Paris: Editions des Musées Nationaux, 1980.

Shirin Neshat
b. 1957, Qasvin, Iran

Sent abroad in 1974, Shirin Neshat was in Los Angeles at the time of the Iranian Revolution five years later. She returned to her native country for the first time in 1990, and was moved by the changes she witnessed to resume an interrupted career in art. Neshat held her first solo exhibition in 1993, with photographs similar to the one in this exhibition. She later turned to moving images, and has since concentrated on a body of film and video installations that suggest the particularities of social relations and bodily awareness in Islamic society. Her work has been shown at the Art Institute of Chicago and the Tate Gallery, London, and received first prize at the 1999 Venice Biennale.

Stories in Martyrdom, 1995. Gelatin-silver print, edition 2/3, 54 ¼ x 39 ¾ inches (137.8 x 101 cm)

Stories in Martyrdom belongs to *Women of Allah*, a series of photographs that present a seated woman, covered except for her hands and feet, cradling a rifle. Martyrdom, Neshat has said, is taught in contemporary Iran to be a moral imperative that proceeds from witnessing divine truth; it is presented as an ultimate honor and expression of fidelity to Islam. It is unclear whether the hands in this photograph are prepared to fire their weapon or mother it. They seem, in any case, to be immobilized by writing; the palms, open like pages in a book, are covered in poetry (by Iranian writer Monirou Ravanipour). The verses, translated by Neshat, read in part: "The earth was trembling . . . children were running to their mother's arms . . . the ugly, black hand had wrapped around the moon . . . the moon was choking, dying before the women's eyes." —MSW

SUGGESTED READINGS
Shirin Neshat. Vienna: Kunsthalle Wien; London: Serpentine Gallery, 2000.
Wallach, Amei. "Shirin Neshat: Islamic Counterpoints." *Art in America* 89, no. 10 (Oct. 2001), pp. 136–43.
Zabel, Igor. "Women in Black." *Art Journal* 60, no. 4 (winter 2001), pp. 16–25.

Gabriel Orozco
b. 1962, Jalapa, Mexico

One of the most renowned contemporary artists to emerge from Latin America, Gabriel Orozco shifts between various aesthetic and geopolitical spaces to create objects that allude to the drift, transience, and mobility of everyday life. To this end, he employs heterogeneous procedures ranging from drawing, sculpture, and photography to video and performance-installations. He rearranges banal ephemera like yogurt lids and fruit, splices through industrially fabricated structures, and reconfigures ordinary environments into temporary situations. These works engage the concerns with process, site-specificity, and institutional critique that oriented Minimal and Conceptual art, as well as Brazilian Neo-Concretism's invitation for viewer participation.

My Hands Are My Heart, 1991. Two Cibachromes, edition 5/5, each 9 x 13 ¾ inches (22.9 x 34.9 cm)

Traditionally seen as generically distinct, sculpture and photography slide into one another in this pair of Cibachrome images. The top photograph isolates the artist's upper torso. His arms, cropped by the frame, fold across the body's midsection, drawing our attention to the votive icon of two clasped hands, their fingers raised in relief around a concealed object. The lower picture proffers a slightly more distant view of the same figure. His hands open to disclose a heart-shaped, red-clay form stamped with the imprint of the artist's fingers. This gesture reveals the indissociability of the artisanal and the mechanical. It also links the sculptural practice of modeling, whereby the object is molded by the hand to the indexicality specific to the photographic image, which exists as a physical trace of the thing to which it refers. —MM

SUGGESTED READINGS
Buchloh, Benjamin H. D., and Alma Ruiz. *Gabriel Orozco*. Los Angeles: Museum of Contemporary Art, 2000.
Temkin, Ann, and Susan Rosenberg. *Gabriel Orozco: Photogravity*. Philadelphia: Philadelphia Museum of Art, 1999.

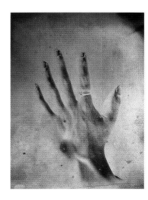

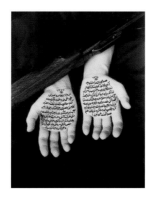

Cornelia Parker
b. 1956, Cheshire, England

A graduate of the University of Reading in England, with a 1982 M.F.A., Cornelia Parker rose to prominence in the late 1980s with a series of inventive sculptural installations. Her work since then has systematically avoided any signature style; rather, Parker has chosen to occupy a range of processes, mediums, display practices, and artistic strategies. She is perhaps best known for *Cold Dark Matter: An Exploded View* (1991), in which she had a garden shed blown up and then hung its reassembled fragments in open space in a gallery. In *Exhaled Schoolhouse* (1990) she covered the exterior of a Glasgow school with chalk lines. The collaborative piece *The Maybe* (1995) consisted of an exhibition-scale installation that included the actress Tilda Swinton sleeping in a vitrine for seven days. For *Pornographic Drawings* (1996–2001), Parker melted down confiscated pornographic videotapes and made drawings with the resulting solutions.

Blue Shift, 2002. Four Polaroid prints, each 3 1/8 x 3 3/8 inches (7.9 x 8.6 cm)

Parker often appropriates objects with well-known historical or cultural associations. For a piece of 2001, also titled *Blue Shift*, Parker bought the dress worn by Mia Farrow in Roman Polanski's film *Rosemary's Baby* (1968), framed it in a light box, and displayed it as sculpture. In this companion piece, she has photographed shots of Farrow in which the blue garment is visible. Farrow's horrified expression, notable in her wide eyes and hand clamped over her mouth, changes slightly from frame to frame. In a witty double entendre typical of Parker's work, the "blue shift" of the title thus refers both to the clothing and to the frozen movement from frame to frame. —NT

SUGGESTED READINGS
Cornelia Parker. Boston: Institute for Contemporary Art, 2000.
Cornelia Parker. Turin: hopefulmonster, 2001.
Tickner, Lisa. "A Strange Alchemy: Cornelia Parker." *Art History* 26, no. 3 (June 2003), pp. 364–91.

Gordon Parks
b. 1912, Fort Scott, Kansas

The youngest of fifteen children, and forced into independence as a teenager, Gordon Parks picked up photography in 1938 as both an expressive and an entrepreneurial activity. Parks talked his way into fashion shoots for clothing stores in Minneapolis and Chicago, then landed a position on the staff of the Farm Security Administration in 1942 by showing work he had made in the black ghettos of Chicago's South Side. These two poles, fashion and documentary, defined Parks's reputation, first at *Vogue* and then as a staff photographer for *Life* from 1948 to 1970. In the 1970s, Parks turned to cinema, directing *Shaft* and several other iconic works of American pop culture. His polymath activities also include music and poetry.

Pastor Ledbetter, Metropolitan Baptist Church, Chicago, 1953 (printed ca. 1994). Gelatin-silver print, 20 x 28 inches (50.8 x 71.1 cm)

A minister stands at his pulpit, arms raised and eyes closed, silently leading his assembly in prayer. The hand is an essential instrument in the Judeo-Christian tradition, where it figures in everything from the earth's creation, to rituals of benediction and ordainment, to daily gestures of worship. The auratic bubble around the pastor's body in this photograph augments his gesture with a hum of electric tension that seems to emanate from his uplifted arms. Those arms summon a force field of hope and reflection, yet the palms also read as spiritual stop signs, arresting all movement and commanding a hushed reverence to match the pastor's own. —MSW

SUGGESTED READINGS
Parks, Gordon. *Half Past Autumn: A Retrospective*. Essay by Philip Brookman. Boston: Bulfinch Press in association with the Corcoran Gallery of Art, Washington, D.C., 1997.
———. *Voices in the Mirror*. New York: Doubleday, 1990.

Irving Penn
b. 1917, Plainfield, New Jersey

From 1934 to 1938, Irving Penn studied at the Philadelphia Museum School of Industrial Art under magazine guru Alexey Brodovitch, initiating a long career of work for and around magazines. Alexander Liberman, art director for *Vogue*, eventually encouraged Penn to devote himself to photography. Over the years, Penn's work has included fashion photographs, still lifes, ethnographic photo-essays, travel stories, nudes, and portraits of key figures in the literary and visual arts. Jumping consistently from genre to genre of professional photography, Penn has approached each with a fresh eye; as a recent show of his *Earthly Bodies* attests, he has never been hemmed in by commercialism.

Mud Glove, New York, 1975. Four-part platinum-palladium print, edition 12/15, overall 50 x 42 inches (127 x 106.7 cm)

Penn's earliest still lifes were promotional images for magazines like *Vogue* and dwelled on the accoutrements of haute couture. In the early 1970s, however, the photographer turned to the trash and detritus of everyday life, creating a series on cigarette butts, among others. This image takes a rotting glove and, typically, isolates it from its context, paradoxically preserving its decay in an archival platinum-palladium print. As in so much of his work, Penn essentially bites the hand that feeds him, subverting the upper-class orientation of so much commercial photography. Yet in opening this unremarkable waste object to the closest scrutiny, he also extracts from its finest details a surprisingly acute beauty. —NT

SUGGESTED READINGS
Foresta, Merry A., and William F. Stapp. *Irving Penn Master Images: The Collections of the National Museum of American Art and the National Portrait Gallery*. Washington, D.C.: Smithsonian Institution Press, 1990.
Penn, Irving. *Still Life*. Boston: Bulfinch Press, 2001.
Szarkowski, John. *Irving Penn*. New York: The Museum of Modern Art, 1984.

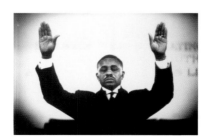

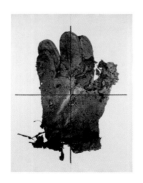

Giuseppe Penone
b. 1947, Garessio, Italy

Among the youngest artists assimilated to the tendency baptized Arte Povera by critic Germano Celant, Giuseppe Penone rapidly gained international attention in the late 1960s. His work was included in survey exhibitions at the Museum of Modern Art, New York (1970), the Mole Antonelliana, Turin (1984), and P.S. 1, Queens, New York (1985); his ongoing museum solo-exhibitions career also began before he was thirty. Penone's performances and installations proceed from an engagement with organic matter that articulates both mystical and ecological convictions. He holds an animistic belief in the kinship between humans and natural things, particularly trees, and has frequently sought to impart a synesthetic experience of art by using such materials as scented laurel leaves, green wood, bark, and running water or ice. "Art which reflects seen and absorbed images, and poetry," he has said, "are both actions which require eyes on the ends of one's fingers."

To Unwrap One's Skin (Svolgere la propria pelle) (detail), 1971. Seven zinc-plate photographs, edition 15/25, each 27 ¹/₂ x 39 ¹/₂ inches (69.9 x 100.3 cm)

Penone has likened the skin to a glove with magical and artistic properties. His image of a handlike, epidermal casing endows the surface of the body with a creative agency, a power to shape conscious experience that Penone maps, inch by inch, in this catalogue of over six hundred photographs showing life-size segments of his own body. To reinforce the equation of skin and hand, Penone features his hands in this project disproportionately, compared to the percentage of skin they actually possess. The seven panels of photographs, moving roughly in sequence from head to feet, were published in 1971 as an artist's book by gallerist Gian Enzo Sperone. —MSW

SUGGESTED READINGS
Penone, Giuseppe. *Svolgere la propria pelle*. Turin: Sperone, 1971.
Tosatto, Guy, et al. *Giuseppe Penone*. Trent: Galleria Civica d'Arte Contemporanea, 1997.
Zero to Infinity: Arte Povera 1962–1972. Minneapolis: Walker Art Center, 2001.

Gilles Peress
b. 1946, Neuilly, France

Contemporary photojournalist Gilles Peress is highly regarded for his odysseys through countries torn by civil strife and revolution. In the late 1960s, he studied political science and philosophy at the Institut d'Etudes Politiques (1966–68) and the Université de Vincennes (1968–71). Peress began to photograph seriously in 1970, documenting life in a French coal mining village defeated by the failure of a major labor strike. He joined the prestigious agency Magnum Photos in 1972, acting as its president in 1986–87 and 1989–90. Peress consistently deploys photography as a tool to empower the viewer to reflect critically on the traumas of contemporary experience—the Irish civil rights struggle in Northern Ireland, genocide in Rwanda, wartime atrocities in Bosnia, and Iran in the throes of revolution. Concerned with redressing the gap between history and memory, Peress records the intimate ephemera of everyday life alongside the unnameable spectacles of catastrophe.

French Hospital, Sarajevo, August–September, 1993, 1993. Gelatin-silver print, 24 x 36 inches (61 x 91.4 cm)

In a letter to Philip Brookman published in *Farewell to Bosnia*, Peress reflected: "I think I have a particular disease that has to do with time and history. I call it the curse of history and it has to do with the fugitive absence/presence of personal and collective memory." This powerful record of wartime injury, drawn from that book, depicts the naked upper torso of a young man against a white hospital bed, his arms raised, foregrounding his amputated hands. The photograph loudly protests the violence of war. It recalls Peress's own family history—his father lost an arm as a soldier in World War II—and urges viewers to reconstruct the reality before them by integrating their individual pasts with our collective present. —MM

SUGGESTED READINGS
Peress, Gilles. *Farewell to Bosnia*. Zurich: Scalo, 1993.
———. *The Silence*. Zurich: Scalo, 1994.

Roy Pinney
b. 1911, New York

Roy Pinney got his start in photography by participating in a research expedition to the rain forest in British Guyana in 1930, and love of adventure motivated many of his subsequent assignments. Pinney worked through the 1970s, first for New York newspapers (covering Mafia assassinations, among other events), then for illustrated magazines and advertising agencies. He had short assignments overseas during World War II and the 1973 Yom Kippur War, and traveled extensively on his own as well. An avid wildlife enthusiast, Pinney has devoted himself over the last quarter century to nature films, including work for the television series *Wild Kingdom*, and to books on animals and indigenous civilizations.

Reading Braille, ca. 1936. Gelatin-silver print, 13 ¹/₂ x 10 ¹/₄ inches (34.3 x 26 cm)

The braille system, named after its blind inventor, Louis Braille, features six raised dots deployed in combinations that largely simulate printed letters. The most commonly used script for the visually handicapped, braille is, however, difficult to learn—as this photograph of small hands working their way across a seemingly immense expanse of text suggests. Recent research indicates that the body processes braille not just through touch but through posture and movement in a complex, mediated process. Nevertheless, in common understanding, touch alone guarantees a visceral communication with the world; indeed, the blind are often thought to possess a visionary awareness that compensates for their lack of ordinary sight. The prominence and gentle lighting of the book in this image reinforce such spiritual associations; one thinks of the miniature hand, affixed to a pointer, that sweeps over lines in the Torah as they are recited during Jewish prayer services. —MSW

SUGGESTED READING
Millar, Susan. *Reading by Touch*. London: Routledge, 1997.

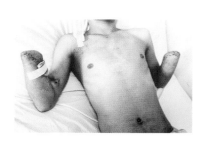

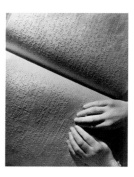

Sigmar Polke

b. 1941, Oels, Germany (now Olesnica, Poland)

After arriving in West Germany at age twelve, Sigmar Polke studied for most of the 1960s at the Kunstakademie in Düsseldorf. There, he met a number of artists who wanted to counter the polarization of art and politics that seemed to reduce the world to a contest between Soviet Communism and American-brand capitalism. Polke and others devised a short-lived but influential movement dubbed "Capitalist Realism," which played the bland heroics of Socialist Realism against the hollow dynamism propounded in capitalist news and advertising. In 1971, Polke undertook a series of "bad" photographs in Paris, trying chemical experiments and antiart techniques that he subsequently extended to his paintings and printmaking. His openness to chance effects and unorthodox materials has had a liberating influence on subsequent artistic generations, which was reinforced through Polke's professorship from 1977 to 1991 at the Hochschule für Bildende Kunst in Hamburg.

Untitled, 1972. Solarized gelatin-silver print, 7 x 9 inches (17.8 x 22.9 cm)

Polke set up his first darkroom in 1972, in a farmhouse near Düsseldorf, where he began "liberating chemicals" in earnest. Hallucinogenic drugs, particularly magic mushrooms, had an important place in Polke's life at this time, and the fantastically altered surfaces of his prints reflect not just his opposition to standard photographic procedures but his state of mind. The most banal actions, such as handling a small box, could give cause for intense, fascinated contemplation. Here, for instance, Polke created a solarized print, silvering the contours of the image by exposing the developing print to light for an instant before placing it in the final fixative bath. This shamanistic handling, which approaches modern technology as a quasi-alchemical interaction with the environment, relates to a broad current of neoprimitivist artistic practices in Europe, particularly in Germany and Italy, at that time. —MSW

SUGGESTED READINGS

Schjeldahl, Peter. "The Trashmaster." *The New Yorker* 74, no. 38 (Dec. 7–14, 1998), pp. 207–10.

Sigmar Polke. Photoworks: When Pictures Vanish. Los Angeles: Museum of Contemporary Art; Zurich: Scalo, 1995.

Robert Rauschenberg

b. 1925, Port Arthur, Texas

An inclusive and prolific artist, Robert Rauschenberg was associated in the 1950s and 1960s with a multitude of avant-garde movements in the United States and Europe, including Surrealism, Abstract Expressionism, the Situationist International, Nouveau Réalisme, and Pop art. Initially a photographer and abstract painter, Rauschenberg began in 1954 to make "Combines," assemblages of painting and heterogeneous objects; he later employed the same collagelike process to create silkscreen paintings with an array of found photographic imagery. The success of these works allowed him to pursue his grander technological projects of the 1960s and 1970s—both three-dimensional and in printmaking—that remain cornerstones of his artistic practice today. Rauschenberg has also been a committed advocate for artists' rights and liberal political causes, and he traveled the planet in the 1980s to further crosscultural exchanges hindered by global politics.

Cy + Relics, Rome, 1952 (printed ca. 1993). Gelatin-silver print, edition 7/50, 20 x 16 inches (50.8 x 40.6 cm)

Rauschenberg and painter Cy Twombly met in 1951, then studied together the following year at Black Mountain College, the progressive arts school in North Carolina. The two Southerners became fast friends and traveled to Italy by boat, later settling for a time in Rome. (Twombly has resided in Italy ever since.) For those familiar with Twombly's art, which conveys classical grandeur through smears and scribblings, this photograph seems a humorous allusion to monumental finger painting. Rauschenberg, too, painted directly with his hands on occasion during those years. But the image is arresting mostly for its disparity in scale. Sandwiched among these outsized fragments, Twombly seems to join their ranks in empathic petrification. His sketchbook in hand, he nevertheless stands too close to use it, preferring instead to contemplate a resting boulder-size sculpture that seems eternally prepared to point the way.

Norman's Place #2, 1955 (printed ca. 1980). Gelatin-silver print, edition 2/50, 20 x 16 inches (50.8 x 40.6 cm)

With the immediacy and casualness of a beatnik filmmaker, Rauschenberg frames a scene at a friend's apartment in which anything that might satisfy narrative expectations—the man's face, the room itself, the view through the window—is shoved half out of sight. The resulting image parodies film noir, leaving the viewer to concentrate on a half-hidden subject apparently awaiting a telephone call. The silence and the erotic suggestiveness of Norman's pose heighten our suspense. Looking at the slightly blurred phone and the man's tensed arm, we cannot tell whether he is waiting to make or receive this call, or perhaps choosing not to respond to a telephone that is already ringing. —MSW

SUGGESTED READINGS

Hopps, Walter, and Susan Davidson. *Robert Rauschenberg: A Retrospective*. New York: Guggenheim Museum, 1997.

Robert Rauschenberg Photographs. New York: Pantheon, 1981.

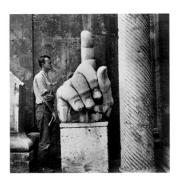

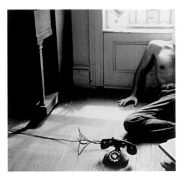

Man Ray (Emmanuel Radnitzky)
b. 1890, Philadelphia; d. 1976, Paris

Man Ray was a key member of the Dada and Surrealist circles in New York and Paris from the 1910s through the 1930s. Although best known for his photographs, and next for his humorous or unsettling object-sculptures, Man Ray rested his claim to art above all on his activities as a painter. He nevertheless marketed his other skills tactically. Arriving in Paris in 1921, he quickly established himself as a portrait photographer, working with artists and for magazines such as *Vanity Fair* and *Vogue*. At the same time, his cameraless images, which he dubbed "rayographs," were well publicized and became key symbols of innovation for artists throughout Europe. In 1940, Man Ray relocated for ten years to Los Angeles, where he was given his first retrospective exhibition (1944). Museum shows and critical studies have followed regularly since the mid-1960s.

Rayograph with Hand and Egg, 1922. Gelatin-silver print photogram, 9 ¹/₂ x 7 inches (24.1 x 17.8 cm)

Man Ray described the fantasy-laden imprint of objects placed on or above photosensitive paper and exposed without the intermediary of a camera as a liberation that let him create "directly with light itself." These new photographs also stressed origination rather than reproduction, the conventional function of photography. In this image, for instance, the artist moved his hand during exposure to create a second "shadow" hand seemingly from thin air. In their day, Man Ray's darkroom experiments had an allure of science and mystery. Given that context, the egg balanced on the artist's fingertip may be likened to Christopher Columbus's presentation, egg in hand, to the Spanish court, in which he proposed that the world was a globe and as such could be circumnavigated. The ovoid fingered by Man Ray hangs upside down, however. In the new world of the rayograph, objects float as planes of light and darkness, and the earth is made flat once more.

Untitled, 1924. Gelatin-silver print, 9 x 6 ¹/₂ inches (22.9 x 16.5 cm)

This combination photograph—superimposing a detail from a portrait of Marcel Duchamp onto a picture of a chair—appeared in the first issue of *La révolution surréaliste*, in December 1924. It heralded a rich strain of Surrealist photography in the 1930s and for several decades afterward, when negatives and prints were manipulated to "reveal" the irrational life contained within ordinary objects. The approach was indebted to occultism and spiritualist movements, in which cameras were often used to provide "proof" of phenomena inexplicable by scientific methods. This image by Man Ray also presents the chair as a love object, ready to receive the sitter's backside with caresses—and it literalizes the "armchair" as well.

Hands (Mains), 1949. Solarized gelatin-silver print, 10 x 8 inches (25.4 x 20.3 cm)

Hands are everywhere in Man Ray's work. The homonymic relation of his pseudonym, Man, and the French *main* inspired several objects and photographs; the fetishistic suggestion that women's hands are ideal sites of commercial and erotic exchange emanates from numerous other works. Man Ray photographed hands covering pudenda, breasts, and buttocks; hands bedecked by jewelry, blacked in ink, and painted like gloves; hands and arms doubled by or hidden behind substitutes in paper and wood, or made to seem missing in imitation of the Venus de Milo. The elongated fingers of this model's hands, rimmed in solarization, are like delicate porcelain objects or perhaps like an object rising out of its shadow. The contact between palm and fingers also provokes an uncanny sense of contact between the viewer and the image—yet the latter remains trapped within its gelatin-silver emulsion, suspended as if under glass. —MSW

Suggested Readings

de l'Ecotais, Emmanuelle, and Alain Sayag, eds. *Man Ray: Photography and Its Double*. Corte Madera, Calif.: Gingko Press, 1998.

Foresta, Merry A., et al. *Perpetual Motif: The Art of Man Ray*. Washington, D.C.: National Museum of American Art, Smithsonian Institution; New York: Abbeville Press, 1988.

Mileaf, Janine. "Between You and Me: Man Ray's Object to Be Destroyed." *Art Journal* 63, no. 1 (spring 2004), pp. 4–23.

O. G. Rejlander
b. 1813, Sweden; d. 1875, London

The Victorian photographer Oscar Gustav Rejlander vigorously championed Pictorialist art photography throughout his career. Born in Sweden, Rejlander studied painting, sculpture, and lithography in Rome before moving to England. Settling in Wolverhampton in 1846, he earned a modest living as a painter. He took up photography in 1852, creating sentimentalized character studies of street urchins, domestic genre scenes, and theatrical moral allegories. The best known of these staged representations, *The Two Ways of Life*, used models and props to exemplify the paths of virtue and vice, posed according to the model of Raphael's *School of Athens* (1510–11). These dramatic performances are reinforced by rhetorical illumination and sewn together by his signature photographic style, combination printing—the technique whereby multiple negatives are joined together, printed on a single sheet of paper, and rephotographed to produce a seamless print.

Study of Hands, 1850s. Salt print from wet-collodion negative, 7 ³/₄ x 9 ¹/₂ inches (19.7 x 24.1 cm)
Study of Hands, 1850s. Albumen print from wet-collodion negative, 5 ¹/₂ x 6 ¹/₂ inches (14 x 16.5 cm)

These two hand studies record the hands of a married woman gracefully set around the small antique object resting delicately on the drapery covering her leg. The oval salt print is ethereal in effect, its subject haloed by the disembodied glow of light that dissolves the edges of her form as it expands toward the periphery of the image. In the albumen print counterpart, the dark material of the model's dress fills the image, intensified by the bits of black around its edges and recesses. In both, the hand is not merely an anatomical subject. It also refers to Rejlander's darkroom manipulations, offering an allegory of the intention and artifice used to mold "the pencil of light" into the picture of art. —MM

SUGGESTED READINGS
Bunnell, Peter C., ed. *The Photography of O. G. Rejlander*. New York: Arno Press, 1979.
Spencer, Stephanie. *O. G. Rejlander: Photography as Art*. Ann Arbor, Mich.: UMI Research Press, 1985.

René-Jacques (René Charles André Giton)
b. 1908, Phnom Penh, Cambodia

René Giton turned to photography full-time around 1930, after flirting with poetry and literature. Working freelance under the adopted name René-Jacques, he placed his photographs in popular illustrated magazines and in exhibitions for initiates at the little galleries Studio 28 (1934) and the Pléiade (1937), among others. René-Jacques came into his own after World War II, presiding over inaugural manifestations of corporate professionalism in his field: the Association Nationale des Photographes Publicitaires et de Mode (1945); the Groupe des XV, with Robert Doisneau and others (1946); and SPADEM, the agency responsible for protecting artists' copyright. Honored with retrospectives in France in 1984 and 1991, René-Jacques has reciprocated by donating the majority of his negatives and prints to the French state.

Hand and Dice (La main et les dés), ca. 1928. Gelatin-silver print, 9 x 6 ¹/₂ inches (22.9 x 16.5 cm)

This early work, made when Giton still thought of himself primarily as a poet, stands in the shadow of "Un coup de dés jamais n'abolira le hazard" (A throw of the dice will never abolish chance; 1897) by Stéphane Mallarmé. Mallarmé's poem, first published in 1914, inspired many writers intent on treating language as a medium of visual expression. For René-Jacques, who soon turned to illustrating poetry collections with his photographs, images instead formed a kind of writing: The hand's imprint is a primal signature, leaving negative traces of its creased skin like lines on the page. The image suggests that poetic value, in writing and photography alike, inheres in the open-ended passage from manuscript to print. However, the work acquired a precise and explicitly political valence (perhaps supplied by the artist) as early as 1932, when it appeared in an issue of the progressivist Danish journal *Social Kunst* under the title *War? A Roll of the Dice*. —MSW

SUGGESTED READINGS
Borhan, Pierre, et al. *René-Jacques*. Besançon: La Manufacture, 1991.
Bouqueret, Christian. *Des années folles aux années noires*. Paris: Marval, 1997.

Albert Renger-Patzsch
b. 1897, Würzburg, Germany; d. 1966, Wamel bei Soest, West Germany

Albert Renger-Patzsch's professional career was brief but tremendously influential. As a boy, Renger-Patzsch followed his father's intense interest in amateur photography, and by 1921 he had landed a job in a photography archive. His leap to fame came in 1928, with the appearance of *Die Welt ist schön* (The world is beautiful), a paean to formal harmonies in nature and industry and to the camera's ability to record those harmonies with sober majesty. Renger-Patzsch became a leading voice in the booming world of photography, and in 1933 an instructor at the progressive Folkwangschule in Essen—but the Nazis largely disbanded that institution soon after. Renger-Patzsch withdrew into a semiretirement that lasted until his death, although he occasionally lectured and exhibited, and in his final years accepted a number of national and international awards.

Hands (Potter) (Hände [Töpfer]), ca. 1925. Gelatin-silver print, 6 ³/₄ x 9 inches (17.1 x 22.9 cm)

Renger-Patzsch believed fervently in the photograph as a repository of truthful information about the world. Technique meant everything to him, for photography was a craft, and one could attain truth—and creativity—only through patient work and observation. This photograph of a potter's hands, one of Renger-Patzsch's earliest, may thus be taken as an analogy for his professional self-perception. He would probably have argued that the potter works (with his hands and with the aid of a small machine) to liberate a shape immanent in the lump of unformed clay. Renger-Patzsch certainly brought that understanding to his own photographic practice, in which methodical selection and painstaking technique yielded views that promised a small window onto essentials of form and meaning. —MSW

SUGGESTED READINGS
Albert Renger-Patzsch. Special issue of *History of Photography* 21, no. 3 (fall 1997).
Albert Renger-Patzsch: Joy before the Object. Essay by Donald Kuspit. New York: Aperture in association with the Philadelphia Museum of Art, 1993.

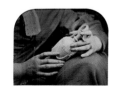
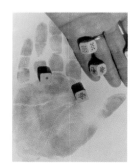
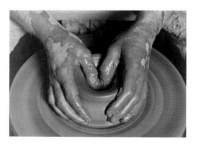

Marc Riboud
b. 1923, Lyons

Marc Riboud was working as an industrial engineer when he began making photo-stories as a hobby. In 1950, he met Henri Cartier-Bresson, who after looking at his pictures strongly recommended that he not give up his day job. For Riboud this discouragement only increased the challenge; soon thereafter, he took a week off work to finish a project and never returned. Cartier-Bresson became Riboud's mentor, eventually offering him a position with Magnum Photos. For the past fifty years, Riboud has traversed the world, capturing images of people immersed in their everyday lives. His most extensive work has been done in China, where he has focused on the hardships of life under Mao and after, always attuned to the small joys people find in the most difficult circumstances.

Jan Rose Kasmir at a Demonstration against the Vietnam War, Washington, D.C., 1967. Gelatin-silver print, 10 x 15 inches (25.4 x 38.1 cm)

One of Riboud's most famous images, this photograph once bore a caption reading, "Confrontation between a flower and the bayonets of soldiers guarding the Pentagon during the March for Peace in Vietnam." The picture, which was not staged, is a textbook example of the "decisive moment" preached by Riboud's teacher, Cartier-Bresson. In this image of opposition between military force and a lone protester, Riboud caught the many contrasts that marked the events of the late 1960s—from the protests themselves, to the generation gap, to the reality of life and death during a time of war. —NT

SUGGESTED READINGS
Capa, Cornell, ed. *The Concerned Photographer*. New York: Grossman Publishers, 1972.
Harris, Mark Edward. *Faces of the Twentieth Century: Master Photographers and Their Work*. New York: Abbeville Press, 1998.
Riboud, Marc. *Photographs at Home and Abroad*. New York: Harry N. Abrams, 1986.

Ringl + Pit
Ringl (Grete Stern): b. 1904, Wuppertal, Germany
Pit (Ellen Auerbach): b. 1906, Karlsruhe, Germany

Grete Stern and Ellen Auerbach met in 1929 in a photography course taught by Walter Peterhans, who was soon to become a photography instructor at the Bauhaus. Auerbach had previously studied sculpture, while Stern held a commercial license as a graphic artist. Both were seduced by the camera as the ultimate instrument of modern vision, and they enthusiastically abandoned their former identities to found an advertising agency in Berlin, its name taken from their childhood nicknames. The images they made over the next five years express the photographic language of the times, with their marked preference for close-ups, dynamic angles, and a focus on dramatically isolated objects. Stern and Auerbach emigrated from Germany in separate directions just months after Adolf Hitler assumed power in 1933, consigning their teamwork to history; thanks to the Museum Folkwang and others, that consignment has been reclaimed within their lifetime.

Soapsuds (Seifenlauge), 1930. Gelatin-silver print, 7 x 6 ¼ inches (17.8 x 15.9 cm)

Like many works by Ringl + Pit, this photograph was created independently, to attract clients to their firm rather than sell customers a particular product. The image bears the stamp of its times in its bird's-eye camera angle, tight framing, and emphasis on simple formal composition. Ringl + Pit focus on a domestic subject, cleaning one's hands, with an attention that conveys practicality and care for domestic hygiene, both hallmarks of advertising aimed at the "new woman." An activity (washing up) that had been seen as feminine would henceforth be recoded as fundamental to modern living for men and women alike. At the same time, advertising photographs such as this can be said to have promoted the further commodification of domestic life, amplifying the choice of purchasable goods for women without changing their status in society. —MSW

SUGGESTED READINGS
Eskildsen, Ute. *Fotografieren hieß teilnehmen. Fotografinnen der Weimarer Republik*. Düsseldorf: Richter Verlag; Essen: Museum Folkwang, 1994.
———. *ringl + pit*. Essen: Museum Folkwang, 1993.

Herb Ritts
b. 1952, Los Angeles; d. 2002, Los Angeles

A self-taught photographer, Herb Ritts majored in economics at Bard College, graduating in 1974 and returning to Los Angeles to work in his family's furniture business. He began taking pictures as a hobby, but when opportunity presented itself in 1978, he did not hesitate to supply photographs for *Newsweek* and a book on men's fashion. By the mid-1980s, he had established a reputation as a celebrity portraitist and fashion photographer. Over the next twenty years, he explored the intersections of photography and commerce, especially within the entertainment industry, creating still photography for movies and album covers and even directing music videos. A dedicated activist, Ritts also donated proceeds from several of his books to AIDS research.

His Holiness the Dalai-Lama, New York, 1987. Gelatin-silver print, edition 9/25, 18 ½ x 14 ¾ inches (47 x 37.5 cm)

Ritts was introduced to the Dalai Lama by his friend Richard Gere; this image, taken in a brief session with the Tibetan leader, exemplifies Ritts's highly effective approach to portraiture. Although many photographers would feel compelled to focus on the Dalai Lama's face, Ritts lets a simple detail of his subject's hand holding prayer beads evoke his spirituality and personal presence. Ritts routinely employed this kind of photographic synecdoche, and was lauded for its use. He also frequently focused on the hands of his subjects, and on their intimate textures, as in his portraits of B. B. King and Merce Cunningham. —NT

SUGGESTED READINGS
Herb Ritts. Paris: Fondation Cartier pour l'Art Contemporain, 1999.
Herb Ritts Work. Boston: Museum of Fine Arts, 1996.
Ritts, Herb. *Herb Ritts: Pictures*. Altadena, Calif.: Twin Palms, 1988.

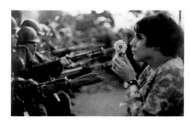

Alexander Rodchenko
b. 1891, St. Petersburg, Russia; d. 1956, Moscow

Alexander Rodchenko played a crucial role in nearly all artistic developments within early Soviet Russia, most importantly Constructivism. With his triptych of red, yellow, and blue monochrome canvases of 1921, Rodchenko was declared "the murderer and the suicide" of easel painting; all artists and art production henceforth were to serve politics and society directly. During the 1920s, Rodchenko designed advertisements, film sets, furniture, and numerous book and magazine layouts featuring dynamic, unusually angled photographs and photomontage experiments. Caught like all intellectuals in an increasingly vicious climate of persecution, Rodchenko concentrated from around 1930 on glorifying Stalinist directives, for example in photographs for the magazine *SSSR na stroike* (Building the USSR). Rodchenko remained an active photographer and designer until his death, frequently in collaboration with his lifelong companion, Varvara Stepanova.

Mother (Mat'), 1924. Gelatin-silver print, 9 x 6 ¼ inches (22.9 x 15.9 cm)

One of Rodchenko's first photographs, this portrait signifies a revolution on many levels. While his mother holds up one half of a pair of spectacles to help her read (a skill she acquired only at fifty), Rodchenko stands before her testing a recently purchased camera, the monocular medium of the future. Rodchenko famously cropped his negative, cutting out the walls and table to yield a dynamic, close-up view. His mother's face, furrowed in concentration, her work-worn hand, and the kerchief wrapped around her head thereby convey a heroic character without trading in sentimentality. We apprehend the resulting picture, moreover, in much the way that Rodchenko's mother puzzles over her reading. The interaction of hands and lenses has in both cases brought the world radically into focus, magnifying earthshaking changes that, for all their promise of clarity, are still difficult or impossible to comprehend.

Morning Wash (Varvara Rodchenko) (*Utrenni tualet [Varvara Rodchenko]*), 1932. Gelatin-silver print, 6 ¾ x 4 inches (17.1 x 10.2 cm)

This photograph, like the preceding one, is a family shot, yet entirely different circumstances surrounded the two images. By 1932, Rodchenko had endured years of politically motivated criticism, causing him largely to abandon his signature use of dynamic camera angles, now labeled "bourgeois" or "formalist" conceits. This bird's-eye view is thus atypical, and it matches the overall atmosphere: sunny, playful, and intensely private. Little Varvara covers her head in mock protection, as if the photographer—or his shadow—were descending to snatch her away. The camera eye has often been called rapacious, and even in fun we may instinctively shield our bodies from its prying gaze. It is probably Rodchenko himself, however, who suggested this pose. The encounter between his shadowy arm and his daughter's hands also offers a tragicomic analogy for the cat-and-mouse relation that seasoned revolutionaries like Rodchenko entertained with the Stalinist state. —MSW

SUGGESTED READINGS
Dabrowski, Magdalena, Leah Dickerman, and Peter Galassi. *Aleksandr Rodchenko*. New York: The Museum of Modern Art, 1998.
Kiaer, Christina. "Rodchenko in Paris." *October*, no. 75 (winter 1996), pp. 3–35.
Tupitsyn, Margarita. *The Soviet Photograph 1919–1937*. New Haven: Yale University Press, 1996.

Paolo Roversi
b. 1947, Ravenna, Italy

Paolo Roversi began his career as a photojournalist at age twenty. In 1973, at the suggestion of photographer Peter Knapp, he moved from Italy to Paris, where he held several assistant positions. He soon became interested in fashion photography and published his first pictures in *Dépêche mode* in 1975. Over the next few years, he established an aesthetic that revolved around experimentation within the controlled environment of his studio. These experiments culminated in 1980, when Roversi began to use eight-by-ten-inch Polaroid film and a spotlight to bleach the tones of his images, a style that has since been much copied.

Hands of Ines de la Fressange, 1980. Polaroid print, 10 x 8 inches (25.4 x 20.3 cm)

This image is an early example of Roversi's use of Polaroid photography from his first major campaign, for Christian Dior. Roversi washes out the surface of the hands of model Ines de la Fressange (later a well-regarded designer), reducing the photograph's texture to a graphic simplicity. The delicate elegance of the forms resemble the effects achieved by Man Ray through solarization; indeed, the one-of-a-kind Polaroid lends an air of formal exploration shared by Roversi's Surrealist forefather. Roversi renders these poised hands, presumably applying a Dior product as we look, with a modern starkness and graceful pallor to entice the viewer and consumer. —NT

SUGGESTED READINGS
Chermayeff, Catherine, ed. *Fashion Photography Now*. New York: Harry N. Abrams, 2000.
Harrison, Martin. *Appearances: Fashion Photography since 1945*. London: Jonathan Cape, 1991.
Shots of Style: Great Fashion Photographs Chosen by David Bailey. London: Victoria and Albert Museum, 1985.

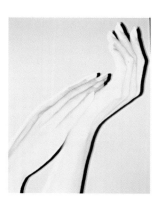

Lucas Samaras
b. 1936, Kastoria, Greece

Resident in the United States since 1948, Lucas Samaras has consistently devoted his art to the improvisation of self-portraiture. After studying with Allan Kaprow at Rutgers University and with Meyer Schapiro at Columbia University, in the late 1950s the young Samaras began to perform in Happenings at the Reuben Gallery, where he met artists Claes Oldenburg, Jim Dine, and others. Throughout the following decade, the artist created multimedia constructions and assemblages that incorporated such diverse materials as pins, mirrors, plastics, and feathers. Samaras turned to photography in 1969, initiating the series *Auto-Polaroids*, which records transformations of the artist's body, embellished by dramatic illumination and skewed camera angles, as well as by his scratching and smudging of the film's emulsion.

Self-Portrait, 1990. Polaroid Polacolor II print, 24 x 20 inches (61 x 50.8 cm)

This Polaroid self-portrait poses the bearded face of the artist head-on, wide-eyed, and half-screened by the splayed fingers hovering over his features. The blue curtain in the background suggests a theatrical setting. The use of unnatural color and shadows, which halo the artist's hair in green and retouch his skin with red tones, relate the artifice of the stage to the more sinister sorcery of magic. Within this photographic theater, the artist both performs and conjures his identity. Like Samaras's hands, which draw our attention to the visage they also conceal, this image suggests that the self comes into being through a relay of presence and absence.
—MM

SUGGESTED READINGS
Levin, Kim. *Lucas Samaras*. New York: Harry N. Abrams, 1975.
Lifson, Ben. *Samaras: The Photographs of Lucas Samaras*. New York: Aperture, 1987.

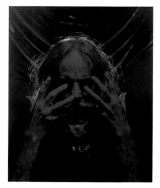

August Sander
b. 1876, Herdorf, Germany; d. 1964, Cologne

A studio photographer, August Sander departed from usual practices when he began to seek out clients among local farmers and villagers in the 1910s and to take unpretentious portraits of them, often outdoors. In the 1920s, Sander announced an encyclopedic project that would incorporate those early portraits into a series of portfolios, collectively titled *Citizens of the Twentieth Century*. Progressing from the countryside to the city, this cycle was to document the types that made up Germany's modern world. Sander was socially conservative and politically naive (although not anti-Semitic), and his project depended on biases that the Nazis largely shared. Nevertheless, he was persecuted under the Third Reich and never fully published his work, although he regained a preeminent place in international photographic circles during the last two decades of his life.

Advertising Photogram for a Glass Manufacturer, Cologne, ca. 1932. Gelatin-silver print photogram, 8 ½ x 7 ¼ inches (21.6 x 18.4 cm)

Sander owned a studio in Cologne from 1910, and although portraiture formed the mainstay of his operation he provided other services as well. This work is especially unusual because it is a cameraless image and a very tightly cropped one. Sander refused by and large to endorse techniques or aesthetics associated with the avant-garde, and indeed made his gallery of twentieth-century portraits using decidedly nineteenth-century equipment. Perhaps the approach here was suggested by Sander's client to keep step with the vogue for "new photography" in the years around 1930. The result is a hand similar in material to the product it advertises. The world has been made blank, without substance or depth, and humanity figures within it as an impenetrable, shadowy absence. —MSW

SUGGESTED READINGS
Bohn-Spector, Claudia. *August Sander*. Los Angeles: The J. Paul Getty Museum, 2000.
Sander, Gunther, ed. *August Sander: Citizens of the Twentieth Century: Portrait Photographs, 1892–1952*. Text by Ulrich Keller. Trans. Linda Keller. Cambridge, Mass.: The MIT Press, 1986.

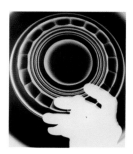

Jenny Saville
b. 1970, Cambridge, England

A graduate of the Glasgow School of Art, Jenny Saville began to exhibit at the age of twenty, two years before receiving her degree. An exhibition at the Saatchi Gallery in London in 1994 created an instant, lasting reputation for Saville, whose large, aggressively painted portraits of seemingly even more massive women have been featured regularly in gallery and group shows since then. Several of her works were included in the 1998–99 traveling exhibition *Sensation: Young British Artists from the Saatchi Collection*. Saville responds pointedly in her work to the vogue for sylphlike models of femininity in contemporary culture. She also combines critical reserve toward her subjects (including her own body) with an orientation toward corporeal excess that is present in the work of earlier British realist painters like Lucian Freud.

Jenny Saville and Glen Luchford. *Closed Contact #3*, 1995–96. C-print mounted on Plexiglas, edition 4/6, 72 x 72 x 6 inches (182.9 x 182.9 x 15.2 cm)

In 1995–96, Saville collaborated with photographer Glen Luchford to make a series of sixteen prints showing the artist pressed naked atop a glass table, her body squeezed and cropped in highly defamiliarizing ways. Kneading her flesh with a demonic energy that may be compared to early performances by Bruce Nauman, Saville grabs, mushes, plies, and otherwise distorts bodily contours suspended levelly against the force of gravity. Her hands, normally removed from carnality by the length of a paintbrush, grapple here directly and visibly with their subject. Confronted by the overwhelming presence of thirty-six square feet of flesh, the viewer shares in this proximity to some degree. And yet, because of the glass pane used to make the image, or perhaps thanks to the Plexiglas box enclosing the print, the results retain a distance, even an impartiality, that recalls specimen preservation in formaldehyde. —MSW

SUGGESTED READINGS
Dunn, Katherine. *Closed Contact: Jenny Saville, Glen Luchford*. Los Angeles: Gagosian Gallery, 2002.
Nochlin, Linda. "Floating in Gender Nirvana." *Art in America* 88, no. 3 (March 2000), pp. 94–97.
Sensation: Young British Artists from the Saatchi Collection. London: Thames and Hudson in association with the Royal Academy of Arts, London, 1998.

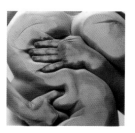

Gary Schneider
b. 1954, East London, South Africa

Gary Schneider moved to New York in the late 1970s from Cape Town, South Africa, and found work engineering lighting and sound for Richard Foreman's Ontological Hysteric Theater while pursuing his M.F.A. at Pratt Institute in Brooklyn. At first, Schneider painted and pursued experimental film, but by the end of the 1980s he had turned primarily to photography. Since then, he has pursued several open-ended series concurrently, including *Portraits*, large-scale prints of friends' faces manipulated by long exposures and innovative lighting; *19th-Century Women*, in which he reprints Victorian-era found negatives; and *Botanicals*, which make the minutiae of biology visible yet abstract.

Henry, 2000. Toned gelatin-silver print, edition 1/5, 36 x 29 inches (91.4 x 73.7 cm)

For many years, Schneider has made cameraless photographs of hands, revisiting a technique used by earlier photographers to investigate the paranormal, but employing it as a means of portraiture. In a number of these pictures, Schneider reworked a negative of his own hand to stand in for those of absent friends. For this particular image, however, he invited collector Henry M. Buhl to place his hand onto the emulsion, where its heat and moisture exposed the film. A true index, this photograph conveys great intimacy yet tells remarkably little about Buhl himself. Like much of Schneider's work, it flirts with hard science, historical photography, and tactile sensuality, while evoking its subject with tenderness and delicacy. —NT

SUGGESTED READINGS
Katz, Vincent. "Gary Schneider: An Interview."
 The Print Collector's Newsletter 27, no. 1 (March–
 April 1996), pp. 11–14.
Schneider, Gary. *Genetic Self-Portrait*. Syracuse:
 Light Work, 1999.
Sedofsky, Lauren. "Gary Schneider's Photographs:
 Through Glass, Darkly." *Artforum* 33, no. 7
 (March 1995), pp. 69–72, 119.

Andres Serrano
b. 1950, New York

Andres Serrano became interested in art as a child, when he found refuge at the Metropolitan Museum of Art, New York, from what he has called an "unacceptable life." At age seventeen, he enrolled at the Brooklyn Museum School of Art, where he studied painting for two years before leaving school and beginning to document the streets of New York in black-and-white photographs. Yet it was not until 1983, after more than a decade in and out of art production, that he matured as a photographer. The many series of photographs he has produced over the past twenty years, which include studies of the homeless, the Klu Klux Klan, and, most notoriously, bodily fluids, have investigated various constellations of the sacred and the secular, always in large-format, high-gloss color prints.

The Morgue (Knifed to Death I and II), 1992. Cibachrome, silicone, Plexiglas, and wood, edition 2/7, two prints, each 32 ½ x 40 inches (82.6 x 101.6 cm)

For the series from which these photographs are taken, Serrano photographed corpses at a morgue, employing extreme close-up framing to preserve anonymity and often to beautify the bodies before him. This technique, as well as Serrano's usual blend of religious and profane imagery, is evident in this pair of photographs. The hands, which may belong to a deceased criminal (note the inked fingers), have been turned toward each other to evoke Michelangelo's fresco *The Creation of Adam* (1508–12); the small incisions in the wrists, made by surgical probes during autopsy, resemble stigmata. Though the title makes it clear that these hands are not living, Serrano nevertheless transmits their peculiar expressiveness, suggesting both the existence of and the impossibility of knowing their owner. —NT

SUGGESTED READINGS
Andres Serrano Works, 1983–1993. Philadelphia:
 Institute of Contemporary Art, University of
 Pennsylvania, 1994.
Blume, Anna. "Andres Serrano." *Bomb*, no. 43
 (spring 1993), pp. 36–45.
Harold, Jim. "*The Morgue*: Andres Serrano." In
 David Brittain, ed. *Creative Camera: Thirty Years
 of Writing*. Manchester, England: Manchester
 University Press, 1999.

Cindy Sherman
b. 1954, Glen Ridge, New Jersey

Since the early 1980s, the work of Cindy Sherman has commanded critical acclaim for its acute investigation of the relationship between looking and being looked at. Sherman attended the State University College at Buffalo, where she majored in art. After graduating in 1976, she moved to New York, where she became involved with performance art and turned increasingly to photography as a means of documentation. In 1977, she began creating the seventy black-and-white photographs of the *Untitled Film Stills* series, for which the artist impersonated clichéd B-movie character types—housewife, librarian, career girl, floozy, and film star. At the end of the following decade, Sherman gradually moved out of the picture, passing from her analysis of femininity as masquerade to the realm of the abject with fairy-tale stories and disaster images that suggest the body turned inside out, suffused in lurid color and artificial light.

Untitled, #240, 1991. Color photograph, edition 4/6, 49 x 72 inches (124.5 x 182.9 cm)

Untitled, #240 derives from the *Civil War* series initiated by the artist in 1991, which displaced the ideal body image with pictures of corporeal dismemberment. The outsized color photograph enlarges a hand that lies just beneath the top border of the print, like a mutilated body part in a grisly crime scene. This ungainly hand is morbidly tinted and illuminated to simulate death and decay. Sprawled on a dirty, weedy ground, the browned, leathery figure not only seems lifeless, it is in fact fake, inorganic; the image's staging of the confusion between animate and inanimate figures the logic of the fetishistic gaze it simultaneously repulses.

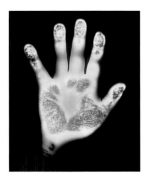

Untitled, #256, 1992. Color photograph, edition 5/6. 68 x 45 inches (172.7 x 114.3 cm)

Beginning in 1992, Sherman responded to the debates on censorship and obscenity spurred by the National Endowment for the Arts controversy by making her *Sex Pictures*. Recalling Hans Bellmer's *poupées* from the 1930s, these images set grotesque hybrid dolls—constructed from genital prostheses and disjunct mannequin parts—in carnivalesque pornographic tableaux. *Untitled, #256* displays one such monstrously sexualized android recumbent, its legs spread and raised. The left hand lies on the floor inertly, while the right thrusts forward between its legs, motioning explicitly toward the sexual organs. If the former gesture—like the background ax—signals the intricate mingling of sex and death, the latter literally sets up an anatomy that speaks less to the play of eroticism than to its shattering. —MM

SUGGESTED READINGS

Cruz, Amada, Elizabeth A. T. Smith, and Amelia Jones. *Cindy Sherman: Retrospective*. New York: Thames and Hudson; Los Angeles: Museum of Contemporary Art, 1997.

Krauss, Rosalind E. *Cindy Sherman, 1975–1993*. New York: Rizzoli, 1993.

Osamu Shiihara
b. 1905, Osaka; d. 1974, Osaka

The son of a wealthy couple, Osamu Shiihara studied Western-style painting at the Tokyo University of Art. He took up photography as a hobby after graduation in 1932, and soon joined an amateur photographers' club known for its inclination toward the New Vision photography in Europe. Shiihara produced nudes in the manner of Man Ray, Bauhaus-style experiments in texture and composition, and street studies indebted to Eugène Atget and contemporary German photojournalism. In 1941, he created a noteworthy series documenting the presence of exiled Jews in Japan. Forced to work when the family fortune was lost during World War II, Shiihara continued his photographic activities thereafter only on a minor scale.

Composition, 1938. Solarized gelatin-silver print, 12 x 10 1/8 inches (30.5 x 25.7 cm)

Shiihara was an academic painter, and he extended the respect for craft, tradition, and beauty inculcated in art schools to photography as well. The popularization of New Vision photography, however, rapidly established a "tradition of the new" and caused a concomitant shift in notions of the beautiful. This study of multiplying, disembodied hands depends for its aesthetic appeal on a thorough acceptance of New Vision conventions as disseminated by Man Ray, László Moholy-Nagy, and others, which are visible in many of the works in this exhibition. Shiihara seized here on the dialogue between facsimiles of the human body, in this case a form for displaying gloves, and actual body parts, a favorite theme for self-styled avant-gardists during the 1930s. —MSW

SUGGESTED READINGS

Traces of Light in Modernism: Koshiro Onchi, Osamu Shiihara and Ei-Kyu. Essay by Rei Masuda. Tokyo: The National Museum of Modern Art, 1997.

Tucker, Anne W., et al. *The History of Japanese Photography*. New Haven: Yale University Press in association with the Museum of Fine Arts, Houston, 2003.

Lorna Simpson
b. 1960, New York

Since the 1980s, Lorna Simpson has worked with language, photography, film, and installation to depose racial and sexual stereotypes. A student of photography at New York's School of Visual Arts, Simpson also completed an M.F.A. at the University of California, San Diego in 1985. She began her artistic career as a documentary photographer, but quickly moved on to challenge the genre's ostensibly objective representation of the "other." Simpson paired spare photographic portraits—frequently presenting the faceless figure of an African American woman in a static pose—with enigmatic textual fragments. The silent pictures contrast with the emotions sounded by the accompanying words, activating the participation of subject and viewer in the construction of meaning.

Lower Region, 1992. Three color Polaroid prints and engraved Plexiglas, edition 3/4, overall 26 x 60 inches (66 x 152.4 cm)

This triptych depicts an anonymous woman in a ribbed dress. Each close-up of her pelvic region is distinguished by the position of her hands—hooked to her waist, resting on her thighs, and crossed at her midsection. The middle photograph is distinguished by the triangular form stitched to her dress in horizontal lines. This icon of feminine sexuality is set in parentheses by the subject's hands, whose gesture echoes the framing structure of the enclosing photographs. Pointing to what is absent from view, this work formalizes the voyeurism associated with the visual pleasure of looking. The transformation of the woman's body into sexual image is unerotically redoubled, reflecting the desiring look of the spectator back on itself. —MM

SUGGESTED READINGS

Jones, Kellie. *Lorna Simpson*. London: Phaidon Press, 2002.

Willis, Deborah. *Lorna Simpson*. San Francisco: Friends of Photography, 1992.

Wright, Beryl. *Lorna Simpson: For the Sake of the Viewer*. Chicago: Museum of Contemporary Art, 1992.

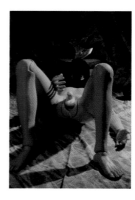

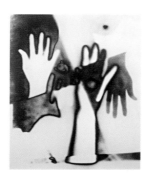

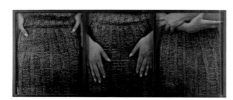

W. Eugene Smith
b. 1918, Wichita, Kansas; d. 1978, Tucson, Arizona

Regarded as the master of the photographic essay, W. Eugene Smith first took up photography as a teenager working for his hometown newspapers. In 1937, he ended a brief stint at the University of Notre Dame to move to New York and work for *Newsweek*, beginning a lifelong career in magazine photography. Within two years, Smith had signed his first contract with *Life* magazine, for which he would photograph until 1955. Among his most famous projects during this period are "Country Doctor" (1948) and "Spanish Village" (1951). After leaving *Life*, Smith joined Magnum Photos, but his essays were rarely published in full due to his increasingly uncompromising editorial opinions.

Waiting for Survivors: The Andrea Doria Sinking, 1956. Gelatin-silver print, 8 ¼ x 13 ⅜ inches (21 x 33.9 cm)

This image is from the only full essay Smith completed for Magnum Photos—on the sinking of the Italian ocean liner *Andrea Doria* after it collided with another ship. Ironically, Smith shot this series because he and his assistant were the only photographers John Morris, Magnum's executive editor, could find to get to the docks in time for the survivors' arrival. In this photograph, a nun looks out of the frame above the camera as if to God, and raises one hand to her lips as if holding her breath. With this simple gesture, Smith captured the anxious mixture of hope and dread felt by those awaiting news of their loved ones. —NT

SUGGESTED READINGS
Mora, Gilles, and John T. Hill, eds. *W. Eugene Smith Photographs 1934–1975*. New York: Harry N. Abrams, 1998.
W. Eugene Smith, with an Essay by Jim Hughes. New York: Aperture, 1999.
Willumson, Glenn G. *W. Eugene Smith and the Photographic Essay*. New York: Cambridge University Press, 1992.

Lord Snowdon (Anthony Armstrong-Jones)
b. 1930, London

Anthony Armstrong-Jones, Earl of Snowdon, became interested in photography while at Eton, and later during his time at Cambridge, where he studied architecture. In 1951, he had his first picture published in the British society magazine *Tatler*, after prematurely leaving an apprenticeship with society photographer Baron. The following year, Snowdon opened his own studio and began to publish regularly in *Vogue*, *Harper's Bazaar*, *Tatler*, and *Sketch*. By 1957, he had been asked to photograph the Queen of England, and his career was assured. He became an earl upon announcing his engagement to Princess Margaret, whom he married in 1960. In the more than forty years since, Lord Snowdon has become best known for his portraits of English royalty, high society, and celebrities.

Eduardo Paolozzi, 1988 (printed 2000). C-print, 15 ⅜ x 16 ⅛ inches (39.1 x 41 cm)

Choosing to portray Scottish artist Sir Eduardo Paolozzi with only a close-up of the artist's hand may seem ironic, considering that much of Paolozzi's sculpture and graphic work upheld the cool, automated sensibility of Pop art. Nevertheless, in this picture Snowdon has placed Paolozzi's hand on an earthy surface, where it rests with bits of dirt or rock still clinging to its fleshy palm and fingers. The photograph hints at both labor and slackness. The artist's hand is etched by years of fertile, creative production (Paolozzi was sixty-four when this portrait was taken), yet it seems deceptively infantile. Summoning these contradictions in such a simple composition, Snowdon elegantly and efficiently captures the complexities of his sitter. —NT

SUGGESTED READINGS
Cathcart, Helen. *Lord Snowdon*. London: W. H. Allen, 1968.
Photographs by Snowdon: A Retrospective. London: National Portrait Gallery, 2000.
Snowdon: Sittings 1979–1983. Introduction by John Mortimer. New York: Harper and Row, 1983.
Snowdon: Stills 1984–1987. Introduction by Harold Evans. London: Weidenfeld and Nicolson, 1987.

Southworth and Hawes
Albert Sands Southworth: b. 1811, West Fairlee, Vermont; d. 1894, Charlestown, Massachusetts
Josiah Johnson Hawes: b. 1808, East Sudbury (now Wayland), Massachusetts; d. 1901, Crawford's Notch, New Hampshire

The studio of Southworth and Hawes was known as *the* portrait salon in America; it drew to its rooms the elite of Boston society. Before switching to professional photography, Southworth earned a living as a drugstore proprietor and Hawes as an itinerant portrait painter. Both were inspired by a series of lecture-demonstrations of the daguerreotype process delivered by Jean Baptiste François Fauvel-Gouraud, a former student of Louis-Jacques-Mandé Daguerre and his company's sales representative. In 1843, Southworth and Hawes formed their partnership. Conceived as the Boston counterpart to Nadar's studio in Paris, their salon's renown depended on its meticulous attention to the character and expression distinguishing each personality.

Mother and Nursing Child, ca. 1844–50. Half-plate daguerreotype, 5 ½ x 4 ½ inches (14 x 11.4 cm)

Southworth and Hawes executed numerous studies of mother and child groups. This warm, domestic portrait delineates a three-quarter view of a mother nursing an infant who is seated on her lap and pressed close to her body. This emphasis on physical contact runs throughout the image—meshing together the richly patterned blanket with the solid dark and light of the baby's dimpled swathing and the mother's stiffly creased dress; the textured materiality of fabric with the corporeality of smooth, plump infant flesh; and, above all, the hands of its subjects. The baby's hand rests lightly on the mother's, which reaches to pull open her dark blouse front. Enhanced by delicate illumination and flesh-tinting, the poignant touching of one gesture with another evokes the intimacy between manual craft and photographic reproduction. —MM

SUGGESTED READING
Sobieszek, Robert A., and Odette M. Appel. *The Daguerreotypes of Southworth and Hawes*. New York: Dover Publications, 1976.

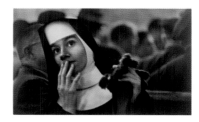

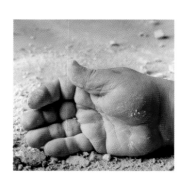

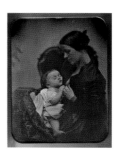

Edward Steichen
b. 1879, Luxembourg; d. 1973, West Redding, Connecticut

A painter who preferred photography, and a natural aristocrat despite his working-class upbringing in rural Michigan, Edward Steichen was a born emissary for camera art in the camp of painting and sculpture. A prize-winning Pictorialist after 1900, he also facilitated exhibitions of European avant-garde artists from Paul Cézanne to Pablo Picasso, in alternation with shows of ambitious photographers, at Alfred Stieglitz's 291 gallery in New York. Steichen cultivated the company of gray eminences in art (Auguste Rodin) and banking (J. P. Morgan), and in the interwar years he furthered his own celebrity status as chief photographer at Condé Nast. Steichen also commanded photography and film units in both world wars. His most famous exhibition venture, the 1955 *Family of Man* show, depended as much on his essentially patriotic, humanist vision as on his knowledge of photography.

J. P. Morgan, Esquire, 1903 (printed 1920s). Gelatin-silver print, 9 1/2 x 7 3/4 inches (24.1 x 19.7 cm)

Although the sitter's face—particularly his pustulant nose, heavily retouched—attracts the greatest initial attention in this portrait, it is the clutched, clawlike hand that secures its atmosphere of brooding tension. In a manner directly reminiscent of J. A. D. Ingres, particularly the painter's rendering of the "amphibious" hands of M. Bertin (1832), Steichen seems to have flattered his bourgeois patron, while scrutinizing his anatomy to almost critical effect. One has the impression that the great financier grips his chair with a menace born of flabby anxiety. The prestigious trappings—cravat and gold timepiece—seem almost caricatures as a result. Yet Morgan was apparently quite pleased with the likeness, and his satisfaction and handsome payment helped pave the way for Steichen's rapid ascent in the world of society portraiture. —MSW

SUGGESTED READINGS
Clarke, Graham, ed. *The Portrait in Photography*. Seattle: University of Washington Press, 1992.
Smith, Joel. *Edward Steichen: The Early Years*. Princeton: Princeton University Press in association with the Metropolitan Museum of Art, New York, 1999.

Alfred Stieglitz
b. 1864, Hoboken, New Jersey; d. 1946, New York

The photographic career of Alfred Stieglitz began during a decade spent in Germany in the 1880s. Stieglitz returned home in 1890 galvanized by "art photography" (known in the United States as Pictorialism), and he soon rose to prominence as an amateur photographer through editorial positions and awards at international salons. He then undertook a trio of declarative ventures: a society of Pictorialist photographers known as the Photo-Secession; a gallery, called 291, that exhibited their work and later that of avant-garde artists such as Constantin Brancusi and Pablo Picasso; and a journal, *Camera Work*, devoted to these new art forms. Stieglitz's association with Georgia O'Keeffe, whom he met at 291 in 1916, has become legendary. In the 1920s and after, Stieglitz concentrated his exhibitions on a select circle of American artists, and occasionally showed his own work as well.

Hands with Thimble, 1920. Gelatin-silver print, 9 1/2 x 7 1/2 inches (24.1 x 19.1 cm)

Hands with Thimble is considered an iconic facet of the "composite portrait" Stieglitz made with Georgia O'Keeffe beginning in 1917. It encapsulates many contradictory values that the young, gifted painter embodied for Stieglitz: mother and child, virgin and vamp, soul mate and Other. Those conflicting valences are concentrated in O'Keeffe's hands, the vehicle of intense emotional expression. While her right hand pushes straight up, as if engaged in matronly labor, the fingers on her left hand describe an arabesque that is connected to work only by a thread, and that appears intensely erotic in its studied ornamentality. The thrusting, sheathed middle finger of the "working" hand, aimed more or less directly at the open circle of thumb and index finger next to it, suggests libidinous conquest with a frankness that rivals Stieglitz's close inspection of O'Keeffe's breasts and sex in other photographs in the series. —MSW

SUGGESTED READINGS
Georgia O'Keeffe: A Portrait by Alfred Stieglitz. New York: The Metropolitan Museum of Art, 1978.
Greenough, Sarah. *Alfred Stieglitz: The Key Set: The Alfred Stieglitz Collection of Photographs*. Washington, D.C.: National Gallery of Art; New York: Harry N. Abrams, 2002.

Paul Strand
b. 1890, New York; d. 1976, Orgeval, France

Among the most formidable proponents of the "straight" style in photography, Paul Strand displaced Pictorialism with a distinctly American modernist aesthetic that advocated the objective, lucid, and precise analysis of form and structure. Strand was enrolled at the Ethical Culture School in New York, where he studied with Lewis Hine, who introduced him to Alfred Stieglitz's 291 gallery. Between 1915 and 1917, Strand worked in close contact with Stieglitz. Stimulated by the eminent photographer's exhibitions of avant-garde American and European art, the young Strand created a breakthrough corpus of sharp-focus photographs, including abstracted still lifes of kitchen bowls, candid portraits of people on the street, and dynamic, architectural cityscapes. This work established the originality of his vision, which sought to realize "a range of almost infinite tonal values which lie beyond the skill of the human hand."

Hands of Georges Braque, Varengéville, France, 1957. Gelatin-silver print, 4 1/2 x 5 3/4 inches (11.4 x 14.6 cm)

Profoundly influenced by the Cubist experiments of Georges Braque and Pablo Picasso, Strand applied their abstract reordering of pictorial art to photography. An older Braque reappears here as subject. The photograph focuses on the artist's dark hands, which are wrapped around a rounded, incised, white object set on the flat plane of a grainy, gray slab. The photograph is woven together by visual rhymes that coordinate the diagonal sliver of shadow slicing across the upper perimeter of the image with the parallel placement of the light stone, or the artist's veined hands with the crinkled cloth of the sleeve. Braque's tactile gesture reminds us of the dialogue between the artist and the photographer, marking a lyrical correspondence between Braque's activities as a sculptor and Strand's lifelong commitment to craftsmanship in photography. —MM

SUGGESTED READINGS
Greenough, Sarah. *Paul Strand: An American Vision*. Washington, D.C.: National Gallery of Art, 1990.
Strange, Maren, ed. *Paul Strand: Essays on His Life and Work*. New York: Aperture, 1990.

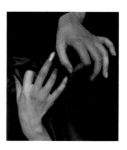

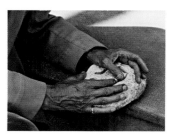

Thomas Struth
b. 1954, Geldern, West Germany

Thomas Struth studied with Gerhard Richter and Bernd Becher in Düsseldorf in the 1970s, and accepted his teachers' penchant for self-conscious impersonality, as well as their fascination with photography as a loaded memory. In 1978, Struth traveled to New York, where he began a series of hushed, unpeopled views that became an early mainstay of his art. Struth has photographed city scenes around the world with a stillness that belies their rushing crowds, capturing a palimpsest of urban activity in wide-angle views printed at environmental sizes. In the same format, he has recorded famous museum paintings and the crowds gathered before them, and more recently has focused on a selection of natural landscapes, chosen as if they too were museum exhibits.

Anci and Harry Guy, Groby, Leicestershire, 1989.
C-print, edition 6/10, 26 x 33 inches (66 x 83.8 cm)

Struth began photographing people in 1985, applying the methodical precision of his cityscapes to contemplative portraits of couples and families he had come to know. Rather than using his familiarity with the subjects to elicit intimacy, he asks them to withdraw, although he does encourage them to look at the camera. The results have the feel of a keepsake produced by the family therapist. Small nuances of gesture acquire ponderous weight, as in the apparently studied limpness of the hands in this image. Although the two sit close to one another, they do not touch, a fact that suggests resignation or melancholy. One has to wonder, however, whether this impression constitutes an insight into the subjects or results from Struth's own reserve. In either case, his late-twentieth-century view of an English couple appears filtered through seventeenth-century Delft. —MSW

Suggested Readings
Thomas Struth 1977–2002. Essays by Charles Wylie et al. Dallas: Dallas Museum of Art, 2002.
Thomas Struth: Portraits. Essays by Thomas Weski, Norman Bryson, and Benjamin H. D. Buchloh. Hannover: Sprengel Museum; Munich: Schirmer und Mosel, 1997.

Maurice Tabard
b. 1897, Lyons; d. 1984, Nice, France

Born in France but trained largely in the United States, Maurice Tabard worked as a portrait photographer in Baltimore and New York in the 1920s. In 1928, Tabard settled in Paris, where he befriended Surrealist poet and photography enthusiast Philippe Soupault. Tabard soon came to operate in the convergent fields of Surrealism and fashion/advertising, publishing "difficult" photographs in art journals such as *Bifur*, while submitting similar, more accessible commissions to *Marie-Claire* and *Harper's Bazaar*. Tabard never counted himself a Surrealist, but he explored Surrealist motifs (for example, the isolated hand) and assiduously refined techniques favored by the avant-garde, such as solarization and double exposure. He continued to work as a magazine photographer, a teacher of art history and photo craft, and a darkroom experimentalist into the 1950s and 1960s.

Study (Etude), 1930. Gelatin-silver print, 7 x 5 inches (17.8 x 12.7 cm)

Tabard was fascinated by solarization, and soon after he made this photograph he began a prolonged investigation of its properties. The term refers to the impact of an intense light source on undeveloped, photosensitive surfaces. When intentional, it is usually achieved in the darkroom by exposing a still-developing print or negative to light for an instant. An unpredictable reversal of tones occurs, giving an effect of reverie that Tabard both courted and sought to control. The apparently bronzed hand in this image is superimposed with the ghostly image of a racing car, which moves through the solid substance of the hand as if through air. Tabard viewed solarization, which reverses the usual process of fixing an image, as a metaphor with which to challenge the conventional understanding of photography as a practice that allows our hands to write with light and our eyes to make sense of the results. —MSW

Suggested Readings
Krauss, Rosalind E. *L'Amour Fou: Photography and Surrealism*. Washington, D.C.: Corcoran Gallery of Art; New York: Abbeville Press, 1985.
Maurice Tabard. Texts by Pierre Gassmann et al. Paris: Contrejour, 1987.

William Henry Fox Talbot
b. 1800, Melbury Abbas, Dorset, England;
d. 1877, Lacock Abbey, Wiltshire, England

A distinguished mathematician, scientist, and philologist, William Henry Fox Talbot is one of photography's inventors. Inspired to reproduce what he saw on grand tours in Europe, Talbot's experiments with light-sensitive chemistry led in 1834 to the discovery of photogenic drawings, which traced the silhouette of objects pressed to paper sensitized with silver chloride and exposed to light. In 1839, Talbot improved on these "drawings" with the development of a negative/positive calotype process, which treated writing paper with light-sensitive chemicals, such as silver nitrate and potassium iodide, to produce a negative from which positive paper prints could be made. Unlike the unique, metal-plate daguerreotype, whose invention was announced in France only a few weeks earlier, the paper calotype was printable and reproducible, predicting as such the mass media reproduction of the photographic image.

A Stanza from the "Ode to Napoleon" in Lord Byron's Hand, prior to April 4, 1840. Photogenic drawing negative, from an original ink-on-paper manuscript, 5 3/16 x 7 1/2 inches (13.2 x 19 cm)

This image reproduces the last unpublished stanza of "Ode to Napoleon Bonaparte," written by the Romantic poet Lord Byron in protest against the leader's flight into exile. It is a photographic negative created by contact printing from the original manuscript page, which was lent to Talbot by his neighbor, the Irish poet Thomas Moore. The fragile paper traces Byron's elegant cursive in white against a dark ground. It weaves his handwritten inscription together with the photographic transcription generated by the action of light on paper, setting before us an eloquent reminder of Talbot's ambition to make "every man his own printer and publisher." —MM

Suggested Readings
Buckland, Gail. *Fox Talbot and the Invention of Photography*. Boston: David R. Godine, Publishers, 1980.
Schaaf, Larry J. *The Photographic Art of William Henry Fox Talbot*. Princeton: Princeton University Press, 2000.

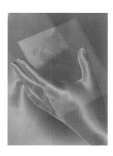

Sam Taylor-Wood
b. 1967, London

Sam Taylor-Wood's photographs and video installations create highly mannered geographies of human emotion. Taylor-Wood received her B.A. from Goldsmiths College of the University of London in 1990, and rapidly emerged as part of the Young British Art scene in London. Her work operates at the crossroads of photography, film, video, and sculpture; it culls its sources from high art and popular culture alike—painting, fashion photography, television, and film. Her *Soliloquy* series (1998–99) choreographs friends and actors in expressive vignettes that fuse the still image with the mise-en-scène of theater, while pastiching the format and iconography of Renaissance altarpieces and predellas. A large Cibachrome print casts its contemporary subjects in art historical settings—the supine nude woman of *Soliloquy III*, for example, evokes Diego Velázquez's *Rokeby Venus* (1647–51)—while a horizontal footer plays a panoramic filmstrip of their thoughts and fantasies.

Travesty of a Mockery, 1995. Two C-prints, edition 3/3, each 15 x 23 inches (38.1 x 58.4 cm)

The double stills that comprise this work are derived from the video installation *Travesty of a Mockery* (1995), which pictures a couple arguing across a room by projecting a shot of each party on opposite walls. In this photographic rendition, the left-hand panel shows a woman in profile, her right hand gesticulating toward the white appliances of the kitchen behind her. The right-hand panel displays her irate interlocutor, a man with his head turned toward her and hand raised with finger outstretched in apparent accusation. The formal structure of isolation (of each figure) and juxtaposition (of the two photographs) thematizes a dynamic of alienation and connection. That tension is sustained by another ambiguity: Does this scene record an actual event or a staged performance? The subjects' hands create a silent theater of gesture, deferring narrative resolution. —MM

SUGGESTED READINGS
Sam Taylor-Wood. Milan: Fondazione Prada, 1998.
Sam Taylor-Wood. Zurich: Kunsthalle Zürich, 1997.

Wolfgang Tillmans
b. 1968, Remscheid, West Germany

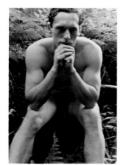

The first photographer to be awarded the Turner Prize, in 2000, the German-born Wolfgang Tillmans is celebrated for his timely chronicles of Generation X and youth culture denizens of music and fashion. Tillmans attended the Bournemouth and Poole College of Art, Dorset, in 1990–92, and then settled in London. The artist's portraits of friends at home and at work, which have appeared in magazines such as *i-D* and *Interview*, mingle the conventions of reportage and commercial photography. If these features mime Conceptual art's extension of the gallery structure into the context of magazine publishing, Tillmans's subsequent photo installations blur the distinction between the documentary and the staged. Pinned casually to the wall, snapshots are juxtaposed with laser prints and magazine pages, gathering together old and new images of contemporary social life—raves and festivals, gay subcultures, and protest rallies—while setting personal images and domestic still lifes alongside celebrity portraits.

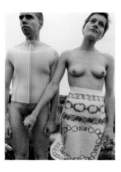

Arndt Sitting Nude, 1991. C-print, edition AP 1, 16 x 12 inches (40.6 x 30.5 cm)
Lutz & Alex holding cock, 1992. C-print, edition 2/3, 23 ⁵/₈ x 19 ⁵/₈ inches (60 x 49.8 cm)
Smoker (Chemistry), 1992. C-print, edition AP 1, 16 x 12 inches (40.6 x 30.5 cm)
Cornel, Zurich, 1993. C-print, edition AP 1, 12 x 16 inches (30.5 x 40.6 cm)

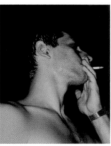

Tillmans's photographs often present an intimate, autobiographical storyboard. His subjects appear caught unaware—a nude Arndt seated outdoors with hands clasped to his chin in absorbed contemplation; an unnamed model dragging on a cigarette with head turned away from the viewer; and a fatigued Cornel slouched in a café with eyes shut and hand affixed to one side of his face. Tillmans's confessional narratives often do not so much seize an unplanned moment as project the artist's "personal visions" onto the world outside. These images frequently depend on a hand's gesture to enact or convey a given situation, pairing the premeditated script of the fashion shoot with the informality of the candid snapshot. Consider the stylish, if half-dressed, couple of *Lutz & Alex holding cock*. Looking away from the camera, the bare-breasted Alex extends her hand to conceal her companion's exposed genitals, coyly doubling exposure and exhibition. —MM

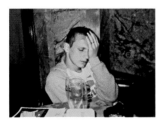

SUGGESTED READINGS
Wolfgang Tillmans: Burg. New York: Taschen, 1998.
Wolfgang Tillmans: Portraits. New York: Distributed Art Publishers, 2002.

Unknown photographers

In 1775, Franz Anton Mesmer proposed the theory of "animal magnetism": that a tidal current of invisible fluids in human bodies could be made to flow in specific directions by the "passes" of a qualified person's hands. Mesmer spent the rest of his life cultivating the reputation of his own hands—particularly his prodigious index finger—to unblock obstructions of "mesmeric fluids" among the willing poor and hypochondriacal nobility of France, Belgium, and Switzerland. His theories were increasingly challenged and modified by, among others, the Scottish physician James Braid (1795–1860), who introduced the term "hypnotism" to describe a state of "nervous sleep" induced by hand motions and the manipulation of shiny objects near a patient's eyes. In the 1850s, when these images were made, waning mesmerism and rising hypnotism overlapped within a field of medical investigation whose practitioners balanced between scientific legitimacy and popular obsession with the occult.

Scene of Medical Hypnosis (?), 1856. Quarter-plate ambrotype, 4 x 3 inches (10.2 x 7.6 cm)
The Faith Healer (or Hypnotist), ca. 1855. Sixth-plate daguerreotype, 3 x 3 ¹/₂ inches (7.6 x 8.9 cm)

Mesmer was convinced that bodily energies flowed through the extremities—head, hands, feet—and formed circuits of communal "harmony" when individuals made contact at those points. These ideas seem to be demonstrated in *The Faith Healer*, where the "operator," as he was known, touches one hand to the subject's forehead and the other to his left hand and to the right hand of an assistant or possibly a second subject. In *Scene of Medical Hypnosis*, subject and operator communicate through touch, mediated by a kerchief, but also through verbal or perhaps telepathic suggestion; the fingertips on their left hands extend upward, in parallel, as if the operator were pulling on an invisible thread. Both photographs attest to the power attributed to hands as a conduit for healing energies—an agent of direct connection between otherwise self-contained individuals. —MSW

SUGGESTED READINGS

Forrest, Derek. *Hypnotism: A History*. London: Penguin Books, 2000.
Gauld, Alan. *A History of Hypnotism*. Cambridge: Cambridge University Press, 1992.

Unknown photographer

The Independent Order of Odd Fellows was founded as a fraternal society in 1843, when the American Odd Fellows decisively split from their British forebears. At its height in the 1910s, today the I. O. O. F. boasts nearly half a million members, second only to the Freemasons in United States fraternal-organization membership. The infrastructure of the society and the format of its rituals owe much to Freemasonry, and the Odd Fellows may have thrived at times as a more working-class-oriented splinter group for disaffected Freemasons. The I. O. O. F. nevertheless remains a fully independent society; its internal workings are shrouded in secrecy, but it is dedicated to "Friendship, Love, and Truth as basic guides to the ultimate destiny of all mankind."

The Sovereign Grand Lodge I. O. O. F. (one page), 1890s. Album with platinum prints, 12 ³/₄ x 10 ¹/₂ x 2 ³/₄ inches (32.4 x 26.7 x 7 cm)

A complex system of signs, symbols, and gestures communicates identity, membership, and levels of authority in the order's hierarchy. The officers of the Sovereign Grand Lodge, the national headquarters of the I. O. O. F., kept extensive records of their symbolic system for educational purposes. These were called Albums of Unwritten Work, and were accompanied by a textual resource explaining each numbered gesture. The signs revolve around specific gesticulations of the hands, encoded with meanings to be revealed only to worthy members of the order. To the uninitiated contemporary viewer, they remain opaque and enigmatic, yet hauntingly beautiful. —NT

SUGGESTED READINGS

Axelrod, Alan. *The International Encyclopedia of Secret Societies and Fraternal Orders*. New York: Facts on File, 1997.
Carnes, Mark C. *Secret Ritual and Manhood in Victorian America*. New Haven: Yale University Press, 1989.
Odd Fellowship Illustrated: A Full Illustrated Exposition of the Ceremonies of All the Degrees of the Lodge and Encampment, and the Rebekah or Ladies Degree. Chicago: Ezra A. Cook & Co., 1874.

Jeff Wall
b. 1946, Vancouver, Canada

Trained as an artist and an art historian, Jeff Wall has taught art at the University of British Columbia since 1987. His posed, urban tableaux, the first of which date from around 1980, often engage in dialogue both with influential paintings or genres of painting from earlier centuries and with art historical methods developed in recent decades (feminist, post-Structuralist, and postcolonial theory). Wall has written about ideas in art history as they relate to his own work and that of many other contemporary artists, including Dan Graham and Stephen Balkenhol. In addition to retrospective exhibitions in Europe (1995 and 2000) and the United States (1997), he has been the subject of an academic monograph and has published a book of his own art criticism.

Rear, 304 East 25th Avenue, Vancouver, 9 May 1997, 1:14 & 1:17 p.m., 1997. Gelatin-silver print, edition 1/2, 97 x 143 inches (246.4 x 363.2 cm)

A landscape, Wall has stated, is a moment of passage filled with formal and social contradictions. Positioned at a middle distance from this scene, we can make out what appears to be a destitute woman standing by the closed back door of a derelict house. We cannot quite see what it is that brings her there, but we may have our suspicions. It is the hands that answer our question, enlarged in an inset (have we drawn nearer, or perhaps taken up binoculars?) so that we can watch as they reach toward the drug dealer's hole. "In modernity's landscapes," Wall writes, "figures . . . are recognized as both free and unfree; or possibly misrecognized. . . . Another way of putting this is that, in a landscape, persons are depicted on the point of vanishing into and/or emerging from their property." —MSW

SUGGESTED READINGS

Brougher, Kerry. *Jeff Wall*. Los Angeles: Museum of Contemporary Art; Zurich: Scalo, 1997.
Chevrier, Jean-François, ed. *Jeff Wall: Essais et entretiens 1984–2001*. Paris: Ecole Nationale Supérieure des Beaux-Arts, 2001.
de Duve, Thierry, Arielle Pelenc, and Boris Groys. *Jeff Wall*. London: Phaidon Press, 2002.

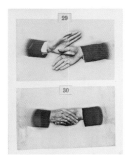

Andy Warhol
b. 1928, Pittsburgh; d. 1987, New York

Born to immigrants from the Ukrainian-Slovakian borderland, Andrew Warhola in his earliest drawings exchanged the realities of working-class Pittsburgh for fantasies of Hollywood and Madison Avenue. At twenty-one, he moved to New York, Americanized his name, and began a career in illustration that lasted through 1962, nearly two years after his first successes in the world of high art. A celebrity by the mid-1960s, Warhol crossbred "high" and "low" in nearly every area of postwar media culture: film, current events, rock music, advertising, and others. He proved an original commentator on American society and on his own work, following neither the midcentury model of the inarticulate visionary nor the path of art-school sophistication forged by his younger peers. Instead, Warhol created, both in his work and in his comments on it, an impression of accessibility, even superficiality, that remains among the most provocative cultural phenomena of our time.

Self-Portrait, 1983. Polaroid Polacolor print, 4 ¼ x 3 ½ inches (10.8 x 8.9 cm)

Warhol claimed the Polaroid (patented 1973) as one of his favorite tools, exploiting its instantaneous delivery in professed admiration for the effortless, impersonal production of art. His numerous self-portraits, meanwhile, convey his obsessive fascination with celebrity, sexual identity, and other aspects of his personality—including an enduring preoccupation with mortality. In many Polaroids, Warhol seems to play dead, either by setting his face in a blank, postmortem stare or through mock dramas of hanging or strangulation at the hands of others. Here, the artist's left hand flops in the harsh light, in a forensic snapshot created by his right. For all its apparent casualness—the ostensible antithesis of Théodore Géricault's carefully detailed morgue studies—this image links Warhol to a grand Romantic tradition: the artist's death by his own hand. —MSW

SUGGESTED READINGS
Bastian, Heiner. *Andy Warhol Retrospective*. London: Tate Publishing, 2001.
Michelson, Annette, ed. *Andy Warhol*. Cambridge, Mass.: The MIT Press, 2001.

Weegee (Usher Fellig)
b. 1899, Lemberg, Austria (now Lvov, Ukraine); d. 1968, New York

Born Usher Fellig, Weegee, as he renamed himself, is the most celebrated photographer of news photography's golden era. Weegee immigrated to New York in 1910, where he lived on the Lower East Side. He left school at fourteen to help support his family. From 1925 to 1935, he was on the staff of Acme Newspictures, and for the next twelve years he worked as a freelance photographer for various daily newspapers. During this period, Weegee documented dramatic and gritty subjects—ranging from fires, arrests, and murders to the seamy landscapes of the Bowery, Harlem, Coney Island, and Times Square—raising them out of the night's darkness with the illumination of a blazing, high-wattage flash gun. These "famous pictures of a violent era" were collected in the photographer's first book, *Naked City*, published in 1945.

Hands, early 1950s. Gelatin-silver print, 6 x 4 inches (15.2 x 10.2 cm)

In 1947, Weegee began to experiment with multiple exposures, copy negatives, and various devices such as mirrors, plastic sheets, and kaleidoscopes to create his *Distortions*. This image, derived from that fantastic series, zooms in on a white-jacketed person, with shoulders spliced at the top and sleeve cropped at the right framing edge. The left hand grasps the right wrist, an action multiplied by the two pairs of clasped hands knotted around the waist and abdomen. The restraint of one gesture, which pulls downward, is counterpoised to the affectionate ebullience of its horizontal other, working in tandem with the stark, tonal contrast that organizes the picture. Equally immediate in effect, this concise portrait of intimacy—a theme revisited by Weegee throughout the 1940s—forms the lighter counterpart to the photographer's hard-boiled visual narratives of the urban underworld. —MM

SUGGESTED READINGS
Barth, Miles. *Weegee's World*. New York: Little, Brown and Company, 1997.
Stettner, Louis, ed. *Weegee*. New York: Knopf, 1977.

Edward Weston
b. 1886, Chicago; d. 1958, Carmel, California

Edward Weston began his career around 1910 as a portrait photographer, working out of his home in the Los Angeles suburb of Glendale. After a decade of waning faith in his job and his marriage, Weston departed for Mexico in 1923 with a lover, Tina Modotti, and the eldest of his four sons. Sensual and deeply aestheticizing, his subsequent studies of everything from nude bodies to nautilus shells, seaweed, clouds, and carcasses convey a rigorous carnality that has had tremendous influence in photography. A founding member of the group f/64 in 1932, Weston gained acclaim in the closing decade of his life—with a 1946 retrospective at the Museum of Modern Art, New York, and a jubilee portfolio in 1952—even as, debilitated by Parkinson's disease, he became unable to use a camera.

Tina Modotti, Glendale, 1921. Platinum print, 9 ½ x 7 ½ inches (24.1 x 19.1 cm)

Both Weston and Modotti started in the world of melodrama: Modotti as a heroine on the Italian American theater circuit, Weston by making publicity shots for hopefuls in the burgeoning movie industry. A hackneyed pose (the innocently sensuous damsel clutching at her breast) underlies their interaction in this photograph, yet this paper character screens stronger emotions. Despite the softening blur and highlights, Modotti exerts an absorptive power, with her slightly arched eyebrows and firmly set lips—details intensified by her proximity to the picture plane. Her hand, terminated below the wrist by a glinting bracelet, seems to advance from the capacious shadow of her overcoat in obeyance to the joint desire of photographer and model, spreading over the latter with a force that is at once protective and autoerotic. —MSW

SUGGESTED READINGS
Dimock, George. "Edward Weston's Anti-Puritanism." *History of Photography* 24, no. 1 (spring 2000), pp. 65–74.
Thau Heyman, Therese. "Modernist Photography and the Group f.64." In Paul J. Karlstrom, ed. *On the Edge of America: California Modernist Art, 1900–1950*. Berkeley: University of California Press in association with the Archives of American Art, Smithsonian Institution and the Fine Arts Museums of San Francisco, 1996, pp. 242–70.

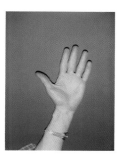

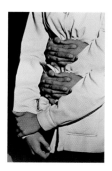

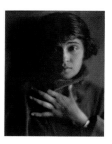

Minor White
b. 1908, Minneapolis; d. 1976, Boston

That Minor White graduated from college with a degree in botany and a minor in English is fitting, for his photographic work, which he took up in earnest in 1937, fuses a scientifically straightforward approach with a poetic sensibility. From dialogues with friends like Meyer Schapiro and Alfred Stieglitz, and in his positions at the George Eastman House, Rochester, and the California School of Fine Arts, White developed a technically refined and psychologically astute style. In 1952, he cofounded *Aperture* magazine and became its first editor and production manager. His work there illustrates his lifelong interest in nonnarrative pictorial sequences with minimal but evocative textual support.

William Larue, 1960 (printed 1960s). Gelatin-silver print, 8 5/8 x 7 3/4 inches (21.9 x 19.7 cm)

White's photography derives much of its lyricism from his personal experiences. He met William Larue at a workshop in Portland, Oregon, in 1959, and Larue became his close friend and traveling companion for many years. This image appeared in a sequence with more straightforward portraits of Larue and photographs of the shore at Point Lobos in California, home of White's friend Edward Weston, who had died two years earlier. Here, White emphasizes the humanity of Larue's hand by focusing on contrasts. If the stone on which his hand rests suggests geologic permanence, and the fly to its left nature's fragility, then Larue is literally caught in the middle: mortal yet resilient, vulnerable yet able. —NT

SUGGESTED READINGS
Bunnell, Peter C. *Minor White: The Eye That Shapes*. Princeton: The Art Museum, Princeton University, 1989.
Minor White: Life Is Like a Cinema of Stills. Milan: Baldini & Castoldi, 2000.
White, Minor. *Rites and Passages*. New York: Aperture, 1978.

Garry Winogrand
b. 1928, New York; d. 1984, Tijuana, Mexico

Like Diane Arbus and Lee Friedlander, Garry Winogrand began his career as a commercial photographer in the 1950s, but soon received artistic validation from the Museum of Modern Art, New York, and increasingly pursued independent work. The three photographers were united in the 1967 exhibition *New Documents*, which cemented Winogrand's status and contributed to his cultlike popularity in the following years. Winogrand taught at art schools in New York, Chicago, and Austin in 1967–78, lecturing and advising students with the restless enthusiasm that marked his own staggeringly prolific creative output. Photography represented a life process to Winogrand and, in his later years, a form of therapy. The several hundred thousand undeveloped negatives and contact prints left at his death from cancer signal a historical extreme in the art of the roving eye.

New York City, 1969. Gelatin-silver print, 11 x 14 inches (27.9 x 35.6 cm)

In important respects, this is an obvious photograph. A needy black man approaches the arm of his white "benefactor," whose clean suit jacket contrasts strongly with the beggar's heavily soiled overcoat. The exchange seems to be an illustrated definition of the "handout," a demonstration of the disparities of race and class in America allegorized as a fistful of change and an open palm. But as is often the case with Winogrand, his proximity to his subjects also yields a subtle social portrait. In this gritty, careening street, the beggar's own suit and fully buttoned shirt seem shabby but refined—not so far, in fact, from the office-worker clothing worn by the man giving him assistance. The photograph registers the street person's half-step forward, the weight of his clothes, and the difficult to read set of his mouth and shoulders. Its pregnant indeterminacy rests above all in his gaze, which may be directed at the outstretched hand or at the unseen face of the man tendering it. —MSW

SUGGESTED READINGS
The Man in the Crowd: The Uneasy Streets of Garry Winogrand. Essay by Ben Lifson. San Francisco: Fraenkel Gallery in association with Distributed Art Publishers, 1999.
Szarkowski, John. *Winogrand: Figments from the Real World*. New York: The Museum of Modern Art, 1988.

Joel-Peter Witkin
b. 1939, New York

Joel-Peter Witkin's life reads like a roster of the macabre. From the car accident that sent a decapitated head rolling to his feet when he was six, to his early photographs of the Coney Island freak show, to his army position photographing corpses in the 1960s, Witkin has been continuously immersed in death, pain, and bodily transgression. He addresses these themes in his photographs not as social realities but as existential states steeped in spiritual meaning; it is not surprising to learn that Witkin was raised in a devoutly Catholic home. Since 1975, when he moved from New York to Albuquerque, Witkin has increasingly referenced art history in the construction of his elaborate tableaux.

The Boy with Four Arms (Il Ragazzo con quattro bracci), 1984. Toned gelatin-silver print, edition 1/15, 20 x 16 inches (50.8 x 40.6 cm)

The subject of this photograph assumes the *contrapposto* stance of Renaissance Europe, yet his body is by no means the classical ideal. He has four arms; he is an anatomical outcast. To emphasize the importance of the young man's flesh, the skin of the photograph itself has been marred by blotches and scratches. The figure wears a mask, again calling attention to surfaces and as if to say that the outer appearance of his body is disconnected from, and even unrelated to, his inner self. The question of the young man's body, with its manifold appendages, becomes confused with the manipulations of the photographer, and with the viewer's questions about the meaning that might reside beneath this mask of masks. —NT

SUGGESTED READINGS
Badger, Gerry. "Towards a Moral Pornography: Joel-Peter Witkin." In David Brittain, ed. *Creative Camera: Thirty Years of Writing*. Manchester, England: Manchester University Press, 1999.
Celant, Germano. *Joel-Peter Witkin*. Zurich: Scalo, 1995.
Witkin, Joel-Peter. *The Bone House*. Santa Fe, N.Mex.: Twin Palms, 1998.

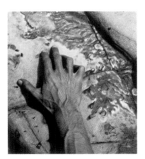

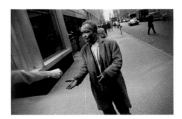

David Wojnarowicz
b. 1954, Red Bank, New Jersey; d. 1992, New York

David Wojnarowicz suffered an abusive, alienating childhood that, as one friend put it, would have turned many people into serial killers. That Wojnarowicz became an artist and a compassionate political activist is a tribute to his character. After traveling in the United States and abroad in the 1970s, Wojnarowicz settled in the East Village of New York, where he began in 1979 to elaborate allegorical narratives in film, photography, and painting. From the mid-1980s, he led artists' initiatives to fight AIDS, censorship, and homophobia. His frank treatment of sexuality, particularly male homosexuality, and of death was both galvanizing and mournful, even elegiac, and testifies to the conditions for creativity in the early AIDS era.

Untitled (Frog), 1988–89. Gelatin-silver print, edition 2/5, 16 x 20 inches (40.6 x 50.8 cm)

Animals, particularly frogs, often function in Wojnarowicz's work as emblems of the vicissitudes of human existence. In 1979, for example, Wojnarowicz filmed a pair of disembodied hands as they coaxed a frog in his short fable *Teaching a Frog to Dance (or Building a Patriotic Beast)*. His sense of humanity as a manipulative, subjugating force increased throughout the 1980s, not least because of public indifference and hostility to people with AIDS. Following the death of his partner, Peter Hujar, who had been a great animal lover, Wojnarowicz created further populist allegories featuring frogs, including a photograph titled *What's This Little Guy's Job in the World* (1990). In the present image, human and animal communicate at cross purposes; the terrorized creature is gently held aloft, forced by circumstances beyond its control to trust in the fickle touch of sympathy. —MSW

SUGGESTED READINGS
Corporal Politics. Essays by Donald Hall, Thomas
 Laqueur, and Helaine Posner. Cambridge, Mass.:
 The MIT List Visual Arts Center with Beacon Press,
 Boston, 1992.
Lippard, Lucy, et al. *David Wojnarowicz: Brush Fires
 in the Social Landscape*. New York: Aperture, 1994.
Wojnarowicz, David. *Close to the Knives: A Memoir of
 Disintegration*. New York: Vintage Books, 1991.

René Zuber
b. 1902, Doubs, France; d. 1979, Meudon, France

René Zuber discovered photography in 1927, after moving from Paris to Leipzig to pursue a publishing career. He had been trained as an engineer, which could explain his early interest in Albert Renger-Patzsch, whose 1928 book *Die Welt ist schön* (The world is beautiful) pioneered an almost scientifically objective strain of art photography. Upon his return to Paris, Zuber helped introduce the German's unusual perspective and compositional style to humanist photojournalism. In 1934, with Maria Eisner and Pierre Boucher, he founded Alliance Photo, a celebrated agency that inspired Robert Capa to found Magnum Photos thirteen years later. Zuber gave up photography after World War II, turning to publishing and documentary filmmaking.

Hands and Lens (Mains et objectif), 1928. Gelatin-silver print, 4 3/4 x 3 3/4 inches (12.1 x 9.5 cm)

One of Zuber's earliest works, this photograph shows the strength of Renger-Patzsch's influence on him. It is a straightforward representation of a man's hands adjusting the lens of a large-format camera. The task and image have a reflexive quality, as such calibration almost certainly went into the making of Zuber's picture itself. Even in such an early work we can detect the seeds of Zuber's humanism: Behind the coldest, most objective photographic lens we will always find a dynamic, expressive individual, manufacturing the image before us. —NT

SUGGESTED READINGS
Frizot, Michel. *A New History of Photography*. Cologne:
 Könemann, 1998.
Molderings, Herbert. "René Zuber (1902–1979)."
 Cahiers du Musée national d'art moderne, no. 3
 (Jan.–March 1980), pp. 70–73.
de Thezy, Marie, with Claude Nori. *La photographie
 humaniste, 1930–1960: Histoire d'un mouvement
 en France*. Paris: Contrejour, 1992.

Project Team

Art Services and Preparations
Scott Wixon, Manager of Art Services
 and Preparations
David Bufano, Chief Preparator
Jeffrey Clemens, Associate Preparator
Derek DeLuco, Technical Specialist
Mary Ann Hoag, Lighting Designer
Barry Hylton, Senior Exhibition
 Technician
Elisabeth Jaff, Associate Preparator
 for Paper

Conservation
Julie Barten, Conservator, Exhibitions
 and Administration
Mara Guglielmi, Paper Conservator

Construction
Michael Sarff, Construction Manager

Curatorial
Jennifer Blessing, Project Curator
Megan Luke, Curatorial Assistant
Luis Croquer and Matthew S. Witkovsky,
 Hilla Rebay Fellows
Alison M. Barnett, Amanda Blumberg,
 Sarah R. Caylor, Patritsia Massouraki,
 and Shannon Wearing, Interns

Education
Kim Kanatani, Gail Engelberg Director
 of Education
Pablo Helguera, Senior Education
 Program Manager, Public Programs
Sharon Vatsky, Senior Education
 Program Manager, School Programs

*Exhibition and Collections Management
 and Design*
Karen Meyerhoff, Managing Director
 for Collections, Exhibitions,
 and Design

Marion Kahan, Exhibition Program
 Manager
Ana Luisa Leite, Manager of Exhibition
 Design
Carolynn Karp, Exhibition Design
 Assistant
Robert McGarry and Greta Perez, Interns

External Affairs
Helen Warwick, Director of Individual
 Giving and Membership
Kendall Hubert, Director of Corporate
 Development
Gina Rogak, Director of Special Events
Oliver Dettler, Graphic Designer

Fabrications
Peter Read, Manager of Exhibition
 Fabrications and Design
Stephen Engelman, Technical
 Designer/Chief Fabricator
David Johnson

Global Programs, Budgeting and Planning
Christina Kallergis, Senior Financial
 Analyst

Graphic Design
Marcia Fardella, Chief Graphic Designer
Cassey Chou, Senior Graphic Designer
Concetta Pereira, Production
 Coordinator

Integrated Information and Management
Lynn Underwood, Director of
 Information Integration and
 Management
Danielle Uchitelle, Database
 Administrator

Legal
Gail Scovell, General Counsel
Brendan Connell, Assistant
 General Counsel

Maria Pallante-Hyun, Intellectual
 Property Counsel and Licensing
 Representative

Marketing
Laura Miller, Director of Marketing
Ashley Prymas, Manager of Marketing

Photography
David M. Heald, Director of Photographic
 Services and Chief Photographer
Kimberly Bush, Manager of Photography
 and Permissions

Public Affairs
Betsy Ennis, Director of Public Affairs
Jennifer Russo, Public Affairs
 Coordinator
Anne Edgar, Public Affairs Consultant

Publications
Elizabeth Levy, Director of Publications
Elizabeth Franzen, Managing Editor
Lisa Cohen, Editor
Meghan Dailey, Associate Editor
Lara Fieldbinder, Production Assistant
Tracy Hennige, Production Assistant
Laura Morris, Editor
Melissa Secondino, Production Manager
Edward Weisberger, Editor

Registrar
Meryl Cohen, Director of Registration
 and Art Services
Kaia Black, Project Registrar

Theater and Media Services
Michael Lavin, Director of Theater
 and Media Services

Visitor Services
Stephanie King, Director of
 Visitor Services

Index of Reproductions

Page numbers in bold refer to reproductions in essays and plates. Many of these works also appear in the catalogue entries (pp. 198–255).

Berenice Abbott
Hands of Jean Cocteau, 1927, **99**

Vito Acconci
Passes, 1971, **165**

Ansel Adams
Georgia O'Keeffe, 1976, **83**

Janine Antoni
Ingrown, 1998, **162**

Diane Arbus
Child with a Toy Grenade, Central Park, New York, 1962, **90**

Eve Arnold
Malcolm X, 1961, **86**

Richard Avedon
Joe Louis, Prize Fighter, New York City, 1963, **44**
Palermo, Sicily, September 3, 1947, 1947, **130**

John Baldessari
Five Male Thoughts (One Frontal), 1990/1996, **144–45**

Tracey Baran
Ivy, 2001, **195**

Tina Barney
The Watch, 1985, **193**

Herbert Bayer
The Lonely Metropolitan, 1932, **54**

Hans Bellmer
Untitled, 1934, **107**

Dawoud Bey
Shinaynay, 1998, **86–87**

Mel Bochner
Actual Size (Hand), 1968, **27**

Margaret Bourke-White
Untitled (Hands Playing Violin and Cello), ca. 1940s, **57**

Brassaï
Cast of Picasso's Hand, ca. 1943, **100**
Untitled illustration from Minotaure 2, no. 6 (winter 1935), **107**

Helen Pierce Breaker
India Ramosay's Hand, 1935, **39**

Anton Bruehl
Threading the Needle, 1929, **63**

John Bulwer
Chirogram from Chironomia: Or, the Art of Manuall Rhetoricke, 1644, **37**

Larry Burrows
Reaching Out, Battle of Hill 484, South Vietnam, 1966, **178**

Claude Cahun
Self-Portrait ("I Am in Training Don't Kiss Me"), ca. 1927, **78**

Julia Margaret Cameron
Vivien and Merlin, 1874, **36**

Robert Capa
Leon Trotsky Lecturing Danish Students on the History of the Russian Revolution, Copenhagen, Denmark, November 27, 1932, 1932, **36**

Henri Cartier-Bresson
The Visit of Cardinal Pacelli, Montmartre, 1938, **172**

Maurizio Cattelan
Black Star, 1996, **163**
Mother, 1999, **52**

Sarah Charlesworth
Trial by Fire, 1993, **142**

Larry Clark
Untitled, 1972, **49**

Chuck Close
Mark Morrisroe, 1984, **69**

Charles M. Conlon
Eddie Cicotte, ca. 1913, **62**

John Coplans
Self-Portrait, 1986, **157**

Jules Courtier
Cast Hands of Eusapia Palladino, 1908, **24**

Gregory Crewdson
Untitled, 1995, **53**

Imogen Cunningham
Martha Graham, Dancer, 1931, **85**

Bruce Davidson
Three Men in Garden Cafeteria, New York City, 1976, **182**

Rineke Dijkstra
Tecla, Amsterdam, the Netherlands, May 16, 1994, 1994, **192**

Robert Disraeli
Love's Triumph, 1932, **118**

Robert Doisneau
Picasso's Breads, Vallauris, 1952, **155**

František Drtikol
Horror, 1927, **119**

Pierre Dubreuil
Gernod!! (Crevettes), ca. 1929, **114**

Eugène Ducretet
X-ray Study of a Hand, 1897, **28**

Jeanne Dunning
Long Hole, 1994–96, **160**

Harold Eugene Edgerton
Champagne Bottle, ca. 1939, **34**

William Eggleston
Untitled, ca. 1975, **187**

Touhami Ennadre
Traces of Bleeding Hands, 1998, **20**

Elliott Erwitt
Vice President Nixon and Soviet Premier Khrushchev during the "Kitchen Debate" at the U. S. Exhibition in Moscow, 1959, **177**

Frederick H. Evans
Portrait of Aubrey Beardsley, 1894, **78**

Walker Evans
East Entrance, ca. 1947, **108**
Gypsy Storefront, 1562 Third Avenue, New York, 1962, **109**
Untitled, 1929, **132**

Andreas Feininger
Untitled (Finger Printing), 1942, **25**

Donna Ferrato
Injured Woman on the Street—McKeesport, Pennsylvania, 1983, **184**

Robert Filliou
Hand Show, 1967, **25**

Marc Foucault
Untitled, 1946, **55**

Robert Frank
Pablo and old man—New York City 2, 1958, **35**

Leonard Freed
Martin Luther King Being Greeted on His Return to the United States after Receiving the Nobel Peace Prize, Baltimore, 1963, **180**

Lee Friedlander
Salinas, 1972, **186**

Anna Gaskell
Untitled #84 (resemblance), 2001, **53**

Mario Giacomelli
My Head Is Full, Mama, 1985–87, **66**

Ralph Gibson
From The Somnambulist, 1967, **48**

Gilbert and George
Black Gargoyles, 1980, **148**
Bottle Bar, 1973, **140**

Nan Goldin
Joey in my mirror, Berlin, 1992, **188–89**

Douglas Gordon
Three Inches Black (no. 9), 1997, **164**

Alan Govenar
The Hand of the Murderer #7, 1995, **57**

Emmet Gowin
Nancy, Danville, Virginia, 1969, **90**

Dan Graham
Body Press, 1970, **136**

Joseph Grigely
Amy V., Ghent, January 30, 1997, 1997, **74**
Josephine P., Rotterdam, 1996, 1997, **74**
Wassily Z., Vienna, June 9, 1997, 1998, **74**

Jan Groover
Untitled, 1990, **73**

Andreas Gursky
May Day II, 1998, **166**

John Gutmann
The Cry, 1939, **120**

Raymond Hains
Hand Multiplied by a Play of Mirrors, 1947, **123**

Rachel Harrison
Untitled (Perth Amboy Series), 2001, **151**

D. O. Hill and Robert Adamson
John Clow of Liverpool; Merchant and Art Collector, ca. 1845, **16**
The Misses Grierson, ca. 1845, **18**

E. O. Hoppé
"Snakes": The Sinuous Arms of the Famous Dancer Roshanara, ca. 1918, **39**

Peter Hujar
David Wojnarowicz, 1981, **89**

Louis Igout
Set of Hands, ca. 1880, **40**
Untitled illustration from Minotaure 2, no. 5 (May 1934), **111**

Pierre Jahan
Hand with Five Eyes, 1947, **55**

Consuelo Kanaga
Hands, 1930, **46**

György Kepes
Hand, ca. 1939, **29**

André Kertész
Arm and Ventilator, 1937, **115**
Distortion Portrait of Carlo Rim and André Kertész, 1930, **116**

William Klein
School Out, Dakar, 1963/printed and painted ca. 1995, **197**

Gustav Klutsis
Let Us Fulfill the Plan of the Great Projects, 1930, **43**

Barbara Kruger
Untitled, 1985, **41**

Dorothea Lange
Migratory Cotton Picker, Eloy, Arizona, 1940, **43**

Jacques-Henri Lartigue
Florette in Cannes, 1942, **64**

Clarence John Laughlin
The Auto-Eroticists, 1941, **121**

Annie Leibovitz
Liberace, Las Vegas, 1981, **158**

Annette Lemieux
Transmitting Sound, 1984, **167**

Helen Levitt
New York, ca. 1939, **35**

Alexander Liberman
The Hands of Marcel Duchamp, 1959, **44**

El Lissitzky
The Constructor, 1924, **129**
The Current Is Switched On, 1932, **128**

Richard Long
Midday on the Road, 1994, **20**

Ernest Lowe
A Union Organizer's Fists, 1961, **76**

Dora Maar
Danger, 1936, **117**
Nusch Eluard, Paris, 1936, **84**

Adrien Majewski
Mr. Majewski's Hand, ca. 1900–10, **24**

Sally Mann
Last Light, 1990, **91**

Robert Mapplethorpe
Lowell Smith, 1981, **67**

Mary Ellen Mark
Mother Teresa, Meerut, 1981, **71**

Paul McCarthy
#14 Untitled (Taking Photo), 1999, **31**
Right Hand (Propo Series), 2001, **21**

Ralph Eugene Meatyard
Untitled (Hand in Doorway), 1961, **52**

Annette Messager
Lines of the Hand ("Fear"), 1987, **58**

Lee Miller
Condom, 1930, **32**

Lisette Model
Lower East Side, New York, 1942, **183**

Tina Modotti
Flor de manita, 1925, **32**
Hands of a Marionette Player, 1929, **127**

László Moholy-Nagy
Photogram, 1925, **29**

Pierre Molinier
Untitled, 1969, **124**

Vik Muniz
Dürer's Praying Hands, 1993, **134**

Eadweard Muybridge
Movement of the Hand; Drawing a Circle, plate 532 of Animal Locomotion, 1887, **23**

Nadar
Paul Legrand, ca. 1855, **36**

James Nasmyth
Back of Hand & Shrivelled Apple. To Illustrate the Origin of Certain Mountain Ranges By Shrinkage of the Globe., 1874, **23**

Bruce Nauman
Studies for Holograms (a–e), 1970, **138–39**

Charles Nègre
Hand Study, 1850s, **28**

Shirin Neshat
Stories in Martyrdom, 1995, **59**

Gabriel Orozco
My Hands Are My Heart, 1991, **169**

Cornelia Parker
Blue Shift, 2002, **150**

Gordon Parks
Pastor Ledbetter, Metropolitan Baptist Church, Chicago, 1953, **173**

Irving Penn
Mud Glove, New York, 1975, **131**

Giuseppe Penone
To Unwrap One's Skin, 1971, **26**

Gilles Peress
French Hospital, Sarajevo, August–September, 1993, 1993, **55**

Roy Pinney
Reading Braille, ca. 1936, **75**

Sigmar Polke
Untitled, 1972, **141**

Robert Rauschenberg
Cy + Relics, Rome, 1952, **152**
Norman's Place #2, 1955, **185**

Man Ray
Anatomies, 1929, **96**
Hands, 1949, **103**
Rayograph with Hand and Egg, 1922, **97**
Untitled, 1924, **92**
Untitled (Dr. Lotte Wolff), 1932, **25**
Veiled-Erotic (Erotique-voilée), illustration from Minotaure 2, no. 5 (May 1934), **105**

O. G. Rejlander
Study of Hands, 1850s, **60**

René-Jacques
Hand and Dice, ca. 1928, **104**

Albert Renger-Patzsch
Hands (Potter), ca. 1925, **42**

Marc Riboud
*Jan Rose Kasmir at a Demonstration
 against the Vietnam War, Washington
 D. C.*, 1967, **179**

Ringl + Pit
Soapsuds, 1930, **61**

Herb Ritts
His Holiness the Dalai-Lama, New York,
 1987, **70**

Alexander Rodchenko
Morning Wash (Varvara Rodchenko),
 1932, **91**
Mother, 1924, **81**

Paolo Roversi
Hands of Ines de la Fressange, 1980, **64**

Lucas Samaras
Self-Portrait, 1990, **149**

August Sander
*Advertising Photogram for a Glass
 Manufacturer, Cologne*, ca. 1932, **133**

Jan Saudek
My Son, 1966, **47**

Jenny Saville and Glen Luchford
Closed Contact #3, 1995–96, **33**

Gary Schneider
Henry, 2000, **135**

Andres Serrano
The Morgue (Knifed to Death I and II),
 1992, **159**

Cindy Sherman
Untitled, #240, 1991, **160**
Untitled, #256, 1992, **51**

Osamu Shiihara
Composition, 1938, **103**

David Shrigley
Hate, 2002, **77**

Lorna Simpson
Lower Region, 1992, **143**

Rena Small
Andy Warhol's Hands, 1985, **20**

W. Eugene Smith
Stockade, 1954, **174**
*Waiting for Survivors: The Andrea Doria
 Sinking*, 1956, **175**

Lord Snowdon
Eduardo Paolozzi, 1988, **44**

Southworth and Hawes
Mother and Nursing Child,
 ca. 1844–50, **47**

Edward Steichen
J. P. Morgan, Esquire, 1903, **80**

Alfred Stieglitz
Hands with Thimble, 1920, **12**

Paul Strand
*Hands of Georges Braque, Varengéville,
 France*, 1957, **44**

Thomas Struth
*Anci and Harry Guy, Groby,
 Leicestershire*, 1989, **194**

Maurice Tabard
Study, 1930, **102**

William Henry Fox Talbot
*A Stanza from the "Ode to Napoleon"
 in Lord Byron's Hand*, prior to
 April 4, 1840, **22**

Sam Taylor-Wood
Travesty of a Mockery, 1995, **137**

Wolfgang Tillmans
Arndt Sitting Nude, 1991, **190**
Cornel, Zurich, 1993, **190**
Lutz & Alex holding cock, 1992, **191**
Smoker (Chemistry), 1992, **190**

Unknown artist
Untitled, ca. 1930, **19**

Unknown photographers
The Faith Healer (or Hypnotist),
 ca. 1855, **171**
Scene of Medical Hypnosis (?), 1856, **171**
The Sovereign Grand Lodge I. O. O. F.,
 1890s, **40**
Study of a Seated Veiled Woman,
 ca. 1854, **49**

Jeff Wall
*Rear, 304 East 25th Avenue, Vancouver,
 9 May 1997, 1:14 & 1:17 p.m.*, 1997,
 146–47

Andy Warhol
Self-Portrait, 1983, **157**

Wendy Watriss
Vietnam Veterans Memorial, 1984, **48**

Weegee
Hands, early 1950s, **122**

Edward Weston
Tina Modotti, Glendale, 1921, **79**

Minor White
William Larue, 1960, **65**

Garry Winogrand
New York City, 1969, **181**

Joel-Peter Witkin
The Boy with Four Arms, 1984, **125**

David Wojnarowicz
Untitled (Frog), 1988–89, **68**

René Zuber
Hands and Lens, 1928, **30**

Contributors

Jennifer Blessing is Project Curator at the Solomon R. Guggenheim Museum.

Kirsten A. Hoving is the Charles A. Dana Professor of Art History at Middlebury College.

Ralph Rugoff is Director of the CCA Wattis Institute for Contemporary Arts in San Francisco.

Melanie Mariño teaches the history of photography at the School of Visual Arts in New York.

Nat Trotman is Curatorial Assistant at the Solomon R. Guggenheim Museum and a Ph.D. student at The Graduate Center of The City University of New York.

Matthew S. Witkovsky is Assistant Curator in the Department of Photographs at the National Gallery of Art, Washington, D.C.

hand of God ○ *to hell in a handbasket* ○ *the end is at hand* ○ *unseen/hidden hand* ○ *cold hand of death* ○ *hands of the executioner* ○ *black hand* ○ *laying on of hands* ○ *kiss the hand* ○ *join hands* ○ *fold hands* ○ *idle hands* ○ *lend a hand* ○ *in the palm of my hand* ○ *eating out of my hand* ○ *take my hand (in marriage)* ○ *helping hand* ○ *hand out* ○ *hand-to-mouth* ○ *on the other hand* ○ *like the back of my hand* ○ *gain the upper hand* ○ *hand in hand* ○ *handhold* ○ *close at hand* ○ *handy* ○ *handyman* ○ *handy dandy* ○ *old hand* ○ *all hands on deck* ○ *right-hand man* ○ *ranch hand* ○ *stagehand* ○ *handmaiden* ○ *wait on hand and foot* ○ *handiwork* ○ *handicraft* ○ *handmade* ○ *handwrite* ○ *handle* ○ *handler* ○ *handlebar mustache* ○ *manhandle* ○ *glad-hand* ○ *handily* ○ *out of hand* ○ *out of my hands* ○ *lift a hand* ○ *raise hand against* ○ *offhand* ○ *show of hands* ○ *raise your hand* ○ *sea of hands* ○ *hands-on* ○ *have a hand in* ○ *hand it in* ○ *try hand at* ○ *set hand to* ○ *hand off* ○ *hands off!* ○ *handpick* ○ *handicap* ○ *wringing hands* ○ *evenhanded* ○ *get a grip* ○ *grasp a concept* ○ *reach exceeds grasp* ○ *grasping personality* ○ *cross fingers* ○ *green thumb* ○ *butterfingers* ○ *ham-fisted* ○ *heavy-handed* ○ *backhanded* ○ *iron hand* ○ *ironfisted* ○ *light touch* ○ *light fingers* ○ *to finger* ○ *finger man* ○ *untouchables* ○ *touching* ○ *touchy* ○ *touchy feely* ○ *touched (in the head)* ○ *in touch* ○ *out of touch* ○ *losing touch* ○ *retouch* ○ *manual* ○ *manipulate* ○ *manuscript* ○ *maneuvers* ○ *chiropractic* ○ *give me five/ten* ○ *thumbs up* ○ *thumbnail sketch* ○ *left/right-handed* ○ *southpaw* ○ *digits* ○ *digital* ○ *palm/handprint* ○ *first/secondhand* ○ *hand-me-down* ○ *handlist* ○ *handbook* ○ *handkerchief* ○ *four in hand* ○ *handsome* ○ *handcuffs* ○ *handgun* ○ *hand grenade* ○ *palmreading* ○ *poor/good hand (of cards)* ○ *in private hands* ○ *lay hands on* ○ *hand-to-hand* ○ *hand in glove* ○ *handbreadth* ○ *hand job* ○ *finger fuck* ○ *fisting* ○ *fisticuffs* ○ *hand over fist* ○ *clean/dirty hands* ○ *wash my hands of it* ○ *shake hands on it* ○ *hand over* ○ *left hand doesn't know what right is doing* ○ *one hand tied behind my back* ○ *a bird in hand is worth two in a bush* ○ *bite the hand that feeds you* ○ *caught with his hand in the cookie jar* ○ *she's a handful* ○ *the hand that rocks the cradle is the hand that rules the world* ○ *she has more goodness in her little finger . . .* ○ *hat in hand* ○ *see the (hand)writing on the wall* ○ *I've got to hand it to you* ○ *in good hands* ○ *I'm in your hands* ○ *you have my heart in your hands* ○ *death by his own hand* ○ *kill you with my bare hands* ○ *come out with your hands up* ○ *put up your dukes* ○ *hands down* ○ *hand down a decision* ○ *the moving finger writes; and having writ, moves on . . .*

WORDS AND PHRASES RELATED TO HANDS *compiled by Jennifer Blessing*